Esthetics
of the Moment

Critical Authors & Issues

Josué Harari, Series Editor

A complete list of books in the series
is available from the publisher.

Esthetics of the Moment

LITERATURE AND ART IN THE

FRENCH ENLIGHTENMENT

THOMAS M. KAVANAGH

PENN

University of Pennsylvania Press

PHILADELPHIA

Copyright © 1996 University of Pennsylvania Press
All rights reserved
Printed in the United States of America on acid-free paper

10 9 8 7 6 5 4 3 2 1

Published by
University of Pennsylvania Press
Philadelphia, Pennsylvania 19104-6097

Library of Congress Cataloging-in-Publication Data
Kavanagh, Thomas M.
Esthetics of the moment : literature and art in the French Enlightenment /
Thomas M. Kavanagh.
 p. cm.
Includes bibliographical references and index.
ISBN 0-8122-3379-4 (cloth : alk. paper)
1. Ut pictura poesis (Aesthetics) 2. Arts, French. 3. Arts,
Modern—18th century—France. I. Title.
NX549.A1K38 1996
700'.944'09033—dc20 96-30919
 CIP

CONTENTS

LIST OF ILLUSTRATIONS

ACKNOWLEDGMENTS

This book owes many debts of sincere gratitude. I want to thank Josué Harari, Marie-Hélène Huet, and Robert Tomlinson, who read the manuscript at various stages and whose generous suggestions were of immense help. I would also like to thank Tim Clark, Tom Crow, and Jacqueline Lichtenstein, colleagues or former colleagues, whose fine example and good counsel helped me think through what I wanted to say.

I gratefully acknowledge the permission of the following to reproduce their illustrations in this book: Musée du Louvre, Paris (1, 3, 7, 11, 12, 16, 18, 19, 21, 29, 31, 38, 40, 46); the Minneapolis Institute of Arts (2); the Devonshire Collection and the Chatsworth Settlement Trustees (4); Musée des Arts Décoratifs, Paris (5); the Trustees of the British Museum, London (6, 25, 27, 48, 49, 50, 51); Bibliothèque Nationale, Paris (8, 47); Die Staatliche Schlösser und Gärten, Schloss Charlottenburg, Berlin (9, 13, 41); Mrs. Oliver Colthurst, photo credit (10); the Baltimore Museum of Art, the Mary Frick Jacobs Collection (14); the National Swedish Art Museums, Stockholm (15); the National Gallery, London (17); the Cleveland Museum of Art (20); Musée de la Chasse et de la Nature, Paris (22); Musée Jacquemart-André, Paris (23); the Trustees of Halton Manor, England (24); Fondation Ephrussi de Rothschild (26); the Los Angeles County Museum of Art (28); Musée des Beaux-Arts et d'Archéologie, Besançon (30); State Hermitage Museum, Saint Petersburg (32, 39); the Trustees of the Wallace Collection, London (33); the Frick Collection, New York (34, 35, 36, 37); National Gallery of Scotland, Edinburgh (42); Musée Greuze, Tournus (43); Pushkin Museum, Moscow (44); Musée des Beaux-Arts, Lyon (45).

An earlier version of chapter 4 appeared in *Modern Language Quarterly* 55, no. 2 (1994) under the title "Reading the Moment and the Moment of Reading in Graffigny's *Lettres d'une péruvienne*" and a part of chapter 6 appeared in *Michigan Romance Studies* 14 (1994) under the title "Casanova's Autobiography of Chance." I thank the editors for their permission to use them here. All translations are my own except when otherwise noted in the first reference to a given work.

plications. Chapter Four turns to Françoise de Graffigny's highly successful novel, *Les Lettres d'une Péruvienne*, and its recounting of another voyage, that of a fictive Incan woman whose separation from her native culture and forced integration into French society occur literally without a moment's notice. Having lost one world and finding another thrust upon her, she comes finally to speak for everywoman as she discovers within her experience of the moment the unique basis of a true independence. The final chapters of Part One consider two figures who became eponymic of the vastly different implications of the century's preoccupation with the moment. Rousseau, harking back to Lahontan's fascination with the *bon sauvage* while sharing Graffigny's sense of alienation from European society, used his own vision of the moment's alchemy to generate not only an iconoclastic rewriting of human history but an eminently seductive redefinition of happiness as a series of moments generated by an affective memory abolishing the distinction between past and present. Chapter Six takes up the century's other great practitioner of autobiography, Giovanni Giacomo Casanova. Utterly unlike Rousseau in his attitude toward life in society, Casanova nevertheless elaborated within his *History of My Life* a strikingly similar celebration of the moment as the temporality of a happiness born in his acceptance of chance.

Part Two turns to painting as the other major arena of the moment's triumph. The two opening chapters of this section center on how the question of the moment and its representation became a predominant concern within the theoretical debates on the nature of painting that would inform the Enlightenment's practice of that art. Chapter Seven examines Roger de Piles and his defense of color as a systematic challenge to the suppression of the non-narrativized moment demanded by the esthetic theories of the Royal Academy and its privileging of history painting. The following chapter looks at a later stage of that same debate in the work of the other major art theorist of the early eighteenth century, Jean-Baptiste Du Bos. Concentrating on his excentric interpretation of even as thoroughly classical an artist as Poussin, I show how his analysis foregrounds not the painter's narrativized *invention* of his subject, but the spectator's always momentary and sensual *perception* of the finished work. In so shifting the center of analytic interest, Du Bos himself becomes an eloquent example of how the new premium placed on a moment outside any sustaining narrative refashioned the way that period understood paintings from a very different past. The three following chapters move away from esthetic theory to a consideration of those artists who best exemplify this celebration of the moment. Chapter Nine analyses Watteau as a painter whose languid images seek to capture the very essence of

the moment as a force of corporeal presence subverting the extended temporality of narrative intent. Chapter Ten examines the ambiguous yet crucial figure of Chardin and how the traditional division of his works into the separate categories of the still-life and the domestic scene has obfuscated what in fact is his systematic dismantling of that distinction through a representation of the moment that serves to redefine the very concept of classical mimesis. Chapter Eleven turns to Boucher and Fragonard as the two artists whose works most explicitly elaborate a thematics of sexualized desire as a primary vector of the moment's sway. Rather than reducing the works of these two artists to symptoms of a degeneracy associated with the abuses of the *ancien régime*, I argue that their concentration on the instant of desire's apparition exemplifies the attention to the moment that redefined the culture to which they speak. My final chapter analyses the very different work of Greuze as the artist most responsible for the foreclosure of the moment that would characterize the coming of the Revolution. Reducing the visual image to a vehicle consolidating the spectator's perception of an always moralizing narrative, Greuze not only returns to the semiotic protocols of classicism but prepares the way for the explicitly politicized images of David as the artist who would most clearly represent the new age of progress and responsibility. None of these chapters dealing with individual artists claim to speak of all that is important in their work. Instead, my intention is to bring into focus those aspects of their work that contributed to and redefined the period's abiding fascination with the emerging lessons of the moment.

* * *

This study of the moment as a force at work throughout Enlightenment culture runs a very real risk of being misunderstood. It is obvious that our existence consists in great part of a protracted process of negotiations and compromises that ends only with the end of life itself. Every move within such exchanges in turn depends on the integrating narrative we choose to see as both informing and emerging from the flow of events making up the moment-to-moment progress of our lives. This story of the self not only influences our choices at any given instant, but provides the basis for whatever meaning we finally see in those moments' succession. To claim to make sense of life outside such narratives, to claim to experience a moment stripped free of story's ballast, can easily seem little more than an abstracter's dream.

Yet the defining characteristic of Enlightenment culture was a concentrated effort to do precisely that: to lower one's eyes from the grandiose

sequences of society's structuring narratives and look more closely at empirical reality in all the nakedness of a here and now freed from the supports of an assumed past and an expected future. If that posture had a value and opened the way to what had not been known or thought before, it was because so many of that period's writers and artists were willing to run the risk of such a misunderstanding.

My interest in the concept of the moment that I am trying to develop here grew out of an earlier study of chance and its relation to the Enlightenment.[1] In that study I examined the cultural implications of the fact that the triumph of what we today call probability theory and the rise of the novel not only occurred during the same period, but were part of a single shift in our understanding of the world and how we represent our place within it. My major focus in that study was on gambling as an activity central to the social and cultural practices of the *ancien régime*. I argued that the experience of gambling and the questions it raised were intimately related both to the development of probability theory and to what I called "the novel of experience," as parallel attempts to domesticate the threat of chance against which the mainstream of Enlightenment thought explicitly defined itself.

Moving back from France's ubiquitous *tables de jeu*, I found myself still fascinated by one of probability theory's most vexing problems. The whole range of its central figures—from Pascal, Huygens, and Leibniz in the late seventeenth century to Laplace, Poisson, and Quetelet as the proponents of that theory's nineteenth-century mutation into the far more imperial science of statistics—was concerned with a shared dilemma. In all its variants, probability theory became the locus of a singularly explicit dialectic between, on the one hand, a constant drive to present physical and social phenomena as understandable and explicable by universally valid laws and, on the other, a troubling and therefore motivating awareness of an inadequacy within their analyses, of their inability to resolve within their theorems and conclusions the conundrum of the specific moment.

The challenge of the moment looms as a limit, as something that remains stubbornly recalcitrant to the protocols of the abstract law. The science of probability theory may well tell us exactly what the odds are of throwing a given point with two dice. That science remains, however, embarrassingly mute when it comes to speaking of what point will in fact be thrown at any specific moment. Statistics may tell us almost exactly how many suicides will occur in a given city within a given period of time. But it tells us nothing about whether or when this individual will become part of that number.

One of the most fruitful approaches to that paradox haunting the development of probability theory was provided by the late nineteenth-century German mathematician, Johannes von Kries, in his 1886 study of probability.[2] Von Kries proposes that this conflict between the universally valid law and the unpredictable specificity of the moment be understood as a tension between what he calls the "nomological" and the "ontological," between the sphere of law and the sphere of being.

Von Kries's distinction between the nomological and the ontological provides a particularly useful tool for understanding a dynamic at work within all cultures. In its broadest sense, culture is the site of a dialectic between, on the one hand, a nomological, Laplacian attempt to articulate an enabling knowledge of the universal and the necessary and, on the other hand, an ontological, Nietzschian awareness of the moment as the always specific temporality of a freedom pertaining to the realm of the individual. The sovereign predictability of the law may empower us but, as Milan Kundera has eloquently put it, there always remains the question mark of chance and the moment whispering to us of something beyond the law's empire. "Chance and chance alone has a message for us. Everything that occurs out of necessity, everything expected, repeated day in and day out, is mute. Only chance can speak to us. We read its message much as gypsies read the images made by coffee grounds at the bottom of a cup."[3]

Looked at this way, the tenor of any given culture might be defined as a function of its management of this conflict between the nomological and the ontological, between the necessary and the fortuitous, between the law and the moment. All cultural activity might be seen as oscillating between two antithetical attitudes toward the challenges of the moment. In every period there is an established, self-assured, and profoundly reassuring culture whose essential function is to extoll and embellish those sense-giving narratives through which society and the individual are invited to discover the meaning of their day-to-day endeavors. This culture reduces the moment to the status of an occasion for reaffirming the present's continuity with both the past it completes and the future it prepares. Just as surely, however, there is a second, refractory culture which refuses such narratives in favor of an iconoclastic, deconstructive, and disconcerting celebration of the moment. Within this other culture, the present is approached not as a bridge between past and future but as the elected temporality of a freedom, a discovery, and a possibility of happiness situated in a moment that refuses its continuity with the known past and the expected future.

Critics have used any number of terms to distinguish between these

two tendencies. While von Kries spoke of the nomological and the onto-logical, others have designated them as the classical and the romantic, the Apollonian and the Dionysian, the symbolic and the imaginary, the public and the private, the conformist and the subversive. No matter what vocabu-lary we adopt, the difference between them turns on their attitude toward the moment, toward the unfolding of the present as a temporality of in-determination placing its question mark at the interstices of past and future.

At the level of intellectual abstractions the present is easily imagined as one with past and future. At the level of lived experience we just as surely sense that the freedom of the passing moment, the indetermination of the present in which we live and act, sets it apart from the fixity of what is past and the uncertainty of what is still to come.

* * *

Pascal succinctly captured this paradox of the moment's ambiguity. His famous *Pensée* 172 begins with an insistence that our habit of defining the present through past and future brings with it the risk that we lose all con-tact with the one temporality in which we actually exist. Concerned with a past and future over which we have no control, we blindly surrender the only reality truly within our grasp.

We are never satisfied with the present. We anticipate the future as too slow in coming, as if to hasten its course; or we recall the past as though to stop its too rapid flight. We are so imprudent that we wander in times which are not ours, and we think not at all of the only one which belongs to us. We are so vain that we dream of times that have no reality and thoughtlessly overlook the only one that exists.[4]

Enthralled by an imaginary narrative entirely of our creation, we reduce the present to a negotiation whose finality lies entirely in the future. "We think hardly at all of the present;" Pascal continues, "and, if we think of it, it is only to use it to cast some light on the future."

Turning his attention to the results of this proclivity, Pascal completes his syllogism with the conclusion that, for those lost in the stories of their lives, happiness and life itself become objects of an eternal postponement. "Thus we never live, but we hope to live; and, always preparing ourselves to be happy, it is inevitable that we should never be so." For Pascal, this insight was part of the portrait he planned of the misery of life without God and without the consolation of a faith lifting the individual beyond the antino-

mies of what is only rational. An important current of eighteenth-century thought, the object of this study, clearly agreed with Pascal as to our loss of contact with the present. Its response to that sobering fact would, however, be radically different from the remedy Pascal sought to propose. Rather than preparing the way for an act of faith, those later voices sought instead to look directly at the elusiveness of the present and to develop, as strategies for achieving happiness within it, what could well be called epistemologies of the moment.

* * *

A final clarification before beginning. In foregrounding this notion of the moment and in focusing my attention on how a number of very different writers and artists set about giving substance to its present as a temporality of happiness and freedom, I am well aware that such privileging of the moment can never occur in isolation from narrative. In the case of the literary text, writers such as Graffigny and Rousseau eloquently show that the force of the moment can be portrayed only through its dialectical interaction with a story, real or imagined, for which events in their devastating presentness provide the overwhelming inflection. In the case of painting, the fundamentally mimetic orientation of eighteenth-century art implied that reference be made to characters, situations, and settings assumed to have a past and future as well as a present. Yet, within those continuities, the artist of the moment clearly chose to give a primary and iconoclastic preference not to the uninterrupted confluences of present with past and future but to the singular power of the moment as a temporality standing outside of and defining itself against those assumed coherencies.

Such writing and such images may well begin with an imitation of life and its susceptibility to narrative. They choose, however, to present the essence of that life as an epiphany of unexpected discontinuities rather than as a fulfillment of promised coherencies. The life portrayed in these works is one open far more to the abrupt redefinitions of the surprise than to the predictable certitudes of the sequence. In the works I will consider here, the focus is on figures able to redefine themselves in moments of freedom situated within a present undetermined by past and future. Speaking of life as unexpected and aleatory, they exist as self-surprising masters of their present.

Cognizant that these conflicting attitudes depend on each other as opposites, each of which is necessary to the perception of the other, the

PART ONE

Writing the Moment

1
VERSIONS OF THE MOMENT

What historians of France refer to as the eighteenth century most often finds itself deprived of nearly a quarter of its expected lifespan. Traditionally, it has been defined as beginning in 1715 with the death of Louis XIV and ending in 1789 with the coming of the Revolution. While few would quibble over the status of 1789 as setting off what followed from what preceded, the status of 1715 as a valid point of demarcation seems from today's perspective a holdover from the protocols of diplomatic history. Yet, in terms of the new attention to the moment in question here, the Regency's breaking of the dead king's will, the coming to power of Philippe d'Orléans, and the realignment of France's alliances away from Catholic Spain toward Protestant England all represent different but inter-related facets of an important departure and reorientation. These aspects of the Regency turn on a break, implicitly sanctioned at the highest level of civil government, with the predominance of the Church's authority as the guardian of an orthodoxy relegating the present and the moment to the insignificance of a bridge between a past and future equally subservient to the doctrine of divine providence. It is not so much that a political tilt toward the foyer of English protestantism legitimized or brought to the fore any system of religious beliefs less anchored in a sense of providential history but rather that the now palpable rift between crown and church created a different set of possibilities. Any number of subversive voices and practices hostile to both Roman and Protestant providentialism were now able to express themselves with a freedom and candor unimaginable within the austere dogmatism of Louis XIV's twilight decades. The rift between church and state during the Regency held none of the high drama of the Revolution's confiscation of ecclesiastical property or its enforced nationalization of the clergy. Yet the very stridency of the Revolution's rejection of the church was itself, I would argue, the symptom of a new intolerance toward other voices which was to make of the century's last decade a period infinitely less amenable to any real subversion of its newly established values than had been the compliant politics of abandoned religious zeal and complicitous winks toward unorthodoxy practiced by the Regency and the half-century following it.

If, in comparison to 1789, 1715 might today seem eminently forgettable

as a point of historical reference, it is because the Revolution and its ideo-
logical aftermath so completely ended the hiatus in monolithic authoritari-
anism, begun in the divided agendas of the Regency, which was to run its
twisting and often incoherent course during that period we call the Enlight-
enment. If the Sun King's synthesis of church and state was first fissured by
the regency following his death, it is not enough to say that by 1789 it and the
ancien régime had been entirely dismantled. Judged in terms of its own sup-
pression of the moment, the importance of 1789 lies not so much in what it
ended as in what it initiated. The Revolution marked the beginning of a new
and far more comprehensive ideology of the secular state which was to influ-
ence profoundly the future course of French, European, and world history.

What before the Enlightenment had been a theocentric ideology of
providence defining the present moment as the pre-ordained working out
of a divine plan stretching from creation to the end of time found itself
replaced by an ideology entirely different yet strikingly similar. The Revolu-
tion stands as the end of the Enlightenment because it rejected and redefined
the eighteenth century's newly discovered and infinitely problematic aware-
ness of the moment as a present undetermined by past and future, as a sense
of the always arbitrary foundations of any cultural narrative. In place of the
interrogations, ambiguities, and subversions concomitant with the Enlight-
enment's dismantling of any *civitas dei* defining the complementary roles of
church and crown, the Revolution substituted the new and far more viru-
lently catechetical orthodoxy of a *civitas terrana*, a *civitas hominum*. The co-
herence of its efforts depended not on any divine or transcendental principle
subordinating the moment to itself, but on a new vision of the present mo-
ment as the arena of humankind's proud perfecting of itself and the world
around it according to the purely secular protocols of science, progress, and
technology.

The Revolution and the nineteenth century certainly dismantled the
heritage of the *ancien régime*. They did so, however, in the name of a new
orthodoxy of humankind's self-sustained and self-directed quest for progress
and perfection. That quest dictated that every present moment be seen as
the arduous yet ultimately triumphant transition from a past of ignorance,
conflict, and deviance to a future of scientific knowledge, rational order,
and enforced normality. The ideals the nineteenth century sought to realize
may in large measure have been born of the Enlightenment. Their coales-
cence into a unified and coercive ideology of progress nonetheless deprived
their Enlightenment sources of the iconoclastic, corrosive, and subversive
role they had so consistently played within the context of the *ancien régime*.

With the loss of their defiance of a lingering past and with their becoming enshrined as the only recognized principles of value, they achieved a domination that marked them as enemies of the moment. Rather than speaking of the fleeting, undetermined present as a temporality of truths unglimpsed by those who wore the blinders of established dogma, they, like the doctrine of providence they rejected, reduced the present moment once again to an inherently insignificant instant which achieved value and meaning only to the extent it continued a now secular project begun in the past it perfected and aimed at the future it prepared.

Understanding the French Enlightenment, what sets it off from what preceded and followed it as well as its meaning for us today, turns on its unique sense of what I am calling "the moment": the ways in which a newfound attention to the pleasures and challenges of an undetermined present informed its culture, its economic practices, its literature, and its art. Each of these interdependent registers became the locus of a celebration of the moment as a temporality offering a previously unsuspected freedom from the fetters of continuity, from the tyrannies of an allegiance to past and future. It is here more than anywhere else that the Enlightenment most clearly traced out the project of its own fleeting moment.

* * *

Evidence of this new fascination with the moment is everywhere. The hallmark of polite sociability, developing out of the *salon* culture of the seventeenth century, became not an ability to display one's learning but a talent for all those forms of exchange incarnating the instantaneous flash of brilliance and wit. Building on and generalizing the lapidary art of the maxim, the art of conversation became in the eighteenth century a proficiency in the verbal pyrotechnics of the sharp retort, the well placed epigram, the *pointe*, and the *trait*.

If at mid-century Rousseau chose a self-imposed exile from Parisian salon life, it was not only by reason of his intellectual conviction that life in society corrupted the individual. An even stronger factor was his frequently repeated lament that he was incapable of holding his own in the verbal repartee that formed the ideal of polite conversation. Never able to master what he calls "that fashionable Paris jargon full of little witticisms and subtle allusions,"[1] and obsessed with the poor impression he felt he always left of himself in any social setting, he could only rage against his hopeless *esprit de l'escalier*, his ability to come up with the right reply only after he had left the

group and was on the way down the stairs. Society placed its highest value on that elusive combination of mental agility and compact verbal grace summarized in the term *esprit*. Writing at the end of the century, but struggling to describe the fervent pleasures of a world he felt the Revolution had so brutally swept away, Rivarol defined this crucial trait as, more than anything else, an art of the moment. "*Esprit* is that faculty which sees immediately, flashes, and strikes. I say immediately because vivacity is its essence. A dart and a bolt of lightning are its emblems."[2]

Classicism's Cartesian quest for a representation of reality endowed with the atemporal truth of mathematics, what Pascal called its *esprit de géométrie*, yielded on all fronts to a new, specific, and empirical approach to the physical and social worlds imagined as a continual flux in which timing and a careful attention to the specifics of the moment were everything. This new *esprit de finesse* rejected the pretensions of the timelessly true in favor of a knowledge anchored in the here and now of the single situation and the unique moment. Diderot, in his Prospectus to the *Encyclopédie*, defines as his guiding ambition a desire to gather together, in an order that will be only alphabetic, all the myriad elements of a knowledge forever in the making. The unintegrated juxtaposition of that work's precise entries was intended to initiate a series of innovative intersections and confluences within the ongoing development of a knowledge finally adequate to a world which "offers us only specific things, infinite in number and without fixed and determined divisions."[3]

* * *

Contrary to what one might expect, it was in the realm of finance and economic theory that the eighteenth century discovered its most powerful experience of the moment. The Regency was in many ways defined by the frenzy of the three-year period during which every sector of French society was first stimulated and then traumatized by the most overwhelming epiphany of the moment's power ever witnessed by European society. John Law's interlocking "System" of stock companies and a newly created national bank that integrated all French financial institutions into a single corporate structure began its work in a context where economic wealth was assumed to be synonymous with the tangible, stable, and enduring values of land (the ownership of which provided the nobility with a self-definition extending even to its names) and gold (the value of which was independent of its often debased representation in royal coinage). Land and gold

were defined by their imperviousness to the moment and the fluctuations it might bring.

Directly challenging that stability, Law's System turned on the creation of a series of stock companies, first the Compagnie d'Occident and finally the much larger Compagnie des Indes, which broke down the previously clear separation between fluctuating credit instruments and stable land values. The shares and notes of Law's companies were defined not, as had previously been the common practice, in terms of a monetary value but in terms of the land and extensive riches expected to flow from Louisiana, Senegal, and France's other possessions in China and the Indies. The power that Law's System would eventually exercise over previously stable land values, however, went far beyond this new approach to their definition.

One year after their original issue in December of 1718 at a value of five hundred livres, Compagnie des Indes stocks were selling at ten thousand livres, almost twenty times their issue price, providing a return on one's investment of nearly two thousand percent. As a result of that vertiginous rise in price over so short a time, land values plummeted: all who could scrambled to convert their land holdings into liquid assets which could then be invested in Law's stocks to profit from their seemingly endless rise in value. The System did, of course, crash even more quickly than it had risen. During that second phase the same land, which so many had sold at whatever price they could, found its value multiplied as it became one of the rare refuges from the stock's decreasing worth.

A distinguished line of economists have argued over whether Law should be seen as a genius, an enlightened economic theorist who anticipated the power of credit two hundred years before Keynes, or as a rank swindler whose manipulations would eventually cost France the hard-won predominance it had achieved during the glory years of Louis XIV. What remains indisputable is the fact that the rise and fall of Law's System provided not only France but the whole of Europe with a stunning confirmation of the moment's hegemony. Fortunes were made and lost depending on whether one had chosen the right moment to buy and the right moment to sell, with land as well as credit instruments revealing themselves to be equally subject to abrupt fluctuations of investor confidence.

This dawning of the age of credit as an epiphany of the moment's power reached every segment of French society. What began as an engine of growth enriching not only nobles and manufacturers but also peasants and artisans became a state of generalized bankruptcy that prompted a return to all the worst financial and fiscal practices of the past. France's collective experience

of the moment's sway, of its power to set itself apart both from the past it so giddily replaced and the future so few were able to anticipate, impressed itself on the national psyche as a phenomenon that mirrored and intensified what was happening in the less volatile precincts of literary and artistic life.

* * *

In the arts of the period, the emphasis was on the *far presto*, the sketch, and the rapidly executed crayon drawing capturing in the speed of their production the vitality of life as it was lived. What art historians today call the Rococo is, as the distinctive style of that period, usually defined as an outgrowth of the Baroque, as the transformation by the French school of a style originally anchored in the Counter-Reformation orchestrated by Rome and its satellites. Traditionally, the arrival of the Baroque style within Parisian circles is seen as having been resisted and postponed by its arch-enemy, seventeenth-century French classicism. As the somewhat ethereal abstractions of art history would have it, it was only well after its Roman apogee that the fluid forms and teeming vitality of the Baroque made their way into France by way of such painters as Antoine Watteau, Jean-Baptiste Chardin, François Boucher, and Jean-Honoré Fragonard. Yet, even in terms of these painters most often cited as the Rococo's premier practitioners, something quite different was actually happening. The traditional Baroque draws its pathos from a contrast between the sensual vividness of its forms and the metaphysical backdrop of death's inevitable sweeping away of all that seemed so very much alive. The Baroque's emphasis on a vibrating sensuality presupposes life's subordination to that other realm of disincarnated spirituality to which all are destined by death. While speaking to and through the senses, the Baroque bears witness to a reality beyond the senses, to a higher order giving them their evanescent value.

While at a stylistic level the French Rococo may appear quite similar, it breaks with its Baroque sources in important ways. Gone from the French version is any allegiance, implicit or explicit, to the omnipresence of death as the ultimate truth that gave the Baroque its fullest meaning. Both styles may center on the sensuality of the incarnate moment, but the form that would define eighteenth-century French style elides from its vitality any hint of the moment's antithesis within the timeless eternity of death. Instead, the dazzling spectacle of the instant reigns supreme, erasing even the suspicion of death and its enforced exit from the realm of the moment.

Within a culture devoted to the delights of moments abolishing even

the hint of death, the most bizarre misunderstandings became possible. Speaking of yet another art of the instant, the science of fireworks that reached new heights during the period under the guidance of Ruggieri and Torré, the chronicler Bachaumont describes how a prematurely exploded rocket during a display given at the Place Louis XV caused a conflagration so overwhelming that more than one hundred thirty persons lost their lives. Never suspecting that death could be so close, Bachaumont points out, "many of those watching imagined that this huge explosion was a new kind of show, as it provided a most impressive sight and illuminated the Place magnificently."[4]

Discussing the overwhelming premium placed on the sudden and fleeting pleasures of what he calls "immediate experience," Patrick Wald Lasowski insists that this aspect of the period's culture not only corroded any traditional sense of morality based on an awareness of death but served to "inspire its literature even in the rhythm of its sentences."[5] Jean Weisgerber, in a more recent study, extends the paradox of this preference even further with his claim that, for the eighteenth century, "the *hic et nunc*, the very moment in which one experiences, feels, and takes pleasure [jouit], must necessarily be seen as its only permanence."[6]

* * *

Theater, the art form and cultural practice obliged to respond most immediately to the changing tastes of its audience, provided the context for two quite different confirmations of the public's infatuation with the delights of the moment. One concerns the development of an entirely new genre of theatrical presentation, and the other the success of the period's premier playwright.

Society's fascination with the liberating alchemy of the moment, its insistence on creating ever more numerous venues for staging breaks in the continuities of aristocratic life, manifested itself most clearly in its massive embrace of the new genre called *parades*. These short, privately performed playlets took their origin from the boisterous and bawdy presentations of the *théâtre de la foire*, an institution which had recently been rejuvenated by its integration of the actors left without a stage when the king ordered the closing of the *Comédie Italienne* in 1697.

As originally staged by the *théâtre de la foire*, the *parades* had a function much like today's movie previews. These brief and tantalizingly obscene skits were presented on the open balcony of the theater used during the *Foire*

Saint-Germain and the *Foire Saint-Laurent* in full view of the passing crowd. As overdone as possible, they were meant to catch the crowd's attention and pull as many people as possible into the theater as paying customers for the main performance. The more they could hint at in terms of sexual or satirical content, the better the box office they generated.

Aimed at the most popular audience, these previews provided the basis of a new form of private theater that quickly became the preferred entertainment of an aristocracy that included all ranks of the French nobility. Around 1707, Thomas-Simon Gueullette built his reputation in Paris as the organizer of *parades* as private amusements separated from any public performance. In them, members of the nobility, their faces whitened and with a few lines memorized more as an occasion for free-flowing improvisation than as any serious theatrical effort, played comic roles drawn from the tradition of the *commedia dell'arte*. Harlequin, the comic plotter undone by his absurd stratagems, strutted before the timid and melancholic Pierrot. Colombine, the flirtatious coquette, did her best to outwit Pantalone, the raging father or betrayed husband.

The attraction of the *parades* for their high born participants lay in the moment of discontinuity they produced by projecting their aristocratic cast into the exotic postures of the most comically vulgar parodies. Temporarily suspending the protocols of social interaction that governed the aristocracy's rigidly structured world, the dubious antics of the *parades* provided their players with the liberation of a carnavelesque inversion of highest and lowest.

The *parades'* broad comedy also held the attraction of mocking the elaborate narratives and extreme stylization of classical tragedy, the genre imposed as a norm by the same monarchy that had so systematically undercut the nobility's powers and prerogatives. When the aristocracy mounted the stage, it was not to represent the didactic pathos of tragedy's exalted heros, but to experience all the momentary liberations of the comic surprise, the vulgar aside, and the scatalogical lazzo. The burlesque hilarity of the genre's false liaisons (*mon voyage z'est remis t'a demain*), inversions (*mircloscope* for *microscope*), and word plays (*ridevaux* for *rivaux*)[7] were a colossal parody of the exaggeratedly correct diction of the Comédie Française. In all aspects of their comedic texture, the *parades'* antithesis of player and character generated a moment of freedom from society's sustaining narratives of social identity and monarchical grandeur.

In its more traditional public setting, the period's theatrical practice was effectively redefined by Pierre Carlet de Chamblain de Marivaux's comedies

of manners. No one more effectively transposed onto the stage what had become the new conversational style of the period. Marivaux's plays incarnate the rapid exchanges of an ever evolving dialectic of sentiment based on an acute attentiveness to the always startling fruits of the unexpected moment. Turning his back on the comedy of character brought to perfection by Molière and its reliance on unchanging, monomaniacal types—the miser, the hypocrite, the hypocondriac—who shape every instance of reality to the contours of their defining obsessions, Marivaux chose instead a comedy in which everything hangs on what transpires within the moment, on the fleeting expression of half-recognized feelings and desires that are only glimpsed in the flow of witty and always disconcerting dialogue. While Henri Bergson's classic definition of the comic as "the mechanical being imposed on the living" may well apply to Molière's art, the mechanical and the predictable have nothing to do with the pyrotechnic vitality of Marivaux's exchanges between characters whose feelings turn on little more than a word uttered in a certain way and in certain circumstances. Rather than existing as implacable machines forcing reality to fit the unvarying shape of their manias, Marivaux's young lovers exist through feelings that have no shape or continuity beyond the pure present to which their exchanges give birth.

In his most famous comedy, *Le Jeu de l'amour et du hasard*, Marivaux's characters bring with them no legacy of the past aside from their vague identities as masters or servants—roles exchanged in this case as the action's initiating premise. Everything they proceed to do is decided in terms of a future that never extends beyond the *aveu*, the partner's avowal of true or feigned feelings. Concerned with a present that comes to exist only within its characters' exchanges, this work takes as its unique subject the moment of love's unexpected birth. This love, as Marivaux's other titles frequently tell us,[8] is always a surprise that redefines the instant of its unanticipated discovery. Love declares itself as a new birth transforming the characters into presences no longer able to control what they say, do, or feel. The moment of love's discovery takes place as an epistemological crisis: the sudden realization by the lovers that they no longer understand why they do what they do. The language of their exchanges, unlike the diction of classical comedy, becomes a series of exclamations and half spoken sentences interrupted as quickly as they are begun. The message of their form is that the speakers are no longer masters of what they say. "Since that moment I no longer know myself";[9] . . . "I don't understand what is happening to me";[10] . . . What is happening to me is inconceivable."[11]

Separated from the reassuring coherence of acting in accord with a plan

formulated in the past or with a goal situated in the future, Marivaux's characters experience life as a continual surprise divested of its links to anything beyond the present. To love, as Marivaux's title tells us, is to discover oneself as an uncomprehending player in a game governed only by desire and chance, *le jeu de l'amour et du hasard*. The reign of chance having abolished the character's control over any extended temporality, consciousness grasps only the single instant of a passing moment it experiences all the more intensely for the fact that it cannot be understood.

The paramount device in *Le Jeu* is the mask, the adoption of an identity which will last only so long as the characters choose to hold it before their faces. As such, the mask brings with it the freedom of a moment sundered from past and future. The past of who I was disappears behind the mask's illusion, while the future of who that mask implies I must continue to be can be abolished in the instant I discard it. In its traditional form, the mask was adopted as a tool for maintaining control over a situation by creating the option of a second identity that could be prolonged or relinquished at will. The essence and brilliance of Marivaux's theater lies in the way he raises the traditional dynamics of the mask to the second power. By staging a confrontation of mask with mask, he transforms what began as a strategy of control into a series of moments when the "truth" of the characters' real identities becomes as unreal as the masks themselves. Born in the dynamics of a dialogue between characters who hope to retain control through their strategy of the mask, their encounters assume the unexpected shape of a crisis concomitant with the discovery of a love that poses unanswerable questions to both the mask and the supposedly stable identity behind the mask. Struggling to remain independent of the expectation that they will accept their predesignated partner, Marivaux's characters find within the distance of the mask a proximity so unsettling in its effects that their identities as masters of their situation disappear within the disarray of the moment.

The lightness and inebriating unpredictability of Marivaux's comedy flow from a mirror effect that intensifies the power of the moment. As in *Le Jeu*, not one but both members of his pairs choose to protect themselves behind the ruse of the mask. In so arranging things, Marivaux eliminates from his use of this device all the more somber tones that would appear were an unmasked character to fall victim to the illusion created by another. With both characters simultaneously perpetrators and victims of a shared stratagem, neither is perpetrator and neither is victim. Instead, both become partners in a dance of discovered love all the more intense for the

fact that the characters have no anchor holding them safe from the ebb and flow of their ever-changing moments. Through his singular redoubling of the mask's dynamics, Marivaux creates the paradoxical impression that his carefully scripted exchanges take place in the pure present of the passing moment, that the action of his plays evolves within an immediacy freed from any allegiance to past and future. Marivaux's characters could, were their love to allow them the luxury of such introspection, repeat the frequently quoted confession made by the older woman writing the "Mémoir of What I Did and Saw During my Life" in his *Spectateur français*:

Strictly speaking, I live only in this very instant as it happens. It flows out of another which is already over, when, it is true, I was alive, but only as what I no longer am. It is as though I had never existed. Couldn't I very well say that my life doesn't last, but is always beginning? . . . Looked at this way, what is life? A perpetual dream, except for the very instant one takes pleasure in, and which in its turn becomes a dream.[12]

The only sentimental liability of Marivaux's predilection for characters engulfed within the moment comes from the fact that the ever-changing present can take away all that it has given. Love's present effectively precludes the continuing allegiance of a fidelity that can be promised only as a denial of the character's far more important fidelity to the moment. As the comtesse in *L'Heureux Stratagème* puts it, "far from finding infidelity a crime, I am of the opinion that one must never hesitate even a moment to commit one when tempted, unless you are trying to deceive people, which is something to be avoided at any price."[13] Even that disappointment, however, never becomes in Marivaux a cause of despair. If one has the courage to follow the logic of the moment to its conclusion, one of its most paradoxical axioms becomes, as Marianne realizes when her lover Valville leaves her for Mademoiselle Varthon, that infidelity in fact opens the way to love's rebirth within the moment. "Now he is chasing after someone new, and that will in turn make me someone new and more appealing than ever. He will rediscover me, so to speak, in a form he has not yet known."[14] Happily, the pessimism of those who would caution that what lives by the moment must also die by the moment is, in Marivaux, compensated for by the reassuring corollary that what has died within one moment can then be reborn within the next. In a universe limited to the present, the dichotomies of truth and falsehood, of fidelity and infidelity, become irrelevant.

* * *

This new premium placed on the moment is also at work in the development of the novel. At the level of form, not only did the century see an ever-greater exploitation of such shorter and more compact variants of the novel as the *conte* and the *nouvelle*, but the genre came more and more to take the shape either of a collection of letters or a loose stitching together of extended dialogues—devices that foregrounded the on-going present either of letter writing or of actual speech between characters.

At the level of theme, the novel, like Marivaux's theater, chose as its preferred subject matter the moment of desire's birth and death. Prévost's *Manon Lescaut* makes clear that the narrative coherence one gives to life can never be anything more than a retrospective and highly suspect integration of encounters that in fact occurred without a moment's notice. As concerns this primacy of the moment within the novel's concerns, however, no writer is more representative than Claude Prosper Jolyot de Crébillon. Staging over and over aristocratic society's fascination with the unpredictable meanderings of love's short form, the *amourette*, Crébillon introduces any number of characters whose debonair amorality became the basis of his consignment within literary history to the category of the *second rayon*, the licentious, and the pornographic.

While the allusive and always metaphoric diction of his descriptions makes the sexual component of Crébillon's texts seem decidedly tame in comparison to what we would today call pornography, he nevertheless effected a major modification of desire's representation within the novel. That modification had, however, far more to do with its relation to narrative structure than it did with sexual explicitness. Prior to Crébillon's reworking of the *roman licentieux*, the prototype for that genre within *ancien régime* France was Nicolas Chorier's *L'Académie des dames* of 1655.[15] That text, remaining very much within the tradition of the classical *ars erotica*, organized its depictions of sexual activity as a series of tableaus presenting a variety of physical positions. The individual tableaus followed one another with no more coherence than a sequence of days each of which brought with it a particular posture or combination of characters. In Chorier, as in the tradition he culminates, the pornographic novel was the verbal equivalent of a series of images educating the reader in the ways that bodies might pleasure one another.

Crébillon effectively reversed the proportions within that recipe. The actual physical descriptions became playfully elusive while the narrative links between them, the representation of the events bringing a given pair of bodies together, became paramount. "Time," as Peter Cryle put it in speak-

ing of Crébillon, "became the key dimension of pleasure."[16] The question giving shape to the narrative was no longer how the various body parts would fit together, but how the characters, gaining in psychological depth what they lost in exposed skin, would manage to maneuver their chosen partners toward the bliss of acquiescence.

Timing became the crucial element within this new variant of the pornographic novel. To be a man or woman of the world was to know how to make things move along neither too slowly nor too quickly toward an outcome about which neither partner had any serious doubt. Facing at every instant the question of what was to be done here and now, the temporality of the moment became paramount in this new form of novelistic representation. Unconcerned with any lasting fidelity between their couples, Crébillon's novels highlight each action as an attempt to bring into the present the desired moment of surrender. Carrying that off in turn depended on a refined art of seizing and taking advantage of every moment which life in polite society might offer as an occasion of seduction. The clever remark, the fleeting touch, and the well placed compliment, all intended to focus the target's narcissism on the seducer as a vehicle for its indulgence, depended above all on choosing the right moment for their maximum effectiveness.

While Marivaux's lightness of tone depended on the simultaneity of a discovery and a disarray shared by both partners, Crébillon's novels imposed a rigid gender distinction on the dynamics of the moment as the temporality of seduction. The term *moment* itself assumed within his novels the sense of a distinctly feminine vulnerability to sexual aggression. In *Le Hasard du coin du feu*, Clerval clarifies for Célie what he sees as specifically feminine about that term. "The moment," he states, "is a certain movement of the senses as unexpected as it is involuntary. A woman may hide it, but if it is noticed or sensed by someone interested in taking advantage of it, it puts her in the gravest danger of being more compliant than she believed she could or should be."[17] While Crébillon's women are defined by this innate vulnerability, his male characters assume the opposite posture of the predatory *libertin*. These men arm themselves for what is always a battle of the sexes with a refusal to experience any desire that would threaten the conscious control of their actors. Never allowing the passions of the heart to hold sway over the calculations of the head, the male is defined by a paranoid insistence on his mastery of every situation he chooses to exploit.

For Crébillon's male characters, love and its potential compromises of self-containment are replaced by the distanced indulgence of what they recognize only as their *goût*, a term that limits desire to the status of a passing

fancy that never survives the moment of its satisfaction. The playwright and composer Charles Collé nicely captured in his *Un Homme aimable* how it was that love's displacement by *goût* became a transformation that insures an epiphany of the moment in the term's more traditional sense.

Dit-on à présent: je vous aime?
Non l'on dit: j'au du goût pour vous.
Ce goût dont une âme est saisie,
Et qu'on prend pour du sentiment,
Souvent n'est qu'une fantaisie;
Mais il amène le moment.[18]

[Does one say today: I love you?
No, one says: I have a taste for you.
That taste by which the soul is possessed,
And which people mistake for a feeling,
Is often only a fantasy;
But it leads to the moment.]

Confined to a search for what will be enjoyed in a present cut off from past and future, Crébillon's characters indulge themselves in what can only be called a *libertinage du moment*. While his distribution of the roles of seducer and seduced along gender lines creates a world distinctly different from the one inhabited by Marivaux's mutually enamoured couples, Crébillon is equally distant from the icy calculations and protracted manipulations Pierre Choderlos de Laclos portrays a half century later in *Les Liaisons dangereuses*. Sexual seduction may remain the coin of Laclos's realm, but his characters, female as well as male, Merteuil as well as Valmont, distinguish themselves by the fact that their exploitations of the moment's desires are only a means used to consolidate a far more oppressive domination of the other. In Laclos, the moment's play of seduction is a tool serving to secure a power which recognizes no limit to its duration. In Crébillon, the seducer's attention to the moment ends as soon as pleasure has consigned desire to a past that will be forgotten as quickly as it was experienced.

Writing as he does, Crébillon assumes far more than he argues for the complicity of his readers with the world he depicts. Offhandedly discarding the devices of careful plot development and suspense (his best known novel, *Les Égarements du coeur et de l'esprit*, delivers not even half the story promised in its preface), the eliptic and highly coded exchanges between his characters leave the reader with no choice other than to follow along

with complicitous fascination or close the book. Concerned only with the refined art of exploiting the passing moment, his characters are untouched by any sense of responsibility toward a past or future including the other or the self within a shared reality. Depicting characters drawn from an aristocracy which is defiantly, gloriously, and joyfully irresponsible, Crébillon placed himself outside what would become the mainstream of the novel's subsequent development. Unconcerned with the individual's relation to any history extending beyond the self in its present, his celebrations of the moment could only be rejected by later generations of readers who would look to the novel for answers to far more ponderous questions.[19]

While one might argue that the fixation on the moment reached a kind of dubious summit in the light entertainments Crébillon turned out well into the century, the real stakes and larger implications of that fixation can be understood only when we step back from Crébillon's Parisian aristocracy and look instead at how a different vision of the moment's power grew out of the far more unsettling experience of the New World. It was in that distant world that Europe first discovered a culture of the moment whose disconcerting differences would redefine even its perception of itself.

2

LAHONTAN AND THE MOMENT
BETWEEN CULTURES

After ten years as a soldier in Québec, the Great Lakes region, and New-foundland, Louis-Armand de Lom d'Arce, better known as the baron de Lahontan, deserted his post and returned to Europe. In the early years of the eighteenth century, he published three works describing his life and travels in Canada, the Indian society he discovered there, and how he, as a European, found himself redefined by those experiences. Few writers tell us more about the complex chemistry of transcultural description and the multi-valenced role it would play in the French Enlightenment than does this soldier, spy, and chronicler of the late seventeenth-century colonization of New France.

Lahontan's major works, the *Nouveaux voyages* and *Mémoires de l'Amérique septentrionale* of 1703, and the *Dialogues de Monsieur de Lahontan et d'un Sauvage dans l'Amérique* of 1704,[1] stand as the century's first and most important examples of how the attempt to translate one culture into the language of another brought with it the elaboration of a new sense of time and a new focusing on the moment as a redefinition of the individual's place within the very substance of history. On the one hand, Lahontan's positive ideal of the Huron as *bon sauvage* will take shape around a continually reiterated insistence on the ability of the members of that faraway culture to live within the present moment as a temporality of unparalleled freedom. On the other hand, the portrayal of that distant ideal will take on meaning for Lahontan's European audience only to the extent it expresses itself both as a devastatingly negative critique of metropolitan society and as the indication of how, through a new way of situating oneself in the present, those wrongs might be put right.

Lahontan was, in far more than a figurative sense, well prepared to appreciate what it meant to live from moment to moment. At the time of his birth in 1666, his father, a member of the minor nobility of Bayonne, was already deep in debt. While a series of expedients allowed him to avoid the worst up to his death in 1674, the entire estate was tied up in lawsuits brought by creditors by the time Lahontan was eleven. Six years later, barely seventeen years old, he set out for Canada, most probably as a junior officer

in the naval forces that were then being dispatched to help in the longstanding campaign against the Iroquois who had taken the side of the English. During the next ten years Lahontan's life consisted of long winters spent reading the classics or participating in occasional hunting parties and of summers devoted to military expeditions along the Niagara frontier and as far west as the Minnesota River. These expeditions were in the close company of the Huron warriors who had allied themselves with the French. Lahontan made two return voyages to France during that period; both motivated by what turned out to be futile efforts to salvage some small part of the family estate. It was during one of those trips, while stopping at the French settlement of Plaisance in Newfoundland, that, quite by accident, he played a major role in a battle that would bring both the high point of his military career and the beginning of its inglorious end. Already promoted to captain in 1691, his distinction in leading a detachment of sixty Basque sailors as they repulsed an English attack on Plaisance led to his being assigned there in 1693 as *lieutenant du roi*. That new posting might have led to even greater glory had it not been for the fact that Lahontan found himself under the command of a man who detested him in every possible way, François de Mombeton de Brouillan, the governor of Newfoundland. The violent quarrels between the two soon generated a series of carping letters by Brouillan to Versailles denouncing Lahontan as a man who failed to do his duty, never followed orders, and who "concerns himself with absolutely nothing here, except what might serve his pleasures."[2]

Lahontan, realizing he could never win that battle and fearing his imminent arrest, abruptly deserted his post and fled to Portugal. At the age of twenty-seven, his military career was over, he had broken with France, and he had no financial resources on which to fall back. The rest of his life was spent in travels that took him to Portugal, Holland, England, Denmark, and various German principalities, where his vivid personality and considerable social skills gained him entry into the most exclusive social circles. When the French showed no interest in his discreetly tendered proposal that he might serve their interests as a spy in either Holland or Spain, he was quick to offer for sale to the English a detailed *Projet pour enlever Kebec et Plaisance* which revealed as much as he knew about the current state of New France's military defenses.

The diversity of his acquaintances and admirers and the intensity of the mark he left on them can be seen in a letter from Gottfried Wilhelm Leibniz dated November 10, 1710. After pointing out that Lahontan, unlike Jacques Sadeur, the fictional hero of Gabriel de Foigny's *La Terre australe connue* of

1676, "is a man quite real," Leibniz goes on to say of him that "he lacks neither intelligence, nor human experience, nor, I might add, knowledge." After offering a brief summary of what Lahontan has taught Europe about "the Americans of those regions who live together with no government of any kind but in peace," Leibniz did not hesitate to qualify that now stateless traveler's vision as "a political miracle, unknown to Aristotle and unheard of by Hobbes."[3] Whatever his international fame, his long travels as a man without a country meant that we know neither where he died at the age of fifty nor where he is buried.

 * * *

Lahontan's three major works are all centered on what he discovered during his career as a soldier in the New World. Each of them presents essentially the same personal experiences, geographical descriptions, and ethnographical reflections—but in three quite different forms. The first, the *Nouveaux voyages*, is cast as a series of twenty-five letters written between November 8, 1683 and January 31, 1694 to an uncle in France to whom Lahontan describes the new continent he is in the process of discovering. His second work, the *Mémoires*, abandons the epistolary format and offers instead separate chapters dealing with topics as diverse as the flora and fauna of New France, the conflicting political ambitions of France and England in North America, and various aspects of the Huron society and culture he encountered there. His third work, the *Dialogues*, consists of what are presented as the transcriptions of five conversations between a Frenchman, appropriately enough designated as "Lahontan" [whose name I will enclose in quotation marks whenever it refers to the rather slow-witted character representing the European everyman participating in these conversations as opposed to Lahontan the author] and a Huron chief named Adario. Those dialogues, the first of their kind in European literature, amount to a cross-cultural debate between two distinct and oppositional voices who meet to discuss religion, law, happiness, health care, and marriage customs.

These three reworkings of the same material differ from each other primarily in terms of the perspective from which they are written. The first is a clearly Eurocentric discourse written by a young Frenchman for his equally French uncle who remains at home. The second assumes the more distanced perspective of a classifying and historicizing voice that organizes its material into analytic headings and presents it with an apparent objectivity unattached to any explicitly personal viewpoint. The third, the *Dialogues*,

moves in a quite different direction. Dropping any pretense to an objective, third-person discourse, it opts for the direct interaction between mutually defining and mutually contesting first and second-person voices identified with specific personalities.

Whether presented through letters, analyses, or dialogues, Lahontan's Canada fascinated its European readers. His work was re-edited eight times in the twelve years following its original publication, and was quickly translated into English, Flemish, and German. What most stimulated his readers' imaginations about these Hurons from another world, what set them apart from Europeans, was the radical freedom of their way of life. "The Savages are wholly free from care; they do nothing but eat, drink, sleep, and ramble about in the night when they are at their villages. Having no set hours for meals, they eat when they are hungry" (1,650). Even when gathered together in a community, each individual remains untouched by any obligation flowing from a consensus established in the name of the group. Free to do as they wish, their lives are a succession of moments unmediated by any larger obligation forcing them to attune their present to a communal past or future: "Everyone is his own master, and does what he pleases, without being accountable to another, or censured by his neighbor" (2,857).

What most characterizes the Huron is an inexhaustable capacity for self-determined activity. To be a Huron is to incarnate an uncompromised potency allowing the individual to respond to any contingency presented by the natural world. When Lahontan tries to express what it means to be a Huron, his most frequent trope is a stringing together of verbs expressing activities which assure the independence of the individual. "Among them the true qualifications of a man are, to run well, to hunt, to bend the bow and manage the fuzee, to work a canoe, to understand war, to know forests, to subsist upon little, to travel a hundred leagues in a wood without any guide, or other provision than his bow and arrows" (1,639–40).[4] To be a Huron is to retain at every moment the ability to act as one chooses. The individual Huron lives independent not only of social consensus, but of a harsh natural world characterized by its demanding extremes. "They are indefatigable and inured to hardships, insomuch that the inconveniences of cold or heat have no impression upon them" (1,634).

In the *Dialogues*, Adario, like the European "Lahontan" with whom he speaks, is a soldier. His prowess in battle and his actions as a warrior are, however, carried out in a context distinctly different from that giving meaning to the actions of a colonial officer. For Lahontan and the soldiers with him, every skirmish and expedition draws its meaning from its relation to

the larger political goal of consolidating and expanding an empire which had far more meaning in the ministries of Paris and London than it did on the shores of the Saint Lawrence. The Huron's feats of arms, to the contrary, retain an entirely personal finality. He fights not for any abstract notion of empire, but for the consolidation of a purely personal sense of *gloire*. Were you to be a Huron, Adario tells his interlocutor, "your riches would be of the same stamp as ours, and consist in the purchasing of glory by military actions" (2,852).

The result of this self-containment, of this living of life as a present complete within itself, is a robust health and longevity far surpassing anything known to Europeans. "The savages are very healthy, and unacquainted with the infinity of diseases that plague the Europeans. . . . If a man dies at the age of sixty years, they think he dies young, for they commonly live to eighty or a hundred; nay, I met with two who were turned of a hundred several years" (1,637). The Huron way of life is grounded in the tangible reality of a body carefully fashioned to preserve the individual's capacity to act as he wishes in even the most demanding circumstances. Its purpose lies not in the possession of any object, wealth, or empire distinct from the self, but in the preservation of the individual's all-surmounting potency. What the Huron seeks, Lahontan tells us, is a "contentment of mind which far surpasses our riches" (1,639).

The Huron lives within the forever reborn freedom of the present because he has chosen to define his existence as a way of being rather than as a drive toward possessing. He dwells within the realm of *l'être* rather than of *l'avoir*. In his every action, the Huron seeks to capture, possess, and accumulate nothing beyond his warrior's consciousness of an enhanced glory consubstantial with the fact of his being. Lahontan's Hurons live untouched by such notions as property and empire. They exist outside the realm of the object possessed because, as a reality distinct from their autonomous being, it carries with it the extended and enslaving temporality of the European and the purposes he serves. The object possessed speaks less of any present in which it might be enjoyed than it does of a past when it was acquired and of a future in which it will be threatened. To traffic in objects is to subordinate the free present of self-contained potency to the bloated temporality of a history bringing with it obligations to both past and future. The Huron remains free because he possesses nothing beyond his being within the present.

* * *

Thus far I have approached Lahontan's description of the Huron ideal as though it were coherent within itself. In fact, what he has to say about the Hurons, the overwhelming desirability of the ideal they represent, cannot be read as ethnography, as an attempt to present objectively what he had found on another continent. Whether he writes to his uncle, assumes the posture of the reflective analyst, or engages his namesake in dialogue with Adario, what Lahontan has to say about the Hurons is part of a thoroughgoing critique of French society.

The inseparability of his New World ideal from a vision of Europe's degeneration is nowhere more apparent than in his treatment of religion. While he makes occasional reference to the Huron belief in a "Great Spirit" who created the universe and remains present in all things, Lahontan's focus always returns to what distinguishes Huron religion from its European counterparts: reason alone, rather than any version of a Holy Scripture, is their only guide to what must be believed; Huron religion is uncompromised by any equivalent to Christianity's division into its Roman and Reformed variants; and Huron culture would never tolerate the chasm they perceive between what the Christian missionaries preach and how the practitioners of that religion actually live their lives. This voice seeming to speak of things Canadian continually reiterates a distinctly European discourse of secular rationalism which was immediately recognizable by Lahontan's more free-thinking readers as well as their ecclesiastical opponents. The Jesuit editors of the *Journal de Trévoux* quickly qualified what he had to say about religion as "a summary of the strongest arguments of our Deists and Sociniens against the submission we owe our faith and against the docility of reason before the empire of Revelation."[5] The equally orthodox Jacques Bernard, writing in the *Nouvelles de la République des Lettres*, saw Lahontan's statements on religion as such old news that they merited no reply. "As the greatest part of his challenges are hardly different from those of our libertines, which have been answered a thousand times, we will not tarry over them."[6]

The real goal of Lahontan's rewriting of the same material in three versions becomes clearest in the last of his treatments, the carefully staged debate between Adario and "Lahontan." The explicitly dialogic form of that version compels the aggressive voice of the other to speak not only of the Hurons, but, because he has visited France and learned its language, of the contrasts between those two societies and the individuals they produce. The real purpose of Lahontan's writing has everything to do with the impact he sought to have on his European readers, with an insistence that the reality

of the Hurons become a vehicle for forcing his readers to adopt a new way of looking at their own society. While writing about a New World, Lahontan, like Montaigne before him,[7] invites his compatriots to become part of what Roger Caillois would later call a "sociological revolution." His goal is to invite his French audience to look at their own society as though they were part of a different, alien culture.[8]

The Huron is, as we saw, free. But that freedom can only be understood in contrast to the enslavement of the individual within European society. What is said about the Hurons in the *Mémoires* depends on a close acquaintance with a broad cross-section of European institutions: monarchy, colonial wars, family structure, *lettres de cachet*, and public executions.

They [the Hurons] brand us [the French] as slaves, and call us miserable souls whose life is not worth having, alledging that we degrade ourselves in subjecting ourselves to one man who possesses the whole power and is bound by no law but his own will; that we have continual jars among ourselves; that our children rebel against their parents; that we imprison one another, and publickly promote our own destruction. (1,639)

In the *Dialogues*, Adario cannot describe what he means by Huron fraternity until he has first unmasked what grotesquely passes in France as the freedom of even its most exalted personnages. "The grand Lords that you call happy lie exposed to disgrace from the king, to the detraction of a thousand sorts of persons, to the loss of their places, to the contempt of their fellow courtiers; and in a word their lost life is thwarted by ambition, pride, presumption, and envy. They are slaves to their passions and to their king, who is the only French man that can be called happy, with respect to that adorable liberty which he alone enjoys" (2,856). Only when the fiction of European liberty has been disposed of can Adario go on to describe the very different reality of his own world. "There are a thousand of us in one village, and you see that we love one another like brethren; that whatever anyone has is at his neighbor's service; that our generals and presidents of the council have not more power than any other Huron; that detraction and quarreling were never heard of among us" (2,856). Even at the level of the single sentence, Adario's joy at being a Huron must express itself through a contrast with the servitude of the French: "I would rather continue as what I am than pass my life in those chains" (2,861).

Such chains are, for Adario, both literal and metaphoric. No one can deny, he insists, that the French have forged for themselves bonds of metal enslaving each to all. In Europe, the gold and silver shackles of money im-

pose a universal bondage. Money is the link and common denominator of all possessions. It is the universal prize and recompense motivating the European's every action. The quest for money, as much as any shared language or religion, provides the animating principle of all they do. To be a Huron is to reject the contamination of everything money implies. In the *Mémoires*, Lahontan concedes that there are a small number of Hurons who have become Christian, who live on the outskirts of the French settlements, and "among whom money is in use." Aside from that corrupted minority, however, the Hurons refuse all contact with what is the universal dissolvant of human relationships. "The others," Lahontan insists, "will not touch or so much as look upon silver, but give it the odious name of the French Serpent. They will tell you that amongst us [the French] the people murder, plunder, defame, and betray one another for money, that husbands make merchandise of their wives, and the mothers of their daughters, for the lucre of that metal" (1,638).

Speaking through Adario, Lahontan's denunciation becomes even more sweeping. Calling money "the tyrant of the French" and "the tomb of the living," the Huron chief universalizes the influence of money as the single cause of all human vice. "Money is the father of luxury, lasciviousness, intrigues, tricks, lying, treachery, falseness, and in a word, of all the mischief in the world" (2,850). Confronted with Adario's diatribe, the hapless "Lahontan" offers a rebuttal which only confirms his adversary's position. Europe would no longer be Europe, but only "the most dismal confusion that imagination itself can reach," were it deprived of the foundation sustaining its vast edifice of parasitism. "Do you not see, my friend," "Lahontan" insists, "that the nations of Europe could not live without gold and silver, or some such precious thing. Without that symbol, the gentlemen, the priests, the merchants, and an infinity of other persons who have not strength enough to labour the earth, would die for hunger. Our kings would be no kings; nay, what soldiers should we then have? Who would then work for kings or anybody else?" (2,851).

This blanket indictment of the three estates making up *ancien régime* society—the clergy, the nobility, and the people—implies a universal subjugation to the tyranny of money and the unhappiness it brings. Even the wealthiest and most powerful members of that society—"this prince, this duke, this mareshal, this prelate"—are devoured by an envy that transforms the fullest coffers into a source of anguish at the thought that others deprive them of having everything. "Your great Lords hate one another in their hearts; they forfeit their sleep, and neglect even eating and drinking, in

making their court to the king, and undermining their enemies; they offer such violence to nature in dissembling, disguising and bearing things, that the torture of their souls leaves all expression far behind it" (2,856).

Trying to explain to Adario what happiness can mean in such a context, "Lahontan" finds himself forced to admit that it is the very opposite of the tranquil self-sufficiency the Hurons so naively associate with that term. "To be tranquil of mind passes in France for the character of a fool, of a senseless, careless fellow. To be happy, one must always have something in his view that feeds his wishes" (2,857). Europe, with its ideal of happiness divorced from the Huron tranquility of "confining his wishes to what he enjoys" (2,857), has, thanks to the corrupting influence of money, seen even its most fundamental ethical concepts subverted to the point where any term implies its contrary. In the same way that the self-sufficient Huron can never be deemed "happy," so also he is excluded from the European category of "honor." "A Huron," Adario points out, "is a stranger to money and a moneyless man is no man of honor in your way" (2,863). But, Adario is quick to add, nothing would be simpler than for him to transform even the most vile slave into a man of honor according to the French definition of that term. "I have only to bring him to Paris, and furnish him with a hundred packs of beaver skins, to answer the charge of a coach and ten or twelve footmen. As soon as he appears in an embroidered suit with a retinue, he will be saluted by everyone and introduced to the greatest treats and the highest company" (2,863). Such "honor" no longer has anything to do with the qualities of the person so designated, but depends entirely on the amount of money at one's disposal. Between the lackey and the man of honor there is no difference in kind. All possibility of a distinction between the two has been dissolved by the anonymous force of money. In fact, given the moral valence of the activities through which money is acquired, the lackey is a far more suitable candidate for this redefined station of the honorable than anyone constrained by a fidelity to the now archaic values once associated with that term. "In fine, he'll be such a man of honor as most of your French footmen come to be after they have made shift, by infamous and detestable means, to pick up as much money as will fetch that pompous equipage" (2,863).

* * *

Two versions of what is essentially the same question must be asked concerning this idealized portrait of the Huron as *bon sauvage*. What moti-

vated Lahontan to describe the Hurons as he did? And what do the reactions of his readers to these descriptions tell us about the broader European society to which his works were addressed? What Lahontan found or imagined in Huron culture was in many ways the metaphoric resurrection of a lost ideal rooted far more in French than in New World history. Everything positive about the Hurons, everything that sets them apart from their colonizers, recapitulates the central tenets of the feudal ideology that sustained the declining nobility of which Lahontan was an exemplary representative. The son of a dispossessed family from the minor nobility, Lahontan writes within a political context that had been reshaped by nearly four decades of rule by Louis XIV. The Sun King's consolidation of political power within a centralized monarchy had been accomplished at the direct expense of the local nobility. His two-pronged strategy of reliance on royal *intendants* drawn from the ranks of the wealthy bourgeoisie and the direct encouragement of a mercantilist economy had effectively brought to heel those nobles who had once claimed an effective independence from the crown within the limits of their fiefs.

Under the feathers and war paint of savages free within a Golden Age, the primitive Huron is a metaphor incarnating the values of a class struggling to recapture the legacy of its lost past. The Hurons, like the feudal nobility, are represented as a warrior class. The *gloire* of each individual is, as we saw, a function of his prowess in battle, of the fortitude with which he defends rights and privileges accruing to him as a fact of birth. Aside from the greater or lesser prestige of glory achieved by each, all are equal and all are masters of their separate domains. The Huron chief, like the king of times now past, is simply a *primus inter pares* in relation to the other warriors. He exercises no jurisdiction over his peers beyond the privilege of enlisting their participation in campaigns against any alien foe threatening the common good. The Huron chief, unlike the French king, could never set out to abrogate or compromise the privileges (from *privilegium*, a "private law") that allow his peers to rule within their separate domains. Absent from Lahontan's mythical Huron society is any trace of the bourgeois, of a class juridically inferior to the nobility yet so powerful through its control of trade and finance that a potentially despotic monarch had to ally himself with them in his efforts to subjugate his aristocratic equals. If money has for Lahontan become a principle of universal degradation, it is because, seen from the perspective of the nobility from which Lahontan came, its power exists only at the misguided sufferance of a king who has allowed it to become an object of universal greed. Only the increasingly marginal nobility lives according to a different

ethos of personal glory precluding participation in trade and commerce as derogations of their social status. The Huron, like the ideal noble, lives untouched by an economy based on money and exchange. His is an economy of the gift, of the promise kept, of a conspicuous consumption intended to signify personal independence from the constraints of carefully calculated balance sheets.

There is, however, a second, more tragic implication to this metaphoric equivalence between the Huron and the French nobility. As independent and uncorrupted as those forest warriors may be, it is clear throughout Lahontan's works that these native peoples are doomed to ever greater subjugation by Europe's colonizing powers. The Hurons and Iroquois no longer battle each other as traditional and respected enemies who provide, each for the other, challenges provoking ever greater valor and courage. Both nations have been reduced to the status of proxies in the service of Europe's conflicting imperial ambitions, the Hurons as instruments of the French and the Iroquois of the English. Their European colonizers see them as expendable resources to be exploited until they are exhausted into extinction. It was not surprising, as Lahontan watched his career and future being destroyed by Brouillan's reports to Versailles, that he should see these impotent victims of monarchic colonialism as metaphors of himself and his class. The bitter irony of his identification with these doomed nations comes through most clearly when, in a discarded preface to the *Dialogues*, he claims his only wish is to return to Canada and live with the Hurons because "they have not been reduced to the fatal necessity of bending their knee before certain demi-gods whom we adore under the pretty title of Ministers of State."[9]

Paradoxically, a current of nineteenth-century socialist thought associated with Pierre-Joseph Proudhon and his disciples chose to misread Lahontan's Hurons as the prescient anticipation of an anarchism to come, and as the primitive models of imagined utopian communities whose members would remain unfettered by the demands of any organized state. In fact, Lahontan's fascination with the Amerindian societies he encountered in the New World was far less the anticipation of any variant of a socialism to come than it was an allegiance to the past. Jean-Marie Apostolidès goes so far as to argue that Lahontan's portrayal of Huron society should be read as a variation on the explicit arguments in favor of a restored feudal nobility offered by his contemporary, Henri de Boulainvilliers. Boulainvilliers's thesis in his *Histoire de l'ancien gouvernement de la France* is that the privileges of the nobility derive from the fact that, as a class, they represent the descendants of the Frankish warrior who defeated and subjugated the Gauls, thus lay-

ing the foundation for French society as it would continue throughout the *ancien régime*. For Boulainvilliers, all the "reforms" effected by Richelieu and Louis XIV as they consolidated the centralized power of the monarchy are nothing more than illegitimate and intolerable infringements on rights grounded in the historical fact of that defining past. As Apostolidès sees it, Lahontan simply transposes in terms of a geographic separation the same argument which Boulainvilliers expressed through an appeal to the lessons of the past. Lahontan's Amerindians and Bougainvillier's Frankish warriors thus provide, from two different perspectives, parallel arguments that the privileged status of the nobility be restored. For Apostolidès, Lahontan's Hurons become what he calls a "translation of the mythic situation of a feudal nobility."[10] There is, however, he claims, an important liability to Lahontan's choice to situate his ideal at a geographic as opposed to a historical remove. In allowing geographic separation to displace temporal continuity, Lahontan becomes guilty of what Apostolidès calls a *dédialectisation de l'histoire* and condemns himself to the ultimately irrelevant exercise of describing an "equality of all men . . . which has no existence outside of discourse" (pp.79–80).

* * *

While Apostolidès's preference for Boulainvilliers's historical argument over what he dismisses as Lahontan's utopianism may make perfect sense to our post-Marxian eyes, its appeal to twentieth-century sensibilities has the disadvantage of compromising our understanding of why, at the beginning of the eighteenth century, Lahontan found so much larger an audience than did Boulainvilliers's diatribes of class resentment. Lahontan may, consciously or unconsciously, have fashioned his portrait of the Hurons as the dream of a nobility restored to its past prominence. Arguments in favor of that program were certainly an important component of early Enlightenment resistance to an increasingly muscular monarchy. In this context, a document like Montesquieu's fable of the Troglodytes in Letters XI through XIV of *Les Lettres persanes* could fruitfully be read as a similar exercise in fantastic ethnography whose demonstration of the risks of despotism inherent in an unchecked monarchy finally convey a justification of the nobility not unlike Boulainvilliers' or even Lahontan's. Reading Lahontan this way does bring into focus one aspect of his intentions. Such a reading says, however, very little about the intensity of the response his works evoked in a literate public extending far beyond the disenfranchised nobility.

There is finally something decidedly anachronistic in presupposing that all those readers who reacted so enthusiastically to what Lahontan had to say about Huron freedom and independence did so because they saw them as a metaphor for a class whose preferences had been eroded by an ascendant monarch.

If Lahontan's Hurons exercised the fascination they did, it was because those nomadic and self-sufficient warriors retained a liberty allowing them, at every moment, to enjoy the circumstances of life as they found them. Lahontan's images of healthy, happy, and unencumbered men and women living in forests and along lakes teeming with game and fish spoke eloquently to a Europe where famine was rife and political oppression everywhere. Lahontan's descriptions of the Huron way of life always returned to the invitation Adario never tires of repeating: "'tis your interest to turn Huron, in order to prolong your life. You shall drink, eat, sleep, and hunt with all the ease that can be; you shall be freed from the passions that tyrannize the French" (2,858). It was hardly necessary to be a member of the marginalized nobility to look with longing on a world where each could say "I am master of my own body, I have the absolute disposal of my self, I do what I please, I am the first and last of my nation, I fear no man, and I depend only upon the Great Spirit" (2,831). That dream held an appeal equally as intense for the cramped city-dweller, the struggling merchant, the unemployed artisan, or the oppressed peasant as it did for those consumed with aristocratic resentment. While few peasants or artisans could be counted among the literate public that grabbed up so many re-editions of Lahontan's works, his vituperation of a society based on money, rank, and obligation spoke clearly to broad currents of frustration that extended even into the ranks of the established bourgeoisie that had so profitably submitted to the designs of the crown and thus might be assumed to be Lahontan's most obvious "class enemies." "What is proper conduct [la bienséance]?" Adario asks at one point, "Is it not an everlasting rack, and a tiresome affection displayed in words, clothes, and bearing?" (2,860).

Lahontan's New World ideal appealed to his readers not so much as members of any particular class, but as beings endowed with a physical body. The Huron body is a resilient nexus of physical strength and acquired skills allowing them to live in nature on their own terms and as the equal to any challenge it might present. The Hurons are at peace with themselves and their world because, at the inalienable level of their physical bodies, they exist as islands of corporeal autonomy. Lahontan's repeated celebration of the Huron body elaborates itself in tandem with his equally frequent cri-

tiques of its European antithesis: the elaborate protocols of court dress and ceremony whose constraining absurdity spoke eloquently to those agents of the crown who experienced such rituals as their daily reality. Adario can only marvel at what he saw in France and the freely chosen insanity of those who submit themselves to such constraints: "Could I ever accustom myself to spending two hours in dressing, shifting myself, putting on a blue suit and red stockings, with a black hat and a white feather, besides colored ribbons? Such rigging would make me think myself a fool" (2,860). The Huron body is, to the contrary, a force that draws from nature the sustenance of its moment-to-moment independence. The European body, contorted by the obligations of a rigid hierarchy, is the effaced vehicle of vestiary signs confirming the individual's subservience to the social order.

Lahontan's resurrection of a body his readers knew primarily through its repression is confirmed by his foregrounding of Huron sexuality. Lahontan's description of the directness and freedom of Huron responses to the moment of desire would find no equal in European literature until the 1770's when the travel narratives of Louis-Antoine de Bougainville, his companions Fesche and Comerson, as well as Denis Diderot's *Supplément au voyage de Bougainville* would establish the island paradise of Tahiti as a *Nouvelle Cythère*.

In the chapter of the *Mémoires* entitled "Amours and Marriages of the Savages," Lahontan provocatively points out that, from a European perspective, "the girls indeed are a little foolish, and the young men play the fool with them not infrequently" (1,669). In the *Dialogues*, the pompous voice designated as "Lahontan" responds to Adario's description of the sexual freedom the young Huron men and women enjoy before marriage by labeling it as a "lewdness [putainisme]" that erases any dividing line between the Hurons and rutting animals: "In a word, all this scene of liberty reduces their way of life to a continued course of debauchery, by granting to nature, in imitation of the beasts, an unlimited satisfaction of all its desires" (2,883). As the term *putainisme* suggests, the crucial difference between European and Huron sexuality turns on the far greater liberty and candor of Huron women. In what can be read as a projection of male desire which will be taken up even more insistently by Europeans writing about the *Tahitiennes*, Huron women are presented as intensely lascivious. Enjoying and practicing sex far more often than their European sisters, they are imagined as paying a price at the level of their fecundity: "It is for the same reason, my poor Adario, that they conceive not so easily as ours. If they did not indulge themselves too much in the frequency of embraces, and receive

them with an over-bearing keenness, then the matter calculated for the pro-
duction of children would have time to assume the necessary qualities for
the business of generation" (2,877). To a Europe obsessed with increasing
its birth rate and ready to equate a nation's wealth with female fecundity,
the commodification of women and the subordination of their desire to the
duty of child-bearing is only a metaphor away. The character "Lahontan"
quickly naturalizes all these implications: "It's the same case with a field that
is sowed continually without being suffered to lay fallow" (2,877).

Huron sexuality, as is already clear from the European's scandalized re-
actions, distinguishes itself by a redefinition of the woman's relation to her
desire. "Lahontan" insists on pointing out to Adario that, although "the lib-
erty which your boys have of going naked" may be exotic, that practice has
a social effect which is distinctly troubling: "[that liberty] creates a terrible
hurricane in the minds of your young girls; as they are not made of brass,
so the view of those parts which decency forbids me to name, can't but call
up the amorous fire, especially when the young wantons show that nature is
neither dead nor untrue to the adventures of love" (2,878). Responding to
his ambiguously scandalized yet fascinated European interlocutor, Adario
pragmatically observes that, since the young Huron women are "as fickle
as yours," they do benefit from certain obvious dimensions of that practice.
"The young women taking a view of the naked parts, make their choice by
the eye; and for as much as nature has observed the measures of proportion
in both sexes, any woman may be well assured what she has to expect from
a husband" (2,879).

The playful obscenity of this exchange does not mask what is a crucial
distinction between Huron culture and European patriarchy. Each offers a
quite different answer to the question of who has the authority to script
the family narratives according to which each generation will form the next.
"Are not women," Adario subversively asks, "entitled to the same liberty as
the men?" (2,882). In the closing dialogue entitled "On Marriage," Adario
begins the day's conversation by announcing to his European visitor that he
has just visited his daughter and learned she is set on a marriage of which he
disapproves. Rather than evoking any paternal authority, he quickly resigns
himself to his daughter's choice. As he explains his position to his stunned
interlocutor, the daughter's words take the place of the father's as he offers
a verbatim restatement of her rebuttal of an authority he admits he has
no right to invoke. What Adario's daughter says through her father stands
as a stark refusal of Europe's arranged marriages and makes explicit the
commodification of women on which that practice is based. For European

readers long accustomed to a regime in which neither a man nor a woman could marry before the age of twenty-five without the father's consent,[11] this statement attacks, in the name of feminine desire, the overwhelming control of the family narrative exercised by the father in the choice of a son-in-law. "What do you think father! Am I your slave? Shall not I enjoy my liberty? Must I for your fancy marry a man I do not care for? How can I endure a husband that buys my body of my father, and what value should I have for such a father as makes brokerage of his daughter to a brute?" (2,876).

Instead of being ruled by a narrative imposed by the father, the Huron woman exercises in her choice of a husband the same freedom of the moment she has enjoyed since puberty. Both the *Mémoires* and the *Dialogues* contain elaborate descriptions of a nightly ritual Lahontan calls "running the match" (*courir l'allumète* or *courir la lumète*). According to this practice, unmarried Huron men would, once the sun had set and the unmarried women had retired for the night, take a small stick and light one end of it in the communal fire. Holding it like a torch, each would then proceed as a supplicant to the hogan of the woman he wished to court. When the man presented himself at the foot of the woman's bed, the choice of how to respond in that moment was entirely hers. "He makes up to her bed, and if she blows out the light, he lies down by her; but if she pulls her covering over her face, he retires" (1,672). As he describes this practice, Lahontan insists that this was not simply a formalized preliminary between established couples. More often than not, a young woman would find herself solicited on any given night by a succession of different suitors. "What is most singular is that they will allow anyone at all to sit upon the foot of their bed, only to have a little chat; and if another comes an hour after, that they like, they do not hesitate to grant him their last favors" (1,673). The woman's choice as to whose torch is extinguished and whom she turns away from is entirely a function of her reaction to the moment's inspiration, caprice, and desire. The freedom of this choice, which "Lahontan" can only see as an incredible libertinage, stems directly from the woman's insistence on preserving her freedom and independence. "The reason for this is . . . that they will not depend upon their lovers, but remove all ground of suspicion both from the one and the other, that so they may act as they please" (2,673).

Everything Lahontan has to say about this ritual and the choices it affords the Huron women places that culture in what is, for his readers, a disorienting middleground of transcultural imagination. On the one hand, his description of the women's behavior is not without echos of what eighteenth-century France would call the "coquette." On the other hand,

such a term clearly has no meaning within a culture where there is no equivalent to the repression of female sexuality so much a part of French society. Lahontan's readers find themselves up against the impossibility of any adequate translation of the practices of one society into the language of another distinctly different society. While the European reader, like the dense "Lahontan," may tend to impose on that other society such notions as "libertinage" and "coquette," if not "perpetual debauchery" and "lewdness," it is equally clear that those terms make no sense in a context where their necessary corollaries of constraint, repression, and patriarchy hold no sway.

Lahontan highlights this same impossibility of transcultural equivalents when, in describing the men's reaction to such "promiscuity," he insists on the inadequacy of what, for the European, would be the obvious reaction of jealousy. Attempting to express this conceptual discontinuity, Lahontan can only enumerate what the Hurons seem to be missing and how, where his readers would expect one term, only a quite different one is appropriate. "They are altogether strangers to the blind fury which we call love. They content themselves with a tender friendship, that is not liable to all the extravagencies that the passion of love raises in such beasts as harbor it; in a word, they live with such tranquility, that one may call their love simple goodwill" (1,66). After insisting that the Hurons are "discreet beyond imagination" and qualifying their "friendship" as a sentiment which "although strong" is "free of transport," he settles on a wording for his description of this masculine non-jealousy which again brings us startlingly close to the ethos of *le petit maître*: "he is very careful in preserving the liberty and freedom of his heart, which he looks upon as the most valuable treasure upon earth." From all this, crossing again the assumed demarcations of cultural value, he goes on to conclude that "they are not altogether so savage as we are" (1,669).

The power of Lahontan's text derives from its uncertain oscillation between the reassuringly familiar and the unsettlingly exotic. The unstable amalgam of the known and the inexpressable frees language from its responsibility to impose the continuities of a single culture on the recalcitrant reality of the other it purports to describe. Rather than confirming the superiority of any European culture or social order, Lahontan subverts the fiction of fixed identity. His works chronicle a confrontation of cultural values extending even to the intimacies of desire and sexuality. Lahontan may well approach the reality of Canada and its Hurons with the prejudices of his particular class. What he discovers there, and what he attempts to communicate to his readers, nonetheless expresses an experience of cultural relativity.

Living that reality and describing it for his reader lead him from where he once was to a new destination and a new identity which is neither entirely of the one or entirely of the other. He and his readers come to inhabit a shifting middleground of what is between the two, of life's inevitable fluidity and discontinuity. Lahontan's work speaks of how travelers and readers, no matter how heavy the ballast of the same, might draw from their fascination with the other a glimpse of their power to become other than what they were. Life, this late seventeenth-century voyager, soldier, and deserter has learned, is a series of discontinuous moments and random intersections holding open the possibility that the individual might become other than what the social order chooses to dictate.

Lahontan stands between two possible readings. At one extreme, we might, like Apostolidès, read his portrayal of the Hurons as an extended metaphor defending the values of the nobility in their resistance to a centralized monarchy. Approached in this way Lahontan's text becomes a kind of fable over which he retains complete control. On the other hand, such a reading too rapidly discounts what is clearly Lahontan's very real fascination with the subversive power of the other to call into question the stability of cultural identity. Lahontan's Hurons live their lives as a series of disjunctive, non-cumulative moments within a nature to which they are always the equal. As such, and by reason of that otherness, they represent for their European audience the opening of a new perspective on their own momentary and momentous experience of life as a potentiality that overflows the constraints of any culture's categories. Lahontan, in his attempt to translate Huron culture into a language understandable by his compatriots, becomes the spokesperson not only of some exotic other, but, through that other, of a much broader recognition of the moment and its subversive potential. His vision is one with that of those writers and artists who would, each in their own sphere and their own way, extend and continue this celebration of the moment as a hallmark of the most distinctive currents of French art and letters throughout the Enlightenment.

Nowhere does the coherence between Lahontan's geographic exoticism and the most virulently iconoclastic tradition of early modern European thought become more clear than in the next work I will examine. In the article entitled "Epicurianism" which he wrote at mid-century for the *Encyclopédie*, Diderot not only uses that classical philosophical doctrine to articulate an epistemology and an ethics perfectly consonant with Lahontan's New World version of the moment, but he explicitly equates that strategy

3

DIDEROT AND THE EPICUREAN MOMENT

> Puisque nous voulons être heureux *dès ce moment* . . .
> —Diderot, "Epicuréisme"

It is frequently pointed out that the emergence of "happiness" as an object of legitimate human pursuit is one of the Enlightenment's most important legacies. It is less often recognized that this shift from the spiritual to the terrestrial brought with it a new attitude toward temporality, a new way of understanding our existence within time. Only when, as in the brief epigraph quoted above, the desire for happiness is accompanied by a second, more impetuous demand privileging the moment and insisting that happiness be accessible within the here and now of the present, can we begin to understand the role that quest played across a broad spectrum of the Enlightenment's cultural and artistic practices.

This epigraph is taken from a mid-century text by Denis Diderot, the article on "Epicureanism" which he wrote for Volume Five of his vastly influential *Encyclopédie* published between 1751 and 1772. In this relatively extensive article (it runs almost ten pages in the Hermann edition of his *Oeuvres complètes*), Diderot turns that doctrine of ancient Greece into the source of a renewed and powerful genealogy including all that has been best within the historical limits of recorded philosophical thought. On the one hand, Epicurus was himself a central figure of the Golden Age of Greek philosophy. On the other, his rediscovery in the seventeenth century gave birth to an awareness of nature and a quest for happiness that would inspire a long line of carefully enumerated seventeenth- and eighteenth-century French thinkers and artists whom Diderot designates as the most influential figures of their times.

As he offers his résumé of Epicurus's thought, Diderot adopts a tactic that, while apparently self-effacing, allows him maximum aggressivity. Rather than offering a learned restatement and critique of Epicurus's teachings, Diderot adopts the device of prosopopeia, allowing the long dead philosopher to speak in his own voice: "it is therefore he who will speak in the

rest of this article."[1] While peppering what he imagines Epicurus having to say with such obvious archaisms as his belief in a flat, disk-shaped earth with the sun revolving around it, Diderot, by claiming not to speak in his own name, sets the stage for two tactics which would otherwise have been impossible. Letting Epicurus speak in the first person cleared the way both for an assault on all religious beliefs going beyond the premises of materialism and for the distinctly positive evaluation Diderot himself would offer of Epicurus's vital influence on modern philosophical thought. These tactics, and the confusion they allowed as to whether Diderot or Epicurus were responsible for what was said, explain why this article was so frequently cited as among the most egregiously offensive to public morals by those of Diderot's ecclesiastic and secular critics who sought to halt the publication of the *Encyclopédie*.

This article, although its content is largely borrowed from Johann Jacob Brucker's *Historia critica philosophiae a mundi incunabulis ad nostram usque aetatem deducta* of 1742–1744,[2] is distinctly original in the way it mobilizes and renders mordantly contemporary a philosophical system which gives a new coherence to and acts as a standard bearer for the wide range of artistic, literary, and social phenomena reconceptualized by the Englightenment's epistemologies of the moment. In so doing, this text provides a highly revealing *mise en abîme*, a rendering of the whole in miniature, of a set of attitudes and demands that were at work throughout the culture of this period.

* * *

The real thrust of Diderot's treatment of Epicureanism can be seen in the very structure of his exposition. The greater part of the article, offered under the heading "De la physiologie en général," offers what amounts to a cosmology, an explanation of the world's fundamental composition as a materialist and atomistic universe bereft of any spiritual principle at the level either of its creator or of its human inhabitants. Yet this apparently objective cosmology is in fact intended only as an hypothesis. The statements made about the physical universe clearly designate themselves as assumptions whose real goal is the defense of an ethics, a code of moral conduct, presented under the heading "De la morale." It is this section that begins with the crucial claim that "happiness is the goal of life" (279) and goes on to define happiness as a state accessible to the individual only through the senses and only within the temporality of the isolated moment. Inevitably, these two registers move in divergent directions. As cosmologist, Epicu-

rus does not hesitate to make statements that claim to delineate objectively the "it" of a material world of which individuals are simply parts. As ethicist, Epicurus makes it clear that the goal of that objectivity is to empower the individual to assume a responsibility which is inherently subjective. It is finally only through specific words and actions circumscribed by the subjectivity of the moment that the "I" must impose meaning on a material universe from which it asks only happiness.

Diderot decides to have Epicurus speak in his own voice not only as a way of protecting himself from the censors he knew he would enrage, but also in such a way that his less hostile readers might understand that it is the gesture of daring to speak of the real in one's own voice, of being willing to contradict what passes as society's reigning doxa, that provides the indispensable foundation of happiness. Epicurus may be hobbled by all the errors of a pre-Copernican vision of the physical universe; those misconceptions do not, however, stop him from taking the essential step of daring to think, to speak, and to act in his own name within his own moment. The real value of Epicurus's thought lies not in the truth value of its cosmology, but in the happiness value of its ethics.

As Diderot speaks through Epicurus to a new generation of potential disciples, his concern is not with the objective validity of the world he describes, but with the ethical consequences that description will have for his readers. "Adopt principles; let them be few in number, but rich in consequences. Let us not neglect the study of nature, but let us apply ourselves particularly to the science of morality" (269). The goal of philosophical inquiry is not so much a correct knowledge of nature as it is the self-directed creation of the conditions necessary for happiness. Because happiness must always be personal, any too easy surrender to what passes as objective runs the risk of erecting a barrier to that goal. "What point would there be to a profound knowledge of beings outside of ourselves, if we were able, without that knowledge, to lessen fear, eliminate suffering, and satisfy our needs" (269)?

As though anticipating Kant's reorientation of philosophical thought via his premise that the impersonal objectivity of the neumenon remains forever inaccessible to human knowledge, Diderot's Epicurus subordinates the question of cosmology to that of its efficacy as an avenue toward happiness. Diderot's position, communicated in a single sentence, is that knowledge must maximize our happiness and minimize our suffering. "What goal are we setting ourselves through the study of physiology, if it is not to know the

general causes of phenomena so that, freed from all vain terrors, we might indulge our reasonable appetites without remorse; and, after having enjoyed life, be able to leave it without regret" (270).

* * *

Diderot's précis of epicurean cosmology is straightforward and traditional. The universe is an eternal composite of two categories: matter and emptiness (*le vide*) with no higher order opening the way to the spiritual in any of its variants. Matter in all its forms is composed of basic elements called atoms. Indivisible and unalterable, endowed each with its own specific characteristics, those atoms are the fundamental building blocks of nature. All the actual instances of matter we perceive are finite composites of such atoms.

Our ability to know the material universe occurs as a dialectic that remains forever limited to the specificity of the moment. On the one hand, our sense perceptions of nature's fleeting composites are limited by the ultimate unknowability of the atoms that combine to form them. "Even though we attribute to the atom all the dimensions of tangible bodies, it is nonetheless smaller than any imaginable portion of matter. It eludes our senses since their range provides the limits of what we can imagine, be it in terms of smallness or of greatness" (271). On the other hand, we ourselves, as material sensoria endowed with a consciousness of that matter outside us, are also forever-changing composites of atoms and thus unable to establish our knowledge of the world on any stable foundation. Knower and known are one within the shared, inevitable flux of the passing moment.

All that happens within the material universe, the reality of change, is likewise the result of another dialectic concomitant with the nature of these atoms. Following the Lucretian model which would play so important a part in his thought,[3] Diderot describes atoms as participating in two distinct movements. On the one hand, each atom is endowed with an intrinsic falling movement, a *pondération* which, were the atom to exist in isolation, would continue forever unchanged and unimpeded. On the other hand, atoms always occur in composites and are therefore inflected by a second movement generated by their intersections, by what Diderot calls "the movement of reflection which the atom receives upon encountering another" (271). This second movement, the *clinamen* (a term Diderot does not use in this article) is relative and temporary, a momentary effect of the ever-changing configuration of atoms at any given instant. It is from the convergence of

these two movements of falling and collision that there emerges the universe we seek to know. "It is to this coming together that the shocks, the coherences, the composites of atoms, the formation of bodies, and the order of the universe with all its phenomena must be related" (272).

The clear implication of this model of both the world around us and of our own sensate bodies is that there neither is nor ever was any integrated coherence of purpose guiding the vicissitudes of the universe. Material reality, our own as well as the world's, is a dialectic of the unknowable determinism of individual atoms as they fall and of the pure accident of composite atoms as they collide. Among the major casualties of epicurean physics are the classical conceptions of time and space as categories susceptible to an objective measurement divorcing them from the subjectivity of our specific situations. "What revolts our imagination are the false standards of space and time we have fashioned for ourselves. We relate everything to the point in space we occupy, and to the short instant of our existence" (274).

The very notion of an epicurean cosmology represents a contradiction in terms. Rather than defining a set of basic principles governing the universe, that philosophy implies the relativity of all possible knowledge. "Our world is but a small portion of a universe whose limits have been set by the weakness of our senses; for the universe in itself is unlimited" (273). If the great majority of humankind has blinded itself to that fact by choosing to believe in the fantasy of some purposeful principle imposing order and coherence on the universe, it is because no price is too high when it comes to avoiding a recognition of the simple fact that "the world is a result of chance, and not the execution of a plan" (273).

Epicurean epistemology presupposes an unbridgeable gap between the world as it is and the world as it might be known. As concerns the world as it is, the only suitable term is that of "chaos": "Atoms have been in motion since the beginning of time. Considered in terms of the general agitation from which all beings have emerged over time, this is what we have named *chaos*" (273). It is only within a different register and by reason of an always relativized dialectic of knower and known that there emerges something we might understand as a "world" onto which we have projected the stability of nature. "Considered after the various natures had developed, and after order had been introduced into this portion of space such as we perceive it, this is what we have named *the world*" (273).

As parts of a larger whole which humankind can neither capture nor comprehend within the constructs of its knowledge, the individual must refrain from expecting of that world anything other than the most complete

indifference. "Let us refrain from relating the transactions of nature to our-selves. All things have come into being through no other cause than the universal chain of material beings which was at work, either toward our hap-piness, or toward our unhappiness" (274). All those mental constructs we might designate as at one with the ordered reality of a world held safe from primordial chaos finally yield to an immensity that invalidates our most fun-damental conceptions of space and time. "But to judge our world, we must compare it to the immensity of the universe and to the eternity of time. This globe, even if it were a thousand times larger, would still fall under the sway of the general rule, and we would see it as subject to all the accidents of the molecule" (274).

* * *

How, if all is subject to what Diderot calls "the accidents of the mole-cule," can we move from the cosmological to the ethical? How, in a universe where the concept of the objective has no meaning, can we elaborate any guide to subjective conduct? Where, within the moment of pure accident, might one anchor the temporality of individual responsibility? Can there be any link between the universe as a whole and individual consciousness as a part?

In his attempt to open this apparently blocked passage, Diderot re-defines two concepts borrowed from the realm of metaphysics: that of the soul and that of the mind (*l'âme* and *l'esprit*). Refusing the spirituality usually associated with those terms, he insists on their existence as corporeal reali-ties. Were the soul, as so many claim, to be immaterial, it would necessarily remain in absurd irrelevance to the materiality of the body: "its heteroge-neity would render impossible any action upon the body" (275). The mind is in turn posited as part of the soul, "the most agile [déliée] portion of the soul" (276). Diffused throughout the soul's substance, mind is a fortiori dif-fused throughout the body. Defined as one with the body, its seat is the heart and its vibrations in response to sense perceptions are the source of all subjective experiences of joy and sadness, pleasure and pain. While the mind may, in its actions upon itself, generate representations of things that do not exist, it produces its fantasies no differently than does the eye its visions: "the soul thinks, as the eye sees, by simulacra and images [des idoles]" (276). Generating pleasure and pain as responses to the body's material situation, the soul and mind become the site of the eminently subjective and poten-tially ethical reactions of desire and aversion.

The human condition, as Diderot here defines it, is to exist at the intersection of two distinct orders. Both are material, but each exists in a form incommensurable with the other. One order, that of reality as a whole, is the object of human consciousness. It is a never-ending and properly timeless cycle of accidental transformations flowing from the movement of its constituent atoms. The other, the order of individual consciousness as the material vibrations of soul and mind, exists only within the present moment of positive pleasure and desire or negative pain and aversion. To define the human condition as the intersection of these two orders implies both a limit and a force. The limit lies in the fact that what we know is ultimately circumscribed by the impossibility of any knowledge adequate to the immensity of the whole. The force lies in the fact that, as concerns individual consciousness, that epistemological handicap brings with it both a precious liberation from the imagined demands of any supernatural agency and the emergence of a truly personal dimension of ethical duty. "Let us conclude for ourselves that the study of nature is not superfluous, since it leads men to a knowledge that assures peace in his soul, that frees his mind from all vain terrors, that lifts him to the level of the gods, and that brings him back to the only valid reasons for his fulfilling his duties" (277).

For Diderot, the value of philosophy, what establishes it as the one endeavor truly worthy of human attention, is its ability to confront existence as a phenomenon engulfed by the moment's subjectivity. No matter how immense the context of our existence, consciousness obliges the individual to think and act within the present. "Man is born to think and to act. Philosophy exists to control man's knowledge and will. Everything that strays from that goal is frivolous" (268). Ethics, unlike the impersonal hypotheses of cosmology, will always be the function of a subjectivity anchored in the moment. The first principle of what Diderot calls *la morale* derives from the individual's desire for personal happiness: "happiness is the goal of life; that is the secret confession of the human heart" (279). That demand, Diderot is careful to insist, presides even over those actions which seem most antithetical to the attainment of happiness: "he who takes his life sees death as a good" (279). As concerns the ethics that might derive from this constant of human motivation, Diderot designates as "the first step of our moral philosophy" what he calls "the search for what constitutes true happiness" (280). It is in terms of this quest that, as we saw in our epigram, the primacy of the moment becomes apparent. "Since we wish to be happy as of this very moment, let us not postpone until tomorrow learning what happiness is. The madman always prepares to live, but never actually lives" (280).

Replacing the traditional *carpe diem* with an even more exigent *carpe momentum*, this search for happiness in the present involves recourse to criteria equally as quantitative and equally as materialist as the philosophical system of which they are a part. Happiness comes as the result of a careful attention to an ethical algebra comparing the pluses and minuses of any given course of action. Insisting again that a question usually addressed in metaphysical terms be clarified by its translation into the language of the senses, the words Diderot uses to express the elements of these equations are not the abstract notions of *plaisir* and *souffrance*, but their more explicitly sensual variants of *volupté* and *peine*. "As a general rule, when delight [la volupté] brings no pain [aucune peine] as its effect, do not hesitate to embrace it. If the pain it brings is less than its delight, embrace it still. Embrace even that pain from which you can promise yourself a greater pleasure" (269).

The separation of this ethical system from any spiritual foundation is part of Diderot's explicit renunciation of any impersonal, objective, and timeless criterion of the morally good. Instead, the good is presented as a function of what will always be a specific, subjective, and passing moment. While the consoling universality of the metaphysical may be lost, this approach to happiness brings with it the premium of establishing that state as a goal attainable by individuals caught up in the here and now of actual experience. This happiness may be less grandiose in its pretensions, but its modesty hardly justifies a spurning of its reality. Again appealing to a tangible metaphor of sense experience, Diderot resolves this question of relative values by asking another: "because my eye does not penetrate the immensity of space, would I then disdain opening it to the objects that surround me?" (280)

Man may well be part of a physical universe where, at the level of the unknowable whole, all that occurs is a result of chance accidents flowing from the movement of its constituent atoms. That truth need not, however, compromise the individual's power to elect a goal and to act in such a way that, even if only subjectively and with no possibility of justification in terms of any principle beyond himself, his existence escapes the moral insignificance of all that happens only by accident. "We must have a goal present in our minds, if we do not wish to act *aimlessly* [*à l'aventure*]" (281; emphasis mine). This reopening of the door to purpose and moral responsibility, a door Diderot had carefully closed at the level of the material universe, depends on a crucial distinction. Individual actions become purposeful and ethical not because they are in harmony with some moral order surpassing subjectivity, not because they affirm the subservience of the imperfect many to some metaphysical One, but because an act of individual choice with no

justification beyond itself has fashioned within the world's chaos a fragile and circumscribed island of moral significance.

This distinction between a teleology derived from a principle superior to humankind and the quite different purposefulness resulting from individual choices made within the specific moment informs Diderot's presentation of even the most basic facts of human physiology. Can we, he asks, assume that our faculties of vision and locomotion mean that we were *intended* to see and walk? Drawing a careful distinction between the timeless coherence of some divinely imposed design and a state resulting from individual actions taken within the moment-to-moment progress of time, Diderot rejects the first hypothesis in favor of the second. "No intelligence presides over this mechanism. With everything taking place as though it did not exist, why should we assume such an intervention? Eyes were not made to see, nor feet to walk. Rather an animal had feet and walked; it had eyes and saw" (275).

* * *

Epicurean happiness is presented as a confluence of two distinct strategies. On the one hand, the recognition of choice as the foundation of ethical conduct opens the way to morally significant action on the part of the individual. On the other, the individual must adopt a negative, countervailing strategy militating against what Diderot sees as the principal obstacle to such ethical happiness. Why is it, he asks, that so many are unhappy? Why is it that Epicurus's simple message must rely on an elaborate and essentially purgative philosophical system to explicate its insights?

Humankind can achieve happiness only after it has been freed from the self-inflicted delusions that blind it to the moment's truth. What Diderot has to say about these impediments to happiness presupposes a potentially negative view of the relationship between the individual and society. If happiness is so frequently refused, it is because errors born of fear are both encouraged and exploited by the social order. That exploitation, akin to what we would today call ideology, depends on a register of false inductions transforming the moment from an instance of choice and happiness into the raw material of overarching narratives enforcing the individual's compliance and conformity. The moment becomes vulnerable to such absorption within the sequence because of a human tendency to mistake abstract representations existing only in language for reality itself. The first duty of the *philosophe* is to refuse such abuse by the institutions of social authority. "The philosopher

will feel contempt for all authority and will walk directly toward the truth, brushing aside all the phantoms that present themselves on his way. . . . Why do people remain engulfed in error? It is because they take words for proofs [des noms pour des preuves]" (269). So many are deceived not only because they believe in the existence of verbal phantoms, but because, once we have entered that shadowy domain, our every attempt to take the measure of our situation is vitiated at its source.

For the individual consciousness, there are two orders of reality: that of actually existing material objects and that of the conclusions drawn about them through an exercise of reason or belief. "In nature there are only things and our ideas. Consequently, there are only two kinds of truths, those based in existence and those based in induction. The truths based in existence have to do with the senses; those based in induction with reason" (269). For this second realm of induction and reason, the rule guiding our conduct must be the opposite of what it was for those physically real objects capable of becoming a source of *volupté*. For the real, it was the rule of *carpe momentum*, of the immediate seizure of whatever happiness is possible, that provided the guiding principle of our conduct. For the more slippery realm of reason, the rule is exactly the opposite. "Precipitation is the principal source of our errors. I will therefore never tire of saying to you, *wait*" (269). In relation to these abstract inductions, we must, because the stakes are so high, wait and reconsider before lending credence. Any misplaced assent to their existence will be accompanied by a cutting off of our access to the material reality such abstractions obfuscate, as well as to the moment's happiness that reality might have brought.

All inductive leaps into the unreal share a single form: there where there is only "the essential activity of atoms" a deluded consciousness imagines an imaginary *cause*. While such belief in a structure of causality rendering the real rational may endow the individual's existence with all the false grandeur of a destiny, of a purpose existence is intended to fulfill, true philosophers will always refuse the comfort of such illusions. Waiting and reconsidering, they will strip destiny of any status beyond the purely physical movement of atoms. "What is destiny other than the universality of . . . activities proper to the atom, considered either in isolation or in combination with other atoms?" (272). If destiny and the entire order of what is beyond the atom must be refused, it is because such allegiance to the metaphysical brings with it an implicit justification of the master narrative of divine agency. Transforming material reality into the handiwork of some supernatural cause, that leap reduces individual existence to the status of an instrument fashioned

to fulfill over time the purposes inscribed within its creation. "The world is one. There is no soul. There is therefore no God. The world's formation requires no intelligent and supreme cause. Why rely on such causes within philosophy, when everything could have been engendered and explained by movement, matter, and emptiness?" (273).

Why, the question becomes, do so many acquiesce to so debilitating a delusion? The answer, as Diderot sees it, lies in the fact that the belief in a creator endowing material reality with metaphysical purpose brings with it a panoply of corollary narratives. These prolongations of cause and effect soaring beyond the limits of physical existence offer the seductive illusion of making sense of and offering recompense for lives lived in a world that offers only a movement of atoms where consciousness longs for the consolations of coherence and continuity. Any belief in divine creation carries with it, for instance, the corollary narrative of an afterlife: of a heaven and a hell, of a reward and a punishment making right what life has left wrong. The power of those myths, as Diderot makes clear in his choice of words, derives from the fictitious "fable" or "story" each would impose on the distorted balance sheet of life's injustices. "Far from us therefore the fable of a hell and an Elyseum, as well as all those mendacious stories with which superstition frightens those evildoers it does not esteem sufficiently punished by their crimes, or compensates those righteous people who do not feel themselves sufficiently rewarded by their virtue" (277).

If so many refuse the moment and look instead for the delusions of life as a purposeful narrative, it is because that quest responds to the abiding, universal, and justified fear that life as it is will never provide any equivalent consolation. It is because we fear injustice that we insist on dreaming our narratives of retribution. But, acting on the basis of that fear, we find wrested from our grasp all access to those unstoried moments providing the only happiness actually available to us.

* * *

Following this restatement of epicurean philosophy through the ventriloquized voice of its founder, Diderot returns to the posture of the encyclopedist speaking in an apparently objective third person. In one short paragraph he qualifies Epicurus as the single classical philosopher who was able to reconcile an ethical system with what Diderot calls "man's true happiness" (281). Only within his thought do we find precepts consonant with both the needs and desires of humankind. People may force or delude them-

selves into embracing any number of other philosophical positions, but only Epicurus has accepted humanity such as it is. "One may become a stoic, but one is born epicurean" (281).

The strategic value of Epicurus's singularity becomes clear as Diderot goes on to offer a brief sketch of the philosopher's biography. If his doctrine is so unlike those of his fellow philosophers, it is because, rather than imposing on reality the coherencies of a system, he embraced all the ambiguities of its diversity. Refusing to approach the world as a systematizer who, because he had "his eye glued to the end of an instrument that magnifies one particular object," ended up missing the "broader spectacle of the nature that surrounds him," Epicurus proceeded instead as "a man of genius," as one of those of whom it can be said that "their activity concerns itself with everything; they observe and learn without ever realizing it" (282). The value of his philosophy lies in the fact that it was born not of the rigorously coherent sequences of any "profound and determined meditation," but of a sustained attention to the random fruits of the undetermined moment, to what Diderot nicely calls "*accidental* glances [des coups d'oeil *accidentels*]" (282; emphasis mine). With no more coherence than a series of random glances, the elements of Epicurus's philosophy, rather than proposing any mythic narration of the world and its creation, became part of and a prod to the quite different and free-flowing story of a happiness offered to the whole of humankind: "precious seeds that develop sooner or later for the happiness of the human race" (282). It is, more than anything else, the status of Epicurean philosophy as a recognition and epiphany of the accidental moment that establishes it as the seed stock of future happiness.

Turning to Epicurus's place in the subsequent development of philosophy, Diderot insists that his respect for reality in all its chaos established him as the source and inspiration for all the most important developments in European thought since the end of the Middle Ages and their thousand year night. His resurrection came in the seventeenth-century works of Pierre Gassendi, a figure whom Diderot does not hesistate to qualify as "one of those men who do the highest honor to philosophy and to the nation" (285). His subsequent disciples, individuals able in their various ways to reconcile "heroism with softness [la mollesse], a taste for virtue with a taste for pleasure, political acumen with literary talents" (285), would include, to name only those most recognizable today, figures as diverse as Molière, Ninon Lenclos, Saint-Evremont, La Fayette, La Rochefoucauld, Rousseau, and Voltaire. The shared trait linking these strikingly disparate names is their participation in an effort to free humankind from a subservience to philo-

sophical and social constructs preventing it from perceiving the moment as the unique temporality of true happiness. For all of them, like their epicurean inspiration, happiness is posited not as the premium of some victorious conquest of nature but as a recognition of human limits. Humankind can find a happiness consonant with its nature only when it accepts the limits of its power. On the one hand, consciousness can never achieve certain knowledge of a material universe which remains forever recalcitrant to the coherences of intellectual representation. On the other, our ambition must be tempered by the realization that we carry with us an innate susceptibility to pernicious delusions born of the mental constructs we so readily substitute for our inability to comprehend the material universe. Happiness can come only with a modesty that finds joy rather than resignation as we turn our attention to the fleeting but inevitable passage of the moment.

Epicurus's parallel lessons concerning the arbitrariness of all cultural constructs and the status of the sentient moment as the unique locus of happiness were, as we shall see, articulated not only in Diderot's reflections on the history of philosophy, but in the very different context of one of the mid-century's most successful novels, the story of an Inca princess compelled by the sad history of her nation to experience at its most visceral level the suffering as well as the jubilation of the moment.

4
GRAFFIGNY'S EPIPHANY OF
THE MOMENT

Françoise de Graffigny's *Lettres d'une Péruvienne* speaks perhaps more elo-
quently than any other eighteenth-century novel about the convoluted re-
lations between experience and expression, reading and writing, reception
and cultural history. First published in 1747, this novel consists of letters
written by Zilia, an Inca virgin of the Temple of the Sun, to Aza, the Inca
prince she was to marry on the very day the Spanish conquistadors invaded
Cuzco and carried her off as their prisoner. An overwhelming sense of the
chance-laden, irreversible "moment" at work pervades both the writing and
successive readings of this fascinating novel. I would like to examine how
abrupt percussions of the moment structure the novel's setting, how that
setting itself intensified the author's own most crucial experience of the mo-
ment, and how the agendas of distinct historical moments have produced
vastly different readings of a text that, first constructed as Inca knotted cords,
or quipus, ultimately embraces an esthetics of the moment as the dominant
form of its heroine's greatest suffering and most intense happiness.

The term "moment" designates a particular intensity of the unexpected
and unpredictable, of an event creating a chasm between the past and the
future. By abolishing what preceded while allowing no anticipation of what
will follow, the moment is often experienced as an instance of pure chance.
Fracturing the continuities allowing the subject to understand and control
what has so drastically happened, the moment announces itself as an end to
any previously secure sense of a symbolic order declaring itself the equiva-
lent of law and nature. Deprived of a coherence between past and future,
the subject experiences the moment as a reshaping of consciousness, an in-
explicable event redefining both the rule of law and the pull of desire. The
chance moment, traumatic or ecstatic, transforms a previously calm percep-
tion of sustaining continuities into an uncomprehending bewilderment at
the jagged tear of the instant in the careful weave of life narratives.

In Graffigny's *Lettres d'une Péruvienne*, Zilia's voice reverberates as a
writing consciousness shattered by the impact of a moment which has abol-
ished the law of her religion, the narrative of her love, and the sense of her

identity. "Since the terrible moment (which should have been torn from the chain of time and replunged into the eternal ideas), since the moment of horror when these impious savages stole me away from the worship of the Sun, from myself, from your love, I experience only the effects of unhappiness, without being able to discover their cause."[1] "Since the moment," obsessively repeated, summarizes Zilia's reaction to the Spaniards' sacking of Cuzco as they obliterated a civilization unable to resist them. Few scenes from world history capture as sharply the calamity of that moment when two cultures clashed in such a way that for one, the Inca victims, their future of defeat and enslavement will be unlike anything for which their previous experience has prepared them. It was very much by chance that, in 1531, after a number of earlier unproductive expeditions, a small band of fewer than two hundred Spaniards wandering on an unexplored continent came upon and, in only a few days, defeated the vast Inca empire.

Graffigny's presentation of this event (which she freely transposes two hundred years into the future so that Zilia might arrive in eighteenth-century France) emphasizes how the Inca, with devastating results, translated the Spaniards' chance arrival into a series of ominous continuities with their pre-existing worldview. Being part of a culture means accepting the power of its sustaining narratives to explain reality, to find within what happens not the haphazard fruits of chance but the working of understood causalities. It was the intensity of the Incas' belief in a rigorously providential view of history that sealed their fate. The Inca emperor Atahualpa, speaking to his people only a short time before his execution by the Spanish, claimed that "in this realm, no bird takes wing and no leaf moves if such is not my will." Such epistemological confidence led, as the Historical Introduction to the *Lettres* makes clear, to a number of fatal "mistranslations" of the Spaniards' irruption within the Incan narrative. "The circumstances in which the Peruvians found themselves when the Spanish landed could not have been more favorable to those newcomers. For some time there had been talk of an ancient oracle that had announced that, after a certain number of kings, there would arrive in their country extraordinary men such as they had never seen, who would invade their realm and destroy their religion" (251). The astrologers who had detected three ominous circles around the moon and the augurers who had seen an eagle pursued by other birds likewise contributed to the Incas' conviction that the strangely dressed Spaniards were in fact the sons of the dreaded Viracocha, the prince of destruction who had been the subject of a nightmare by an earlier emperor appropriately named Yahuarhuocac or "Cry Blood." "The moment they saw the Spaniards with their

ample beards, their covered legs, mounted on animals of a kind they had never seen before, they believed them to be the sons of Viracocha who had proclaimed himself son of the Sun. . . . All bowed before them, for people are the same everywhere" (252). The Incas' tragic refusal of chance and their insistence on translating the Spaniards' appearance in terms of Inca culture only consolidated the catastrophe. Spanish gunpowder and muskets became a sign of protection by Yalpor, the thunder god of justice. The metal bits in the mouths of Spanish horses persuaded the Inca that these "eaters of metal" might be mollified by gold and silver presents—a gesture that only intensified the conquistadors' rapaciousness.

For Zilia, this tragic and profoundly misunderstood moment of the Spaniards' arrival stands in opposition to and draws its meaning from an earlier and equally momentary experience of joy: her discovery that the son of the Capa-Inca, prince Aza, shared the love she felt for him. Now a prisoner of the Spanish, Zilia's thoughts return obsessively to what she describes as "this first moment of my happiness" (263), when as a sacred virgin confined to the Temple of the Sun, she saw Prince Aza for the first time. Her memory of his unexpected appearance in the temple concentrates the force of that event within a moment adding an entirely new dimension to her experience: "You appeared in the midst of us like a rising sun, whose tender light prepares the serenity of a beautiful day . . . astonishment and silence reigned on every side. . . . For the first time I felt distress, agitation, and yet pleasure [du trouble, de l'inquiétude, et cependant du plaisir]" (263).

Beginning in a moment's tragedy made all the more palpable by its opposition to that earlier moment of love's discovery, Zilia's story after the fall becomes that of a forced sea voyage. Ripped away from the ordered world of the temple, Zilia is a prisoner adrift on what, for the eighteenth century, was the realm of chance par excellence. Unforeseeable storms, fires, wrecks, and sea battles were only a few of the aleatory moments punctuating life at sea. One morning, she is awakened on the ship taking her to Spain by explosions so intense that they seem to her to signal "the very destruction of nature" (266). In fact, a French ship, captained by the gallant Déterville, has stormed the galleon on which she is a prisoner. That moment too will change entirely the shape of what lies before Zilia. In limiting her representation of these events—the arrival of the conquistadors, Zilia's departure on the Spanish ship, and the battle at sea—to Zilia's imperfect understanding of them, Graffigny collapses the complex histories of European colonization and Franco-Spanish rivalry to a series of isolated, incomprehensible moments unrelated to the narrative continuities that in fact sustained them.

Seen from Zilia's perspective, the annals of European history become a con-catenation of random moments with no more motivating rationality than a sequence of chance encounters.

Separated from the Inca culture that formerly defined her past and future, Zilia experiences the new world of the sea and what lies beyond it as a series of chance-driven moments occurring with an abruptness so intense that, in trying to understand what is happening to her, she can say only that "each moment destroys the opinion an earlier moment had given me" (271). The hazards of the sea become a senseless emptiness marked only by the progress of her suffering. "The universe is annihilated for me. It is now noth-ing but a vast desert that I fill with my cries of love" (274). Lost in a world with no constancy of law, no coherence provided by a comprehensible sym-bolic order, Zilia's experience of the moment's abruptness becomes the abid-ing modality of all she will discover in exile. Déterville may prove to be the best intentioned of captors, but Zilia's response to his attentions will always be limited by her insistence that "it is chance alone that brought us together" (312). Later, after many more changes, as her story draws to a close, Zilia will propose to Déterville a happiness defined not by the continuities of mar-riage, but by an intensified awareness of existence as a momentary plenitude bringing with it what she has learned to be the only joy life might provide.

* * *

For the eighteenth century, the Spanish conquest of the Inca repre-sented the most momentous and calamitous clash of cultures in recorded history. Writers like Garcilaso de la Vega and Bartolomé de Las Casas—translated, frequently re-edited and widely read in France—told clearly and vividly the terrifying tale of how a small army of Spaniards had, in little more than a moment, determined the sad fate of a New World culture whose population numbered in the millions. The abrupt fall of entire empires and the unimaginable sufferings of their dispersed and exploited inhabitants pro-vided examples of horror surpassing anything previously available to the European imagination. And speak to that imagination they did.

If Graffigny chose this most lurid example of colonial rapacity and human suffering as the background for her story of a woman's shattered love, it was because that setting eloquently expressed an experience of the moment's reversal of which she herself had been the chosen victim. Born in 1695 within the nobility of the then independent duchy of Lorraine, Françoise d'Issembourg d'Happancourt became an influential member of

the Lorraine court through her marriage in 1711 to Huguet de Graffigny, the court chamberlain and *exempt des gardes de corps*. After badly mistreating and physically abusing her during their unhappy marriage, her husband at least had the discretion to die in 1725. At the age of thirty-one, Graffigny was left with the freedom and security of a widow close to and protected by Madame, the duchesse de Lorraine and formerly the regent. During this period Graffigny began a long and intense liaison with the young cavalry officer Léopold Desmarest. The Treaty of Vienna in 1736 shattered Graffigny's social and affective security, however, and redefined the fortunes of the fragile duchy as a function of complex political forces acting from far beyond its borders. Lorraine fell into the hands of Stanislas Leszcynski, who had become the king of Poland in 1733 thanks to the support he had received from Louis XV, who was married to his daughter, Marie. Leszcynski's second reign as king of Poland (he had previously ruled there from 1704 to 1709) came to an abrupt end when the Russians expelled him and imposed Frederick Augustus, the Elector of Saxony, as the new king. Ever the faithful protector, Louis XV obtained the duchy of Lorraine as a consolation prize for Stanislas with the added advantage for himself that, upon Stanislas's death, the duchy would become a possession of France. The Treaty's game of diplomatic musical chairs awarded the duchy of Tuscany as a parallel compensation to the then twenty-eight-year-old duc de Lorraine.

For Graffigny there was no consolation prize. Part of the disbanded court of the now-deposed duc, she suddenly found herself an all but penniless refugee forced to live by borrowing and expediency. Her reversal of fortune at the age of forty-one put her in straits that would well prepare her to recreate, a decade later, that abrupt separation from homeland and beloved under the hyperbolic guise of an Inca princess. After two years of travel during which she relied on the dubious comfort of strangers, Graffigny's long visit to Madame de Châtelet and Voltaire at Cirey during the winter of 1738–39 ended in recrimination when Madame de Châtelet, who systematically steamed open her guest's letters, accused Graffigny of risking Voltaire's arrest by communicating to one of her correspondents an entire *canto* of his incendiary *La Pucelle*. Forced to leave at a moment's notice, Graffigny headed for Paris with only two hundred francs.

The voice that would one day speak as Zilia could well claim that "I have learned that in France travelers pay not only for their food, but even for their repose. Alas! I have not the least portion of that which would be necessary to satisfy the cravings of this greedy people" (320). The contrast between the station in life her upbringing had prepared her for and the daily

reality of solicited loans and indiscreetly extended visits made her acutely sensitive to everything Zilia would suffer from the arrogance of the wealthy. "But alas! how the contemptuous manner I heard used to speak of those who are not rich caused me to make cruel reflections upon myself! I have neither gold nor land nor skills, yet I am necessarily part of the citizenry of this place. O heavens, in what class must I rank myself?" (304). Protected in Paris by the duchesse de Richelieu, but always only inches from the financial edge, Graffigny likewise knew well what Zilia would describe as the antithetical moments making up the days of a nobility living far beyond its means. "Each morning, in a private room, the voice of poverty addresses them through the mouth of a man paid to find the means of reconciling their real poverty with a false opulence. . . . The rest of the day, after having assumed other garments, other quarters, almost another being, overcome with their own magnificence, they are gay and claim to be happy. They go even so far as to believe themselves rich" (330). The final prod to the creation of Zilia's voice came in 1743 when Graffigny was abandoned by her beloved but absent Desmarest, who finally broke off what by then had become a purely epistolary affair. Three years later, her *Lettres d'une Péruvienne* would tell the story of that terrible moment of 1531 in a voice very much inflected by Graffigny's own experience of the political and dynastic reversals in the Lunéville court of 1736. If she transposed events of the sixteenth century into the eighteenth, it was not by error or oversight. Responding to what she saw as a mutual attraction between the moments of 1531 and 1736, Graffigny's story of the Inca princess became a metaphor of everything her own present had become.

* * *

The version of the *Lettres d'une Péruvienne* we read today dates from 1752. Deeply disappointed that the original 1747 version, published anonymously and, like all novels of the period, without a *permission*, had, in spite of its tremendous popularity, brought her only three hundred livres, Graffigny was anxious to find a better arrangement. In 1751, with the help of Chrétien-Guillaume de Lamoignon de Malesherbes, she at last obtained a *permission* for her novel and published under her name a corrected and augmented version with Duchêne for which she received three thousand livres.[2] As Graffigny prepared that second edition of forty-one rather than thirty-eight letters, she sought counsel from her circle of friends on revising the original text. An important indication of how Graffigny's contemporaries responded to her novel can be found in a 1751 letter to her from the then un-

known Anne-Robert-Jacques Turgot—who would, some twenty years later, as *contrôleur général des finances*, become the last but quickly dashed hope of the philosophes for an effective reform of *ancien régime* economic policies. Only twenty-four at the time he wrote to the fifty-six year-old-Graffigny, Turgot was concerned that she make Zilia's story more relevant to the specific moment of French society at mid-century.[3]

Reading Turgot's counsels to Graffigny, one has the strong sense that the person in fact being addressed is Rousseau, whose *Discourse on the Arts and Sciences* had just been crowned by the Dijon Academy. Profoundly disturbed by Rousseau's blanket rejection of the arts and sciences, of everything associated with the nascent *lumières* of the philosophes, Turgot insists that the task Graffigny must set herself is to "to show Zilia as a Frenchwoman, after having shown her as a Peruvian."[4] To accomplish this Graffigny must provide in her revised novel some positive balance to the negative portrait of French society presented in the letters of social criticism.[5] Turgot feels she must add a "French Zilia" because portraying her only as a Peruvian, limiting her voice to observations heavy with primitivism and naive idealism, confines her to an exoticism all too easily interpreted as arguing in the same direction as Rousseau. A French Zilia, whose reading and experience have allowed her to understand how and why European society must be different from the Inca world, would possess a true objectivity. Rather than looking at French society only through Inca eyes, the new Zilia would understand that every encounter with a different society provides an all too fertile ground for ethnocentric prejudices. Turgot's Zilia would, to the contrary, have reached a point where, recognizing this, she can "compare her prejudices with our own" (459) rather than presenting the assumptions of her Inca culture as one with fact and nature.

A French Zilia would understand why what Turgot calls "la distribution des conditions" is necessary and inevitable. Zilia's primitivist espousal of a self-sufficient agrarian culture where all live from what they produce might hold some abstract interest as an exercise in exoticism. It is, however, an ideal Turgot sees as dangerously ambiguous. Uncannily anticipating and setting out to refute what, three years later, will be the central thesis of Rousseau's *Discourse on the Origin of Inequality*, Turgot argues that such an ideal implies a society reduced to a subsistence level where all grow their own food, produce their own implements and clothing, but remain cut off from all the advantages of an organized and integrated economy. As Turgot sees it, inequality between individuals is inevitable. People have different degrees of physical strength, mental genius, technical skill, and commercial

prowess. Not only must society reflect those differences if it is to exist as something other than a totalitarian leveling, but society's division of labor, specialization, and economies of scale, while they produce disparities, allow for the overcoming of far more destructive evils. "What would provide an income to those living in infertile areas? Who would transport products from one region to another? The poorest peasant today enjoys a plethora of goods imported from distant regions. . . . The distribution of professions leads necessarily to some inequality of conditions. Without it, who would strive to perfect the useful arts? Who would spread enlightened ideas? . . . Who would hold in check the ferocity of some and aid the weakness of others?" (461). Challenging what he saw as Graffigny's too facile idealism, Turgot's posture of cold-eyed realism leads him to question even the most revered shibboleths of the day: "Liberty! ... I say it with a sigh, men are not always worthy of you!—Equality! ... we ardently long for you, but can we ever attain you!" (461). Given Graffigny's identification with her heroine, it is hardly surprising that she chose to ignore the young Turgot's suggestions. It was not likely that Zilia should set out to justify the very forces of which her author saw herself as the chosen victim.

The greater part of Turgot's letter (or what we have of it, as the one existing copy is incomplete) consists of suggestions as to how changes in the novel's ending and in the relations between its central characters might make the novel more didactically useful to its readers. Turgot's major concern is with Zilia's refusal to marry either Aza or Déterville. His discomfort with the original ending comes not so much from any explicitly sexist *parti pris* as from what he sees as a glaring internal contradiction. Throughout the first two-thirds of the letters, the reader's attention is, via Zilia, focused on Aza; but his single appearance reveals him to be an odious and unfaithful coward. Similarly, the noble Déterville sacrifices his love for Zilia out of respect for her commitment to Aza, even going so far as to find Aza in Spain and arrange for his coming to Paris. For Turgot, everything goes wrong when, in spite of discovering Aza's unfaithfulness, Zilia continues to insist that he alone, now as someone existing only in her memory, remains the only possible object of any love she might feel. This baroque commitment to an ideal betrayed by reality, Turgot argues, transforms Zilia into an unbelievable anachronism divorced from the moment and conceivable only in another century and another genre. "Having Zilia proclaim emphatically that Aza's infidelity does not release her from her promise turns her into a heroine à la Marmontel, or, if you prefer a comparison more worthy of you, à la Corneille. . . . To make of her sentimental attachment a principle and

a duty is to offer something false, and what is false interests no one" (465). This improbability, Turgot goes on, limits Graffigny's audience and transforms Zilia into a character acting on highly dubious motivations. "Feelings touch, but blustering principles impress only fools; such ostentation can only be the coquetry of virtue" (465).

Turgot does not suggest that Zilia marry Déterville, but that the novel's ending be recast and expanded in such a way that Zilia and Aza provide a useful lesson on the fragile chemistry of domestic conviviality. Why not have it that Aza became involved with his Spanish fiancée only because he had, understandably, given up all hope of ever finding Zilia? It would then follow that, once they had been reunited, his greater love for Zilia would provide touching scenes showing him renouncing his necessarily lesser love for the Spaniard. Certainly Zilia would be able to forgive him on those terms. Modifying the denouement that way, portraying Zilia and Aza as characters who overcome a sense of grievance locking them in the past, would make of their evolving sentiments a dramatic and effective lesson on the prerequisites for all successful domesticity. For Turgot, the truly dangerous threat to conjugal happiness, the "real cause of infidelity and disgust between those who once loved each other" (469) is *amour-propre* and pride. In overcoming their wounded pride, Zilia and Aza could lay bare the disastrous dialectic lying in wait for every unwary couple. "Pride is the greatest enemy of pride. Two bloated balloons can only repulse each other" (470). Zilia and Aza could thus provide an eloquent demonstration of the necessarily double vision that stands as the unique remedy to the dangerous dynamics of misplaced pride: "let us excuse it in others and fear it in ourselves" (470). Who better than Zilia and Aza could demonstrate that the real enemy of domestic happiness is an excessive sense of what one is due? "Nothing in the world is sadder than to be forever concerned with the consideration we feel we are due. That is the best way to make life unlivable. It transforms what we desire into a burden for others. People take pleasure in granting our due only when we refrain from demanding it" (470).

Turgot's other suggestions for adjusting Zilia's story to the needs of the moment concern reforms in the education of children. Building on the limited remarks in Letter 19 concerning the intellectual vacuousness of convent education, Graffigny should expand the novel to include a time when Zilia and Aza, as well as Déterville's sister Céline and her husband, are bringing up young children. Evoking many of the ideas Rousseau would pull together eleven years later in his own iconoclastic synthesis on education, Turgot criticizes existing practices as disastrously pedantic, as a rote ap-

prenticeship of meaningless words cut off from any real experience of the things they designate. "Those whom the whole of nature calls to itself in all its aspects are chained to a single place. Their time is spent on words that are meaningless to them because the meanings of words can only be derived from ideas and those ideas come only by degrees and from a foundation in perceivable objects" (462). The child's moral education must consist not in memorizing verbal definitions of such notions as virtue, justice, and temperance, but in placing children in real-life situations from which they will deduce the necessity and value of virtuous conduct.

* * *

The next important moment in the history of how Graffigny's novel has been read came as a highly curious response to questions raised by another moment of social cataclysm, another empire's fall. Writing in the *Revue des deux mondes* of mid-July 1871, only six weeks after the carnage of the *semaine sanglante* tragically ended the revolutionary government of the Paris Commune (itself the final chapter in the fall of the Second Empire), the conservative Louis Etienne ironically suggests that only the present moment in France's political history allows readers to appreciate Graffigny's novel at its true value. If Etienne chooses to write about what was then an all but forgotten text, it is not, he makes clear, out of any sympathy he might feel with "the charm she exercised on our great-grandmothers."[6]

As though correcting Turgot's criticism that Graffigny's heroine was not sufficiently French, Etienne claims that "Zilia is far more French and European than she seems" (461). For Etienne, the *Lettres*' "Frenchness" lies in their unvarnished portrayal of the real threat to the creation of a truly re-publicain government, free from the taint of France's monarchical heritage. For Etienne, Zilia and her Inca perspective brought to eighteenth-century France one of the first flickers of what has since become the burning political question of contemporary Europe. "It was reserved to Mme de Graffigny to be the first to hazard a series of paradoxes concerning private property. The most striking aspect of her work can only be described, for want of a better word, as socialist" (459). If Etienne feels the rereading of this then forgotten eighteenth-century novel is relevant to a Parisian audience still surrounded by the ruins of its failed revolution, it is on the basis of what in fact is a relatively minor theme in Graffigny's novel. In Letter 20, Zilia observes that "whereas the Capa-Inca is obliged to provide for the welfare of his people, the sovereigns of Europe draw their own solely from the labors of their

subjects" (303). Zilia, as Etienne reads her, is here implicitly recommending to France the Inca model of a centralized state for which all must work and by which all will be supported. If Etienne attributes such considerable importance to Graffigny's passing espousal of a centralized state providing universal welfare, it is because he sees that ideal as synonymous with everything that has gone wrong in France's difficult and delayed transformation from monarchy into republic.

The argument informing Etienne's reading of Graffigny turns on what he calls "parasitism." That word, Etienne points out, only refers in the political vocabulary of the 1870s to the monarchy. Parasitism describes how, a century before, monarchy functioned through an elaborate system of royal stipends consisting of pensions for the nobility, alms for the poor, and countless offices in the service of the centralized state for the bourgeoisie. If France's attempts at a new and truly republican form of government have so clearly failed, Etienne insists, it is because the social changes effected by her revolutions have never been accompanied by any real change in the people's mentality, by any real rejection of a "parasitism" that has survived all changes of government. Sounding like a modern-day welfare reformer, Etienne states that "before 1789 it was thought shameful to receive charity from individuals, but charity from the prince was an envied privilege. Today it is still shameful to ask one's fellow citizens for a handout, but it seems perfectly natural to beg from the Republic a livelihood eliminating any real obligation to work" (462–63). Parasitism, Etienne concludes, did not die with the monarchy. It has survived and multiplied under such new names as "socialism, solidarity, collectivity, and the organisation of labor" (463).

By allowing parasitism to continue, French republicanism has embraced a practice betraying every attempt to leave the abuses of monarchy behind. Under the patriarchal model of monarchy, the king ruled as the often tyrannical father of his people, taxing as he wished, because "people believed that all wealth within the state ultimately belonged to him" (463). While the state may now call itself a republic, it will in fact perpetuate all the evils of monarchy so long as it accords itself the same patriarchal privileges over individual wealth. The true republic must be imagined neither as tyrannical father nor as nourishing mother. Instead, Etienne claims, the Republic must be an "emancipated family all of whose members are brothers owing each other fraternal support" (463). With neither a king nor a father free to spoil his favored children, the older brothers will aid the younger and they in turn will "earn their place on the basis of merit and labor" (463). In denouncing Graffigny's utopian socialism as "parasitism," Etienne rehearses a tenet

of conservative thought going back to Edmund Burke: that the unlimited powers of the state at the heart of the socialist vision would, no matter how generous its social and economic programs, create around it a new court and new courtier class of state agents who will only intensify the very class divisions they claim to abolish. For Etienne, a socialist republic can only become another Versailles, drawing to its service an unlimited corps of officeholders all too anxious to profit from its overzealous administration.

As a novelist, Etienne continues, Graffigny presents a socialism different in one crucial way from that at work in 1871. Rather than offering any "full blown social theory for changing the world," she needed only to "expatiate on her reveries of inconsequential utopias" (462). The product of an imagination untroubled by reality, the *Lettres* could propose Zilia's ideals as pure nostalgia for a lost homeland outside any obligation to enunciate a plan for making them a political reality. In writing a novel rather than a treatise, Graffigny had, as Etienne sees it, the wisdom to choose what will always be the most appropriate vehicle for socialist thought. "If it is true that socialism is the search for an honest and effective way of attenuating the distinctions between what is yours and what is mine [le tien et le mien], that search is always more convincing when carried out with frivolity rather than with scientific method" (459–60). Free to dream, the novel can present its visions of a golden age, communal ownership of property, and generously opened purses with utter disregard for how those ideals would work in the reality of contemporary French society. Zilia, having spent her entire life in an Inca temple, need never trouble herself with the difficult questions that came so brutally to the fore in 1871 — "why those at the bottom, with their pittance, should not demand to be at the top with all its advantages" (462). As an exercise of pure imagination remembering a faraway country, the novel can ignore the violence and bloodshed so sadly concomitant with every transition from the "is" to the "ought."

* * *

After Etienne's tendentious rereading through the embers of the Commune, *Lettres d'une Péruvienne* returned to the placid precincts of literary history. While it had been re-edited, reprinted, and translated over 130 times between 1747 and 1835, there were only two small French editions of the novel during the rest of the nineteenth century and none at all during the first two-thirds of the twentieth.[7] The first book-length study of Graffigny's work was published only in 1913 by Georges Noel. A retired military offi-

cer, Noel expanded on Etienne's negative reading and took as his title *Une Primitive oubliée de l'école des coeurs sensibles*. After yet another half-century the American scholar English Showalter, following the time-honored tradition of devoting one's doctoral thesis to the major work of a minor author, brought new attention to Graffigny's pages with his dissertation entitled "An Eighteenth-Century Bestseller" (1964). These works had little effect, however, on the overwhelmingly negative consensus concerning the value and importance of the novel. In England, Vivienne Mylne conceded that, if the *Lettres* is hardly mentioned in most histories of literature, it is "with good reason."[8] On the other side of the Channel, Henri Coulet's *Le Roman jusqu'à la Révolution*[9] presents the *Lettres* as little more than a mildly interesting variation on what Montesquieu had done better before her and what Rousseau would do more eloquently after her. In 1982, Susan Lee Carrell spoke briefly of Graffigny's novel in her study of "soliloquies of feminine passion," but because "the psychology of the woman in love is never really analysed" concluded that "the main if not only interest of this quite undistinguished work is of a purely historical nature."[10] The seeds of the *Lettres* real resurrection came in 1983 when Bernard Bray and Isabelle Landy-Houillon included Graffigny's *Lettres* in a collection of five love-letter novels published in the large-printing Garnier-Flammarion paperback series.[11] Even as they edited it, however, Bray and Landy-Houillon felt obliged to point out that, thematically and philosophically, the novel was of far less interest than the two works most often cited as its sources, Guilleragues's *Lettres Portugaises* and Montesquieu's *Lettres Persanes*.

Two centuries of obscurity for Zilia (as Etienne's 1871 diatribe hardly brought new readers to the work) ended, appropriately enough, because of developments in the New World. By the mid-1980s the culture wars being waged in American universities over the proper representation of women and minorities in the curriculum had made it egregiously reactionary to introduce the eighteenth-century French novel via reading lists that usually included only such writers as Marivaux, Prévost, Crébillon, Voltaire, Diderot, Rousseau, and Laclos—all of whom, whatever their virtues, fell squarely into the dubious category of Dead White European Males. Riccoboni, Tencin, Charrière, La Guesnerie, and Beaumont were among the important female novelists from the period, but, with the possible exception of Riccoboni, none had generated a significant body of scholarship—perhaps another confirmation of the academy's gender bias. Of greater practical importance, however, none of these women's texts were available in inexpensive editions for class use. The one exception, thanks to Bray and Landy-

Houillon, was Graffigny's *Lettres d'une Péruvienne*. It had other advantages as well. Not only was it written by a woman, but Zilia, its main character and exclusive narrative focus, was also a woman. Graffigny's novel also had the not insignificant virtue of being a relatively short novel at a time when asking undergraduates to read a work of the dimensions of *La Nouvelle Héloïse* had become pure folly.

In addition to the work's physical availability, the new perspectives of feminist scholarship began to contribute significantly to a Graffigny renaissance. Nancy K. Miller, in *The Heroine's Text* of 1980 and even more so in her two 1988 articles on Graffigny, argued eloquently for the crucial importance of the *Lettres d'une Péruvienne* as an exception to the period's implicit law of novelistic production—that female characters must always either marry and submit to the laws of patriarchy or die.[12] For Miller, the real significance of Graffigny's novel lay not so much in its representation of a conflict between European and New World cultures as in its implicit deconstruction of socially imposed gender roles and distinctions. Far more than a foreigner suffering forced integration into French society, Zilia became a symbol of everywoman struggling against patriarchy and finally accepting a place within it only on her own terms. After well over a century with only the most limited readership, *Lettres d'une Péruvienne*, freshly interpreted, became the one text sure to appear on the syllabus of every eighteenth-century French course taught in North America. As late as 1989 a Eurocentric critic like Pierre Hartmann, oblivious to what was happening across the ocean, could claim that Graffigny's novel was hardly known even by specialists.[13] The American momentum behind the work's rise to the highest ranks of the domestic French canon culminated in the simultaneous publication, in inexpensive classroom editions, of both the French original and a new English translation among the inaugural volumes of the Modern Language Association's new "Texts and Translations" series.

Other more tenuous options were also exercised for attuning Graffigny to the dictates of the politically appropriate. Playing the culture rather than the gender card, Janet Gurkin Altman argued that Zilia should be read as a "Third-World intellectual heroine"[14] whose plea for "the respect of cultural difference" (194) establishes her as the spokesperson for a long neglected "Third-World enlightenment (be it fact or fable)" (198). Altman's parenthetical caveat, "be it fact or fable," does have its role to play because, as it has been understood from the eighteenth century to the present, the reality of the Inca culture from which Zilia was to derive her enlightenment did have its darker side. The short entry under "Inca" in Diderot and d'Alembert's

Encyclopédie, for instance, lingers far longer over practices evoking oriental despotism than Enlightenment ideals. "Should someone have offended the king in the slightest way, the city from which he came would be demolished or ruined" or, as concerns their funeral rites, "the wives and servants of the dead king were sacrificed as part of his funeral rites. They were burned at the same moment as his body and on the same pyre."[15] Scholarship has, if anything, been even less enthusiastic about an Inca Enlightenment. Arnold Toynbee, in his Forward to Livermore's English translation of Garcilaso's *Royal Commentaries* (the same work the French translation of which served as the principal source for Graffigny's local color), describes the Inca state as "authoritarian, bureaucratic, and socialistic to a degree that has perhaps not been approached by any other state at any other time or place. . . . The Inca imperial government dictated to its subjects, in detail, the locality in which they were to live, the kind of work they were to do there, and the use that was to be made of the product of their labour."[16] If Enlightenment there was, it came with a dubiously Stalinist hue. This discreet omission of the Inca empire's negative side also qualifies Elizabeth MacArthur's claim that Zilia's enterprise flows from "a desire to escape centralized power structures."[17]

* * *

Graffigny's novel, its composition as well as the multiplicity of its interpretations, well illustrates the force of the moment as it reshapes the cultural context through which writing and reading begin. This dialectic of the continuous and the momentary is in fact inscribed at the core of the *Lettres d'une Péruvienne* in the Inca artifact defining the work's status as text: the quipus or knotted string constructions in which, the novel claims, the first seventeen of Zilia's letters were originally composed.

The material status of these letters as quipus, however, points to a dilemma. The first mention of quipus in Letter 1 is accompanied by a note defining them as "short cords of different colors that the Indians use, for lack of writing, in counting the payment of their troops and the number of their people. Some authors claim that they also used them to transmit to posterity the memorable deeds of the Incas" (258). Referring to the quipus as a counting device, a stringing together of cords and knots representing only the quantitative, numeric counts of persons and sums, calls into question their ability to serve as the material basis of the text we are reading. Quipus, so defined, are like the isolated numbers of a balance sheet, markers lacking any inherent reference to the identity of the objects they enumerate.

The same ambiguity of the quipus' status as writing system can be found in Graffigny's principal source on Inca culture, Garcilaso's *Royal Commentaries*. Born in 1539, only a few years after the arrival of the first Spaniards in Peru, Garcilaso de la Vega was himself an incarnation of the troubled communication between these two cultures. The disinherited mixed-blood son of one of the original conquistadors accompanying Pizarro and the Inca princess Nusta Chimpu Ocllo (herself a second cousin to the last Inca king), Garcilaso had the difficult task of explaining each side of his ancestry to the other. He too states that the quipus were essentially an accounting device, an artifact central to the Inca empire because they made possible the minute inventories of everything countable for its rulers and administrators. Chapter 14 of Book Five of the *Commentaries* opens with an almost Borgesian list of the categories of people, animals, grains, trees, objects, and land configurations which were inventoried and reported back to the emperor upon the conquest of any new territory. Updated annually with even more thoroughness, these counts allowed centralized control of the distribution of goods and peoples throughout the empire. Garcilaso makes scattered references to the quipus' other functions: keeping historical annals, recording the speeches of emperors and dignitaries, and composing poems—all of which seem to imply that the quipus did in fact also function as a written language. These references are, however, usually attributed to Spanish travelers describing phenomena they do not entirely understand.

The explanation of this ambiguity (and perhaps also of why Graffigny dropped the quipus as letters actually exchanged between Zilia and Aza after Letter 2) comes in Garcilaso's most extensive statement on quipus. He begins Chapter 9 of Book Six, "What they recorded in their accounts, and how they were read" by stating that the Inca recorded with their knots "everything that could be counted, even mentioning battles and fights, all the embassies that had come to visit the Inca, and all the speeches and arguments the king had uttered" (331). Garcilaso seems to suggest that the quipus were used for purposes previously described as incompatible with their physical structure. Resolving this apparent contradiction requires understanding precisely how they were used. The "reading" of quipus was confined to a specialized group, the *quipucamayus* (those who have charge of the knots) who supplemented the knotted strings they used as mnemonic devices with what Garcilaso describes as "speeches preserved by memory in a summarized form of a few words [which] were committed to memory and taught by tradition to their successors and descendants from father to son" (332). To a visitor from outside the culture, these *quipucamayus* certainly appeared

to be "reading" a quipu. In fact, however, the quipu as document was legible only to the *quipucamayu* who had memorized the verbal discourse the knots would prod him to recall. Garcilaso concludes that "the Incas had no system of writing," but would "preserve the tradition of their deeds by means of the knots, strings, and colored threads, using their stories and poems as an aid" (332).[18] Here we are not far from Ray Bradbury's *Fahrenheit 451*, where, in a future totalitarian state that forbids books, an underground organization known as Book People memorize whole volumes of the classics and, before dying, teach them to younger members who will continue on as living repositories of the texts. The best contemporary study of the subject, *The Code of the Quipu*, coauthored by an anthropologist and a mathematician, argues that the quipus should be seen as embodying the anthropological "insistence" of Inca culture: they summarize, by reason of their structure and cultural function, the very essence of that civilization as an obsessive counting and centralized control of goods and peoples made possible by the quipus as the instruments of an almost Weberian bureaucracy.[19]

On the basis of the anthropological evidence, then, the message of Zilia's quipus is necessarily ambiguous. They speak as they do only for Zilia at the moment she knots them. She is the single possible reader able to use their mnemonic structure as a prod to speech. Woven within a context of loss and exile, they resurrect through memory a past self with which she no longer fully coincides at the moment of their eventual translation. To transcribe the quipus only she can read into French is to transcribe a past moment of consciousness now redefined by her apprenticeship of an entirely different symbolic system. Her letters exist as an idiolect: what at the moment of the quipus' knotting was readable only by the bereaved self remains, in spite of its translation into French, fully legible only for that single consciousness torn between a memory of the text's earlier moment as quipu and its later and different moment as French.

* * *

The paradox of the *Lettres d'une Péruvienne* as legible idiolect should not, however, surprise. The functions of these letters first as quipus and later as written French are entirely different. As quipus, the first seventeen letters neither had nor sought any audience other than Zilia. If the fiction of an impossible reply from Aza is dropped after its single appearance in Letter 2, it is because Zilia's knotting of the quipus remains a purely self-directed gesture. They have, beyond Zilia as their single reader, no more permanence than

her cries that "like a morning mist, rise up and are dissipated before reaching your presence" (257). If Zilia continues to devote every free moment to the knotting of quipus that can neither be sent to nor read by their intended recipient, it is because they alone keep alive her allegiance to the Inca culture from which she has been so brutally sundered. The quipus become for Zilia the single instrument of her struggle to instill within the chaos of her captivity some semblance of order and meaning. Weaving the quipus transforms despair into hope and becomes Zilia's one expression of a contact with Aza and her Inca past that shuts out the alien present of everything she is forced to experience. "When a single object draws all our thoughts, my dear Aza, events only interest us through the relations we find them to have with that object. If you were not the sole motive force of my soul, could I have passed, as I have just done, from the horror of despair to the sweetest hope?" (276).

In Letter 17, as Zilia's supply of cord runs out, she realizes her quipus can no longer serve to anchor the single meaning she would find in the chaos of experience. Her monomania, now recognized as the illusion it must become, yields to a universe without meaning, a world punctuated only by the random succession of discrete moments that disappear with no trace. "Illusion deserts me, the awful truth takes its place. My wandering thoughts, bewildered in the immense void of absence, will hereafter be annihilated with the same rapidity as time" (299). The depletion of Zilia's quipus materializes the very threat her compulsive weaving is meant to exorcise. More than anything else, the presence, invasiveness, and eventual seduction of France, as a language and a culture, will first force and then draw her away from the conviction that all meaning must refer back to the world she has left behind. A subtle evolution of the novel's form parallels, by a change in the function of the letters comprising it, this transformation of Zilia's mental universe. The first letters, woven as a monologue sustained by the fictive presence of Aza as their only audience, read as a cloistral prayer addressed to the single god of the absent beloved. Zilia seeks to shut out the debased reality of a world populated only by lesser creatures, to reduce experience to her thoughts of Aza and the pain of his absence. "Weary with so many fruitless pains, I thought I could dry their source by depriving my eyes of the impressions they receive from objects. I persisted for some time in keeping them shut" (268). As her voyage continues, however, her eyes are forced to open to what is happening around her. Her monologic dialogue with Aza begins to include references to the man she calls the "cacique" of her "floating room." The letters become perplexed descriptions of persons and things outside the previously hermetic confines of the "I" and "You," herself and Aza. As Zilia

begins to understand French, progressively larger parts of her letters will be devoted to reproducing dialogues with and between third parties outside the couple.

The most important change occurs in the interval between Letters 17 and 18 when the quipus run out and Zilia must complete her apprenticeship of French. To learn and use the language of the other brings with it an alienation from that earlier sense of self, defined exclusively through a native culture. Learning French has forced her to see that the Empire of the Sun is no longer an unfissured totality subject to the single rule of Aza's order. Zilia must recognize that the sacred sun at the center of Inca culture shines on whole continents over which the Inca hold no sway and which will determine the remainder of their fate.

Zilia may continue to write only to Aza, but she does so in a language he cannot read. No longer centered on the intensity of her love for him, her letters describe the French society of which she finds herself becoming a part. The organizing focus of Zilia's letters is no longer the hoped-for resumption of her past happiness with Aza, but a concern with preparing him to understand and find a place within the world of the French. Forced to inhabit a middle ground between Peru and France, Zilia begins to speak as anthropologist and social critic. Having learned the language of the other, Zilia finds that she now sees even her own Inca culture differently. Watching the rapidly shifting alliances and exuberant vivacity of Parisian salon life, Zilia finds herself uncomfortably imagining how those European others would view the reserved decorum of her own people. "They would take our serious and modest demeanor for stupidity, and the gravity of our gait for dullness" (283). In a diction made possible by her status as someone outside the culture, Zilia becomes an astute critic of French society, always attentive to the gaps between appearances and reality. Writing to Aza, Zilia criticizes the dangers of a theatre that represents only the misdeeds of evil men, of a convent life devoid of intellectual stimulation, of a parasitic nobility concerned only with ostentation, of men's contemptuous treatment of women, and of educational practices divorced from any concern with virtue.

At this point Zilia perceives French society not as an alien observer for whom everything is chaos and chance, but as someone who, while remaining other, both understands and critiques its coherence and rationales. The language of the French provides her with cognitive syntheses that both enable her to speak and constitute the audience to whom she ultimately addresses herself. Zilia will continue to write her letters for Aza, but that ges-

ture has become little more than a lingering convention supporting a voice that speaks to a quite different audience. It comes as no surprise that Zilia's last five letters, with little change in their diction, are addressed not to Aza but to Déterville. Zilia's tenaciously proclaimed love had long ago ceased to be the real motor of her discourse. What she writes as letters to a single beloved read as a diary ultimately addressed to the French.

*　*　*

Zilia's real drama turns less on her relation to Aza than on her achievement, within a new language and a new culture, of expressivity without complicity—on her resistance, as she uses French, to being redefined by it. She chooses not to marry Déterville because marriage to a Frenchman, no matter how devoted, would mean her integration within a social order that threatens to abolish her identity. Zilia's trajectory demands, however, that this choice not exist only as a refusal. In refusing Déterville, Zilia simultaneously embraces something positive, something of greater value to her than escaping the socially sanctioned convention of female destiny. At one level, her refusal to marry Déterville is explained as a loyalty to Aza's memory, as her insistence on a distinction between love and friendship. While the memory of Aza will remain as the unique object of a passionate love she wishes never again to experience in the present, Zilia's affection for Déterville will take the form of a friendship different from love, but of no lesser value. "Renounce those tumultuous feelings, those imperceptible destroyers of our being. Come, and learn to know innocent and lasting pleasures, come enjoy them with me [venez en jouir avec moi]. You will find in my heart, in my friendship, in my feelings, all that can compensate for love" (362).

Reminiscent of the protective *repos* chosen by Lafayette's heroine at the end of *La Princesse de Clèves*, this choice is, however, accompanied within Graffigny's text by another ideal of happiness, one based on a resurgent ethos of the moment. Earlier, Zilia's exile from her Inca past had transformed her consciousness into one of moments occurring outside any continuity or coherence. Zilia first experienced the horrors of her captivity by the Spanish as a concatenation of purely present moments cut off from past and future. As she is "saved" by Déterville and enters the more hospitable reality of his world, that same temporality of the moment will continue as the abiding mode of her perception. Zilia's epistemological journey from one culture to another, however, is paralleled by her discovery of an equally momen-

tary plenitude within pure sensation, of an intense joy at her contact with the physical world. Zilia will discover in Europe not only another symbolic order but a self-contained and unmediated experience of physical reality.

In Letter 12 Zilia describes her four day trip from the French port where she has landed to Déterville's home in Paris. Having spent her entire life until the arrival of the Spanish within the Temple of the Sun, Zilia admits, after her coach trip through the French countryside, that "I have savored pleasures during this journey that were unknown to me" (286). She experiences those lush country scenes "which ceaselessly change and renew themselves before my eyes," as a delicious evanescence of ever-changing moments "which transport my soul as rapidly as we pass through them" (286). Rather than attempting to describe that nature, Zilia evokes instead its effect on her, the momentary sensations it provokes, what she qualifies as a "majestic disorder provoking our wonder to the point of forgetting ourselves" (286). What is so happily forgotten in these moments of pure sensation within nature is the other reality of human society, the world of appearances and disappointments that imprison her. Turning away from that world, losing herself in sensation, "a delicious calm penetrates our souls, and we delight in the universe as though we were its sole proprietors" (286). This discovery of a nature that speaks to all the senses at once in a language unlike those of men triggers for Zilia an ecstasy whose intensity initiates the discovery of a new sense and a new self: "a pure delight [une volupté pure] that seems to give us another sense" (287).

This experience of the moment occurs not as a threat to her fidelity to Aza, but as the joyous affirmation of a purely sentient self independent of any symbolic order fashioned by men. Seen from this perspective, Zilia's refusal of marriage to Déterville is less an obstinate commitment to the memory of Aza than it is her allegiance to the experience of a beatific sensation that limits itself to the always momentary present. Her final proclamation is one of autonomy: "the pleasure of being, that forgotten pleasure, unknown to so many blind humans, that thought so sweet, that happiness so pure, *I am, I live, I exist* [je suis, je vis, j'existe] could by itself render us happy, if one remembered it, if one took pleasure from it [si l'on en jouissait], if one realized its worth" (362). Her ability to make that claim flows from her discovery of nature as an arena of momentary intensities that lift consciousness beyond the necessities of any marriage or of any symbolic order. "Is not the mere examination of its [nature's] wonders sufficient to vary and constantly renew ever pleasant occupations? Is one lifetime enough to acquire a slight,

but interesting acquaintance with the universe, with what surrounds me, with my own existence?" (362).

* * *

Zilia issues her final invitation to Déterville in a letter written from the country house representing her independence within French society. Yet Zilia's refuge there continues to depend on the tragedy of her victimage, on her status as part of the debris of Inca culture. Within the country house Déterville secretly purchased for her, behind a locked door, Zilia discovers a room he had specially prepared for her. In it, she finds figures "extremely well drawn, portraying some of the sports and ceremonies of the city of the Sun" (350). These female figures have been painted as wearing an exact replica of Zilia's dress when Déterville first saw her on the Spanish ship. At the room's center, suspended from the ceiling and as though watching over this scene from Zilia's youth, is the golden figure of the Sun that "carried to new heights of beauty that charming solitude" (351). This sunburst is not, however, a surprise for Zilia. Earlier, as she explains in Letter 27, the sunburst appeared as part of the booty from Peru taken from the Spanish ship which Déterville restored to Zilia as its only available rightful owner. From that first moment of contact with the relics of her past, Zilia accepted the sunburst as the foundational symbol of a lost Inca world belonging to the Children of the Sun.

One important change has occurred between Letter 27, when the booty was returned, and Letter 35, when Déterville presents Zilia with the notarized deed making her the sole owner of the country house. The gold temple throne belonging to the Inca king was originally included among the objects given to Zilia. In her room at Céline's chateau, that throne stood as the tangible symbol of Aza, the prince who would one day occupy his father's position. "The golden chair that was kept in the temple for the visiting days of the Capa-Inca, your august father, is placed to one side of my apartment as though it were a throne and represents for me your grandeur and the majesty of your rank" (325). The same throne will find a place in Zilia's country house, but in a partial and transmuted form. After he has the golden throne melted down, Déterville uses the bullion to purchase the house in her name, hire her servants, and to establish a trust guaranteeing Zilia's continued financial independence. "A magical power has transformed it into a house, a garden and land" (351). All that physically remains of the throne

is a "strong box filled with pieces of gold of the French currency." "The re-mains of that magical operation," these gold coins "of the French currency" now symbolize not a fidelity to Aza, but Zilia's integration, albeit in appar-ent autonomy, within French society.

At the close of Zilia's story, the throne, like Aza, is gone. What remains of it, like the memory of her past, sustains a new ideal of happiness limited to the joyous plenitude of the moment. In choosing the moment, Zilia re-nounces her earlier definition of happiness as a future return to the world of her past. Early in her captivity, while still on Déterville's ship, Zilia had looked out on the empty sea around her and had there discovered a meta-phor for her desolation. "If objects mark the boundaries of space, it seems to me our hopes mark those of time. If those hopes abandon us, or if they cease to be clearly delineated, we would no more perceive the passage of time than we do the air that fills up space" (277). Without some hope de-fining a desired future, time, the moment-to-moment reality of the present, exists for Zilia only as an emptiness, a space without reference points that allows only despair. Now, much later and after Aza's visit, Zilia finds herself without the hope of any future that might give meaning to an otherwise pointless present. In place of that hope, and as the lesson drawn from the ecstasy provoked by nature, Zilia has redefined her happiness as the pleni-tude of a moment utterly complete within its present.[20] The possibility of that moment depends, as the financing of Zilia's country estate makes clear, on a transformation of the Inca gold. Her offer to share these moments of happiness with Déterville depends on a throne transmuted into coin just as it does on a love transmuted into friendship.

To marry Déterville, to be bound by a contract obligating her beyond the present, would abolish the self-sufficient euphoria of the moments she invites him to share. To mortgage friendship's present to love's promised future, to repeat with him the passion she saw foreclosed by Aza, would transform the moment's plenitude into its opposite. The temporality of a love promising the future would expose Zilia to what she has already dis-covered to be the most European of all vices: hypocrisy. Love and marriage would make of a friendship that claims only a shared coincidence of present moments an obligation promising and constraining a future beyond their grasp. To love and to marry, as the experience of Zilia and Graffigny so well illustrated, is to become part of a continuity whose hopes and promises cre-ate the possiblity of a gap between reality and appearance, between the truth of the moment and the potential lie of the future. To marry, to speak for the future, is to risk seeing their life together become "an infinity of words

without meaning, of marks of respect without esteem, and of care without affection" (331).

* * *

Graffigny's ideal, as represented by Zilia, is that of a self-contained solipsism, a present moment perhaps shared by the single elected other of friendship, but shutting itself off from the threatening hypocrisies of society. The utopia traced out in the *Lettres d'une Péruvienne* may, like the transmuted gold of the Inca throne, be complicitous with a social order extending beyond the individual. That complicity is, however, never actively sought but only passively accepted. The subtle chemistry of Zilia's final happiness may entail an accommodation to the symbolic, but she accepts that social order only so that she might, through the momentary epiphany of the moment, achieve the plenitude of an imaginary present independent of constraint and expectation. Through no choice of her own, Zilia has come to live within and understand French society. She does so, however, only as part of a trajectory taking her to the country house and away from society. There, as both captive and princess, as both indebted dependent yet mistress of her estate, she transcends the contradictions of those identities within an estheticized present that limits her existence to an utterly fulfilling experience of the moment.

Graffigny tells the story of a single visitor from afar who, in an alien culture, manages to find refuge within a new sense of temporality. In a similar but far more ambitious enactment of that same itinerary, Jean-Jacques Rousseau looks first to the New World and then back to the reality of Europe as he articulates a comprehensive history of the human condition. His history, beginning with our loss of contact with the self-contained moment, will finally lead back to a retrieval of that moment's happiness within an exercise of affective memory taking the form of a never completed autobiographical inscription of the self.

5

ROUSSEAU'S MOMENT BEYOND HISTORY

> Le bonheur est un état trop constant et l'homme un être trop muable
> pour que l'un convienne à l'autre.
> —Rousseau, Ébauche des *Rêveries*

Jean-Jacques Rousseau provides, both in his life and his writings, a case study in the new importance the compact and subversive temporality of the moment would assume in that rethinking of the human condition we refer to as the Enlightenment. From his first attempt in January of 1762 at what was to become his life-long endeavor of putting down on paper the exculpatory story of his life and of how he came to be who he was, the then forty-nine year old Rousseau traced the shape of his life-story to the overwhelming impact of one particular moment. Writing to Malesherbes, the *directeur de la librairie* in charge of royal censorship in France, he insisted that the entire course of his life had been abruptly redefined by a moment's reading that had occurred some thirteen years earlier. Rousseau explains to Malesherbes how, in October of 1749 as he was walking from Paris to Vincennes where he would visit the imprisoned Diderot, he happened to glance at the copy of the *Mercure de France* he was carrying with him. Reading as he walked, his eye was caught by the subject announced for the essay contest proposed by the Academy of Dijon: whether the century's rebirth of science and the arts had done more to corrupt or to purify morals.[1]

What is most striking about Rousseau's description of this scene is the emphasis he places on the decisive impact of that single, unexpected moment. "If ever something seemed like a *sudden inspiration*, it was the effect that reading had on me. *All of a sudden* [Tout à coup] I felt my mind overwhelmed by thousands of flashes of light."[2] Rousseau portrays his reaction to the single sentence of the Academy's announcement as a sudden overload, a rushing to consciousness within a single instant of so great a number of intuitions, insights, and ideas that his mind and body, literally overcome by their cumulative force, are no longer able to function.

Rushes of vivid ideas crushed in on me all at once with a force and confusion that threw me into an inexpressable discomfort. I felt my head caught by a dizziness as

though I were drunk. A violent palpitation overcame me, taking my breath away. No longer able to breath as I walked, I let myself fall to the ground under one of the trees along the road where I spent half an hour in such a state of agitation that, when I got up, I discovered that the whole front of my jacket was wet with tears I never realized I had shed. (1:1135)

This moment on Rousseau's road to Damascus was to leave him with a legacy not of religious truths, but of a suddenly clarified and compelling vision of what he calls the contradictions of our situation, the abuses of our institutions, and of how man, naturally good, has been everywhere corrupted by the society around him.

It is within this single moment that, as it were, Rousseau became Rousseau. The intensity and turmoil of his thoughts establish that instant as a moment radically outside everyday life's consecutive and cumulative progressions. He goes on to explain to Malesherbes that he may well have spent the next thirteen years of his life writing his major works, but they would stand as little more than inarticulate mumblings when compared to the clarity of what he understood during that brief moment that was to redefine his life. "Everything I was able to retain from those hosts of great truths which shined so brilliantly for me during the quarter of an hour I spent under that tree has been feebly scattered throughout my three major writings, the first *Discourse*, the *Discourse on Inequality*, and my treatise on education, all of which are inseparable and together form a single whole" (1:1136).

It is not, however, only the genesis of his most important works and the persecution they triggered that Rousseau describes as moments redefining life's normal sequence of events. In Book VI of the *Confessions*, as he attempts to recount the lost paradise of his happiness at Les Charmettes with Madame de Warens in 1737, he again describes the tenor of that period as an experience of moments defined by their brevity and rapidity. "Here begins the short period of my life's happiness; here I come to those peaceful but rapid moments that have given me the right to say I have lived" (1:225). As he sets out to transcribe them, Rousseau asks only that the act of writing, even as it acknowledges the evanescence that made those moments so precious, might somehow slow their passage. "Precious and ever-regretted moments, begin to run your charming course for me again. Flow more slowly through my memory, if you can, than you did in your fugitive reality" (1:225). As was the case for his ecstatic vision on the road to Vincennes, the dynamic of these moments of perfect happiness again implies a stepping outside of the cumulative and the sequential, a renunciation of any

attempt to represent what was said, done, and thought within conventional narrative form. The moment, as a hallmark of feeling and sentiment, puts him face to face with something that remains beyond the reach of language. "How can I express what was neither said, nor done, nor even thought, but only relished and felt, when I cannot adduce any other cause for my happiness than just this feeling" (1:225).

* * *

From the beginning to the end of Rousseau's work, the moment and its ambiguities will be at the center of both what he wishes to say and how he will be read. As concerns the first work that brought him to the attention of his contemporaries, the *Discourse on Science and the Arts* of 1750, we have seen how its entire inspiration is presented as the fruit of a moment that was to reverberate throughout the whole of his career. At the other end of his life, Rousseau's last work, the short and unfinished Tenth Walk of the *Rêveries du promeneur solitaire* written only three months before his death, opens with the evocation of another crucial moment of his life. "Today, Palm Sunday, it is precisely fifty years since I first met Madame de Warens" (1:1098). Here it is an accident of chronology, his recollection on April 12, 1778 of what happened on that same date a half century earlier, that brings to mind and pen the moment when chance alone guided a sixteen-year-old runaway to the door of a woman who was to have a determining effect on the entire course of his life. "But what is more unusual is that this first moment determined my whole life and by an inevitable chain of events shaped the destiny of the rest of my days" (1:1098).

Rousseau's privileging of the moment from the beginning to the end of his writing career is crucial to the eighteenth century for two reasons. First, its importance to the shape of his own life will find an explicit and colossally aggrandized parallel in the starting point for the properly anthropological vision of mankind he offers in his *Discourse on the Origin of Inequality*. That text is, as we shall see, grounded in another version of the moment's utopia, one that will provide the key to understanding the truth of humankind's present situation. Profoundly subversive in its implications, Rousseau's analysis of an enslavement made visible only by its contrast to the moment-embedded independence of savage man refers back to Lahontan's texts of a half century earlier, but adds to them a dimension of historical analysis that would exercise a decisive influence on the political discourse of the closing decade of the eighteenth century. This Rousseau, the Rousseau

asking his readers to measure their situation against a radical freedom they have allowed their history to abolish, stands as the ultimate mobilization of the thematics of the moment so much at work in the art and literature of the Enlightenment. It is this representation of the moment that would make of Rousseau a central reference for all that the Revolution would impose in the name of a normative nature. Here Rousseau stands both as a culmination of what came before him and as a preparation of what, in the hands of those who would proclaim themselves his disciples, became his lasting stamp on a political history we continue to share.

Second, the shift to the privileging of a more personal, self-embedded sense of the moment that was to mark the last years of his life established Rousseau as anticipating the more tragic vision of the self within history that would follow the disappointments of the Revolution. His *Rêveries du promeneur solitaire*, written at the end of his life, will redefine the moment not as the universal truth of humankind's lost origin, but as the vehicle of a profoundly personal escape from society relying on the fictive representations of individual imagination. Synthesizing past and present into a sustained ecstasy, the *Rêveries* are intended to lift the individual consciousness outside the ravages of time and beyond the reach of other men.

* * *

In his Preface to the *Discourse on the Origin of Inequality* Rousseau sets up the opposition on which his entire argument will depend: that between man "such as Nature formed him" and man redefined by "all the changes that the sequence of time and things must have produced in his original constitution."[3] The paradox at the core of Rousseau's argument lies in his claim that the meaning of human history, the shape of its ethical implications, can be understood only by stepping outside that history, only by abstracting man from "the sequence of time and things," and returning to a moment of origin that brings into focus the true significance of all that will follow. The *Discourse* itself is divided into two parts. The first offers a careful portrait of "savage man" (an adjective chosen for its etymological sense of "forest dweller" from the Latin *silva*) such as he existed in the timeless moment of his congruence with nature. The second, comprehensible only on the basis of the first, encompasses the whole of human history from savage man's first cautious movements away from isolation to the vastly different present of a civil society in which the individual is able to define himself only as a function of the myriad others who mediate his very consciousness of himself.

Rousseau's argument is as direct as it is iconoclastic. His vision of savage man as he who reveals the moral truth of human history depends on his being the antithesis of everything Rousseau's contemporaries might hypothesize about our origins on the basis of existing knowledge. All such knowledge, as a product of mankind's degeneration over the course of history, only vitiates our vision by projecting onto that utterly different moment of origin a series of irrelevant intellectual constructs that say far more about what humankind has become than about how it once was.

In returning to the moment of mankind's origin, Rousseau not only consolidates this text's foundation in a starting point that exists in epistemological isolation from all the later changes and consequences we know as history, but he offers what amounts to a phenomenology of savage man emphasizing his consciousness as an always momentary perception of the present as present. Closer to the animal than the human, savage man knows only perception and sensation. What he perceives may inspire passing reactions of desire and fear, but those momentary responses to a given stimulus never approach the complex consciousness of what we would call thought. "Savage man, desiring only the things he knows and knowing only those things the possession of which is in his power or easily acquired, nothing should be so tranquil as his soul and nothing so limited as his mind" (3:214). Savage man's existence consists of a series of random events experienced only in the present. As such, they never come together in the integrated, projective form of episodes drawing their meaning from some larger narrative of consciousness extending the implications of the moment over time. What might be seen as a deficiency from the viewpoint of integrative coherence in fact constitutes the foundation of his adequacy to any challenge that might occur within the present. Speaking not unlike Lahontan, Rousseau sees the real strength of savage man as his being able to "have constantly all of his strength at his disposal, to be always ready for any event, and to always carry himself, so to speak, entirely with himself" (3:136).

Living from moment to disjointed moment, savage man is unencumbered by any consciousness of the self that relies on "the linking [l'enchaînement] of ideas which are perfected only successively" (3:199). Rousseau's use of the word "enchaînement" oscillates between two senses of the word: the link that relates the present to some other moment and that link as a metonymy of all the fetters that will one day come so totally to enchain natural man. If savage man lives outside such concatenations, it is because his consciousness, limited to the present moment, remains unfissured by any awareness of what might be as opposed to what is. Using a term that will

play a crucial role in the very different ideal to be articulated in the *Rêveries*, Rousseau defines savage man as being without "imagination." "His imagination suggests nothing to him; his heart asks nothing of him" (3:144). Undisturbed by any mental faculty that might project him into a moment different from the present he lives, savage man experiences desire only as an immediate response to the purely physical reality of the self and its situation.

Limited to a consciousness of the moment outside cumulative time, savage man lives within a mental universe where all discoveries and haphazard advances of knowledge disappear with the individual who happened to make them. "Art perished with its inventor; there was neither education nor progress" (3:160). This absence of any consolidation of what has been acquired at one moment within those that follow it allows Rousseau to imagine man's natural state as having lasted for an entire age without significant modification. Extending over countless generations, it is experienced by all who live within it as a series of full yet unrelated moments born for each anew within an original purity carrying neither a trace of the past nor an anticipation of the future.[4] Savage man lived life as a single moment repeated again and again over the course of centuries. As a species, humankind may grow old. Yet, as individuals, each remains forever young: "with everyone always starting from the same point, centuries passed in all the crudeness of the first ages, the species was already old, yet each remained ever a child" (3:160).

*　　*　　*

Part Two of the *Second Discourse* attempts to close the epistemological gap opened by Part One. Having asked his readers to imagine savage man as alien to everything they might assume and to everything they have been told (even by a Lahontan who speaks of Hurons as already socialized within their communal culture) Rousseau sets out to explain how humankind has passed from the otherness of nature's timeless starting point to that totally different state we know so well yet understand so little. My goal here is not to rehearse the intricacies of Rousseau's argument of how humankind first evolved away from isolation toward a "familial state" and then fell victim to the regimes of private property and the civil state. I intend instead to show how, even within the shape of the extended history Rousseau proposes to his readers, the unexpected yet all-important moment continues to function as the crucial regime of temporality, as an ideal which will be lost only as it is displaced by other, degenerative forms of temporal imagination.

From its opening sentence, Part Two of the *Discourse* adopts a rhetorical strategy distinctly different from the timeless portrait of savage man offered in Part One. It begins by evoking an event which has meaning only in terms of an extended sequence: "The first person who, having fenced off a plot of ground, took it into his head to say *this is mine* and found people simple enough to believe him, was the true founder of civil society" (3:164). This event depends not on a single individual isolated from his fellows, but on "the first person" who, in relation to a group, was able to impose his will upon theirs and redefine both them and himself. This moment of a first enclosure—the enclosure of self and other within a shared acquiescence to the notion of property—is rich with implications for the future. "What crimes, wars, murders, what miseries and horrors would the human race have been spared by someone who, uprooting the stakes or filling in the ditch, had shouted to his fellow men: Beware of listening to this impostor" (3:164). At the same time, this event also presupposes a protracted and cumulative past without which the act of enclosure could never have taken place. "This idea of property, depending on many prior ideas which could only have arisen successively, was not conceived all at once in the human mind. It was necessary to make much progress, to acquire much industry and enlightenment, and to transmit and augment them from age to age, before arriving at this last stage of the state of nature" (3:164).

Rousseau emphasizes the importance of a properly sequential understanding of subsequent human history by beginning this second part of the essay with a moment that, rather than picking up the thread of his argument where Part One had left it, projects the reader into an as yet unexplained future moment that will become comprehensible only after it has been integrated within a still-to-be-enunciated series of motivating causes and effects. Rousseau's readers, no longer asked to imagine themselves within the atemporal moment of a natural state independent of any sustaining narrative, are abruptly confronted with the fact that understanding what they read depends on their careful attention to what he referred to in his Preface as "the sequence of time and of things" (3:122). Each stage within the sequence of changes Rousseau previews for his readers will take place as a progressively more complete alienation of the individual from the independence and self-sufficiency he knew as a being "always entire with himself" (3:136). This anticipatory glimpse of the first act of enclosure thus occurs within Rousseau's text as an unexpected illumination not only of that stage within mankind's evolution but of what precedes and follows it. That fleeting vision of a ter-

rain so different from the lone savage's primeval forest imposes on Rousseau the duty to serve as the historian of these sad changes.

Rousseau's argument, as well as the explanation of his shift from a rhetoric of the unfissured moment in Part One to a plumbing of the complex temporalities of reciprocal consciousness in Part Two, rests on his insistence that an awareness of the other always brings with it a redefinition of the self. Individuals do not simply draw closer to and interact with each other; rather, proximity and exchange radically alter the individual's perception and valorization of the self. Consciousness of self becomes permeated by an awareness of the other. The new dimension of the comparative, of the larger and smaller, the stronger and weaker, the slower and faster, generates an awareness of self in relation to the other that subverts what before had been the autonomy of the individual's self-generated sentiments and feelings.[5] No longer alone in its solitary present, consciousness projects itself at every moment into the uncertain future of possible encounters with others in relation to whom the individual who was once stronger runs the risk of being redefined as weaker. As the fear of such reversals within the future becomes conceivable, satisfaction within the present is likewise compromised by the possibility that it one day be consigned to a lost and regretted past. A progressively more invasive consciousness of the self in relation to the other brings with it the full regime of temporality. The once unfissured present is fractured into a perilous negotiation between past and future.

The present is reduced to an anguished anticipation of what lies beyond it, a knowing-beyond, a para-noia, inspiring constant insecurity and fear. The awareness of self has now become an awareness of how that self exists as a variable waiting to be redefined by the myriad imaginable versions of an uncertain future in which every action within the present must be evaluated and decided. To live within this paranoia, to live within society's continual juxtapositions of the self with the other, is to enter an arena of reciprocal hatreds spawned by the resentment of what all have made of each.

* * *

The formation of the civil state flows directly from the mutations implicit in this growing dependence of each on all. Moral inequality, transforming the consciousness of the self into a violent demand for recognition by the other, exacerbates natural inequalities to the point where all interaction among individuals becomes an unregulated struggle for domination

and mastery. The ownership of land, things, and other men has become a reality; but a reality sustained only by the prerogatives of force. Designating something or someone as one's property depends on the always precarious ability to repel all who would challenge that claim. "The destruction of equality was followed by the most frightful disorder; thus the usurpations of the rich, the brigandage of the poor, the unbridled passions of all, stifling natural pity and the as yet weak voice of justice, made men avaricious, ambitious and evil" (3:176). Life within such a community soon becomes indistinguishable from a state of general warfare.

This movement toward a universal violence prepares the moment which Rousseau has carefully staged as the revelation of his readers' hidden truth. In the midst of that chaos, the richest and most cunning, those best able to recognize the precariousness of their positions and to take measures to protect them, formulate a stratagem which will transform their adversaries into their protectors. For the first and only time in this text Rousseau sets aside his third-person narration and offers his readers instead a verbatim rendition of the consumate exercise in duplicity that made dupes of all its listeners. This rich man's ruse consists in his appeal to a vision of the future which redefines what must be done in the present. The speaker's entire argument relies for its cogency on the seductive verbal portrait of a future in which all are imagined as benefiting equally from a deceivingly beneficent reign of justice, law, and peace.

"Let us unite," he says to them, "to protect the weak from oppression, to restrain the ambitious, and to secure for everyone the possession of what belongs to him. Let us institute regulations of justice and peace to which all are obliged to conform, which make an exception of no one, and which compensate in some way the caprices of fortune by equally subjecting the powerful and the weak to mutual duties. In a word, instead of turning our forces against ourselves, let us gather them into one supreme power which governs us according to wise laws, protects and defends all the members of the association, repulses common enemies, and maintains us in an eternal accord." (3:177)

For those who have grown accustomed to thinking of the present only in terms of what it implies for the future, for those who must otherwise imagine their future as a continuation of violence, oppression, and inequality, this comforting mirage offers a hope as irresistible as it is fallacious.

In terms of what is said, this speech reiterates with biting irony what Rousseau saw as the great lie his contemporaries have chosen to believe so fervently. His entire history of humankind has been structured in such a

way that, at the point where his audience would least like to hear it, one of its principal players steps out of that faraway scene and confronts the reader with a speech echoing all the optimistic rhetoric of solidarity and progress his readers so frequently heard around them. Here, however, that rhetoric is revealed as a false and meretricious vision of the future. An illusion woven of words, it is a mirage blinding its listeners to the reality it conceals.

Such was, or must have been, the origin of society and laws, which gave new fetters to the weak and new forces to the rich, destroyed natural freedom for all time, established forever the law of property and inequality, changed a clever usurpation into an irrevocable right, and for the profit of a few ambitious men henceforth subjected the whole human race to work, servitude, and misery. (3:178)

Rousseau ends his portrayal of human history with a devastating contrast between its beginning and its end. At one extreme, there was the savage man who lived entirely within the moment and entirely within himself. At the other, there is "the sociable man, always outside of himself, [who] knows how to live only in the opinion of others from whose judgment alone he draws the sentiment of his own existence" (3:193). Having lost all contact with the autonomous present of a consciousness aware only of itself, the individual's sense of worth now finds itself postponed within a process of infinite deferral. Whatever judgment he might make of himself within the present always hangs on a future judgment of the self by the other. Transformed by society, civilized man knows himself only as he attempts to control how others might know him. The self's present is forever waiting on a future entirely in the hands of others.

* * *

Rousseau's argument in the *Second Discourse* relies on an opposition between the eternal present of savage man living in the state of nature and the unreal future of civilized man deluded by his dependence on others. At the end of his life Rousseau will rewrite this trajectory, but in the opposite direction. Stepping back from what had become an always painful awareness of a menacing other that now includes the whole of humankind, Rousseau begins his *Rêveries du promeneur solitaire* with the proclamation that he has become the affective equivalent of the savage man with whom everything began. "I am now alone on earth, no longer having any brother, neighbor, friend, or society other than myself."[6]

The single question he addresses, the only one that still holds any mean-

ing for him, is that of the self abstracted from any trace of the other. "But I, detached from them and from everything, what am I?" (1:995). Rousseau presents this new quest not as a freely made choice of narcissism, but as a resigned acquiescence to the single alternative left him by the anonymous yet universal mass of his fellows. "The most sociable and the most loving of humans has been proscribed from society by a unanimous agreement. . . . They are now strangers, unknowns, in short, nonentities to me—because that is what they wanted" (1:995). To turn away from other men is to turn away from the paralyzing specter of a future of continued suffering they have it within their power to impose on him. If, Rousseau insists, he is ever truly to know himself, it must be within a moment held safe from any anticipation of a future defined by his vulnerability to what he knows he must fear from those others. "Real evils have little hold on me; I resign myself to those I experience, but not to those I dread. My alarmed imagination brings them together, turns them over and over, draws them out, and increases them. Anticipating them torments me a hundred times more than being in their presence, and the threat of them terrifies me more than their actual arrival" (1:997).

Rousseau's project in the *Rêveries* becomes that of capturing, representing, and drawing the only pleasure still available to him from the experience of his own random sensations, feelings, thoughts, and memories. As such, these reveries will have no more coherence than the chance succession of whatever enters his mind from one moment to the next. "I will say what I have thought just as it came to me and with as little connection as the ideas of the day before ordinarily have with those of the following day" (1:1000). As he writes this work, Rousseau both proposes and realizes a solipsistic utopia: that of his containment within a seamless yet chaotic continuum of sensation, feeling, and reflection enjoyed outside all influence of the other.

This turning away from the other sets the *Rêveries* apart from the earlier variants of Rousseau's long autobiographical endeavor. The *Confessions*, in spite of its title, reads far more as an accusation of the other than as an indictment of the self. The silencing of his detractors it seeks will depend on the precise and exculpatory narrative Rousseau offers to God and his fellows. This text will justify his actions through a careful examination of the real motivations that were at work throughout what is presented as the integrated story of his life. The *Confessions* relies on and expresses a faith in narrative's careful concatenation of cause and effect as the only means for communicating the complex interdependence of self and other necessary for judgment.

By 1772 this faith in narrative had given way to the quite different enter-
prise of the *Dialogues*. Obsessed with the accusation of hypocrisy he sees
everywhere leveled against him, Rousseau accepts the fact that no retelling
of his life, no matter how carefully written, can convince his readers of his
innocence so long as his enemies can claim that he is lying, that there is a
chasm between the real Rousseau and the figure conjured up in his pages.
"And what if," he imagines his enemies claiming, "this sublime jargon in-
spired by the hypocrisy of an exalted brain is nonetheless dictated by a base
soul [une âme de boue]" (1:667). Rousseau's response to this prior disquali-
fication of any justification he might offer is the delirious and painfully para-
noid attempt to arrive at a form of writing, a sustained dialogue between
"Rousseau" and a character designated only as "the Frenchman" that will
provide an irrefutable proof of the veracity of its author. Rousseau's goal in
the *Dialogues* is nothing less than the impossible production of a language
in which lying becomes impossible, a language whose status as statement
(as *énoncé*) guarantees its veracity as utterance (as *énonciation*). Staging such
scenes as a careful rereading of all he has written and a long visit to the au-
thor by the hostile Frenchman, Rousseau tries frantically to close that gap
between text and writer where the possibility of hypocrisy begins. The *Dia-
logues* are an attempt to insure that the moral quality of its author be abso-
lutely, unquestionably, and totally represented within what is written. Not
only is this work written within the shadow of the other, but its sole pur-
pose is to compel that other to become an effective double of the author
concerning the judgment to be made of his moral value.[7]

It is against this background of the *Confessions* and the *Dialogues* as dis-
tinct yet complementary enterprises that the singularity of the *Rêveries* be-
comes clear. Unlike what Rousseau attempted first as the telling of his whole
story and subsequently as the irrefutable proof of his sincerity, the *Rêveries*
proclaims its genesis in a saving obliviousness to any concern with the other
as witness, as judge, and even as reader. Seeking only to record the day-to-
day variations of what he calls the "barometer of his soul," Rousseau would
renounce all concern with giving this text the coherence or cogency it would
need to interest anyone beyond himself. "My enterprise is the same as Mon-
taigne's, but my goal is the complete opposite of his: he wrote his *Essays*
only for others, and I write my reveries only for myself" (1:1001).

In fact, this turning away from the other as reader exists far more as
an ideal inspiring the work's composition than as an achieved goal. Time
and again Rousseau is overcome by the difficulty of the task he has set him-
self. At every turn of his writing the tug of the menacing other threatens

to reassert itself. This constellation of ten short and finally unfinished fragments reads as a discontinuous and frequently interrupted text because, at each point where the intrusion of the judging other becomes preponderant, Rousseau's only recourse is to end his text and begin anew.

It is not so much that writing is cut off from any concern with reading, but rather that Rousseau's assumed readership is turned back upon and limited to the single instance of the writer become reader. Rousseau writes only so that he himself might read. That act of reading again will both re-establish contact with the moment of happiness that first inspired the text's composition and multiply to potential infinity the time spent within that happiness. "Reading [these reveries] will recall the delight I enjoy in writing them and, causing the past to be born again for me will, so to speak, double my existence" (1:1001).[8]

The transcription of this new happiness takes two distinct forms within the *Rêveries*. The first occurs as the unexpected rediscovery of a moment freed from time within what before had been the tedium of life as an inescapable narrative of persecution. The second, an extension from present to past of the lesson learned in the first, consists in the re-creation of a lost moment from time gone by with such an intensity that the act of writing abolishes all separation between past and present.

The Second Walk centers on an event dated to a specific day, October 24, 1776, as a moment that will play a crucial role in determining how Rousseau writes the *Rêveries*. What happened to Rousseau during that day's after-dinner walk near the village of Charonne, his near-fatal accident when he was knocked unconscious by a large dog racing in front of a carriage, paradoxically provides an experience of happiness so intense that it becomes the model for what his writing would seek to achieve up to his death some twenty months later. Simply put, Rousseau's accident was a near-death experience that would redefine how he lived the rest of his life.

Walking down a country road, stopping from time to time to gather a plant for his *herbier*, Rousseau's thoughts turn to the question of what sense he might make of a life he now senses to be nearing its end. Addressing that question, he reaffirms the innocence and passivity that has been his posture in the face of evil throughout his life.

What have I done here below? I was made to live, and I am dying without having lived. At least it has not been my fault; and I will carry to the author of my being, if not an offering of good works which I have not been permitted to perform, at least a tribute of frustrated good intentions, of healthy feelings rendered ineffectual, and of a patience impervious to the scorn of men. (1:1004)

A short time later, toward six o'clock in the evening, his attention abruptly refocuses on the present when he sees a group of nearby pedestrians suddenly step off the path. To his surprise, a great dane running at full speed in front of a carriage comes into view. He quickly decides that the only way he can avoid being run over by the dog is to leap into the air and let it pass under him. Unfortunately, Rousseau times his jump badly. The next thing he remembers is regaining consciousness in the arms of the four passersby who pick him up after the force of the running dog spun his body around in mid-air and led to his headfirst fall to the ground.

His return to consciousness is marked not by pain or fear but by an experience of the moment he can only describe as a revelation. "I perceived the sky, a few trees, and a little greenery. This first sensation was a delicious moment. It was my only contact with myself [Je ne me sentois encor que par là]" (1:1005). This moment of regained consciousness represents a second birth, the rediscovery of a self in perfect harmony with all it perceives, even to the point of feeling that it is he who, in his very act of perceiving them, endows those objects with their existence. "I was born into life at that instant, and it seemed to me that I filled all the objects I perceived with my frail existence." A pure sensorium one with all it perceives, his consciousness is concentrated within a present moment free of reference to any other temporality defining the self as a socialized, other-dependent individual. "Entirely absorbed in the present moment, I remembered nothing. I had no distinct notion of my person nor the least idea of what had just happened to me; I knew neither who I was nor where I was" (1:1005).

Along with any identity based in the past, there likewise disappears from his consciousness any concern with the future. "I felt neither injury, fear, nor worry" (1:1005). Overcome by the moment's plenitude, he watches the blood flowing from his wounds "as I would have watched a brook flow, without even suspecting that this blood belonged to me in any way" (1:1005). Oblivious to the threat of any other outside the self as well as to his own injuries, Rousseau's entire sense of existence has been redefined by a "rapturous calm" inscribing itself in his consciousness as an intensity of happiness to which "I find nothing comparable in all the activity of known pleasure" (1:1005).

Rousseau's accident quickly led to rumors of his death which in turn provided him a glimpse of what he was convinced was a plot to publish falsified versions of his works once he could no longer denounce them. In spite of that, the ecstasy of those first moments of regained consciousness and of the later act of transcribing them produces the driving force for his con-

tinued composition of the *Rêveries* as the quest for a more sustained form of the beatitude he first experienced on the brink of death. His most elaborate explanation of this new goal of writing comes in the Fifth Walk. There, thinking back to the weeks he spent more than ten years earlier, in 1765, on the Ile de Saint-Pierre where he took refuge after the stoning of his house at Môtiers, Rousseau redefines the act of writing as the vehicle of an equally perfect experience of happiness. Now focusing not on a recent experience like his accident but on the recalling of a lost past, Rousseau uses the moment of ecstasy provided by his near death as a paradigm for the creation, within writing, of a retrospective happiness comparable in intensity to what he discovered after his fall.

Many years earlier, when he first described his stay on the Ile de Saint-Pierre in Book Twelve of the *Confessions*, Rousseau presented the experience of drifting in a small boat on the Lac de Bienne as both an epiphany of the moment ("I gave myself over completely . . . to following without any rule the impulsion of the moment") and as the source of a pleasure "which it is impossible for me to describe or to understand" (1:643). Returning again to that memory as he wrote the Fifth Walk, Rousseau insists that he discovered there what it was "to feel my existence with pleasure and without taking the trouble to think" (1:1045). This opposition of feeling to thought becomes the distinguishing trait of those moments from the past which provide the happiness his writing seeks to create.[9] Struggling to understand how that process works, Rousseau begins a careful analysis of the convoluted temporality on which the happiness of writing the *Rêveries* depends. Contrary to what might be expected, Rousseau insists that it is not the intensity of the pleasure experienced during the remembered event that makes it a fertile ground for this new endeavor. "In the vicissitude of a long life, I have noticed that the periods of sweetest enjoyment and most intense pleasures are not those whose recollection most attracts and touches me" (1:1046). To the contrary, it is their very vividness and singularity, everything that makes them "short moments of delirium and passion," that devalues them as "only points too sparsely scattered along the path of life [des points bien clairsemés dans la ligne de la vie]" (1:1046) and disqualifies them as the basis of any sustained happiness. "They are too rare and too rapid to constitute a state of being; and the happiness for which my heart longs is in no way made up of fleeting instants, but rather a simple and permanent state which has nothing intense in itself but whose duration increases its charm to the point that I finally find in it a supreme felicity" (1:1046). The attainment of this lasting beatitude depends, in other words, far less on the specific tenor

of any cause outside the self than it does on the purely internal awareness of existence they inspire. The self-contained nature of the bliss Rousseau will find within the resurrection of memory endows him with an autonomy comparable only to that of God in relation to his creation. "What do we enjoy [De quoi jouit-on] in such a situation? Nothing external to ourselves, nothing if not ourselves and our own existence. As long as this state lasts, we are sufficient unto ourselves, like God" (1:1047).

As he attempts to explain this new metaphysics of beatitude, Rousseau emphasizes more and more strongly the independence of the consciousness engaged in memory from the world outside the self. The happiness of composing the *Rêveries* is possible only when he is "able to spurn all the sensual and earthly impressions which incessantly come to distract us from it [the precious sentiment of contentment and peace] and to trouble its sweetness" (1:1047). Rousseau's search for happiness in writing the *Rêveries* depends on a strangely ambiguous relation between the self and its experience of the world outside it. On the one hand, it is the lasting memory of the tangible details of his experiences on the Ile de Saint-Pierre that makes possible the happiness he achieves within the act of writing. On the other hand, the efficacy of those memories depends on his closing the self off from all experience within the present. An awareness of the world outside the self is simultaneously the source of what is best and the source of what is worst. The valence of experience changes from positive to negative as the subject moves from a past existing only within a remembering consciousness beyond the reach of any person or event outside the self to the raw vulnerability of the actual present in which the fate of the self remains subject to the intrusions of all who surround it. Taking refuge in memory, Rousseau exists only within the infinitely extendable "state" of all that might be recalled within the description of his stay on the island. In the present of his last years in Paris, however, Rousseau is subject to a vast panoply of seen and unseen forces able, at any moment, to redefine the shape of his lived existence. In opposition to his passive presence within the infinitely varied narratives of persecution imposed upon him by his enemies, Rousseau chooses the ecstasy of dwelling, through writing, in a past moment utterly beyond their grasp.

The value of reverie is a function not only of the textualized memory that sustains it, but of the liberation it brings from "the yoke of fortune and other men" (1:1047). What began as an attempt to define reverie as a happiness set apart from and more durable than the evanescence of those "sweetest enjoyments and most intense pleasures" limited to the passing present of experience becomes the celebration of a new-found force of the moment

abolishing the separation between past and future. The act of recollection may begin as an instant of joy within the scenarios of suffering imposed by what is outside the self. Yet that moment, so fragile in relation to the world of hostile others, is transformed by memory. It becomes a continuity whose duration is as extensive as the act of writing through which the present preserves the past's resuscitation. As a consolation whose goal is "to remember one's self while forgetting one's troubles" (1:1048), this potentially infinite prolongation of the moment becomes an exercise of freedom redefining even what might appear to be its most blatant antithesis. "This kind of reverie can be enjoyed wherever we can be quiet, and I have often thought that in the Bastille—even in a dungeon where no object would strike my sight— I would still have been able to dream pleasurably" (1:1048).

* * *

What, before the dawn of historical time, Rousseau's lone savage experienced as a series of full and self-sufficient moments concomitant with his ability to "carry himself entirely within himself" (3:136) becomes, at the end of Rousseau's life, the product of a practice of memory and writing enclosing the subject of reverie within an equivalent autonomy. In the same way that, in the *Second Discourse*, the radical self-enclosure of savage man was recognized as a fiction that may never have existed, Rousseau, in writing the *Rêveries*, finds refuge in an experience of happiness utterly contrary to the fact of his fate. Here, however, the purpose of the fiction is not his audience's fuller understanding of their history, but the self-directed erasure of any incompatibility between the joys of a remembered past and the sensory perceptions of his existence within the present.

Upon emerging from a long and sweet reverie, upon seeing myself surrounded by greenery, flowers, and birds . . . I assimilated all those lovely objects to my fictions; and finally finding myself brought back by degrees to myself and to what surrounded me, I could no longer mark out the point separating the fictions from the realities. (1:1048)

Reverie is neither a rejection of nor an escape from the present. It is instead a mobilization of the present toward the resuscitation of a past that allows the present to be lived differently. Life within the present may well be punctuated by seemingly endless encounters with the enmity of his fellows. The exercise of fiction, the art of what Rousseau calls imagination will, however, transform that hostility into the precious resurrection of a long

ago and far away over which those others have no control. "But at least they will not prevent me from transporting myself there each day on the wings of my imagination and from enjoying for a few hours the same pleasures as if I were still living there. . . . In dreaming that I am there, do I not do the same thing?" (1:1049).

The explicitly fictional work of an imagination engaged in reverie changes the very nature of the present. No longer a site of vulnerability and suffering, the present of imagination makes of representations drawn from the past something more vivid, more intense, and more purely pleasurable than the past experiences which first triggered its work. Imagination, fictionalizing the past within the present, reorganizes the past's random shards into an illusion and a presence preferable to and more exalting than even the most faithful work of memory alone.

To the allure of an abstract and monotonous reverie, I join charming images which make it more intense. In my ecstasies, their objects often eluded my senses. Now the deeper my reverie is, the more intensely it depicts them to me. I am often more in the midst of them and even more pleasantly so than when I was really there. (1:1049)

Imagination, grounded in and elaborating on a past recaptured by reverie, provides Rousseau with an escape from the burden of time. It allows him to experience the present of consciousness as something other than a Janus-faced anxiety poised between regret for the past and fear for the future. The power of the *Rêveries*, the power of the bliss enacted within their composition, relies on a choice more complex than that of past over present, of memory over life. Few writers have been more acutely aware than Rousseau of the tragedy of time, of the individual's inability to achieve any real grasp of the present as the unique but vitiated temporality of existence. "Everything is in continual flux on earth. Nothing retains a constant and fixed form, and our affections, which are attached to external things, necessarily pass away and change as they do. Always ahead of or behind us, they recall a past which is no longer or foretell a future which often is not to be: there is nothing solid to which the heart might attach itself" (1:1046).

How, given this instability, can the individual achieve a happiness worthy of that name? "Is there even in our most intense enjoyments," Rousseau asks, "an instant when the heart can truly say: *I would like this instant to last forever*" (1:1046). For him, a positive response to that question must come not as the enshrining of a lost past, but as the consciousness of a present held safe from past and future, a present freed from the burden of time. True happiness must exist as "a state in which the soul finds a base

solid enough to rest itself on entirely and into which it gathers its whole being, needing neither to recall the past nor encroach upon the future, and in which time is nothing for it" (1:1046).

Rather than as an allegiance to the past, this happiness imposes itself as a purified present which "lasts forever without making its duration noticed and without any trace of time's passage" (1:1046). While memory may recall the past, reverie's crucial function is to trigger an effusion of imagination within the present moment such that it rises above any separation from past and future. The work of imagination initiates an exaltation of existence such that "this sentiment alone fills it completely" (1:1046). Only in this way can the individual discover "not an imperfect, poor, and relative happiness such as one finds in the pleasures of life, but a sufficient, perfect, and full happiness which leaves the soul no emptiness it might feel a need to fill" (1:1046).

There is, finally, a fundamental similarity between the portrait of savage man presented in the *Second Discourse* and the final beatitude of the Lone Walker exalted by reverie and imagination. Savage man is free, happy, and self-sufficient because, unaware of time as a progression from past through present to future, he lives only within himself and only within the moment. He represents, for Rousseau, a necessary even if fictive starting point for understanding what we have become precisely because, before the dawn of historical time, he is without imagination—"his imagination suggests nothing to him" (3:144)—and therefore indifferent to all those involvements with his fellows that will one day bring about his ruin. At the other end of history, when all are enslaved to the society around them, the faculty of imagination so alien to savage man now provides the only access to a moment outside of time, to a moment become a "state" the happiness of which is so intense that Rousseau can wish it to last forever.

Existence for savage man was a moment both felicitous and forever because it occurred in a saving ignorance of any link between the present and what preceded or would follow it. Savage man was pre-narrative man. For the Lone Walker, it is a more complex chemistry of memory, reverie, and imagination that produces a moment whose happiness allows a similar escape from sequential time. Synthesizing remembered past and sentient present into a moment of consciousness impervious to a future controlled by hostile others, the Lone Walker is post-narrative man. Rousseau's twin fictions of the savage man and the Lone Walker, standing before and after the horrors of history, impose themselves as parallel epiphanies of a moment escaping the tyranny of time.

6

CASANOVA AND THE MOMENT
OF CHANCE

Here, morality is nothing; intensity all.
—Stefan Zweig, *Adepts in Self-Portraiture*

Why is it that, unlike Rousseau's *Confessions*, Casanova's fascinating and per-
plexing *Histoire de ma vie* rarely receives serious consideration in studies of
autobiography as a genre? To some extent, this is the predictable result of
the discomfort many critics have felt with the sexual candor and disabused
frankness concerning human motivations that are so integral to Casanova's
vision. At a deeper level, however, it is the place of honor Casanova grants
to the moment and chance that places his text squarely outside the canonical
protocols of autobiography. Much as Clément Rosset has pointed out that
Western philosophy begins with the expulsion of chance,[1] it is clear that a
similar evacuation of chance presides over the traditional formulas of auto-
biography. To write the self is to situate the self, to place the uniqueness of
its existence and passions within a vast array of other forces—individual and
social, physical and moral—shaping and determining the story of the self to
be told. An autobiography is never only the story of the self. It is the story
of a self born within, reacting to, and reshaping the world to which it tells
its story. The written self achieves coherence thanks to a dialectic of causali-
ties, a conflictual interaction between causes and effects exterior to the self
and that lifetime of projects, passions, and desires through which the writ-
ing self comes to exercise a sway over the world of which it is a part.

 Put differently, the writing subject must, before it can begin to de-
scribe the adventure of the self, achieve a perception of the world's chaos
as an integrated, comprehensible, and therefore manipulable sequencing of
causes and effects. It is only as a result of that perception of the world's co-
herence that the writing self may in turn become the agent of a second and
specifically personal order of causality consisting of the motivated and rea-
soned actions it undertook to force from the world an acknowledgment of
its existence. To write an autobiography is to establish the self as a nexus of
the passive and the active, as an interplay of what the self suffers and what

the self effects. To write the self is to establish it as a triumph over chance, as a series of moments become story.

Given the place it grants to chance and the moment, Casanova's autobiography is unique within the genre. Chance has presided, it would seem, over every aspect of this work's production and dissemination. It was certainly by chance that, at the age of sixty and after having been expelled a second time from his native Venice, the penniless Casanova was offered refuge by Count Joseph-Carl-Emmanuel de Waldstein as the resident librarian at his remote chateau in Bavaria. It can only have been by chance that, after four years of boredom and melancholy in those decidedly inhospitable circumstances, Casanova hit upon the solution of spending up to thirteen hours a day (which, he claimed, passed as though they were thirteen minutes) for the eight years before his death writing the over 4500 manuscript pages of his story. If he chose to write in French rather than his native Italian, it was because that language was more likely to be read by the chance visitors to that isolated spot with whom he avidly shared his manuscript.[2]

It was equally by chance that, twenty-two years after Casanova's death, his grand-nephew, Carlo Angiolini, happened to approach the publishing house of Friedrich-Arnold Brockhaus in Leipzig asking whether they would be interested in publishing the manuscript he had inherited. That chance inquiry led to Brockhaus's beginning to publish a German translation of Casanova's memoir in 1822. By the time the fourth volume had appeared, the publisher decided that Casanova should also appear in French—not, however, as he had written it, but in a back-translation from the German. It was by a singularly infelicitous turn of chance that, four years later, with an eye to capturing the French-language readership that even the defective back-translation had created, Brockhaus's son commissioned a local language teacher, Jean Laforgue, to edit Casanova's original French to the tastes of the day. Laforgue not only censored the text (though less than one might expect), but felt strangely free, whenever Casanova expressed his distinctly *ancien régime* political preferences, to rewrite the text in such a way that Casanova spoke as a convinced *républicain*.

It was certainly by the most outlandish *hasard de guerre* that Casanova's original manuscript, after surviving the destruction of the Brockhaus offices during allied bombing in 1945, was transported in wheelbarrows by American soldiers to the train that would carry it to Brockhaus's new offices in Weisbaden. Finally, the vagaries of chance provide perhaps the least damning explanation for why, even after the authentic French manuscript had been published in a limited joint edition by Brockhaus and Plon, both the

Pléiade and (still incomplete) Livre de poche editions chose to reprint the vastly mutilated Laforgue rewrite rather than Casanova's actual text.[3]

The sway of chance hanging over the composition and publication of Casanova's memoir has also extended to criticism of his work. Because he wrote his most important work in French, but because he was Italian and had published a number of minor works in that language, Casanova scholarship is almost haphazardly distributed between those two areas in most research libraries. More importantly, since Casanova's italianate French could hardly find favor with those who would equate serious literature with stylistic purity, Casanova's text has been granted an at best dubious place in the canon of French literature. Clearly standing as the most important *mémorialiste* between Saint-Simon and Chateaubriand, Casanova has nonetheless never been granted an acceptance even approaching that accorded those two writers. Félicien Marceau has astutely pointed out that, rather than being taken seriously as an author, Casanova has far more frequently been transformed into a literary character falling somewhere between Don Juan and Lovelace or between Gil Blas and Figaro.[4] Casanova the writer (without whom there would obviously be no Casanova the character) has, however, never been given recognition in any way comparable to that accorded Molière, Richardson, Lesage or Beaumarchais as the creators of their respective characters. His demotion is all the more paradoxical in light of the fact that it would be impossible to cite another author who, on the basis of his autobiography, has achieved the same universal recognition as a sexual and social type.

As though reacting against the long line of literary critics who felt they must distance themselves from Casanova's total cynicism toward human and divine laws, François Roustang offers in his *Le Bal masqué de Giacomo Casanova* a reading which carefully abstains from any moral judgment. Roustang sets out instead to make explicit a series of subconscious motivations in Casanova's work which will allow the reader to recognize Casanova's narrative as the product of causalities perceptible only from a psychoanalytic perspective. For Roustang, the coherence of Casanova's story lies in a compulsion to enact seductions that abolish any fixed gender identity such that his refusal of sexual distinctions becomes the token of a far greater ambition. It is only, as Roustang sees it, to the extent Casanova moves beyond sexual difference that he can affirm his imaginary power as a force that exists outside all restraints of paternal authority. Father-daughter incest becomes for Roustang's Casanova the ultimate utopia of an obliterated symbolic order.

As provocative as Roustang's interpretation may be, Casanova's reader

cannot help but feel a certain discomfort with the selectiveness of Rous-tang's examples. While an ambiguity of male and female identity certainly plays an important part in many of Casanova's erotic scenarios, it is also true that there is an overwhelmingly larger number of equally charged erotic adventures in which such ambiguity plays no real role. Roustang's examples are certainly significant but so too are the others. What, finally, is most important about Roustang's study is not so much any particular interpretation it offers but the directness and candor with which it confronts the difficult question of critical objectivity that resurfaces in every instance of even the best Casanova criticism. In a one-page postscript to his study where he adopts the posture of addressing Casanova directly, Roustang asks his reader to read again but differently, the preceding study which first presented itself as a self-assured psychoanalytic analysis of Casanova. Now recognizing the impossiblities of what he has attempted, Roustang concludes that "it would seem indecent to me, and all but impossible, to gather together the various insights your statements have provoked into a nicely ordered case study."[5] Recasting what we have just read, Roustang's closing statement admits frankly that Casanova's text calls into question any posture of mastery and objectivity on the critic's part: "Without you, I would never have arrived at insights I never even suspected, nor discovered new points of view on questions that have haunted me all my life, . . . Without your stories, all that would have remained buried away, because it was only in expressing them to you that I was able to state them for myself" (173).

What is it about Casanova's text that moves a critic as honest as Roustang (honest in the sense of applying to his own interpretation the same professional suspicion he brought to Casanova's text) to end his study by freeing his subject from the constraining causalities he has just enunciated? Roustang's postscript reinscribes within his reading a very Casanovian dimension of chance: the chance of who he happens to be as reader and of the questions his past has led him to pose to the work being studied. Once so recognized, this dimension of chance throws an entirely different light on the study we have read as thesis, as the apparently objective description of subconscious motivations transforming the momentary episodes of Casanova's life into the working out of over-arching conflicts and compulsions. Roustang's self-ironizing postscript is the result of a last glance backward at what he has written, at the work he set out to explicate, and at the inevitable disparity between the two. Roustang's final image of Casanova is that of someone who escapes him, someone who, try as Roustang might to cap-

ture him within his reading, eludes his critical grasp: "Even if I had wanted to hold you back and capture you, I know you would have managed to get away. . . . Your presence stays much with me, but like an other so familiar that he remains a stranger" (173).

* * *

How is it, the question becomes, that Casanova was able to inscribe within his story this sense of freedom, this recalcitrance to categorization, that has disconcerted even his most astute readers? Casanova is first and foremost a champion of the moment, of its chance and fortune, of his resolute determination to play and risk, win or lose. As seducer and gambler, he is a man who lives entirely within the present moment. Anyone reading the twelve volumes of Casanova's memoir is immediately struck by their systematic discontinuity. Casanova's narrative gift is one that allows him to create for each event he describes a sense of the present moment so complete that the reader is immediately drawn into and fascinated by this story of chances taken, of fortune unfolding, and of outcomes decided within seemingly undetermined and unpredictable moments. Though part of a life remembered, each event takes place as though it were independent of any motivation anchored in the past or of any finality projecting it into the future. The reader can open Casanova's text to any page and within a few sentences lose any sense of being unprepared to understand the story being told. If Casanova's narration so easily achieves this plenitude, it is because his is an utterly solipsistic present. He speaks within a moment centered on and concerned only with the feelings, reactions, and desires of a story-telling voice simultaneously at the center and circumference of all that happens in the text. Casanova's story unfolds within a temporality where individual moments exist outside any obligation to coalesce into a greater or more significant whole giving birth to a continuity of purpose and intention extending beyond the present. Casanova's single abiding choice is to trust his luck at every moment of a present which, freed from past and future, is experienced as richer and more vital than any continuity. The dynamic of Casanova's choice expresses itself clearly when he explains why—no matter how delightful his companion of the moment, he preferred to set off alone as he moved from place to place. Speaking as someone who has carefully calculated the odds in favor of the unencumbered and discontinuous moment, of leaving the past behind, he points out that: "she [the mistress of the moment] would stop me from

finding fifty good fortunes in each of the cities where I happened to stop. If I had a mistress with me, she would stop me from taking the charming Irene to the ball tomorrow."[6]

This privileging of the moment likewise reflects itself in Casanova's stylistic tendency to shift as quickly as possible from a distanced narration of past events to their restaging in the present of conversation and repartee. This drive to theatricalize the narrated past as on-going dialogue both accounts for the immediate accessibility of his text and for its liveliness and openness to the unpredictable eddies of the unfolding moment. It was this quality of his prose and its striking contrast with the style of his earlier didactic writings on various political controversies that led the Prince de Ligne to underline in his portrait of Casanova the pleasure and surprise he felt as he read his friend's manuscript during his visits to Dux: "His style resembles that of old fashioned prefaces. It is long, diffuse, and heavy. But if he has a story to tell, for example that of his adventures, he does it with such originality, such naïveté, and such a dramatic sense of how to tell every episode, that one cannot admire it too much. Without knowing it, he is far better than *Gil Blas* and the *Diable boiteux*."[7]

As he composed his portrait of Casanova, the Prince chose to disguise his friend under the pseudonym of "Adventuros." And it is clear that Casanova's constant transmutation of calcified past into free-flowing present eminently qualifies his diction as that of the adventurer. The word "adventure" comes from the Latin *ad-venire*, evoking the challenge and suspense of what is still "to come" and cannot be foreseen. The term evokes, however, not so much the sense of an immediate future as it does the radical uncertainty of a present moment lived as always open to its redefinition by the chance event. The *Grand Robert* defines the adventure as "something unforeseen, unexpected, and extraordinary that happens to someone." It is this sense of the unforeseeable and the unknown which, far from representing a liability, becomes for Casanova the very foundation of his happiness. "Our ignorance becomes our only resource; and the truly happy are those who cherish it" (1:viii). The adventure, like so many of the scenes Casanova chooses to restage, is "a hasardous and dangerous undertaking" (1:viii). To describe something as happening *à l'aventure* is to point to it as occurring "by chance, without any set plan, without reflection" (1:viii).

Casanova stands as the prototype of the adventurer because he is someone not only willing but impatient to take his chances and try his luck. Casanova remains an adventurer because no matter how numerous his conquests and victories he remains indifferent to their consequences and prerogatives.

As a man bound by no past and aiming at no future, he is untouched by the ambitions of any consequent will to power or of any commitment to a goal extending beyond a tasting of the moment's pleasures. Casanova the adventurer represents in this respect a sexual prototype entirely different from the Don Juan figure. As a seducer of women, Casanova aims only at awakening in his prospective partner an awareness of the possible pleasures of the passing moment. His seductions lack entirely that darker, metaphysical tinge of concerted evil that compels Don Juan, the Spanish grandee acting out of a profoundly medieval and Christian misogyny, to confirm his own power by repeatedly tricking his victims into a sexuality meant to degrade them either as virgins deflowered or as wives proved faithless. For Don Juan, every woman represents the potential consolidation of a nefarious and abiding will to power exalting the self through a debasing of the other. For Casanova, every woman is the co-celebrant of a pleasure experienced as an epiphany of nothing more than the full and fleeting potential of their shared moment.

A citizen of Venice, Casanova the adventurer is most in his element as the masked carnival goer. The masked ball, a scene Casanova lovingly stages again and again in his story, is the adventurer's utopia. It represents a reduction of the individual's social identity to the pure present of its momentary apparition. Robert Abirached has underlined the congruency between the dynamics of the carnival and the Casanovian adventure: "the individual is reduced strictly to himself, such as he defines himself in the present moment. He merges exactly with the gestures he makes and with the words he speaks, because he is deprived of everything that previously constituted him: his personality, his family, his situation, his past. He becomes the man without qualities and without a face, who sees without being seen. His is an irresponsible anonymity of which nothing can temper the audacity."[8]

The carnival's distillation of the individual to a discontinuous moment represents the purest form of the Casanovian ideal because it is only within that present that his writing can achieve its most profound purpose. Casanova sets out to tell the story of his life in such a way that, although it is the story of a lost past, each moment finds itself infused with the openness, expectation, and suspense of a present moment whose shape and outcome are subject only to the sway of chance. The singular diction of Casanova's narration is, however, equally rooted in a second present: the present of the act of writing, the melancholy present of the eight years spent at Dux between the ages of sixty-five and seventy-three composing the story of his life from the moment of his first conscious memory at seven to the age of forty-nine when the narrative abruptly breaks off in Trieste. Casanova's prose repre-

sents a sympathetic alchemy of these two distinct presents: the lost present of the moment remembered and the painfully palpable present of an inhospitable reality from which the act of writing represents his only escape. In the same way that the lost present of the past is radically solipsistic in its exclusive concentration on a narrated I, so also the later present of the narrating I is an equally solipsistic moment of desire seeking to please only the self as it relives those happier days through their recreation in words.

Casanova's autobiography is in this respect distinctly unlike Rousseau's *Confessions*. Whatever might be confessed in the twelve books of the story Rousseau offers of his life is, as we saw, reshaped in such a way that confession becomes explanation and explanation justification. In his short Preface, Rousseau insists that his autobiography's status as the first fully and truthfully painted portrait of an individual will allow it to be used by all as a point of reference and comparison for understanding themselves. In return, he asks from his readers only a fairness he feels he has never encountered in his contemporaries. The opening paragraphs of Rousseau's first book, however, redefine his text as a proof of his innocence so irrefutable that it is with it in hand that he will present himself to his Creator on judgment day. Rousseau's attempt at autobiography is crucially concerned with its readers and with shaping their reactions to the story being told. Casanova, presenting his work simply as *L'Histoire de ma vie*, shows no concern with any judgment of himself or his life to be made by the reader. He makes no attempt to convince or manipulate those he imagines one day reading his work. Rather than addressing his readers as a potential tribunal he might anticipate and control, Casanova writes, as did Rousseau when he reached his own epiphany of *Les Rêveries*, solipsistically and for himself alone as the single most important reader of his work. Writing and reading become for Casanova a single act, a collapsing of the distinct temporalities of the story told and the act of its telling into a single present of time resurrected and the act of its resurrection. His is a present so pervasive and so compelling that it lifts the writing subject above and beyond the tragic reality of the separation between those two moments.

Toward the end of Book Eight, Casanova's story reaches a moment of intensity so great that he is led to step outside the pleasure of his continuing story and reflect on what is happening to him as he writes. Staying in the country with the Count Ambroise and his family, Casanova, taken with the Count's daughter Clementine, arranges a surprise dinner in Milan for the entire family. When they arrive at the inn where the faithful Zénobie has arranged everything, they enjoy an exquisite meal together. As they

consume the three hundred oysters imported from Venice and over twenty bottles of champagne, everyone's happiness—that of the host as well as the guests—rises to new heights. Casanova extends for page after page his description of the details of this almost hypnotic memory. Toward the end of this scene, moved to laugh out loud at the "silly moralists [sots moralistes]" who would claim that "there is no true happiness on earth," Casanova reflects on the power of this memory to which his text is an on-going homage: "this happiness passes, but its ending does not stop it from having existed, nor does it stop the person who experienced it from testifying to its existence" (8:271). What he experienced that day and remembers so much later becomes an example of "those hours which make a man happy, and which return to make him so each time that, sound of body and mind, he recalls them" (8:271–72). Addressing his reader directly in his Preface, Casanova anticipates the importance of such moments by pointing out that if at some points he seems to "paint in too much detail certain adventures," it is because his exhausted soul is now "reduced to taking pleasure only through memory [réduite à ne pouvoir plus jouir que par réminiscence]" (1:xix). It is this goal of being able to *jouir par réminiscence*, to achieve a "bliss" which is as much metaphysical as physical, that drives Casanova's act of writing.

The dynamics of this blissful synthesis of the distinct moments of the story told and of its telling most clearly reveals itself in an episode from Book Nine when Casanova is traveling with Marcoline from Italy to England in 1763. Having left Marseille and hoping to reach Avignon by evening, they find themselves delayed when their coach breaks down at a crossroads near Aix-en-Provence. As they wait for the arrival of a blacksmith, Casanova and Marcoline are invited to spend the night at a nearby chateau by its mysterious chatelaine, a widowed countess. When later that evening Casanova decides to pay his respects to his hostess by joining the small group gathered in her bedchamber, he senses they have met before, but he is unable to recognize her because she remains hidden in the deep shadows of her canopied bed. To Casanova's mild surprise, it is the bisexual Marcoline who is chosen to spend the night in the chatelaine's bed and who, the next day, after they have reached Avignon and traveled too far to contemplate turning back, presents him with a letter she has promised to deliver only when they have reached that point of no return. The elusive countess, Casanova is stunned to learn, was none other than Henriette, his beloved mistress of almost sixteen years earlier.

Each time Henriette is mentioned in Casanova's memoirs, she is placed among that small number of women he feels he truly loved. Although he

first met her in Cesena when she was in soldier's disguise and the penni-less companion of a Hungarian officer, she was in fact a Frenchwoman of high birth. His description of their time together in Parma those many years ago was marked by her transformation from a moment's diversion into the limitlessly fascinating representative of a social class to which Casanova could only aspire. For him, Henriette would always stand as the perfect in-carnation of feminine intelligence and wit. It is this memory that the letter handed over by Marcoline now brings back. The letter itself consists only of an address written in Italian, "To the most honest man I have known in this world," and, at the bottom of the otherwise empty page, the simple signa-ture, "Henriette."

As he reads this non-letter that consists only of salutation and signa-ture, Casanova finds himself plunged into a kind of trance, a state beyond any concern with the journey before him: "Seeing that, I remained mo-tionless both in body and soul" (9:86). His mind is invaded instead by a half-remembered verse from Ariosto's *Orlando furioso*, "Io non morri, e non rimasi vivo [I did not die and I did not remain alive]" which leads to his ad-dressing directly the distant and inaccessible Henriette:

Dear Henriette whom I loved so much and whom it seems to me I still love with the same ardor. You saw me, but you did not want me to see you? Perhaps you thought your charms had lost the power with which they captivated my soul sixteen years ago, and you did not want me to see that in you I had loved someone who was only mortal. O cruel Henriette, unjust Henriette! You saw me, but you did not want to know if I still loved you. I did not see you, and I could not learn from your beauti-ful mouth if you were still happy. That is the only question I would have asked. . . . You are a widow, Henriette. You are wealthy. Let me imagine that you are happy. Perhaps you laughed with Marcoline only to let me know that you are. My dear, my noble, my divine Henriette! (9:86–87)

This ecstatic colloquy with the absent Henriette is presented as occur-ring not at the moment of the text's composition, not as Casanova sits alone in the chateau at Dux, but at that very moment almost thirty years earlier when he read the signature at the bottom of the blank page: "Marcoline, surprised at my long ecstasy, never dared disturb me. . . . 'Do you know,' she later said to me, 'that you frightened me? You became completely pale. For a quarter of an hour you looked as though you had lost your wits'" (9:87). What is happening here in Casanova's narrative, what he describes as the "long ecstasy" of speaking directly with the absent object of his memory, is an emblem and anticipation of what will be accomplished throughout Casa-nova's later narration of his life. This scene offers in miniature a model of

the dynamics of Casanova's entire autobiography. Rather than a lament consolidating a sense of loss flowing from a juxtaposition of then and now, of memory and reality, Casanova strives for a discourse retrieving the lost beloved as a presence so intense that it recreates the past as present. This scene, with its *I* and *you* overcoming in their dialogue the separations of time and space, symbolizes and prefigures Casanova's entire enterprise as an attempt to abolish within his text the saddening antinomies of then and now, of a life to be lived only in retrospect and a death that draws nearer each day.

In his attempt to recapture a lost past, Casanova adopts a strategy distinctly different from that of Marcel Proust in his *A la Recherche du temps perdu*. Proust's goal is to fashion within language a script of memory whose carefully wrought verbal texture might complete and replace the debased and contingent reality of lived experience. Writing *La Recherche* was, for Proust, an escape from the tragic evanescence of the moment and lived experience. Transcribing into words an ideal available only through the alchemy of language and involuntary memory, Proust's text is meant to stand forever outside the ravages of time. Casanova's goal is entirely different. Rather than attempting to create a language beyond time and contingency, he seeks as complete a resurrection as possible of those aspects of experience which, for Proust, rendered it base and meaningless: its status as aleatory, fractured, fleeting, and unmastered—its status as moment. Proust's text offers itself as a monument standing beyond the ravages of time. The author as person may die, but his creation will live on as it is read by generations to come. Proust's work follows not only the circular trajectory of bringing us, in its closing pages, to the point where the narrator may at last begin to write the work we have just read, but also the other-directed trajectory of a text which, having conquered the vicissitudes of time, stands readable by all within an infinite future. Casanova, unlike Proust and with a sincerity far less compromised than Rousseau's, writes only for himself. No fewer than three times within the short space of his Preface and first chapter, he repeats the motto he has adopted from Cicero: "Necquicquam sapit qui sibi non sapit" [He knows nothing who does not himself profit from what he knows] (1:vi,xxi,1). Casanova's writing is the vehicle of a *jouissance par réminiscence* intended to recapture for its author the real and palpable pleasures of a contingent and chance-driven present teeming with all the undecided potentialities of the moment. Casanova seeks not the past recaptured, but the present revivified. His text sets out to achieve not a victory over time, but a resuscitation of the delicious uncertainty of life lived within the temporality of an aleatory moment forever subject to the surprises of

rings, expensive jewelry, fine clothes, and carefully groomed wigs he wore when playing—a very particular kind of snuffbox: "They [two masked sisters Casanova had just met] asked me for some tobacco. I gave them my snuffbox with its secret compartment containing a scandalous miniature. I had the impertinence to show it to them, and one of them, after carefully examining it, gave me back the snuffbox, telling me that as a punishment for my crime, I would never learn who they were" (8:166). The erotic miniature hidden in the snuffbox functions as a kind of relay, an abrupt reminder of the proximity of these two versions of the moment seized. The prim sister referred to here may first recoil at Casanova's reminder, but she will substantially revise her reaction within only a few pages.

The similarity of the gambler's and the seducer's privileging of the moment not only places the latter at but a transition's remove from the former, but points to gambling as a model for the kind of seduction with which Casanova's name is most often associated. More often than not, Casanova's liaisons with one or another of his partners begins and ends with no more necessity than the random falling together of two cards in a particular deal. For the fleeting moment of the game's play, each is all important to the other. That importance, however, is no more grounded in a significant past and no more implies a future commitment than would the coming together of a jack and queen in a given hand. Life's successive shuffles of desiring bodies deploy the individual within configurations that hold together for no longer than what Chantal Thomas has aptly referred to as "le temps d'une curiosité."[10]

Gambling's status as a central metaphor within Casanova's life story inevitably raises the question of his personal ethics, the question of whether or not he forced the moment by cheating. This question has been complicated by the fact that critics who find themselves fascinated yet at the same time repulsed by Casanova's omnivorous sexuality often compensate for that ambiguity by roundly (and anachronistically) condemning him as nothing more than a vulgar cheat. Ignoring the eighteenth century's decidedly uncertain boundary between honorable conduct and "correcting fortune," they resolve in relation to Casanova the gambler questions left open in their relation to Casanova the seducer. At the opposite extreme, those literary historians unabashedly sympathetic to Casanova adamantly defend him on this charge.[11] Casanova, like anyone of the period who derived a substantial part of his income from gambling, was well acquainted with the techniques of cheating and was perfectly adept at forcing or holding back a card at pharaon. His most frequent recourse to that skill, however, came in low stakes

social games where allowing an attractive woman to win against his bank served as the opening gambit to an eventual seduction. He candidly admits that, on a number of occasions when he discovered a dealer was cheating, he sold his silence by buying into the bank for a percentage of the winnings and thus profited indirectly from the cheating he left undenounced. While certainly cynical, this reaction was perfectly consonant with the "live and let live" attitude Casanova took toward a world about which he had no illusions. There is, however, an important difference between that posture and the systematic dishonesty of the professional cheat. The fact is that, on those occasions when he was engaged in a duel at high stakes, Casanova lost far too frequently to have been the kind of gambler whose skill at cheating could have made him a sure winner.

The ambiguity around this question stems from the way Casanova describes certain scenes from his initiation as a gambler. It was during his short career as a soldier at the age of twenty in Corfu and Constantinople that Casanova first encountered serious gambling. He tells how he often played with and lost heavily to a professional gambler named Maroli. When Casanova decided he would stop playing, Maroli took pity on the young loser: "having seen on my return that I was determined to play cards no longer, he thought me worthy of being let in on the wise precepts without which games of chance are sure to ruin all who love them" (2:102). What, the question becomes, does Casanova mean by the "wise precepts" to which he is here introduced? For those who would dismiss Casanova as a cheat the answer is obvious: Maroli taught him the mechanic's slights of hand allowing him to control the cards. In fact, the expression "wise precepts," taken in the larger context of how Casanova describes his gambling, refers to something quite different. What Casanova first learned from Maroli was a new approach to wagering grounded in the birth and slow propagation of a new science which was to redefine the practice and significance of gambling as a social ritual central to aristocratic life. Reflecting on that period of heavy losses and how he was forced to pawn everything he owned, Casanova points out that "such is the fate of every man inclined to games of chance, unless he can put fortune on his side by playing with the real advantages arising from calculation and skill. A wise player can profit from both without risk of being deemed a cheat" (2:63). The "calculation" and "skill" Casanova refers to here are terms borrowed from the then emerging *calcul des hasards* or probability theory first traced out in Huygens' *De ratiociniis in ludo aleae* of 1657, Leibniz's *De aestimatione* of 1678, and, most importantly of all for this

context, Montmort's *Essai d'analyse sur les jeux de hasard* of 1708 which was the first book to offer detailed analyses of popular gambling games as well as practical rules for how to maximize winnings.[12] That it is this new science to which Casanova is referring when he speaks of Maroli's "wise precepts" becomes clear not only in the distinction he draws between their application and "being deemed a cheat" but later in his memoir when he describes his protracted duel at pharaon with the banker Carcano in Milan.

During an afternoon visit to Carcano's home, which comes after many public sessions of pharaon where Casanova lost far more than he won, he is greeted by his host's proposition that they play pharaon for the two rings they are wearing—Casanova's being worth three thousand sequins and Carcano's two thousand. Casanova replies that he will gladly accept the challenge, but on the condition that they alternate as dealers. To Carcano's curt reply that he will only play as dealer, Casanova counters with the proposal that they then make changes in the rules so as to minimize the dealer's advantage: "Let's even the odds. Doubles of the same card will not count, nor will the last two cards" (8:176). Pharaon is a relatively simple game: players may bet on any of the thirteen cards from ace to king with suits irrelevant. The dealer then turns over the cards one by one from a shuffled deck. The dealer wins all money bet on the first card he turns and on all other odd numbered turns. The player wins when he has bet on a card that turns up in the second or any other even numbered position. What Casanova is suggesting they eliminate here is the very real banker's advantage that comes from two additional rules: first, that if the same card (say two different sevens) appears in successive odd and even positions, the banker nonetheless collects half of any bets made on the seven; and second, that the last card, the fifty-second, normally a winner for the bettor who has chosen it, is counted as nul. When Carcano refuses, claiming that such changes would give the player an unfair advantage, Casanova's reply confirms his familiarity with the analytic method of probability theory:

The advantages, I said to him, for the dealer are two. The first, which is the less important, consists in the fact that, since you handle the cards, you are not obliged to worry about there occurring any irregularity in the deal. The peace and tranquility of your reason is never disturbed, while the bettor is completely occupied with trying to figure out *which cards the probabilities suggest are more likely to appear on an even rather than an odd turn*. The other advantage is in the timing. The banker deals out the card that wins for him before he deals the one that wins for the bettor. Your success is thus placed prior in rank to that of your adversary [emphasis mine]." (8:176–77)

The wily Carcano, claiming complete incomprehension of such esoteric disquisitions, disingenuously replies that for him everything Casanova has said is *du sublime*.

Learning from the new science, and applying its theorems to the game at hand, was for Casanova the hallmark of the *joueur expert* who capitalizes on every possible advantage in the larger game of life. Casanova opens the second chapter of Book Eleven with a philosophical reflection on humankind's relation to "fortune," to the ironies and surprises of what the Christian would call providence and the sceptic fate: "It is natural that fortune should treat a man who indulges his caprices the way a small child does an ivory ball on a billiard table as he pushes it first one way and then the other so he might laugh when he sees it fall into the pocket. But it is not natural, it seems to me, that fortune should treat that man the way an expert player does the ball, carefully calculating the force, the speed, the distance, and the rebound" (11:35). If fortune plays with us like a bored child at billiards, carelessly knocking us across life's table until it might laugh at our fall, the individual's only defense is to become precisely what the child is not: the "expert player" who draws an advantage from every piece of information he can ascertain at any given moment of life's games.

Casanova's knowledge of probability theory and the fact that his success as a gambler depended far more on it than on cheating point to his ambiguous position at the cusp of a highly significant change in the ethos and practice of gambling which was taking place throughout the eighteenth century. For the nobility and for court society in general, gambling at recklessly high stakes had long been a way of affirming their independence from the ever-expanding rule of money as well as from the untitled yet politically ambitious bourgeoisie incarnating that rule. To lose big and blithely became for the nobility a spectacular (if more and more suicidal) demonstration of their superiority to those for whom the financial bottom line was the only foundation of their social identity. The ubiquitous gaming tables of the *ancien régime*'s final century became the battlegrounds of this conflict between two antithetical definitions of individual value. An insight into gambling's social function for the aristocracy can be found in a description of play at the Ridotto made in 1680 by the visiting Frenchman Limojon de Saint Didier: "the calmness and phlegm with which vast sums are won and lost is so extraordinary that one might think the Ridotto a school . . . for the teaching of deportment rather than a place of amusement."[13] For the traditional aristocracy, individual identity was grounded in an ideal of blood and honor incommensurate with material wealth. For the ever more powerful bour-

geoisie, who one was depended far more on what one possessed than on who one had been born.[14]

Casanova offers in his memoir what must stand as one of the century's most exquisite examples of this clash between two incompatible value systems. In Book Ten Casanova describes the visit by Empress Catherine II of Russia to her recently acquired domain of Riga and the pharaon game she insisted on dealing as banker for the assembled local dignitaries. "To amuse her faithful retainers, she very graciously told them she had decided to set up a small pharaon bank of ten thousand rubles. In an instant that sum in gold and a deck of cards were set before her. Catherine sat down, took the deck, pretended to shuffle, offered the cut to the nearest player, and had the pleasure of seeing her bank disappear before she got through the deck. That had to happen unless the players were idiots, because the cards had in fact not been shuffled and everyone knew what the winning card would be as soon as the one before it had been turned over" (10:95). In spite of the sum that changes hands here, there is no clear loser and no clear winner. In losing the ten thousand rubles, Catherine has reaffirmed her superiority to money as money. By breaking the bank in the short space of one deal, the avid locals have confirmed their convictions as to the patent absurdity of such imperial largesse.

Casanova the gambler provides a particularly revealing perspective on this conflict. The son of an actor and a shoemaker's daughter, Casanova clearly belonged neither to the aristocracy nor to the monied bourgeoisie. As the self-anointed chevalier de Seingalt, his life was, however, a masterpiece of class mimicry. He incarnated a certain prototype of the aristocrat with far more panache and conviction than did the majority of those actually endowed with the proper lineage. Money, for Casanova, was never something to be amassed and prudently multiplied as the basis of one's social status. To the contrary, money existed only to be spent with a lavishness that consolidated the impression of aristocratic independence from its power: "Having plenty of money, I could not wait to take advantage of the first chance to shine by spending lavishly" (8:121). If Casanova took immense pleasure in bestowing gifts even outside the context of seduction, it was not with the hope that they would one day be returned in kind. The gift served rather to consolidate the mutual obligations of those select few to whom he claimed to be an equal and granted the title of friend: "my custom was to never keep count of the money with which I was only too happy to oblige my friends" (8:143). As a gambler who depended on his winnings to continue the life of the traveling aristocrat, Casanova understood full well that

his reputation as a *beau joueur* depended far more on what he lost than on what he won: "I made everyone very happy when I agreed to put up the bank; and after three quarters of an hour I left, delighted to have lost thirty or forty sequins. Were it not for that, I would never have been recognized as the greatest gambler [le plus beau joueur] of all Europe" (8:250).

While recounting his stay in Milan of 1763, Casanova describes in lavish detail a project which stands as a symbol of his canny manipulations of the aristocratic ideal dictating that the most impressive wealth was wealth consumed, wealth squandered, wealth which flung away became the endlessly fascinating proof of one's superiority to all wealth. The background for Casanova's gesture is one of the masked balls that punctuates Milan's long carnival season during which the local aristocracy competed with one another to see who could appear in the most impressive costume. Wishing to oblige his companions of the moment—a young lieutenant and his sister on whom Casanova had designs, their cousin, the lieutenant's mistress and the marquis de F...—Casanova arranged to have Zenobie and her tailor husband prepare for the three women and two men costumes unlike anything ever seen, costumes which could not fail "to surprise, to provoke the greatest curiosity, to draw a circle of admirers from the start to the finish of the ball" (8:195). After spending more than two hundred gold ducats at the most exclusive clothier's in Milan, Casanova prepares the garments for tailoring in a way that astounds Zenobie's husband: "I took a knife from my pocket and started to cut holes in the clothes. Then I put my fingers into them and make rips, two or three inches in this direction, two or three inches in that direction, in the breeches, the vests, the coats, the linings . . ." (8:193–94). He then gives his instructions to the tailor: "Now it is up to you, I told him, to show your skill in repairing these garments, roughly sewing the ripped edges together here, and adding the most mismatched patch you can find wherever it seems most appropriate to you" (8:194). Casanova's plan is to use these "superb dresses turned into rags" to disguise his friends as beggars [des gueux et des gueuses] with each of them carrying a plate to beg alms from the assembled aristocrats. The marquis de F...'s reaction to the finished costumes confirms Casanova's astute understanding of what is truly noble: "The marquis de F... was beside himself as he imagined the impression this mascarade would make, for it would have been impossible to invent anything more truly noble. Everyone would see that these superb and brand new clothes had been ripped up on purpose and so comically sewn back together that they were a charm" (8:199–200).

Worn new and as they had been made, these clothes would have

simply taken their place in an unchallanged hierarchy of ostentatious display. Ripped, rent, half patched with pieces of various clashing fabrics as expensive as the clothes, they become symbols not of what money can buy, but of gratuitous expenditure, of a pure waste that affirmed the iconoclastic satisfaction of individual whim as superior to the power of money. For Casanova, of course, this posture was a pretense, an exploitation made possible by his position as an outsider who, neither rich nor noble, both underlines exactly how much he paid and basks in the extra-monetary effect he achieves.

Casanova's perspective on the world around him, its conflicts and divisions, is that of someone who is a partisan of neither side. What he prizes most is his freedom to move effortlessly across boundaries and frontiers as the moment dictates. Toward the end of his Preface, Casanova raises the question of how his writing the story of his life is related to his impending death. His willingness to consider a mortality against which his entire text is a gesture of defiance comes after he admits that it is a "fear of being hissed" that has made him decide not to publish his memoir while he is still alive (1:xviii). Does this not mean, the question becomes for him, that he is therefore in debt to death? "It horrifies me to imagine myself contracting even the slightest obligation to death, which I loathe" (1:xviii–xix). Casanova abhors the thought of death not for what it represents in itself, not out of any fear of an afterlife or judgment, but because it will deprive him of life as the sum of everything he holds most dear: "Happy or unhappy, life is the only treasure man possesses, and those who do not love it are not worthy of it" (1:xix). Struggling to express why he finds the thought of death so intolerable, he comes upon a metaphor which conveys the essence of his attitude toward life: "death is a monster which drives an attentive spectator from the great theater before the play in which he is infinitely interested has ended" (1, xix).

Life for Casanova is most certainly a theater. As an infinitely amused player on life's stage, he insists on retaining for himself the perspective of the spectator. No matter how delightful any role of the moment may be, it must be played with the same distance that led Casanova the lover politely to refuse the option of any traveling mistress who, as we saw earlier, would only prevent his drawing the fullest possible enjoyment from the fifty other candidates for that role sure to present themselves on his path. For Casanova, the adept of probability theory, these odds of fifty-to-one leave no question as to how he will place his bets.

Casanova's single greatest success in the world of gambling came from his determination to seize every moment in the great theater of life and profit from whatever role a chance-driven world happened to place within

his grasp. His one period of real wealth came from his involvement in a gambling mania where he was never the player, but the observer and overseer. Between the years 1757 and 1759, and thanks to a scenario that vividly demonstrates his ability to derive the maximum advantage from any moment that arose, Casanova found himself named co-director of the *Loterie de l'Ecole Militaire* in Paris, a position that allowed him to profit handsomely from the betting frenzy it inspired. Arriving in Paris as a penniless exile after his escape from prison in Venice, Casanova had only one card to play: his friendship with the influential abbé de Bernis, now a state minister, that went back to the time of their *parties carrées* with two nuns in Venice when Bernis had been the French ambassador. Bernis, as luck would have it, remembered him well. After giving Casanova a roll of one hundred louis to cover his expenses and promising to introduce him into the proper circles, Bernis advised Casanova that the key to success at Versailles lay in new ideas for raising crown revenues: "the man they listen to is the one who brings in the money" (5:20). While grateful for Bernis's advice, Casanova had not the slightest notion as to how state finances worked or might be augmented: "I took my leave full of gratitude, but utterly incapable of finding any way to augment the King's income. Not having the vaguest idea about finances, there was no point in racking my brain. The only thoughts that came to me had to do with new taxes, and, as each of these seemed odious or absurd, I rejected them all" (5:20).

Bernis first arranged a visit for Casanova to the powerful duc de Choiseul, but he was interested only in hearing the story of Casanova's escape from the dreaded Leads prison. It was during a later visit to M. de Boulogne, the *contrôleur général des finances*, and Pâris-Duverney, the famous financial advisor to the king who was then trying to raise twenty million francs to begin construction of the Ecole Militaire, that Casanova saw his opportunity to seize the moment. Claiming, without the slightest idea in mind, that he had a scheme which would raise no less than a hundred million livres, Casanova was astounded to hear Pâris-Duverney reply: "I know what you are thinking of. . . . If you are not engaged, come to dine at my home tomorrow, and I will show you your plan, which is a good one, but which has run into almost insurmountable problems" (5:22). Always ready to take his chances, Casanova prepared his strategy for the next day. "If he thinks he is going to get anything out of me, let him try. When he tells me what he thinks is my plan, I will be the one who decides whether he is right or not. If I understand what he is talking about, perhaps I can add some new detail. If it is beyond me, I will keep a mysterious silence" (5:22).

Once at Pâris-Duverney's, Casanova finds himself part of a group of tax farmers and financiers whose "reasoning was so full of professional jargon that I did not understand a word" (5:23). After dinner, now in Pâris-Duverney's study with a smaller group, the moment of truth arrives as Casanova is handed an in-folio notebook. "I read on the title page: A Lottery Based on Ninty Numbers, with the five winning numbers being drawn at random, etc., etc. I hand him back the notebook and do not hesitate for a moment to tell him that was my project" (5:23).

The proposal Casanova unhesitatingly declares his own had in fact been submitted to Pâris-Duverney some months earlier by two Italian brothers, the Calzabigis, one of whom was present in the study while the other, an invalid afflicted with an unbearable rash that confined him to his bed, had actually formulated this lotto-like scheme on the model of the Genoa lottery. If the French government had not accepted the project, it was because a number of ministers saw the possibility of the emergence of a string of big winners on the early draws as an unacceptable risk for the royal treasury. Casanova, seizing his chance and playing his role, transformed himself into the eloquent spokesman of the mathematical certainty that such a lottery would yield huge profits and pose no threat to crown finances. Pâris-Duverney, dazzled by the enthusiasm Casanova's verbal bravura and cloud of mathematical jargon generated even in this skeptical audience, was sure he had found his man and immediately invited him to address the full counsel of ministers on the subject. Calzabigi, having spent months making no headway against the very objections he watched Casanova wisk away, wasted no time in offering him the co-directorship of the lottery. Within a short time Casanova prevailed over the reluctant ministers and the lottery was established exactly as he insisted: as a crown lottery with the full financial backing of the state treasury. For his troubles, Casanova received a pension of four thousand francs as well as the franchise for six ticket offices. He immediately sold five of them for twenty-six thousand francs and assured the success of his one remaining office in the rue Saint-Denis by paying winners one day after the drawing rather than the stipulated full week. Within a few weeks, Casanova turned its management over to his valet. No one laughed louder than Casanova at Bernis's joke that "without him I would never have known I was an expert in state finances" (5:29).

This ability to seize the moment, to adjust his persona to the ebb and flow of an ever-changing present, was the talent Casanova most consistently pointed to as the key to his successes. As Casanova saw it, it was precisely this gambler's readiness to profit from whatever momentary advantage chance

might bring that was the common thread through all truly great accomplishments. Some years later, aggravated at how an officer named d'Entragues always left their piquet game as soon as he had won ten or twelve louis, Casanova proposed they play an endurance match with a side bet of fifty louis going to whomever outlasted his opponent. After more than fifty hours of play with breaks of no more than fifteen minutes, Casanova found himself exhausted to the point of hardly being able to read his cards. He finally saw his opening when d'Entragues returned to the table after a break of slightly more than fifteen minures. Pointing to his watch and initiating what he calls a "querelle d'Allemand," Casanova managed to disconcert his opponent totally. A few minutes later the exasperated d'Entragues ordered a cup of bouillon to calm himself, but in his upset state he found its effect quite different. First trembling in his chair, he fainted dead away on the table, unrevivable and clearly the loser of their match. As Casanova saw it, his ploy of the punctilious argument over a few moments delay established him as a connoisseur of chance and circumstance equal in merit to a victorious general. "My ruse worked because it had not been planned and could never have been foreseen. It is no different for a general of the army; a *ruse de guerre* can only spring from the head of someone who captains chance and circumstance and has the habit of promptly seizing all the opportunities offered by men and events" (8:70).

* * *

Casanova's decision to tell his story as an autobiography of chance, as a haphazard concatenation of episodes lived from moment to moment, establishes his life as an adventure adamantly resisting integration within any larger context. Celebrating chance, Casanova's diction is, in a very real sense, irreducible to any larger philosophy it might be assumed to exemplify. On the one hand, and in spite of his winking protestations to the contrary, his is clearly a post-Christian and post-classical voice uninflected by any concern with the expectations, laws, and judgment of any order beyond the human. Casanova portrays a world marked more than anything by its universal and nonchalant amorality. The pleasures of the moment he chronicles aim at nothing beyond themselves as their own and only reward. "This [his having renounced any hope based in the future] leaves me only with the liberty to take pleasure in the moment [de jouir du moment]. And I take advantage of it with all my strength. *Carpe diem* is my motto" (11:208).

On the other hand, and with greater consequences for today's reader,

the consciousness of self that informs Casanova's autobiography stands reso-lutely outside the age of ideology ushered in by the French Revolution as the crucial event redefining Casanova's world during the last decade of his life. His exclusive privileging of the present, his solipsistic concern with the pleasures of the moment, and his concerted exaltation of chance presup-pose the irrelevance not only of any theocentric morality but also of the democratic and scientistic ideologies with which the Revolution would dis-place the ethics of Christianity. Casanova remained steadfastly hostile to the Revolution not only as a series of specific historical events but also as the beginning of a new age of ideology. An ideology, whatever its premises and orientation, summons individuals to define and justify themselves in rela-tion to a narrative integrating them within the community of their fellows. Ideology holds out the promise of transforming a juxtaposition of indepen-dent moments into a project in terms of which all individual actions will be measured and assessed.

In his Preface of 1797, written a year before his death, Casanova impu-dently dismisses the new moralities of collective and mutual responsibility by defining in a single sentence what he calls his personal "system": "the reader who enjoys thinking will see in these memoirs that, as I never aimed at any set goal, the only system I followed, if it can be called a system, was to let myself go wherever the wind which was blowing drove me" (1:viii). The term "system," which Casanova here uses as a synonym for his personal phi-losophy or for what the nineteenth century would come to call ideology, by the time he wrote, had taken on as one of its subsidiary meanings the style of play adopted by those gamblers who, rather than relying on luck and bluff, carefully applied the principles of probability theory to their play and bet-ting. Attentive to the moment's ever changing *combinaison des cartes*, their "system" consisted in betting on what the *calcul des hasards* indicated as the most probable outcome to be expected in the turning of the cards.[15] Casa-nova's only system, in life as in gambling, was that of a studied attentiveness to every aspect of what was happening around him and to how he might de-rive the maximum benefit from any given array of possibilities. Casanova's guiding principle was to accept himself as someone "extremely susceptible to the seductions of every pleasurable sensation, always joyful, eager to pass from one pleasure to the next, and ingenious in inventing them" (1:xiii). Passing from one pleasure to the next and ready to invent his own should the need arise, Casanova was always and everywhere the gambler ready to take his chances on whatever the moment offered.

Casanova stands outside the age of ideology because his system of ac-

cepting the possibilities, negative as well as positive, of a moment governed by forces of chance beyond human control renders absurd any abstract or impersonal program of liberty. Liberty for Casanova could only be the insolent privilege of the gambler who had both the courage to bet and the luck to win. Exclusively individual and utterly of the moment, it could never become the foundation of an ideology dictating how humankind might remake its world: "It is a fact beyond question that a noble soul could never believe himself not to be free. And yet who can call himself free in this hell we call the world? No one. Only the philosopher could claim that, but at the cost of sacrifices which are perhaps not worth such phantom liberty" (5:251). Having watched from afar the tragedy of the Revolution's giving birth to the Terror and the sad end it imposed on the many friends who fell victim to its executions, Casanova knew only too well how high the price could be of those "sacrifices" made to the phantom of liberty. To make of liberty an enforceable ideal against whose enemies one must rage contradicted Casanova the gambler's most intimate understanding of a world in which moral imperatives, and even the most basic notions of good and evil, were at best dubious concoctions: "my misfortunes no less than my good fortunes have proven to me that, both in this physical world and in the moral world, good comes from evil, as evil comes from good" (1:ix). Forever turning, life's wheel of fortune made a mockery of all those clear distinctions between the supposed goods and supposed evils on which any ideology must base itself. Looking back on the tenor of his own life's trajectory, Casanova saw his story as an inextricable and demystifying conflation of what only fools could categorize as good and evil, vice and virtue: "all my life I was drawn into vice yet at the same time I worshipped virtue" (8:131).

Appalled by the spectacle of a world writhing in the birth of ideology, Casanova recreates within the story of his life a chronicle of the moment's pleasures confirming the futility and inhumanity of all exclusionary ideologies. In place of the dramas of accusation and assigned guilt acting themselves out in the aftermath of the Revolution, Casanova offers the story of his life as the most personal of confessions. It is, however, a confession of a unique kind. Dedicated not to the denunciation of past sins but to the creation of future pleasures, it will allow Casanova to share with his readers a laughter born of accepting their common fallibility and their common humanity: "In the style of my narration you will find neither a show of repentance nor the constraint of someone who blushes in confessing his escapades. These are the follies of my youth. You will see that I laugh over them and, if you are kind, you will laugh over them with me" (1:ix).

In the closing paragraphs of his Preface, Casanova explains how he has arrived at the acceptance of life through which he tells his story. In a world where chance reigns equally over all and where all stand equal before it, it can only be as a gesture of the most futile petulance that we would seek to assign to any other person or group the responsibility for our successes and failures, whatever disappointments and sufferings the moment has brought. Responsibility for our defeats and our victories is always ultimately our own. Even to suggest that simple premise has, however, become a dangerous luxury in a world given over to what threatens to become a universal orgy of blame and recrimination: "I would gladly have displayed the proud axiom *Nemo leditur nisi a seipso* [no one suffers other than by his own doing], if I were not afraid of offending the vast number of those who, whenever anything goes badly for them, cry *It is not my fault*" (1:xxi). Even in only conditionally evoking this proud motto of "No one suffers but at his own hand" Casanova rejects the politics of guilt and victimage he saw being acted out by those who, in the name of new and ever more sanguinary ideologies, had transformed the Revolution into a hecatomb.

Casanova's final response to the adventure of life is to relive its pleasures through his autobiography of chance and, in writing it, to create for himself and the many readers with whom he shared it a single saving comedy set off from the tragedy of his times; a comedy that establishes a new nobility based not on blood but on a shared laughter: "I can imagine finding no more pleasant pastime than to converse with myself about my own affairs and to provide a worthy subject for laughter to the well born audience that listens to me" (1:xi).

Painting the Moment

7
ROGER DE PILES AND THE MOMENT'S GLANCE

Having concluded my examination of literature with Casanova inviting us to share with him a laugh provoked by the vividly remembered tableaus he conjures up from his past life, I would now like to turn to a direct consideration of painting, to the shape of the moment's role in the theory and practice of image making. An illustrious line of the Enlightenment's most important estheticians and artists anticipated Casanova's call to look at the image as an experience the dynamics of which are intimately related to the force of the moment. In so doing, they enacted within the century's other major arena of esthetic representation a similar refusal of society's continuities in favor of a celebration of the pleasures to be found within a perception of the instant's eminently disruptive power.

In seventeenth- and eighteenth-century France painting became the focus of a conflict that not only reshaped the theory and practice of the art but established between it and the emerging powers of the state a relationship which, at any earlier period, would have been unthinkable. Painting, in the France of Richelieu, Mazarin, and Louis XIV, reached a status unknown to prior centuries. Institutionally reconfigured, it became an important instrument of the drive for power and prestige on the part of a centralized and decidedly imperial monarchy. The stakes involved in the politics of how painters were educated and in how their works might be displayed to an ever broader public rose to a point where that art was redefined by an interplay of forces that extended far beyond the limits of the esthetic. Painting became quite literally an affair of state.

This new context for the practice of painting posed with particular intensity the problem of the moment. How was painting as an art of representation reconfigured by that subversion of the stable, the defined, and the established? It was not, I would argue, by accident that one of the late seventeenth century's most important reflections on the moment grew out of and defined itself as a reaction against what was the most massive state-supported esthetics of painting: French classicism.

The question of how a painting comes to have meaning for its audi-

ence—whether that meaning depends on a careful reading of the image through an elaborate cultural knowledge or whether the painting's meaning lies in an unmediated and direct moment of spectatorship—became an issue of interest not only to practicing artists but to the larger intellectual community. Breaking with a tradition dating back to the Middle Ages, the value of a painting would no longer be seen as a function solely of the professional standing of its creator (of his rank in the closed hierarchy of an artisans' guild), but would come to be more and more directly related to its reception and interpretation within a broader discursive community comprised of spectators and critics, of all those who would view the work of art and write about the effects of that viewing.[1] This new discursive reality of an ever expanding dialogue between the artist and the spectator-become-critic insured painting's transformation from an insular *métier* into a weathervane not only of controversies concerning the relation of painting's semiotic processes to those of the other arts, but also of the defining conflicts within the society it addressed. Out of the conflict between such figures as Charles Le Brun and Roger de Piles, seventeenth-century France would see the beginning of something genuinely new: the practice of art criticism as a discourse charged with motivating, explicating, and controlling the tremendous and potentially chaotic power of the painted image.

The most far-reaching transformation of the practice of painting in seventeenth-century France grew out of a displacement into the realm of state politics of what had begun as a conflict among painters. Since the end of the fourteenth century, and primarily because of the value of the gold and other materials used by artisans, the formal qualification of someone as a "painter" had been regulated by a strictly hierarchical guild known in France as the *Maîtrise*. An individual was recognized as a painter, and thus licensed to accept commissions from the church, the crown, and other paying clients, only after passing through a carefully regulated apprenticeship to guild members. That apprenticeship eventually culminated in the production of a "masterpiece" whose acceptance by the guild brought full recognition of its creator's professional status within the *Maîtrise*. As with most such guilds, the passage from one generation to the next was often a function of family relations, with training and professional recognition passing from father to son. The status and structure of the *Maîtrise* were recognized by a series of decrees issued by the *prévot de Paris* granting it a monopoly over the trade.

As early, however, as 1608 that theoretical monopoly was regularly infringed by the king, the queen and other members of the royal family who, unhappy with the professional independence of guild members, exercised

the privilege of granting *lettres de brevet* commissioning artists of their own choice even when they had not received official recognition by the *Maîtrise*. By mid-century this conflict resulted in a situation where painters were, as Norman Bryson has described it, "forced to choose between two equally undesirable alternatives: either corporatism, or favouritism; either to submit to the exorbitant authority of a guild or to rely on the haphazard patronage of the crown." [2]

If two so unappealing alternatives emerged, it was in large part because what began as a conflict over who, the guild or a member of the royal family, was entitled to commission an artist soon found itself absorbed within a much larger and properly political contest between the Paris Parlement and the crown. This conflict, which the historian Orest Ranum has gone so far as to describe as "the first French Revolution," [3] by 1648 led to the insurrection and overt violence of the *journée des barricades* and the Parlementary *fronde* which resulted in the Court's taking refuge outside of Paris in the relative safety of Saint-Germain. Beginning in the early 1640s the *Maîtrise* regularly allied itself with the Paris Parlement, petitioning it both to limit the number of painters to whom members of the royal family could issue a *brevet* and to exclude all such non-guild painters from eligibility for commissions emanating from the church. The *Maîtrise*, in other words, adopted for its self-preservation a strategy that firmly aligned it with the increasing efforts of the Parlement and the Parisian bourgeoisie to assert an authority distinct from and independent of the crown.

In response to this, the agents of the monarchy quickly found themselves obliged to defend the crown's prerogatives even in the arena of painting. In 1640 Richelieu had convinced Nicolas Poussin to return from Rome to Paris where he was expected to become the champion of the royalist position. Either disgusted by or temperamentally unsuited to such a role, Poussin chose to step away from that battlefield and instead returned to Italy in 1642. It was six years later, in the same year as the parlementary *fronde*, that Mazarin took the first effective step toward institutionalizing the crown's attempt to wrest control over painting from the *Maîtrise*. This took the form of Mazarin's creation of the *Académie Royale de peinture et de sculpture*. The key figure involved in the founding of the Academy was the painter Charles Le Brun, the protégé of the Chancellor Séguier. Adopting as the motto of the Academy's work the phrase *Libertas artibus restituta* [the liberty of the arts restored], Le Brun became the driving force behind what would amount to a redefinition of the theory and practice of painting as a full-fledged "liberal" art. The implementation of Le Brun's program for the

Academy would receive crucial support from the Crown at every turn, not so much out of any sympathy with the esthetic positions he espoused but because, in strengthening the Academy against the *Maîtrise*, the monarchy was, as Bernard Teyssèdre has put it, "all too happy to wrest from parlement a new parcel of what before had been under its jursidiction."[4]

The thrust of what Le Brun was attempting to do, as well as the lasting effect his efforts would have on French art for more than a century, can be seen in his choice of the term "Academy" for this new body. Explicitly modeling itself on the *Académie française* as it had been established by Richelieu in 1634–35, the new Academy of Painting and Sculpture defined its mission as that of recognizing and making explicit the intellectual and cultural dimensions of painting as a fine art. If painting as an art were ever to achieve the fullness of its promise, Le Brun argued, it had to be rescued from the control of a recalcitrant *Maîtrise* made up for the most part of unschooled artisans who saw their work as little more than the exercise of a craft, a workmanlike combining of colors carried out with no consideration for any larger esthetic dimensions. A new sense of class, not the class confered by blood and lineage, but the class of those capable of enunciating the intellectual implications of their artistry, was at the center of Le Brun's agenda. If painting in Paris had never achieved the exalted status it knew in ancient Greece or contemporary Italy, Le Brun proclaimed, it was because it had fallen into the hands of people whose intellectual ambitions were little more than those of domestic servants. "If in Greece, Italy, and all other refined nations, those arts have always been practiced liberally and nobly, we in Paris have seen them reduced to a servile captivity, subjected to tyrannical laws imposed by a guild of valets, and placed within the category of trades."[5]

Le Brun's plans for the Academy centered on the education of artists who would be able to practice painting, as the above passage's operative adverbs indicate, "liberally and nobly." The figurative nobility, of which manually adept craftsmen were clearly assumed to be incapable, depended more than anything else on their reconceiving painting not as a skill at conjuring images but as the art of formulating and communicating a message. The value of a painting was proclaimed to lie not at the level of its signifiers, of its skillfully executed surface, but at the more profound and ennobling level of its signified meaning. The true work of art, according to the Academy, must become the imagistic equivalent of a verbal discourse. The art of painting depended at the level both of its origin and of its purpose on a discourse of learned words: those the painter might utter to himself as he conceived his subject before setting a brush to canvas and those the spectators would

use to enunciate for themselves the work's meaning as they stood before the finished image.

In the same way that a knowledge of rhetoric allowed producers and consumers of verbal discourse both to enunciate more explicitly and to appreciate more fully messages expressed in words, so also the public lectures and discursive analyses of painting at the center of the Academy's curriculum would allow both aspiring artists and an informed public to refine and perfect their production and appreciation of messages for which the visual sign was never more than a vehicle. According to this new approach, the value of a painting was a function of the unity and force of its subject matter, of the story the image set out to tell. The specific visual reality and physical contours of the image became the pictorial equivalent of words. Painting's status as an art depended on what André Félibien, the Academy's official historiographer, would call *théorie*: the artist's ability to conceive of his subject matter in such a way that it figure forth a necessary *grandeur des pensées* and *connaissances spirituelles*. The actual execution of the properly conceived painting was relegated to the more mundane category of *pratique* as little more than a manual dexterity associated with the tradesmanlike concerns of the *Maîtrise*.

The Academy's curriculum was an amalgam cobbled together by borrowing from the period's often idiosyncratic understanding of Aristotelian rhetoric as it had been elaborated in the analysis of poetry and theatre.[6] Ever repeating its guiding principle of *ut pictura poesis* [as in poetry so also in painting], the Academy defined painting as a kind of poetry in images: images that always flowed from and led back to words. It was as a function of this decisive orientation toward the discursive that the Academy would raise to the highest rank the hyper-significant images of history pieces as a form of painting deemed clearly superior to the quotidian and verbally insignificant subjects of the genre pieces and still-lives favored by the *Maîtrise*.

*　　*　　*

Founded in 1648, the Academy in its early years was hardly a great success. More concerned with doctrinal purity than practical influence, its austere program of public lectures and bookish research posed little immediate threat to the *Maîtrise*. As the guild still continued to control most commissions, the majority of young painters chose to affiliate themselves with it rather than with its dour and demanding alternative. The real change in the Academy's fortunes came as a result of the young Louis XIV's decision in 1661 to assume personal control of the government. His ministers, now

responsible directly and only to the King, were granted vast powers. Jean-Baptiste Colbert, the *ministre des bâtiments*, was charged with putting in place what would amount to a state monopoly over artistic production. In the first year of Colbert's tenure, the Academy was given official recognition and financial support by the crown and Le Brun was named *premier peintre du roi*. Le Brun was also designated by Colbert as his personal delegate in charge of the newly created *Manufacture royale des Gobelins*. This last office alone gave Le Brun control over a corps of two hundred weavers and fifty painters.

Le Brun, at least as talented a bureaucrat as he was a painter, immediately set about consolidating his position. In 1663 he established the Annual Prize to be awarded to the painter who best rendered a heroic exploit of the young king. Three years later he initiated the *Prix de Rome*, awarded for the best execution of a biblical scene, which brought with it a year of supported study in Rome. With Colbert's support, Le Brun claimed for himself and the Academy a power over artistic production which had been held previously only by the combined agencies of the church and the crown as commissioning bodies. Le Brun had full power to decide, for the growing number of painters dependent on him, precisely which genres they would work in and what texts or events their images would illustrate. The following year, in 1667, the crown issued a decree grouping together into a single company under Le Brun's control all engravers, decorators, mosaicists, ebenists, and goldworkers. Beginning in 1668, Louis XIV provided, in the form of his massive project for the transformation of the chateau de Versailles, the perfect setting for an exercise of Le Brun's now consolidated powers on a scale never before imagined. Literally hundreds of artists of all kinds worked there under his direct control. By 1675 his pre-eminence was such that he alone was empowered to authorize all decrees emanating from the Academy of which he was by then both chancellor and rector.

As these events make clear, the dominance of Le Brun and of the Academy was made possible only by the unique confluence of an artistic doctrine and an exercise of political power. The Academy and the crown agreed on an absolute privileging of the saga of royal pre-eminence as the primary message to be conveyed and illustrated. For Le Brun and for the crown, the thrust of their shared endeavor was unambiguous: it was, in all its variations, a celebration and glorification of the King. In his poem *De la peinture*, Charles Perrault, Colbert's preferred propagandist, states clearly the essence of this project:

Ainsi donc, qu'à jamais ta main laborieuse
Poursuive de Louis l'histoire glorieuse,
Sans qu'un autre labeur, ni de moindres tableaux
Profanent désormais tes illustres pinceaux.[7]

[Thus therefore may your laboring hand forever
Follow the glorious history of Louis,
With no other task and no lesser tableaus
Profaning from this moment your illustrious brush.]

* * *

Few works better illustrate the artistic practice generated by this singular merging of the esthetic and the political than Le Brun's own *Second Conquest of the Franche-Comté* (Figure 1). This work was so dear to him that, in Nicolas de Largillière's portrait of Le Brun, the painter is shown seated before and proudly gesturing toward a reduced-scale version of that work intended for the vault of the *grande galerie* at Versailles. The *Second Conquest* was to be one of a series of eleven full-scale and eighteen smaller paintings glorifying the person of Louis XIV. Its title refers to the fact that, after taking this territory, the Franche-Comté, on the Swiss border from the Spanish Habsbourgs and then being obliged to return it by the Treaty of Aix-la-Chapelle in 1668, Louis XIV went on to conquer it a second time, a conquest finally consolidated by the Treaty of Nijmegen in 1678.

The painting is a masterpiece of extended allegory. Slightly to the left of its center, a romanized version of Louis XIV strikes a statuesque pose conveying his domination of all the hectic events swirling around him. His left arm and index finger point imperially to a group of imploring women who have been brought to his feet by Mars, the god of war. The women's status as symbols of the towns of the Franche-Comté is confirmed by the ecussons scattered among them. Poised on a rock between Louis and the god Mars is the figure of Hercules, who, with heroic virtue, raises his cudgel to menace the Spanish lion cringing behind the rock fortress that represents the citadel of Besançon. To the lion's right is a terrified enemy soldier. Behind the lion and to its left is the wizened figure of an old man who symbolizes the rigors of winter. Arrayed behind the lion are such further signs of winter as wind, snow, lightning, a fish, a ram, and a bull, the astrological symbols of Pisces, Aries, and Taurus. At the painting's extreme right, perched on a withered branch, is the Imperial eagle representing the help for Spain that had been promised but never delivered. On the other side of Louis as the

central figure, Fame, blowing two trumpets, one for each successful campaign, is seated on a cloud-like mass beside him. Directly above Louis, the bellicose figure of Minerva aids Hercules in his battle. Above her, again in clouds, is the figure of Glory holding an obelisk in her left hand and, in her right, a golden crown soon to be positioned over the King's head. Louis' left hand rests on his staff of command, which is poised on the right shoulder of the vanquished river god of the Doubs, who watches in terror as the winged figure of Victory detaches the laurel trophy from a palm tree at the base of which is piled the booty of Spanish military equipment and battle flags.

As every element within this detailed landscape makes clear, to look at this painting is, quite literally, to read it. Each of the many figures and details making up its busy surface is there not for itself, not for the beauty of its surface or the skill of its execution, but as a symbol meant to dissolve

Figure 1. Charles Le Brun. *Second Conquest of the Franche-Comté*
Musée du Louvre

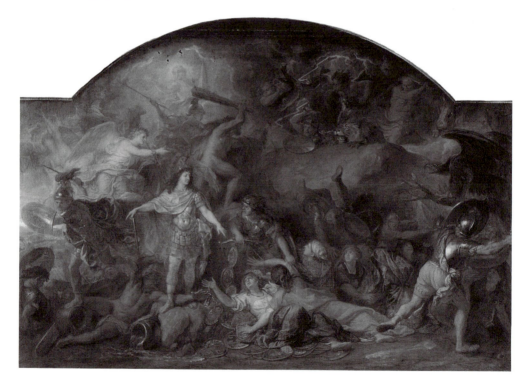

immediately into the discursive meaning it is intended to convey. No element within the painting lingers or solicits the spectator's fascination with its visual surface. Instead, each part draws its meaning from its absorption within the work's overall transformation of image into allegory. The painting qua painting disappears without trace into the discursive narrative of monarchical glory it expresses at the level of its signified meaning.

Le Brun's *Second Conquest of the Franche-Comté* stands as a masterpiece of the kind of history piece mandated by the Academy because, above all else, it tells a story. Yet the story it tells, although clearly drawn from the narrative of history, relies on a semiotic structure antithetical to the uncertainty of the events it chooses to portray. The painting certainly refers to a military conquest drawn from history. But, as represented within this image, that historical sequence of events is stripped of all the uncertainties and ambiguities of any actual moment drawn from the flux of battle. The unstable eventualities of the moment are replaced by a series of visual tautologies that are forever fixed outside time and change. Mars *is* military valor. Fame *is* the blasting trumpet of renown. Glory *is* the celebration of royal conquest. And, above all, the King *is* an icon of his majestic victory over any force that might oppose him. Each of these elements transforms what might have begun in the uncertain here and now of actual history into the immutable eternity of symbolic equivalences. The precariousness of the real is everywhere eliminated in favor of timeless emblems attesting to the inevitability and irresistibility of royal glory.

The genre of history painting promoted by Le Brun and the Academy is at the antipodes of realism. Nothing within the image sets out to convince its spectators that it is a convincing likeness of any person or figure they might encounter within the moment-to-moment unpredictability of real life. What the image provides instead is the representation of an ideal outside time and change. At the level of meaningless fact, France's retaking of the Franche-Comté did take place as a result of countless uncertain combats in a protracted conflict with the Habsbourg empire which, over most of the second half of the seventeenth century, would favor first one and then the other side. No trace of that historical ambiguity is, however, present within this image. Instead, the history piece glorifying the King portrays a radically different sense of time and history. Striving to express the absolute perfection achieved at the impetus of France's glorious monarch and his choosen peers, Monsieur de la Chappelle enunciated, in a discourse delivered to the French Academy in 1699, the new sense of history at work in this immediate equivalence of the real and the ideal.

One could say that there is a kind of fatality or, better put, a sacred order of Providence that has established in all the arts, and among all peoples of the world, a single summit of excellence never to be surpassed and never to be equaled elsewhere. This same immutable order has designated a certain number of illustrious men, who are born, reach the flower of their age, and come together for a short space of time during which they are separated from the rest of common humanity within a circle setting them apart from that lesser world marred either by the imperfections of what is only beginning or by the corruption of what has already begun to grow old.[8]

The argument implicit to de la Chappelle's grandiose claim turns on exactly the same paradox as that at work within Le Brun's painting. What was born, flowered, and has imposed itself within one moment of time has, in spite of that origin, achieved a perfection lifting it outside the vicissitudes of time and change. Having attained the immutable perfection symbolized by the circle that sets them apart, what we see so gloriously before us stands forever separate and untouchable by the lesser feats of all that might one day begin and of all that might one day grow old. Perfection's moment demands that its representation become the token of an unchanging eternity.

* * *

The most direct challenge to the Academy's semiotic absolutism grew out of an entirely different understanding of the moment and its role in both the creation and interpretation of painting. Roger de Piles, in a series of works beginning with his *L'Art de peinture de Charles Alphonse Dufresnoy, traduit en français avec des remarques très nécessaires et très amples* of 1668 and continuing through his *Cours de peinture par principes* of 1708 ultimately became the most important art critic of his period. His reputation continued throughout the eighteenth century, eclipsing even that of Diderot whose *Salons* are so frequently represented as the first instance of serious art criticism in the modern sense of that term. De Piles's *Remarques*, modestly presenting themselves as a translation from the Latin of Dufresnoy's *De Arte Graphica*, in fact trace out a series of positions totally different from those of the Academy in regard to the nature and value of painting as an art.

For de Piles, Le Brun and the Academy with their careful systematizing of painting's rules have effectively expelled from that art every trace of its most essential qualities. For the theoreticians of the Academy, a painting's value was a function of the work's subject matter, its signified content. Its visual elements, the movements, postures, gestures, and facial expressions of its figures, were deemed effective to the extent they eloquently and unam-

biguously expressed the characters' inner feelings. The painting as chromatic surface was asked to disappear as the spectator proceeded directly to an appreciation of the work's signified meaning. This, for de Piles, amounted to nothing less than the disappearance of painting itself. If the work were to be of any value whatsoever, if it were to *be* a painting, it must, before and as a precondition to any perception of its signified meaning, exist as a visual surface, as a pleasing and captivating arrangement of form and color arrayed within the physical limits of the canvas.

Comparing painting to music rather than to poetry, de Piles insists that what he calls the "total economy" of any given work is always a function of the quality (as opposed to the meaning) of its subject. More importantly, this quality is described as something that must impress itself upon the spectators within the very first moment of their perception, their first glance, the *premier coup d'oeil*. "This economy of the whole taken together produces the same effect for the eye as does a musical concert for the ear. There is one fact of great consequence to be observed in the economy of every work, which is that we first recognize the quality of the subject. The painting, upon our first glance at it, always inspires its principal passion."[9] In direct opposition to what Félibien, speaking for the Academy, called the work's "unity of subject" (a concept modeled on the Aristotelian unity of action and referring exclusively to the painting's represented subject matter or signified content) de Piles argued for the primacy of what he chose to call the "unity of object," a term designating the work's immediate effect as visual surface. More than a simple shift in terminology, this insistence on the unity of object was the cornerstone of an entirely different hierarchy of values within painting. Rather than support the unimpeded depiction of subject matter achieved by the distinct line of a Le Brun or a Poussin, de Piles awards a primacy of rank to the dazzling surfaces of a Rubens, to the effect achieved by an arrangement of pigment on canvas that operates before and independently of any subject matter it is intended to portray.

In taking this position, de Piles struck at the very heart of the Academy's esthetic, at its presumption that painting is before all else an art of imitation. For de Piles, it is simply not true that, for the spectators, a painting's surface must yield as rapidly as possible to the perception of a signified meaning. In beholding the figure of Louis XIV such as he is portrayed in Le Brun's *The Second Conquest*, we do not, de Piles insists, scrutinize the details of his placement, posture, gestures, and context so that we might draw conclusions from them according to premises pertinent to how we would react to the same scene in real life. For de Piles, painting is always and obvi-

ously an illusion. It is only when we accept it as such that it can achieve its most important effects upon the spectator. De Piles asks quite simply that we begin to *look* at painting and that we appreciate it on the basis of that first glance defining the moment of spectatorship. Painting must be approached as something other than a vehicle for words, as something more than a means whose only goal is to disappear within an enunciation of the discursive meaning it is assumed both to copy and to convey. As surface and as illusion, the painting must provoke within its spectators an impassioned moment of fascination before it can ever, as signified meaning, appeal to their minds as the representation of a signified meaning. Before it can teach us, the painting must move us.

De Piles's argument that the painting must be recognized as visual surface and the spectator must be considered as fascinated subject turns on his claim that, just as the visual artifact's unity of subject must yield to its unity of object, so must the Academy's privileging of line and design yield to a recognition of the primacy of color. To a large extent, the controversy between de Piles and the Academy repeats the dispute of the preceding century between the Italian colorists of Lombardy and the line-oriented school of Rome. The fundamental notion in question here, that of design or line, has two distinct meanings.[10] At one level, the term "design" referred to the art of drawing, to the work's use of outline or contour to guarantee a perception of the work's subject matter. At a second, more theoretical level, "design" referred to the painter's act of *invention*, to his conceptualization of the subject, to his idealization and deployment of the work's constituent elements. For the Academy, following the lead of the Roman theoreticians, design was the essence of painting. It incarnated and gave shape to the work's ability to express the all-important intellectual and spiritual dimensions of subject matter and meaning. Approached in this way, design was, for the spectator, the indispensable bridge between the painter's canvas and its translation into a discourse of comprehension.

Color and surface, on the contrary, if allowed to become anything more than handmaidens of design, opened the way to a perversion of the work's power to stimulate discourse. As early as 1662, Roland Fréart de Chambray made clear the Academy's position when he denounced all attention to color as the beginnings of a "libertine painting style which has lost all contact with those constraints which in another time rendered that art so admirable and so difficult."[11] Any concern with the colored surface as surface, rather than as what allowed the spectators to better perceive design, could only distract from what Félibien, again enunciating the Academy's synthesis of the esthe-

tic and the political, saw as the ultimate goal of all history painting. "Painting's principal claim to glory lies in its ability to render great men immortal by bequeathing their image to posterity."[12]

To stimulate in the spectator any excessive attention to the painting as colored surface was to encourage a dubious fascination that dangerously postponed the perception of the work's all-important subject matter. Color invited an incongruous concentration on a dimension of the image relating it not to its mimesis of a necessary and providential scene drawn from the unfolding history of monarchic glory, but to the base and insignificant realms of appearance, accident, and chance. Color called attention to what had happened for no other reason than the insignificant fact that it had happened. In deemphasizing color, the Academy was embracing a tradition that dated back to antiquity, which declared that the physical mixing and juxtaposition of different pigments producing the specificity of color was associated with what occurred not by mimetic intention but by random chance. As legend had it, it was the great Athenian painter Apelles who, despairing at ever rendering the foam on the body of a horse he was attempting to paint, finally threw his sponge at the image before him and, by pure chance, its contact with the surface produced a perfect replication of the effect he had so vainly struggled to achieve through his art.

De Piles stood at the antipodes of this tradition. For him, color was the very soul and highest achievement of painting. What he refers to as *la cromatique* must, he insisted, be recognized as the essence of that art. Adopting the Italian distinction between *color* as the physical pigment massed on the artist's palette and *colorito* as the specific way that pigment is used to produce the finished image, de Piles distinguished between what he called *couleur* and *coloris*. For him, to dismiss the importance of *coloris* in favor of line, as the Academy had done, was to eliminate any role for vision from the spectator's appreciation of painting. To condemn color as arbitrary and meretricious was to divorce painting as an art from the realm of the eye. In the *Cours de peinture* he argues that, when the work of art is reduced to line and design, one is no longer talking about painting at all but about sculpture. Line, abstracted from color, is a property that speaks most properly to touch, to that sense specifically addressed by the art of sculpture. Line as distinguishable from color is what we perceive with our hands as they move over the contours of the sculpted object. Painting, as an art addressing vision rather than touch, loses its essence when it foregoes the exploitation of color as a phenomenon perceptible only by the eye. The design so privileged by the Academy's esthetic could never be more for de Piles than what

Jacqueline Lichtenstein has aptly called, "the blind spot of painting [la part aveugle de la peinture]."[13]

* * *

Celebrating color, insisting on its role as that dimension of painting which captures and fascinates the spectator, de Piles rejected the tautological atemporality of the Academy's favored history pieces. Painting must be recognized as an art the goal of which lies not in representing scenes from the timeless and self-contained perfection described by de la Chappelle, but in provoking and consolidating a dynamic concentrated within the very moment of spectatorship. To accept painting as an art of color was to subvert the Academy's hypothesis that its value lay in a timeless and unending dialogue of representation and interpretation carried out at the level of the work's signified meaning.

To the contrary, the work's effect and value are born and draw their force from that first moment when the spectator beholds the image as chromatic surface. The Academy, privileging the work's subject matter as visual statement, assumed that the art of painting could, like rhetoric, be refined by the artist's awareness of universal and rational rules guiding the composition of the image. We saw earlier how the Academy, adopting the principle of *ut pictura poesis*, struggled to establish for painting some equivalent of the doctrine of unities developed by Aristotelian rhetoric as a criterion for judging the excellence of tragedy and other literary genres. In 1675 Henri Testelin, a member of the Academy, defined painting's equivalent of those categories as the unities of action, of location, and of moment.[14] If applying the unities of action and place to the visual image was straightforward, the idea of a unity of moment posed serious problems.

While verbal discourse could easily represent the passage of whatever length of time was necessary to complete a single action within a single place, painting was by necessity obliged to confine the image to only one instant within a narrative sequence. The problem was obvious: how could history painting, as an art forced to choose one moment from an always-larger narrative, achieve a moral richness comparable to that of drama or any other verbal art capable of evoking a far more extensive temporality? This dilemma gave rise to what would become a long tradition of reflections on how the painter should go about choosing the richest possible "significant moment" as the subject of the scene through which he would represent the larger story to which he made reference.[15] All responses to that finally in-

soluble question—should the episode be represented at its beginning, at its culmination, at its turning point, at its point of maximum tension?—began with the assumption that, whatever the choice, the "significant moment" was intended to evoke as clearly and as eloquently as possible the entire episode from which the image was drawn as a context necessary to its interpretation by the spectator.

For de Piles, this reduction of the image's moment to a vehicle of mimetic semiosis could only be a perversion of what constituted the art of painting. Rejecting any quest for a moment whose significance depended on its reference to a larger narrative, de Piles saw the effect achieved by a painting as depending on a confluence of three unpredictable, fundamentally sensual, and ultimately irrational elements: the individual genius of the artist, the visual grace of his specific execution, and the spectators' state of mind at the instant they perceive the painting.

In essence, de Piles shifted the value system sustaining the appreciation of painting away from a science of narrative to the always-sensual dynamics of the momentary encounter between image and audience. The opening chapter of his *Cours de peinture*, "The Idea of Painting," describes that art as one able to "seduce our eyes," to generate for its spectator a momentary experience of surprise and pleasure. "Such an image allows no one to pass by it indifferently . . . without being startled by it, without stopping before it, and without seeking to extend the pleasure of its surprise [sans jouir quelque temps du plaisir de sa surprise]. The true painting is therefore the one which calls out to us by surprising us." [16] This all-important moment of a seduction achieved by surprise points to the play of color as the crucial element within any painting. Surprise and fascination, it is clear, had no role to play in, and were in fact excluded by the kind of extended and knowing scrutiny of the signified subject matter that lay at the core of Le Brun's history pieces. For de Piles, a painting is successful not because it engages us in an articulated act of interpretation but because it generates for the spectator an *enthousiasme* born at first glance and flowing immediately from the moment of the work's perception.

At every turn of his explanation of this enthusiasm so essential to a painting's success, de Piles emphasizes the immediate and momentary quality of its genesis. "The spectator, without being absorbed by any one detail, finds himself *suddenly* and as though in spite of himself transported to a new level of enthusiasm inspired by the painting . . . The painting ravishes the mind through an admiration mixed with astonishment; it takes him by force *without leaving him the time* to reflect on what he is feeling"

(*Cours de peinture*, 70; emphasis mine). De Piles's central concept of enthusiasm not only rehabilitates the moment as sensual surprise, but assumes as the primary cause of a painting's success a value that lies outside the rational and the discursive wherein, by definition, there can be no surprise, no sensuality, and no single moment. In his earlier *Conversations sur la connoissance de la peinture*, de Piles took the even more extreme position that painting's status as a visual art makes it dependent on an element of sensual surprise antithetical to the mind's proclivity toward reflection. "What is a pleasure for the eye consists above all in being surprised, while what is a pleasure for the mind comes only through reflection." [17]

Throughout his writings on painting, de Piles articulates a series of concepts favoring the sensual signifier over the discursive signified, the inexplicable moment of fascination over the calm continuities of analysis. In his *Abrégé de la vie des peintres* of 1699, he insists that understanding how a painting affects its spectator involves a necessary distinction between "beauty" and "grace." A painting can be considered beautiful when it respects proportions and harmonies, when it gives pleasure by following the rigid rules the Academy made so crucial to the artist's apprenticeship. The higher realm of grace, however, can be achieved only when the painting's charm remains inexplicable in terms of such prescribed rules. "Grace surprises the spectator as he feels its effect without understanding its true cause. . . . It might be defined as that which pleases, as that which vanquishes the heart without passing through the mind" (10). It would be difficult to imagine a greater distance between de Piles's understanding of painting and that sustaining the esthetics of the Academy. In 1691, for instance, another spokeman of that body, Noël Coypel, would go so far as to proclaim that the essential faculty of painting's spectator is not a vision that perceives but a reason that cogitates. "He [the spectator] should also be a philosopher, so that he might link together through proper reasoning all the work's parts and understand their effects as a function of their causes." [18]

In placing grace above beauty, de Piles articulates for painting a hierarchy of values similar to Pascal's preference for that *esprit de finesse*, which he sees as outstripping and rising above the ploddingly rational *esprit de géometrie*. Pascal's *esprit de finesse*, like de Piles's grace, relies on a temporality of the moment, on a psychological equivalent of the first glance so crucial to the success of a painting. As Pascal put it, "one must *suddenly* [tout d'un coup] see the thing *in a single glimpse* [d'un seul regard], and not through a process of reasoning" [19] (emphasis mine). Similarly, it is to the primacy of the moment that de Piles turns when, in the *Cours de peinture*, he distin-

guishes between the enthusiasm every effective painting must generate and the quite different concept of the sublime as it had recently been developed by his friend Boileau in his translation of Longinus. "Enthusiasm is also distinguished by the rapidity of its effect, while that of the sublime requires at least a few moments of reflection to be grasped in all its force . . . enthusiasm takes possession of us, while we take possession of the sublime" (71). De Piles's grace and enthusiasm, like Pascal's *esprit de finesse*, are a part of the larger tradition of the *je ne sais quoi* so central to what has been described as the irrational tradition in the esthetics of the *ancien régime*.[20]

De Piles's insistence on the sensual moment of spectatorship as the touchstone of a painting's worth reverses the entire hierarchy of values promulgated by the Academy. Painting's goal is no longer the careful mimesis of its subject matter, but a momentary experience of surprise and pleasure generated by the work's chromatic surface. The work of art, rather than presenting itself as an imitation of the real, exults in its status as illusion and deception. De Piles's whole approach to painting renders irrelevant the Platonic condemnation of that art as a fabrication, as a creation of what is false. De Piles insists that what painting produces is eminently true once we understand that its claim to truth lies not in its status as a copy of the real but in the sensual experience it creates within the audience's moment of surprise and pleasure. As de Piles sees them, the painting's spectators, unlike the birds pecking at Zeuxis's grapes, never for an instant believe in the reality of the image before them and will therefore never feel obliged at some future point to denounce it as illusion. The pleasure of spectatorship comes not because we have been led to contemplate some timeless truth of the work's subject matter, but because, for one brief and inexplicable moment, our eyes have been seduced by the play of color on a canvas that never pretended to be a window on the world.

Unlike the royal propagandists of the Academy, de Piles does not assume that the goal of painting is to address an endless series of future generations who, as they stand before these icons of glory, will grasp again the perfection that once was. For de Piles, the essence of a true painting is born anew within each of those brief but infinitely pleasurable moments when the spectator, captivated by its grace, experiences again an enthusiasm that abolishes the calm distance of interpretation. As an art of illusion and an art of the moment, painting rejoices in its celebration of that fleeting instant when the spectator is no longer certain of where the separation might be drawn between reality and illusion. Painting relates to the spectator's experience of the real not as an idealized copy setting out to teach some truth it must

learn, but as a mirage calling into question by the force of the moment's pleasure her ability to distinguish between what is real and what is illusory. Rather than riveting its spectator to her place and her identity in some supposedly inevitable narrative of history, painting's power of illusion liberates her from the tyranny of all that would impose itself as real. De Piles's privileging of the moment of spectatorship, the first glance, subverts the whole series of careful distinctions and dichotomies that sustain the Classical esthetic: those between the sensual and the discursive, between signifier and signified, between the canvas as surface and the subject matter as depth, and between the necessity of history and the contingency of the moment.

* * *

De Piles's opposition to the Academy and his redefinition of painting's status would in a very real sense prepare the way for what, during the eighteenth century, will be the interlude of the Rococo, the profound attention to the moment practiced by such painters as Watteau, Chardin, Boucher and Fragonard. Writing first as an amateur and a dissident against the massive power of Le Brun and the Academy, de Piles's own trajectory would take him, toward the end of his life and after four decades as a secretary and diplomat in the service of the influential Amelot family, to a position of eminence within the very institution against which he had so long struggled. Returning to Paris in 1697 after four years in a Dutch prison for fomenting a revolution in favor of French interests, de Piles found an art scene that had changed completely during his absence. Many of his old friends and adversaries were dead and the younger generation of painters were no longer passionately involved in the long dispute over the relative merits of line and color, of Poussin and Rubens. Jules Hardouin-Mansart, after being named *surintendant des bâtiments* and *Protecteur* of the Academy in 1699, immediately appointed de Piles's close friend, Charles de la Fosse, as Director of the Academy and de Piles himself as a member, making it clear that all communication between himself and the Academy would be handled by de Piles. Paradoxically, the man who had once been the Academy's most vociferous critic became, for the last ten years of his life, its leading theorist, producing his *Abrégé de la vie des peintres* and *Cours de peinture par principes*.

In spite of so brilliant an end game, the major voices associated with art criticism in the eighteenth century—Jean-Baptiste Du Bos, La Font de Saint-Yenne, and Diderot—would for the most part leave unexploited de Piles's attention to the dynamics of the moment and his recognition of paint-

ing's power as illusion. They would return instead to a mimetic understanding of the work of art, their theories and analyses of painting approaching its represented scenes as though they were copies of real-life scenes. To a large extent, this tendency, rather than reflecting any allegiance to the doctrines developed by the Academy in the 1660s, was a result of the fact that these critics, unlike the theoreticians of the Academy who wrote primarily for other painters, were writing for an ever-expanding audience of educated readers who, although they were interested in painting, had for the most part little access to the actual works being discussed in what they read. In an age when the mechanical reproduction of the image was limited to the technique of engraving—a process which effectively eliminated the specifics of color—it was inevitable that "the painting" be approached primarily as a rendition of its subject matter, as a process of mimesis.

Almost all eighteenth-century art critics were reluctant to deal with the chromatic *facture* of the paintings they discussed. To do so placed them in the position of describing a dimension of the image to which the vast majority of their readers had no access. Uncomfortable with the task of describing the subtle play of color at work in paintings such as those of Chardin, Diderot took refuge in a scantily articulated admiration of what he called Chardin's *magie de faire*: "It is impossible to understand this magic. It is a matter of placing thick layers one on top of the other . . . Rubens, Berghem, Greuze, Loutherbourg could explain this talent to you far better than I."[21] More often than not, that *magie* which had been so crucial to de Piles's approach was reduced to a kind of artisinal knowhow, an artistic arcana destined to remain at the periphery of the educated layperson's appreciation of painting. Similarly, the enthusiasm de Piles saw as the hallmark of the spectator's momentary ravishment by the total visual experience of the painting lent itself poorly to the discursive prose of art criticism. What seemed beyond the scope of critical discourse all too easily found itself devalued as a dubious proclivity toward visual hedonism.

In spite of this return to a largely mimetic view, theoretical discussion of the nature of painting continued to feel the influence of de Piles's celebration of the moment. Writing in the wake of de Piles's insistence that a successful painting must move its spectators before it can teach them, a critic like Du Bos will, as we shall see in the next chapter, reread even so explicitly mimetic a painter as Poussin through an appreciation of the moment that would have been impossible had it not been for de Piles's studied resistance to the protocols of classicism.

8
DU BOS, POUSSIN, AND THE FORCE
OF THE MOMENT

The primacy of the moment, of the beholder's immediate reaction to the artistic object, found an unexpected confirmation in Jean-Baptiste Du Bos's highly influential *Critical Reflections on Poetry and Painting* of 1719. Du Bos, attempting to grasp the entire enterprise of Western art, offers within this work an ambitious and universalizing analysis of the esthetic response. His examples and arguments encompass literary and pictorial works ranging from Homer and Aristotle to the most esteemed practitioners of French classicism. My concern here is with how Du Bos, in making one of his central arguments, offers what amounts to a rereading and revision of that tradition. More specifically, I hope to show how, in the particularly significant case of Nicolas Poussin, Du Bos analyzes two of that painter's most important works in such a way that, rather than incarnating the practices of seventeenth-century classicism, they find themeselves reconfigured as a demonstration of that force of the moment which was to become so central to the esthetics of eighteenth-century France.

The opening sentence of Du Bos's highly influential treatise proposes a shift in the locus of artistic value. Reflecting the growing empirical and sensationist tenor of the period as well as the influence of de Piles,[1] he looks not to the stable past of the finished work, not to its self-contained status as a signifying object, but to the on-going present of the audience's encounter with and reaction to the work of art. Both for readers of a literary text and for viewers of a painting, it is the *plaisir sensible* they experience at the moment of perception that becomes the one sure proof of the work's value. At the heart of this "sensory pleasure" confirming the work's value there is, for Du Bos, a startling paradox: our most intense pleasures as readers and as viewers come from spectacles of suffering. "Men always derive greater pleasure from tears than from laughter."[2] In the theatre, tragedy always moves us more forcefully than comedy. In painting, scenes of human suffering drawn from history and mythology always affect us more deeply than the contemplation of a domestic scene, still-life, or pastoral. The task Du Bos sets himself becomes clear. "I shall dare here to elucidate this paradox and

to explain the origin of the pleasure we find within both verse and painting" (3).

The first step toward understanding this pleasure within suffering comes in identifying pleasure's opposite: the static, torpid oppression of *ennui* which pleasure must displace as the pre-condition of its genesis. *Ennui*, "the langor that flows from the sustained duration of any state of mind" (9), is marked more than anything by a dulling continuity of perception excluding any awareness of the moment as moment. The grip of boredom is loosened only when we are able to "give ourselves up to the impressions made by unfamiliar objects." Pleasure, "the unique remedy against boredom" will "set in motion minds that have grown heavy" and "impart a new vigor to an exhausted imagination" (10).

Poetry and painting are not, of course, the only vehicles of a pleasure able to evince boredom. Du Bos devotes the entire second section of his treatise to a consideration of how, moving from classical Rome to the present, such practices as gladitorial combats, jousts, bullfights and gambling are all similarly structured as pursuits of pleasure's moment. Looking closely at the dynamics of gambling as the one activity from that list with which all his readers were familiar, Du Bos argues that only a fool could believe that what the gambler really seeks in playing is monetary gain. Were that the case, sad experience would long ago have led to that activity's extinction. Du Bos points instead to how the period's all but universal gambling mania expresses itself in an obsession with games of pure chance such as dice and lansquenet rather than with games such as piquet where skill and calculation play major roles. The majority of gamblers are uninterested in games of skill because they lead only to "a more prolonged mental agitation" (24) whereas games of pure chance, with every moment's outcome remaining utterly unpredictable, "hold the soul in a continuous state of emotion . . . in a kind of ecstasy . . . where what happens depends entirely on chance" (24). As will also be the case with esthetic experience, gambling's ecstasy depends on an intensity flowing from the total lack of any rational or predictable continuity between the successive moments of the dice to be thrown or the cards to be turned.

Pleasure's paradox flows from its status as an encounter with passion— with an intensity of involvement, feeling and even suffering always preferable to the dull, timeless experience of passion's absence. "Men generally suffer far more from a life without passions than from what their passions make them suffer" (12). Du Bos defines the specificity of poetry and painting as a function of the encounter they provide with a representation of pas-

sion. Poetry and painting are an imitation, a mimesis, a verbal or pictorial copy creating a virtual reality that inspires passion. "These phantoms of the passions that poetry and painting so ably excite, moving us with the imitations they present, satisfying our need to be occupied with something" (27). As a "copy of the object," the work of art effectively creates for its beholder a "copy of the passion which the actual object would have inspired" (28). If Du Bos insists on the esthetic experience as a response to a copy with a copy, it is because this reign of the mimetic brings with it a salutary concentration within the disjointed moment. Because these copies are artificial they are "capable of occupying our minds *in the very moment we perceive them*, yet incapable of subsequently causing any suffering or actual affliction" (26; emphasis mine). The experience of passion provided by the esthetic object limits itself to the moment in two important and complementary ways. On the one hand, the passion it inspires is encapsulated within an instant of perception shaped by the work of art. On the other, the esthetic experience is bereft of the continuing consequences that our participation in the reality of an actual passion would imply.

As he explains this paradox of suffering's pleasure, Du Bos reaffirms the traditional doctrine of art as mimesis. He does so, however, by insisting on a second paradox. The value of a mimetic work depends not so much on the similarity of the copy to what it imitates, not on any illusory erasing of a boundary between sign and signified, but on a clear awareness of the differences between copy and original. The instant of passion's pleasure achieved by verse or painting depends on an awareness of the copy as copy, an awareness of the copy as distinct from whatever reality it purports to imitate. Paraphrasing Aristotle's *Poetics*, Du Bos explains how this awareness of the copy as copy has the effect of broadening the domain of the esthetic far beyond the limits of what would be tolerable within the real. "Monsters or dead and dying men which we would never dare look upon, or would look upon only with horror, we instead scrutinize with pleasure when portrayed in painters' works. The better they are imitated, the more avidly we look upon them" (28). The "better" characterizing the esthetic moves not in the direction of a realism striving to erase its status as copy, but toward a setting off of the artistic that expands its boundaries well beyond those of experience.

* * *

Thus far I have spoken of Du Bos's esthetic theory as it applies to both poetry and painting, to textual as well as pictorial artefacts. The centrality

he attributes to the moment, the importance of the passion-charged instant of perception, becomes in fact even more pronounced when he discusses the specific semiotic processes of the painting as an art of the visual image. Revisiting the doctrine of the significant moment, he argues that painting, unlike verse, "represents an action shown in only a single instant of its duration" (87). Painting, for Du Bos, offers the artist far less latitude in the depiction of its subjects than does verse. Homer as he describes Achilles or Molière as he draws his portrait of the misanthrope can, given the more protracted nature of discursive semiosis, enumerate and accumulate within the work a large number of specific traits contributing to our perception of those characters. Of those verbal signs, some will necessarily be more eloquent and more effective than others. The temporally extended experience of reading Homer's text or of watching Molière's play allows for a synthesis of the good and the less good, of the effective and the less effective. These elements of varying value coalesce into an integrated whole in such a way that the cumulative result, in spite of its occasional unevenness, will ultimately be effective and moving. The prolonged semiosis of the discursive text offers a very real latitude to the artist who chooses to work with words. The situation of the painter, however, is entirely different. "This is not the case for the painter, who paints each of his characters only at one moment, and who must be able to use a single trait to express a passion on each part of the face where that passion must be rendered palpable" (93).

The extended temporality of the verbal work of art affords its reader a cumulative reaction, a reaction taking the form of a balance sheet in which what is positive can compensate for and overcome the occasional negative. The painter, on the other hand, must manage to get everything right within that single instant in which the spectator will perceive and judge his image. Du Bos illustrates this immediacy of painterly semiosis with an analysis of Poussin's *The Death of Germanicus* (Figure 2). Off-center, to the right and slightly below the painting's mid-line, we see the central image of the prostrate Germanicus, his turned head and bared upper torso outlined by the white sheet and pillow that underline his expiring presence as the painting's semiotic center. Arrayed around him are no fewer than fifteen separate figures. Within the smaller space to his right we see the members of his family. His wife, Agrippina, is the single seated figure. Her grief is so intense that it is veiled by the cloth she holds to her face to wipe her tears. Behind her, three children and a female servant fill out this private space of the family. To Germanicus's left we see spread out horizontally across the rest of the painting the representatives of his public life, the group of ten officers and soldiers

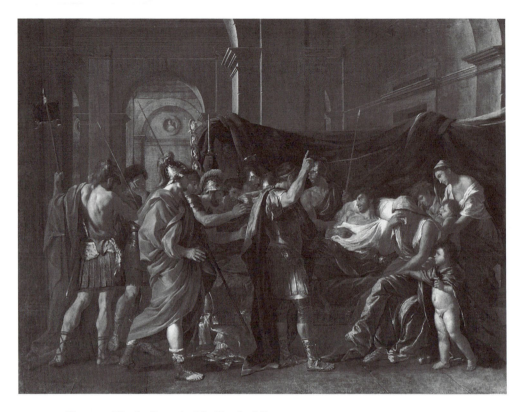

Figure 2. Nicolas Poussin, *The Death of Germanicus*
Minneapolis Institute of Arts

whose reactions to his impending death range from the vengeful declama-
tion of the officer with upraised arm and pointing finger at the painting's
center to the simple soldier at the far left who, holding a spear and toga, uses
his free hand to wipe the tears from his downcast face.

This painting becomes for Du Bos a proof of the consummate skill with
which Poussin, in choosing to include so many different characters within
the frame, was able to "vary in terms of age, sex, nationality, profession,
and temperament, the suffering of those who are watching Germanicus die"
(95). Du Bos takes an obvious delight in verbally enumerating, as a series of
visual signifiers, all the cumulative and mutually reinforcing signs Poussin
was able to juxtapose within the single image of an extended cast of char-
acters locked in overwhelming grief. "The clothing, the colors of skin, of

beards, and of hair, the hair's length and thickness, its natural shape, the physical postures, the resoluteness, the faces, the heads, the expressions, the movement, and the color of the eyes" (96).

Stepping back from Poussin's masterpiece, Du Bos uses it to illustrate a lesson on the comparative semiotics of the image and the word. Would it have been possible, he asks, for a poet working only with words to have communicated to the reader this same intensity of passion? For Du Bos, the essence of Poussin's accomplishment lies in the simultaneous multiplicity of a perfectly rendered grief inscribing itself in so many different versions and on so many different faces. The power of that grief is overwhelming precisely because its every aspect is offered to the spectator within the single instant of perception. The poet, working only with words, would, in attempting to achieve the same diversity, find himself confronted with an insoluble dilemma. Were he, on the one hand, to try to prepare this culminating moment by offering, earlier in the text, descriptions of the diverse characters who would come together around Germanicus's deathbed, "he would have to begin with tiresome details of age, of temperament, and even of the clothing worn by the characters he plans to make part of the principal action" (95). No matter how well done, the effect of such preparation would be that "the reader would not remember them, and he would never feel the very beauty whose understanding depends on what he will have forgotten" (95). Were he, on the other hand, to attempt, once the fact of Germanicus's impending death had been established, to describe one after the other the various participants present in Poussin's image, "it would become an intolerable braking" (96).

Du Bos returns to the comparative semiology of painting and poetry later in his study when he takes up the question of which medium exercises a greater persuasive power over its audience. Once again, his answer to the question he poses takes the form of a consideration of the distinct temporalities through which each medium creates its meaning. Verse, like all language, expresses its meaning through a sequential and cumulative process articulated over time. "Even the most touching verses are able to move us only by degrees, and by bringing the springs of our machine [les ressorts de notre machine] into play one after the other" (415). Du Bos's use here of the machine as a metaphor for the reader reading is based not only on the fact that reading involves the perception of each word after and in terms of the others around it, but even more so on the fact that the verbal as opposed to the iconic sign relies for its interpretation on a mediation by the cultural code of the language through which it signifies. "Words must first awaken in us the

ideas for which they are only arbitrary signs" (416). For Du Bos, the reader and listener must, like a machine, continually shift between the two mutually redefining stages first of understanding each word one after the other and then of interpreting those words through the specific context elaborated by the on going verbal enunciation. Only then can the reader arrive at what, for the painting's spectator, is an immediately given starting point. "Then those ideas must arrange themselves in our imagination, and come together in images which move us and in paintings which interest us" (416). The power of verse, compared to the immediacy of painting, is diminished not only by the protracted temporality of reading's "machinery," but by the fact that, since words arrive at the painting's starting point of the "image" only after those preliminary interpretations, their effect on the "the springs of our machine" are diminished by an "unquestionable principle" concomitant with the metaphor of the perceiving subject as machine (416). "The multiplicity of springs always weakens the movements because one spring never communicates to another the entirety of the force it has received" (416). Du Bos's conclusion is clear: since words rely for their force on a mediated code whereas images rely on an what he sees as a natural code of iconic resemblance, it is painting whose impressions must be "stronger." In its every respect, the greater force of the image is a corollary to its concision within the moment, to its being "more sudden." "[In a painting] we see *in a single instant* [en un instant] that which verse only helps us to imagine, *and that over many instants* [et cela même en plusieurs instans]" (417; emphasis mine).

* * *

For Du Bos, what is specific to painting and what makes it different from verse is its privileging of the moment. Painting, as a visual art, achieves its effect within the single instant of the spectator's passionate reaction to the painted image. In evaluating the importance of what Du Bos has to say about Poussin to the emerging esthetics of the eighteenth century, it is crucial to understand how strongly Du Bos inclines his reading of Poussin's paintings toward a consolidation of the moment's primacy. Poussin, the pre-eminent figure of the French classical style, was above all a painter of history pieces, of subjects drawn from the repertoire of biblical, ecclesiastical and Greco-Roman history. The majority of his works depend for their effect on the spectator's familiarity with the cultural narratives sustaining their meaning. As Louis Marin has succinctly put it in describing this classical esthetic, "in front of the painting, the viewer tells a story to himself,

he reads the painting, he understands the narrative messages. This means that he converts the iconic representational model into language, and more precisely into a story."[3] Du Bos's allegiance to a different primacy of the moment, to an understanding of painting's moment redefined by de Piles's considerations of color, can be seen in the way he elides from his treatment of Poussin's works any explicit reference to the role played by these cultural and narrative codes in their interpretation. If Du Bos consistently downplays the importance of such codes, it is because their own learned and mediated status could only undermine his argument that it is painting's immediacy that makes it a more powerful representation of passion than verse.

The thrust of Du Bos's analysis, the fact that his revisionist reading of Poussin sets out to appropriate that figure from the classical past in the service of his own quite different esthetic agenda, is nowhere more apparent than in his treatment of one of Poussin's best-known works, a painting known both as *The Arcadian Shepherds* and *Et in Arcadia Ego* (Figure 3). Du Bos takes up this painting in a section of his study devoted to the question of how the artist chooses his subjects and how, as Du Bos puts it in his section heading, "they can never be wrong in choosing those which are most interesting in their own right" (52).

Du Bos uses *The Arcadian Shepherds* as his centerpiece for this discussion because, as a work where the country setting is predominant, it provides an ideal illustration of what he sees as the principles guiding the proper composition of landscapes. Poussin, like all those Du Bos refers to as *les peintres intelligens* (54), well understood that a landscape in itself—"deserted countrysides with no human figures" (54)—could never provide the subject for a truly great work. Only when the artist places within the landscape a "subject made up of a number of characters" can it portray an "action capable of moving us and consequently of capturing our attention" (54). But, Du Bos is quick to add, human subjects alone are not enough to insure this fascination within the instant of perception. A subject as banal as "a man walking along a path" or "a woman carrying fruit to market" is never sufficient in itself. The human figures present in the landscape must be captured in the turmoil of passions that provide the organizing focus of the painting. Only then can the human figures communicate their affective experience to the spectator and, in so doing, capture and determine the spectators' attention and contemplation. "Artists choose subjects who are in the throes of passion so that they can awaken our own and capture our interest within their tumult" (54).

As he illustrates this premise Du Bos offers a close analysis of *The Arcadian Shepherds* as a painting which, he points out significantly, "Poussin

painted several times" (55). Today we are familiar with two distinctly different versions of this much-discussed painting. They are usually, after the museums that own them, referred to as the Louvre and the Chatsworth versions. While the Chatsworth version (Figure 4) was clearly painted first, Poussin scholars are in some disagreement as to how much later the second version was done. While all agree that the Chatsworth version was painted between 1628 and 1630, scholars such as Jacques Thuillier, Pierre Rosenberg, Christopher Wright, and Erwin Panofsky date the Louvre version to roughly 1638 or at any rate to a time before Poussin's return from Rome to Paris in 1640.[4] Anthony Blunt, on the other hand, dates the Louvre version as late as 1655.[5]

The two versions depict roughly similar scenes: young shepherds in

Figure 3. Nicolas Poussin, *The Arcadian Shepherds*
Musée du Louvre

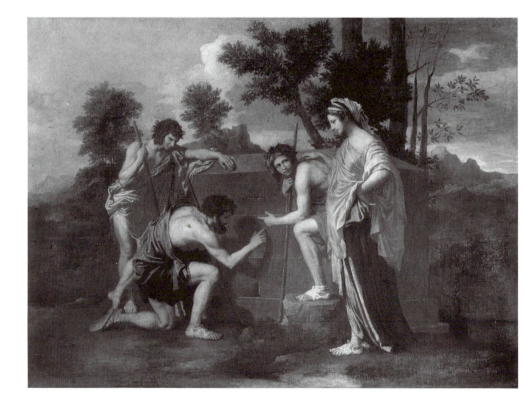

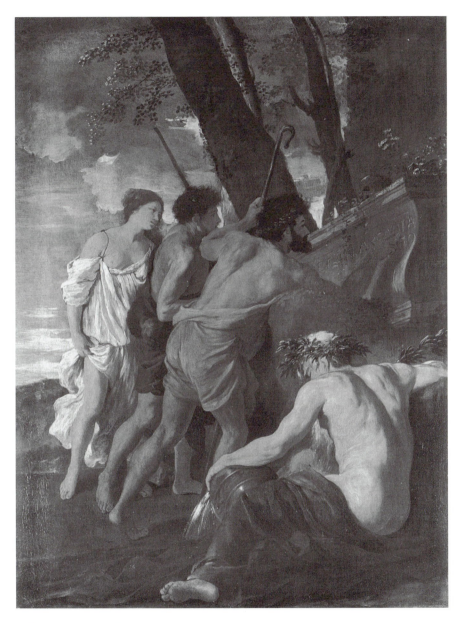

Figure 4. Nicolas Poussin, *The Arcadian Shepherds*

the countryside who come upon a tomb with the inscription "Et in Arcadia Ego." Beyond that core, however, the two versions are substantially different. The earlier Chatsworth version emphasizes the startled surprise of the shepherds as they lean tentatively toward the sarcophagus they have just discovered amidst a clump of trees. Barely visible in the shadows, a skull rests on top of the tomb. The four figures consist of two half-clothed young men tentatively approaching the sarcophagus as the one nearest the painting's center points to the Latin inscription. To their left, a young shepherdess, her right breast exposed, holds up the hem of her garment with her right hand in such a way that her leg is exposed to mid-thigh. The fourth figure, seated on the ground to the left, is an old man holding an urn from which water gushes. He has usually been interpreted as representing the river god Alphaeus, since Virgil, in his fifth *Eclogue*, places his Arcadian tomb near the river of that name. White-haired, with his head bowed in sadness, his loose flesh contrastively emphasizes the youth and sensuality of the three other figures.

The later Louvre version presents this same subject in a very different way. What before was a scene of startled surprise becomes instead a representation of elegiac meditation. The central sarcophagus, no longer hidden among the trees, stands massively visible in an open space. It has now assumed the form of a classical block with a gabled lid. The third male figure is no longer a seated river god but another young shepherd, who joins his two companions to the left as they scrutinize various details of the tomb. The shepherd to the right turns his head away from the sarcophagus as though to make a point to the lone female figure standing directly behind him. She, no longer the sensual shepherdess of the Chatsworth version, appears more like a classical priestess, a figure almost hieratic in posture as her right hand lightly touches the strap across the shepherd's shoulder. With contemplation replacing surprise, the scene has been emptied of what in the earlier version was its most directly emotional content. The skull is gone from the top of the sarcophagus and the more clearly visible Latin inscription has become the effective focus of the composition.

A distinguished series of art historians have offered various interpretations of the phrase "Et in Arcadia Ego" originally suggested to Poussin by his patron, Cardinal Rospigliosi, who was later to become Pope Clement IX. Should those four words be taken to mean "I, death, also dwell in Arcadia" or, referring the statement more specifically to the person commemorated by the tomb, as "I, now dead, also dwelled in Arcadia"? The absence of any verb with a deciding tense—*sum* for the first interpretation, *fui* for the second—

in fact allows both interpretations.[6] Critics as different as Erwin Panofsky, Louis Marin, and Pierre Rosenberg have argued that the subject of the four word sentence, *ego*, changes between the Chatsworth and Louvre versions. In the earlier painting it is seen as a statement made by the visible skull as an obvious symbol of death. It is the skull, they claim, that must be imagined as saying "I, too,—death—am in Arcadia." In the later Louvre version, now with no skull, it is the dead person within the tomb who states "I too once dwelled in Arcadia." Louis Marin further interprets the goddess-like female figure of the Louvre version as a presence symbolizing both memory and written language as supplements to the Arcadian present made necessary by the reality of death.[7] Claude Lévi-Strauss, uncomfortable with this shift in tense and meaning, recently argued that this female figure should be read as death itself, thus again speaking in the present.[8]

In fact, both these versions and the various interpretations offered of them are startlingly different from the way Du Bos describes this work. What he says about the painting could in fact be read as arguing for the existence of a third and subsequently lost version of the same subject.[9] All the details of his eccentric reading do, however, confirm his commitment to establishing a primacy of the moment within Poussin's esthetics—the very primacy all the changes from the Chatsworth to the Louvre versions seem so clearly to contradict.

For Du Bos, there is no ambiguity in the meaning of the tomb's Latin inscription. The "I" uttering that statement is the person buried in the tomb, and that person is a young woman. His certainty on that point comes from the fact that, rather than the epicene skull of the Chatsworth version, his startled shepherds look upon "the statue of a young woman dead in the flower of her youth lying on the tomb in the manner of the ancients" (55). For Du Bos, the epigraph must be read as "But I too once lived in Arcadia [Je vivais cependant en Arcadie]." His emphasis on the adversative *cependant* as an equivalent of the Latin *et* well captures what, as we shall see, is for Du Bos the real source of the image's power.

Du Bos's description of the painting's human figures is also different. Rather than three men and one woman, and with neither river god nor classical priestess, Du Bos enumerates the explicitly sexualized presence of "two young men and two young women adorned with garlands." All these divergent elements of Du Bos's description, present neither in the Chatsworth nor the Louvre version, serve to emphasize the fact that the unexpected discovery of the tomb represents for these two couples an abrupt turning point,

the axial moment when the purpose of their outing finds itself redefined by their having "come upon this sad monument in a place where we easily surmise they were not looking for an object of affliction" (56).

For Du Bos, Poussin's artistry expresses itself most clearly in the passionate expressivity of the characters' faces. We saw how, in describing *The Death of Germanicus*, his attention focused on the subtle variations within the multiple versions of despair mirrored from face to face. Here, in what must finally be described as Du Bos's version of *The Arcadian Shepherds*, it is once again the faces of the four characters that become the central signifiers of the surprise inspired by the tomb's discovery. For Du Bos, their features are icons of that fleeting moment when joy and desire, still present as lingering shadows, yield to the sudden intrusion of a sadder and more contemplative mood itself only on the brink of being born. "We can see on their faces, through the sadness that now overcomes them, the remains of an expiring joy." [10]

This brief moment of expiring joy when the characters' faces are marked by contrary passions each intensifying the evanescence of the other becomes itself an emblem of the painting's ultimate implications: that life itself, inevitably caught short by the eternity of death, must be recognized as but the briefest of moments. Stepping back from a consideration of the painting's details, Du Bos tries to put into words the effect of what they behold on these human figures. "One can almost hear the reflections of these young people on death as sparing neither youth nor beauty, and against which even the most delightful climes offer no asylum" [On s'imagine entendre les réflexions de ces jeunes personnes sur la mort qui n'épargne ni l'âge, ni la beauté, et contre laquelle les plus heureux climats n'ont point d'asyle] (56). The power of these contrary passions defining the specificity of this instant will, as Du Bos sees it, intensify the spectators' absorption within the painting to the point where (as his shift in pronouns indicates) everything the figures within the painting—*they* [elles]—might feel during their moment of surprise reverberates out toward and encompasses a more generic *one* [on] including spectators as well as the painting's subjects. "One easily imagines what moving things *they* will have to say to one another once *they* have recovered from their original surprise, and *one* applies these thoughts to *oneself* as well as to all those *one* cares about" [On se figure ce qu'*elles* vont se dire de touchant, lorsqu'*elles* seront revenues de la première surprise, et l'*on* l'applique *à soi-même* et à ceux à qui l'*on* s'intéresse] (56; emphasis mine).

If Du Bos describes so strikingly different a version of Poussin's paint-

ing, it is because his four human figures within the frame become metaphors for Du Bos himself as the author of a treatise contrasting the esthetics of the verbal and the pictorial sign. The Arcadian shepherds read the Latin inscription on the tomb. But, in Du Bos's version, that act of reading comes only after their perception of a visual work of art: the sculpture of the tomb's occupant, the young girl dead in the flower of her age, now reposing as a *gisant* on the surface of the sarcophagus. What without that statue would only have been the deciphering of a written statement is intensified and made more immediately moving by the instantaneous perception of the carved stone. As part of the tomb, that effigy imposes an immediately tangible sense of the tragic which the inscription alone could never match in its intensity. This Baroque contrast of the solid statue to the now formless flesh beneath it only multiplies the intensity of the moment's experience. The parallel yet hardly simultaneous messages of text and statue come together, as, in Du Bos's words, "one of them indicates the inscription to the others by pointing to it with his finger" (56). The faces of Poussin's figures, struggling to read the words' meaning, already provide us with a model for what must be our own reaction to this representation of what Du Bos calls "the remains of an expiring joy."

It is important to understand what Du Bos's highly idiosyncratic interpretation has done to this painting. One of Poussin's most clearly allegorical works, a painting described by Panofsky as having achieved the utter timelessness of "the revelation of a metaphysical principle which connects the present and the future with the past and overthrows the limits of individuality" (240), has instead become the illustration of a totally different temporality. Poussin's *The Arcadian Shepherds*, reread by Du Bos, even recreated by Du Bos, becomes an emblem of the distinct temporalities governing text and image. Working together here as mutually intensifying dimensions of a single perception, they confirm the primacy of the always abrupt and redefining moment of the visual. Sculpture and inscription, the visible and the legible, become for Du Bos a prod to that moment when joy and sorrow mingle together on the shepherds' faces as a tragic pleasure whose eruption constitutes the very core of painting's esthetics.

* * *

In the twelfth section of Book Two, Du Bos proposes an equally unorthodox privileging of the moment as the temporality of esthetic judg-

ment, of how one might evaluate the true worth of a work of art. Du Bos addresses this question as part of his larger argument that the public just as surely as the experts is fully capable of recognizing the real value of painting and verse. Above all else, he argues throughout his treatise, the successful work of art must be able to touch and move its audience. Deciding what touches and moves is a function not of reason's protracted analyses but of feeling's immediate reactions. While the *critiques* and *sçavans* may form an audience susceptible to the more delayed pleasures of reasoning analytically about the work, it is nonetheless true that each and every reader and spectator knows immediately whether he or she "feels" the work and is moved by it. If the critic's analytic reason has any role to play, it is one that comes only after and as a function of that all-important moment of feeling and judgment. "Reasoning should play a part in the judgment we make of a poem and of a painting only to the extent it confirms the decision first made by feeling. . . . Deciding such questions is never up to reason alone. It must yield to the judgment made by feeling which is the crucial criterion in such matters" (340–41).

While reason may be the arena of a protracted and cumulative meditation on the "how" of the esthetic object, it is the untutored heart as the seat of feeling that renders judgment on the work's value within the very instant of its perception. "The heart, when confronted with a truly touching object, moves of its own accord and in a way which is prior to all deliberation" (342). Arguing for this democracy of feeling, Du Bos points to the artist as the subject of a sensibility that shares with the public this immediate feel for an esthetic merit that is grasped suddenly and at the very moment of perception. "The painters themselves will tell us that they have within them *a sudden feeling which comes into play before examination* [un sentiment subit qui devance tout examen], and that an excellent painting they have never seen before makes *an immediate impression* [une impression soudaine] that allows them, *before any discussion* [avant aucune discussion], to judge its overall worth" (344; emphasis mine).

Throughout his analysis of Poussin, Du Bos makes the case for an attention to the moment as a concept central both to the dynamics of pictorial representation and to the audience's appreciation of the finished work. This primacy of the moment leads Du Bos not only to reread the work of such masters from the past as Poussin, but to enlist that rereading in the enabling of a community of spectators including all who are endowed with the feeling and sentiment necessary to experience the power of the moment.

Having examined how, in the writings of both de Piles and Du Bos, a

new understanding of the moment begins to play an important role in Enlightenment culture and its attempts to set itself apart from the postulates of a classicism whose providential views presupposed a sense of historical necessity encompassing the secular state just as surely as God's plan for salvation, let us now turn to a direct consideration of those painters who most eloquently embodied this new spirit of the moment in their works.

9
WATTEAU'S INCARNATE MOMENT

Fondons nos âmes, nos coeurs
Et nos sens extasiés,
Parmi les vagues langueurs
Des pins et des arbousiers.
—Verlaine, *Fêtes galantes*

Antoine Watteau's changing fortunes over the last two and a half centuries present a number of intriguing paradoxes. When he died in 1721 at the age of thirty-seven, he counted among a small number of painters who could be described as "self-commissioning." Whatever he produced was so sought after that he was effectively independent of the parallel patronage networks of the crown, the church and the growing Parisian private sector. This, coupled with his taciturn and acerbic personality, established him as an appealing if anachronistic candidate for the Romantic prototype of the truly individualistic artist, someone able to respond to his own vision of his art. Yet by the mid-eighteenth century his work had fallen distinctly out of fashion both because its decorative aspects were no longer appreciated and even more because a new sense of "the natural" had begun to affirm itself—one which would soon be equated with the emotional hyper-sensibility of a Greuze. More than a century of neglect and obscurity came to an end when, in 1854, Edmond and Jules de Goncourt proclaimed him the fountainhead of everything they saw as good in eighteenth-century painting, everything outside the sclerotic classicism that had turned its back on him. "All that century's painters," the Goncourts wrote, "who turn away from the Greeks and the Romans resuscitate the attitudes, the postures, . . . the color, the design, and the touch of the dead Master. Watteau triumphs, Watteau reigns everywhere."[1] A year later, Charles Baudelaire, in *Phares*, included Watteau as the only artist of his period to find a place in his pantheon of truly significant painters. In 1867 Paul Verlaine published an entire cycle of poems loosely inspired by Watteau's signature genre, the *fête galante*. Since that flurry of appreciation, Watteau's critical fortunes have only continued to rise.

How, the question becomes, can one explain this puzzling sequence of immediate success and esthetic independence during his lifetime followed by

a century of indifference that in turn yielded to unstinting critical acclaim? The answer, I would argue, lies in the fact that Watteau, whose productive career coincided with the second decade of the century, captured within his work a singular and previously unexpressed intensity of the moment, an acute sense of the inaugural instant that sets his work off both from what preceded and from what followed it. His paintings were, in short, the most telling and significant icons of an ethos specific to his moment.

It was certainly an intense reliance on the moment that characterized what, for his more conservative contemporaries, was the most unsettling aspect of Watteau's compositional technique. In a biographical critique of his work presented to the Academy in 1748 under the title "The Life of Antoine Watteau," his friend and occasional admirer, the comte de Caylus, offered the following description of how the artist worked, a technique, Caylus is quick to point out, which is "certainly not suitable for imitation":

Never did he do a preliminary sketch or outline, however rapid and free, for any of his paintings. It was his practice to rapidly sketch individual studies in a bound notebook in such a way that he always had a great number of such sketches at hand. . . . When he decided to execute a painting, he would turn to his collection and chose from it those figures that best accomodated the needs of the moment [qui lui convenaient le mieux pour le moment].[2]

Caylus's observation, one easily confirmed by even the most cursory examination of Watteau's sketches, portrays his work as doubly anchored in a sense of the moment. In terms of its production, the foundation of his art was a repertory of rapidly drawn sketches capturing the precise texture and tonalities of the passing instant. Watteau's desire for a maximum immediacy of hand to paper was reflected in his preference for *les trois crayons* (black, red, and sanguine chalk), a drawing technique he regularly chose over the more commonly employed medium of pen and ink. The freely moving contact of chalk with paper allowed him to capture rapidly and with an unencumbered sensuousness the kinetic energy and momentary postures of subjects presented within the defining instant of their action. His sketch of a dancing couple (Figure 5) provides an eloquent example of how he turned this use of chalk to the production of images that seem almost like fast-action photographs of an ongoing movement. The Goncourt brothers, in their essay, described this technique as one "all but bringing to life the flat color of the flat paper [vivifiant presque la teinte plate du plat papier]" (68). In terms of his compositional technique, these sketches drawn from the rush of life then became the constituent elements of painted images manifesting

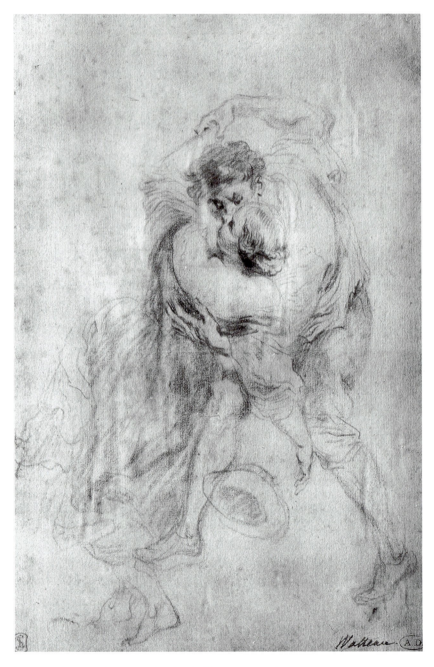

Figure 5. Antoine Watteau, Sketch of a Dancing Couple
Musée des Arts Décoratifs, Paris

a near perfect congruence with intentions as specific and momentary as the genesis of their parts. Watteau's works are, to use Caylus's phrase, a synthesis of "those figures that best accomodated the needs of the moment." A work like *The Surprise* (Figure 6) shows how an image that began as a quickly sketched drawing found its way almost unchanged into a finished painting. In this case, only the drawing's hyper-kinetic image of a hat caught in mid-fall between head and ground was eliminated from the finished version.

Caylus prefaced his remarks on Watteau's drawing technique with the telling observation that "most frequently he drew with no object in mind" (100). This implicit reproach of a kind of pointlessness to Watteau's works provides an important key to understanding both how he differed from his immediate predecessors and why his works fell into critical disfavor so soon after his death. *The Surprise* is a good example of what Caylus meant when he spoke of Watteau's finished works as suffering from the fact that even they had no more discernable "object" than the working notes of his sketches. *The Surprise* could well be described, were one to follow Caylus's lead, as a random juxtaposition of two sketches drawn from life: that of an embracing couple and that of a lone guitar player in theatrical dress seated to the right. Those two images do, within the frame of the painting, come together as a whole. But it remains an ambiguous, unmotivated whole, one no more obviously "significant" than either of its elements considered in isolation. As such it stands as an example of what Caylus would also call "that uniformity one might reproach in Watteau's paintings" (101). Hastening to explain what he sees as being wrong with such uniformity, Caylus continues his argument. "His compositions have no object. They fail to express the force of any passion and are, for that reason, bereft of one of painting's most stimulating dimensions, that of action" (102). Because they express no motivating passion, Watteau's paintings are, for Caylus, devoid of any coherent "action." To the left, a couple embrace. To the right, a man plays the guitar. Both elements of the painting are obviously marked by a certain motion. But where does the image go from there? What led up to these two events? How does the image as a whole contribute to the portrayal of a continuing action?

To such questions, the painting offers no response. What is at stake here for Caylus goes well beyond any quibble over style or technique. In failing to marshal the elements of his image toward the clear representation of some unified action, Watteau has eliminated from his work any appeal to what Caylus calls the spectators' *esprit*, to that dimension of their perception that might lift spectatorship beyond the domain of only sensual pleasure into a higher realm worthy of true admiration. "Action alone . . . ," Caylus goes on

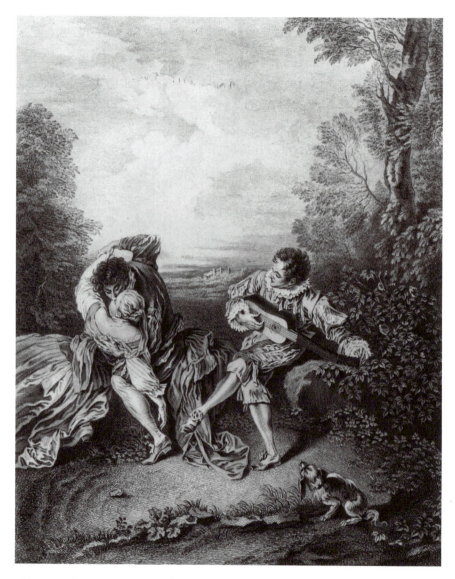

Figure 6. Antoine Watteau, *The Surprise*
Trustees of the British Museum, London

to caution the apprentice painter to whom he speaks, "can imbue your com-
position . . . with that sublime flame which alone speaks to the mind, which
seizes it, uplifts it, and fills it with admiration" (102). In denouncing the ab-
sence from Watteau's paintings of any object, any action, and any appeal to
the spectators' minds, Caylus is, more than anything else, arguing that the
artist must provide within the finished image some springboard to narrative.
For Caylus, the problem with Watteau, what makes his an example other
painters should not follow, is that his juxtapositions of disparate moments
too often remain just that. They fail to come together toward the evocation
of a larger, more inclusive temporality embedding the now of those indi-
vidual moments within some sustained story they serve to illustrate.

In making this criticism, Caylus repeats, some thirty years after the fact,
the same reproach that was leveled at Watteau's work when he was begrudg-
ingly accepted as a member of the very Academy Caylus is here addressing.
Everything about Watteau's candidacy and eventual entry into that body
was irregular and bizarre. Watteau himself never formally sought admission
to the group. In 1712, making his second attempt to win the competition for
the Academy-sponsored scholarship to the French Academy in Rome, Wat-
teau submitted two military scenes and *Les Jaloux*. Again, the scholarship
was denied him. But, at the insistence of two influential members, La Fosse
and Coypel, Watteau was instead, and much to his surprise, accepted on the
basis of those works as a candidate for membership in the Academy itself.
His one remaining obligation was to produce and submit for judgment a
major work. Normally, the subject of such a painting would be assigned by
the Academy's Director and the candidate was expected to execute it under
the loose supervision of two members who could thus confirm that it was his
own work. The Academy's minutes of July 30, 1712 record, however, that, in
Watteau's case, the choice of subject was left "to his choice [à sa volonté]."[3]

Watteau, hardly impressed by what he could only see as a rather irrele-
vant consolation prize for the lost stay in Rome, took more than five years
before he even began work on the painting, and that in spite of a number of
reminders from the Academy that his submission was long overdue. Finally,
on January 9, 1717 Watteau was informed that he had a maximum of six
months to submit his completed painting. In a final gesture of defiance, it
was only eight months later, in August of 1717, that he actually turned over
to the Academy the painting we know today as *The Pilgrimage to the Island
of Cythera* (Figure 7). The records of the Academy for August 28, 1717 show,
however, that the Secretary, after having first recorded that title, scratched it
out and wrote in its place the generic description "une feste galante." More

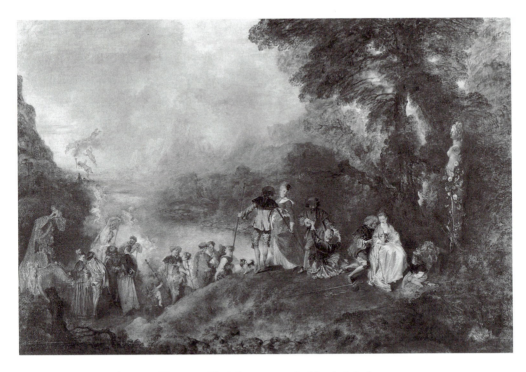

Figure 7. Antoine Watteau, *The Pilgrimage to the Island of Cythera*
Musée du Louvre

was involved in this apparently minor revising of the minutes than a simple change in title. By eliminating the mythological reference to Cythera, the Academy, undoubtedly divided in its judgment of the work, was admitting Watteau to its ranks. At the same time, however, it downgraded that honor from entry into the body's highest category of history painters to the distinctly lesser category of genre painters.

Watteau's entire admission seems to have been the result of compromises between those supporters who originally maneuvered to have what was a candidacy for a scholarship turned into a candidacy for membership and the clever ploys of his equally adamant opponents within the Academy. If, in Watteau's case, the Academy took the highly irregular step of allowing the candidate to choose his own subject, it was perhaps because his more conservative opponents wanted to do all they could to be sure the reluctant candidate was given more than enough rope to hang himself. Which, at least from their perspective, he did.

For us today, the *Pilgrimage* is universally recognized as a summit of Watteau's art, a nearly perfect synthesis of what would be his voice on canvas. For the conservative academicians, however, what was most obvious about this work was its failure to live up to its original title, to portray some recognizable incident that could be associated with the Island of Cythera, to offer some significant illustration of a narrative drawn from the repertoire of classical mythology. Had the work been accepted under its original title, Watteau would have been admitted as a history painter. The imposed change in its designation, one that it would have been understandably difficult for Watteau's supporters to refuse given the exclusively metaphorical basis for the use of that place name, meant that Watteau would receive his membership, but only within a category he was bound to perceive as an insult.

The absence of any concern on Watteau's part with illustrating a scene drawn from a clearly defined narrative not only led to his demotion by the Academy's conservatives and Caylus's later huffing about a failure to engage the spectator's intellect, but also opened the semantic door to what would be the Romantics' later and distinctly adulatory readings of his juxtaposed couples. For them, the obvious absence of a story *in the painting* meant that the canvas should most appropriately be read as a story *about the painter*. According to the often repeated narrative that would become the anchor of so much Watteau criticism, his couples come together in an ominous allegory of fragile and only apparent joy which is everywhere threatened by a sense of tragic evanescence which had to be particularly acute for this painter destined to die at so early an age. For these critics, this insistence on a deep sadness lurking at the core of these passing pleasures from which both artist and spectators seem strangely to be excluded, had the advantage of allowing them to reverse the earlier negative judgments of Watteau's work. It is no less true, however, that the *triste Watteau* imagined by the Goncourt brothers, the Romantics, and the Symbolists stands very much in the way of our understanding why he was both so extraordinarily successful during his short lifetime and so totally rejected less than twenty years after his death. The Romantic image of Watteau as a painter producing scene after scene of the most luminous joy even as he is dying from tuberculosis certainly conjures up an appealing character, but the allure of that imagined drama on the artist's part ultimately distracts us from the more intriguing question of how his work expressed and fashioned the emerging esthetics of the moment.

* * *

Watteau's *Pilgrimage* stands as a masterpiece not because it flows from the suffering of its creator, but because it is both rooted in and redefines the early eighteenth century's sense of the erotic and the visual representation of desire. Appreciating that work on its own terms depends on our placing it within a tradition of visual representations that attempt to portray the situation of the individual in relation to the reality of desire. Watteau's image of juxtaposed couples must be read as a vision of the erotic that redefines a tradition initiated by the seventeenth century, the period from which the costumes of his figures are so frequently drawn. The *Pilgrimage* is both a return to and a highly significant reconfiguring of the attempt to represent the dynamics of desire known as *La Carte de Tendre* (Figure 8), an image that first appeared as an illustration in Madeleine de Scudéry's *Clélie, histoire romaine* of 1654. Looking at that array of words spread across a map, we see, all but

Figure 8. Madeleine de Scudéry, *La Carte de Tendre*
Bibliothèque Nationale

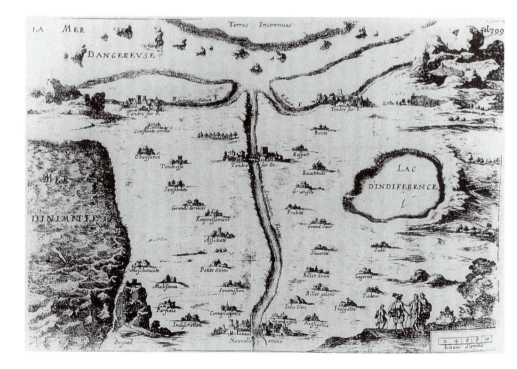

hidden in the lower right-hand corner, the inchoate anticipation of a scene similar to what would become the very substance of Watteau's *fêtes galantes*. A couple, accompanied by two peripheral figures, approach one another as the female figure, dressed in a toga, raises her right arm in a gesture of tentative greeting. These miniature human figures represent the *nouvelle amitié* which, verbally enunciated at the center of the map's lower edge, provides the effective entry point into the mapped territory. From there, the image tells us, the newly acquainted couple might, with ease on the River of Inclination, proceed to a tenderness based on a natural attraction to each other and arrive at the city of *Tendresse sur Inclination*. Then again, setting off from the same point, they also have the option of undertaking a more perilous overland journey. Setting out to their right, they may, by dint of poems and love letters as well as such personal qualities as sincerity, generosity and respect, arrive at the city of *Tendresse sur Estime* — if, that is, they avoid the dangerous detours of neglect and tepidness that risk leading them to the Lake of Indifference. Were they to set out instead to their left, they may, by dint of such qualities as assiduousness, devotion and obedience, arrive at the quite different city of *Tendresse sur Reconnaissance* — if, that is, they avoid both the lonely heights of Pride as well as the indiscretion and pettiness leading to the Sea of Enmity.

This image from Scudéry's novel is perfectly consonant with the abstract and systematizing Cartesianism of its cultural context. Timeless, impersonal categories overhang and define all variants of human conduct. The reciprocated desire of *tendresse* is always, no matter what its specific form, the end point of an itinerary, the last chapter of a story, the progression and stages of which can be clearly marked by verbal constructs enunciating the comportment to be adopted. The specific, corporeal identities of the individuals about to embark on this journey are unimportant. The human forms are nothing more than nameless and faceless exempla, interchangeable figures about to find their way through a predetermined maze of rigorously sequential concepts which anticipate every possible permutation of their mutual affectivity. The absolute primacy of conceptual categories such as those enumerated in Descartes' *Traité des passions de l'âme* of 1650 obliterates any specificity of the incarnate body.

Watteau's *fêtes galantes* effectively reverse the conceptual hierarchy at work in Scudéry's *Carte de Tendre*. That image presents the spectators with a carefully constructed series of words, but leaves to their imaginations any representation of the desiring bodies moving within their semantic fields. Watteau's *fêtes galantes*, on the contrary, show actual couples while leaving

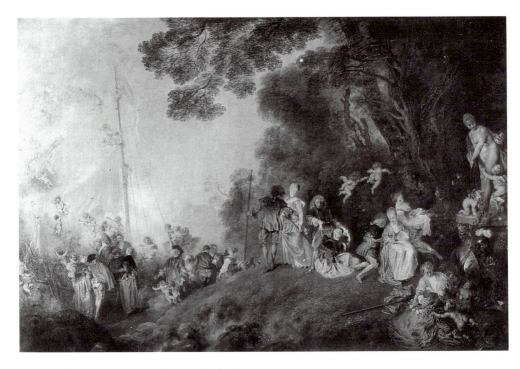

Figure 9. Antoine Watteau, *Embarkation for Cythera*
Charlottenburg Palace, Berlin

entirely to the imagination any intellectual conceptualization of the passions they might be seen as emblematizing. Concerning the visual representation of desire's narrative, the body, now at center stage, has displaced the abstract concept.

The juxtaposed couples of the *fêtes galantes* and their infinite permutations of moments drawn from the ritual of courtship were a subject Watteau painted again and again, marking it as the essence of his vision. The almost compulsive aspect of this return to the same material is well exemplified by his decision to paint, a year or two after he completed the *Pilgrimage*, a second version of that work, done most probably for his close friend Jean de Jullienne, under the title *Embarkation for Cythera* (Figure 9). To a large exent, this second painting was a recreation of the first which, according to the practice of the time, became the property of the Academy to which it had been submitted. Watteau's decision not to surrender his image entirely was at work even before he turned the *Pilgrimage* over to the Academy. While

working on it, he made a number of counterproofs (blank sheets of paper pressed against the still wet canvas so as to produce a reverse image of the original) which, since he had never done a detailed compositional sketch, he later used to paint the *Embarkation*. That second painting reproduces and augments the basic structure of the two clusters of couples in the first painting. To the group of couples on the hill to the right in the *Pilgrimage*, the *Embarkation* adds one below and another to the right of the seated woman. The first shows a man offering still more roses to his partner as she gathers them in the extended apron she holds open with her hands. The second is caught in a caress as the reclining woman touches the right arm of her suitor. This now more concentrated group serves to initiate the integrating undulation of the painting's movement which rises to its mid-point, descends down the hill's slope, and finally rises again with the array of *putti* flowing upwards to the top of the now more prominent boat and mast. To the five couples at the bottom of the hill in the *Pilgrimage*, the second version likewise adds two more who are already on board the boat and replace, in terms of vertical movement, the barechested and unpartnered boatmen of the original version. The proliferation of winged *putti* is even more extreme, passing from twelve in the *Pilgrimage* to thirty-eight in the *Embarkation*. Concerning the paintings' respective styles, the second version uses heightened and more contrastive colors to provide a far sharper treatment of detail. The vague and sometimes sketchy forms of the first version are redone to convey a more intense sense of the presence of the physical bodies. The shadowed Venus term adorned with roses in the *Pilgrimage* becomes a much more emphatic, almost animate statue of Venus and Cupid standing on a wide stone base at the foot of which can be seen armor, a book, and a lyre: objects usually read as symbolizing desire's primacy over all other human pursuits.

Art historians have, ever since Watteau returned to a place of prominence in the canon, proposed various interpretations of this image in two variations. While many scholars have argued for a loose congruence between Watteau's paintings and other aspects of Regency culture (plays referring to a pilgrimage to Cythera,[4] novels such as Paul Tallemant's *Voyage à l'isle d'Amour*, or a clavecin piece like Couperin's *Carillon de Cythère*), the real challenge has been to respond to the criticism first voiced by Caylus and the Academy by arguing for the existence of a narrative framework internal to the painting itself. Generally, scholars have preferred the *Pilgrimage* to the *Embarkation*, largely because the second's augmented cast of characters lends itself even less to the tidiness of any narrative enclosure.[5]

Michael Levey has argued that, contrary to the way the painting was

understood and titled in the eighteenth century, it tells the story not of a departure for Cythera, but of a return from that Island. Since, he claims, the presence of the Venus term denotes her reign over the represented space, the pilgrims must be in the process of leaving its joys for an uncertain return to the precincts of ordinary life.[6] According to another version of this same kind of internal narrative, Charles de Tolnay makes the claim that, reading the painting from right to left, we see emerging from it a representation of what he calls the cosmic cycle of love. As the couples move from the Venus term to the boat (here assumed to be setting off for Cythera), the would-be lovers pass through such stages as persuasion, consent, and harmony. Then, calling attention to what seemed to be the painting's autumnal atmosphere, its choice of twilight as the represented time of day, and the heavy mists blocking any sight of the distant Cythera, de Tolnay sees more somber connotations concerning love's and life's inevitably transitory nature.[7] Twenty years later, Jan K. Ostrowski radicalized this narrative to the point of equating the movement of Watteau's couples with a dance of death.[8] Taking a different tack, Hermann Bauer reasoned that, since Watteau's eight couples can in many ways be read as versions of each other, they should be seen as coalescing into a timeless allegory on the power of the erotic.[9]

Even this brief rehearsal of some of the narrative frames critics have applied to Watteau's painting shows how such readings remain curiously oblique to the real force of his images. Clearly working outside the constraints of narrative, Watteau's esthetic operates on a different basis. His compositions, in these two paintings as well as in the entire corpus of the *fêtes galantes*, may well lack what Caylus called an "object." That pointlessness is, however, a shortcoming only so long as we subscribe to the hypothesis that the image must at some level support a narrative reading. It seems clear that the stories told by Watteau's images are at best the same (what Caylus called their "uniformity") and at worst irrelevant. The informing impetus of his work is elsewhere and his paintings deserve to be approached not in terms of what is obviously missing, but in terms of what is visibly there. What is unique about Watteau's paintings (and what in fact is even more apparent in the *Embarkation* than the *Pilgrimage*) is the intensity produced by the fulgent presence of so many isolated couples incarnating specific moments of intimacy concomitant with their precise physical gestures.

Watteau's art of variations fascinates the spectator because each of his couples exists within a dialectic of contrary aspirations. These couples, by reason of their costumes representing different social classes, their often contorted postures, and their intense verbal and gestural exchanges, exist within

a socialized, rigorously symbolic world of amorous decorum which dictates every aspect of their conduct. Mary Vidal, in her study of conversation as the structuring trope of Watteau's work, emphasizes the backward glance of the central female figure toward the shadowed realm of intimacy she is leaving as the key to the image's meaning. For Vidal, that regretful glance establishes the painting as an icon of "withdrawal from a private to a less private conversation, . . . a departure from intimacy toward sociability."[10] Yet at the same time these couples appear on the canvas as strangely self-sufficient pairs absorbed within themselves and closed off from the figures around them. They appear as though animated by an intensity of sentiment rooted in an imaginary and utterly idiosyncratic dimension of desire. The human figures within a Watteau painting, rather than functioning as synecdoches for some narrative whole to which they finally subordinate themselves, become instead full and autonomous incarnations of specific and self-defining moments drawn from the scenarios of desire. They achieve by reason of this dialectic both a visual specificity and a social anonymity outside of and untouched by any narrative that would assign them any single name or defined identity. Their languid postures and exuberant grace, syntheses of the sensuous and the kinetic, address the spectator at a level of consciousness prior to and more profound than any identity imposed by the imbrication of society's narratives of individuation.

Watteau's *fêtes galantes* have, more than anything else, the visual texture of pre-logical and anti-narrative dream images. His vivid representations of desire caught in only momentary glimpses do not speak to a spectatorial consciousness attempting to locate these characters within historical or mythological narratives. They address instead a deeper, pre-conscious level of sensate awareness populated by imaginary and anonymous memories of a glance exchanged, a body touched, and a desire fulfilled. Paul Verlaine, a poet fascinated by Watteau, captures well the corporeal yet phantasmatic foundation of Watteau's address to his spectator. In "Les Ingénus," a poem from his collection entitled *Fêtes galantes*, Verlaine enunciates within a single brief metaphor the fundamental chemistry of Watteau's images: "c'étaient des éclairs soudains de nuques blanches [it was the sudden flashes of pale napes of necks]." In that short untranslatable phrase, the continuing, indefinite temporality of the French imperfect in the introductory *c'étaient* sets up an oppositional tension with the emphatic instantaneousness of the central metaphor—*des éclairs soudains*—which inscribes the whiteness of the neck within the unstable, oscillating realm of the extra-rational and the phantasmatic. Short-circuiting any interpellation of the spectator as a subject de-

fined by life-narratives consolidating the coherence of a socialized identity, Watteau's images address their audience instead as corporeal subjects sharing a common yet anonymous awareness of sensation rooted in the experience of desire.

Watteau's images, unfettered by story, speak as fragments from a half-remembered dream, as clouded memories beckoning the spectator back to a moment of intense pleasure and excitement recalled far more by eye and touch than by the conscious mind and its self-situation through narrative. His appeal to the spectator as a desiring body is at work even in those paintings which do rely on some cursory narrative reference. *Spring* (Figure 10), done as one of a series of four seasons paintings, may well rely on a naming of the figures of Zephyr and Flora. That reference to mythological narrative is, however, irrelevant to the power of this image of two bodies incarnating a moment of shared desire. The painting speaks not as an allusion to classical mythology, but as an immediately legible image of bodies whose mutual longing for each other expresses itself in the arms that move behind and draw toward the back of the partner, in the leg rising in anticipation, and in the arched right arm which, as it extends a crown of roses, draws haltingly closer to the aura of the desired body.

It is this power of desire that forms the real basis of Watteau's art. The momentary pose that would later become the male figure in the likewise mythologically titled *Jupiter and Antiope* (Figure 11) was first captured, independently of any narrative reference, in one of Watteau's quickly drawn sketches (Figure 12). The transformation from sketch to painting is marked by an elongating of the male body transfixed by desire. The left arm, reaching to pull back the light sheet, becomes extraordinarily long as it forms with the figure's body a gesture of enclosure that attempts to encompass within its sweep the whole of the sleeping woman beneath it. The right hand, simply providing support in the sketch, becomes within the painting an emblem of hesitant desire. The fingers of that hand stretch out toward the reclining body, but appear as though abruptly checked in their approach. What began as the sketch of a particular posture becomes the icon of a body drawn toward and contorted by a desire to enclose within its grasp the totality of the other.

The body as it appears in Watteau's paintings is never the body of realism, *le corps vraisemblable*, asking only to serve as the vehicle of a more fundamental narrative intention. Instead, the reality of anatomy yields to gestures inflected by the distortions of desire. Watteau's figures, like fragments

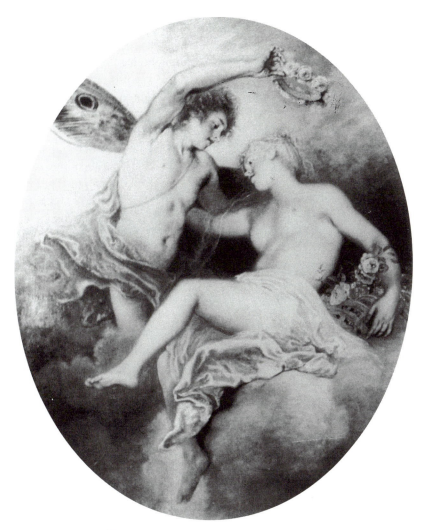

Figure 10. Antoine Watteau, *Spring*
Destroyed; photo by Mrs. Oliver Colthurst; Lady Sybil Grant Collection

from a forgotten dream, display a repertory of poses, touches, and transfixed glances that captivate the viewer through their evocation of a pre-conscious dimension of our existence as sentient, desiring bodies.

What is specific to Watteau's style and the way it is different from that of even those contemporary genre painters most often associated with him, can be seen in a work such as Jean-François De Troy's *The Declaration of Love* (Figure 13). Gesture, posture, and movement certainly have their roles to play in this work. Yet it is immediately clear that we are looking at a world utterly different from Watteau's. The sharply drawn central couple, so well integrated with the peripheral figures, has none of the self-enclosed aura, poised mystery, or postural ambiguity that informs Watteau's emblems of desire. Because De Troy's image coincides so perfectly with its title, because it so immediately subordinates itself to the story it would illustrate, the spec-

Figure 11. Antoine Watteau, *Jupiter and Antiope*
Musée du Louvre

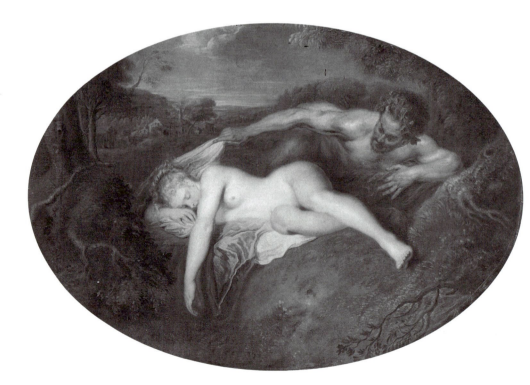

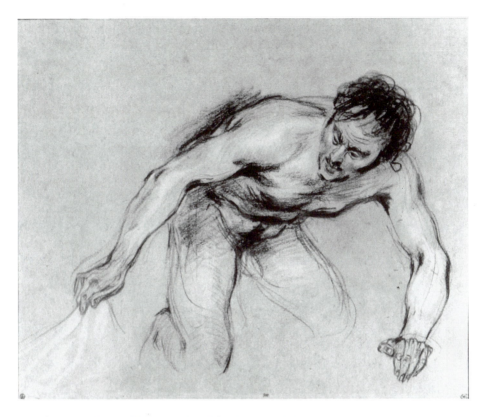

Figure 12. Antoine Watteau, Sketch for *Jupiter and Antiope*
Musée du Louvre

tator is able to relate to it with the distance and objectivity of someone asked only to interpret and explicate. What does the young woman between the couple really feel about this declaration? What is the reaction of the older, maternal woman at the extreme left? Who are the two figures descending the stairs in the background? Responding to such questions involves nothing more than the uninvolved understanding of a narrative which never addresses the spectators as desiring subjects who exist outside the parameters of the represented story. De Troy's is an esthetic of the snapshot. Or, less anachronistically, an esthetic of the illustration of scenes drawn from a novel.

* * *

Watteau's art manifests an awareness of the self-sufficient moment that emerged between and in opposition to both the abstract conceptualization of a Scudéry and the flatly realistic storytelling of a De Troy or a Greuze. Never allowing his rendering of the moment to disappear within the perception of some integrating meaning, Watteau remains outside all allegiance to any potentially ideological dimension of narrative. His images occupy the canvas as an impenetrable surface, as figures alien to the teaching of any lesson or the illustration of any moral truth. They draw their force from an appeal to a phantasmatic and anti-narrative imaginary grounded in the celebration of the incarnate moment. Outside story and its consolidation of nar-

Figure 13. Jean-François De Troy, *The Declaration of Love*
Charlottenburg Palace, Berlin

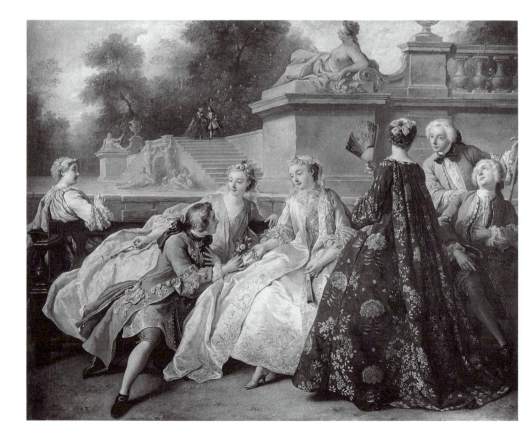

rativized identities, Watteau's paintings neither ask for nor offer any answer to the question "Who am I?" Instead, speaking of the very texture of desire, they ask and offer only visual answers to the more fundamental question "How did it feel?" The emphasis within that question, anticipating the force of what Freud would call *das Es*, is on the impersonal and ambiguous "it," which, as it were, "feels" in my place. The "it" Watteau's images set out to represent exists at a level prior to and more profound than any constructed identity that allows the individual subject to speak as a socialized "I."

We saw earlier how Watteau added still more couples to an already extensive cast of characters as he redid his Academy piece. Significantly, all four of the added couples, like most of the original eight, form what could be described as solipsistic, self-regarding pairs. Each member of those couples is caught within his or her fascination with the proximity of the other. The only exceptions to this are the two simply dressed couples to the left of the painting's center who share an exchange, and the central female figure who looks back over her left shoulder at the others she is leaving. These additions to the painting's second version emphasize Watteau's portrayal of the world as a juxtaposition of individuals ravished by the intensity of the similar yet different moments establishing them as couples, as both subject and object of a shared desire. These images simultaneously present both an intimacy and a promiscuity: the intimacy of those couples oblivious to all that is outside their self-sufficient dyad and the promiscuity of a closeness to one another that renders all the more mysterious the intensity of that intimacy. This clash becomes within Watteau's *fêtes galantes* the central paradox of a double and contradictory imperative to exist within both the specificity of the moment and the collectivity of the social. Finally, however, Watteau's allegiance is to an enactment of desire, both momentary and precarious, which affords the only possible escape from a more extensive narrative that submits desire to law, the individual to the social, and the imaginary to the symbolic. Watteau's power to fascinate derives from his repeated representation of figures who, acting on the moment of desire, achieve a visual intensity that speaks not of what we owe to and take from the society around us, but of a sensuous, incarnate plenitude prior to and stronger than the planned, the conscious, and the social. Consistently refusing the metonymies of narrative, his images impose themselves as proliferating metaphors of desire's moment. They speak not of who we are within society's regimenting stories but of who we are within the incarnate moments of the body.

10

CHARDIN AND THE MOMENT BEYOND NATURE

The organizing trope within most art historical criticism of Jean-Siméon Chardin is the assumption that there were two all but distinct Chardins: the Chardin who painted images of fixed, immobile physical objects and the Chardin who painted domestic scenes teeming with the bustle of everyday life. On the one hand, there is Chardin the painter of hauntingly powerful still-lifes that range from compositions of fowl and small animals arranged for display after a hunt to images of fruits, flowers, kitchen utensils, and the paraphernalia associated with the arts and sciences. This is the Chardin who was given the honor of being presented to and received as a full member of the Academy on the same day as a *peintre des animaux et fruits*. On the other hand, there is Chardin the painter of domestic scenes (*scènes de genre* depicting the people of Paris) that portray the daily life of wives, children, and servants. Studies of Chardin are usually structured as an attempt to separate and date these two components of his work. The general consensus on that question is necessarily nebulous. Chardin produced still-lifes from the 1720s to roughly 1735, when, for approximately sixteen years, he presented only domestic scenes. After 1751 he returned to still-lifes and finally stopped painting domestic scenes entirely after 1760.[1] Since we have very few statements by Chardin about his ideas on painting, there is no really satisfying explanation as to why, toward the age of thirty-seven, he moved from things to people. The most frequently cited anecdotal explanation presents that shift as an ambition to ascend, if not to the top, at least to the more respected and better remunerated middle of the Academy's carefully ordered hierarchy of genres. While never aspiring to the highest category of history painting, Chardin is nonetheless seen as having resolved to move out of the cellar of "animals and fruit," when, according to one story, he took as a personal criticism his friend Aved's rather abrupt explanation as to why he had turned down what seemed to Chardin the enormous sum of four hundred livres to do a portrait. "If only," Aved insensitively remarked, "a portrait were as easy to do as a sausage."

The notion that there are two Chardins, Chardin the painter of what

in French are called *natures mortes* and Chardin the painter of domestic scenes, has created a special challenge for critics dealing with his work. The Goncourt brothers, speaking of his still-lifes, offered a particularly paradoxical explanation of how he straddled those two categories. They decided that his real subject should be seen as "the inanimate life of things [la vie inanimée des choses]" and insisted on how "from his thickened colors there oozes the very sap of life."[2] Other critical problems also arise from this tendency to imagine two Chardins. By mid-century, for instance, it was his domestic scenes, reproduced in a steady stream of engravings, that consolidated his fame as the most popular (but hardly the best paid) artist of his time. Yet, as concerns his more lasting influence on later artists, it was far more Chardin the painter of still-lifes who inspired such artists as Cezanne and the cubists. His original renown as a painter of domestic scenes was in fact eclipsed even during his own lifetime by the overwhelming success of the highly sentimentalized domestic scenes produced by Greuze and his disciples.

For critics addressing the puzzle of the two Chardins, his still-lifes are seen as capturing with an astounding objectivity the physical presence of the objects represented on his canvas. Chardin's images, whether animate or inanimate, an arrangement of fruit and flowers or a kettle and a glass, are described as achieving the kind of vividness and permanence that inspired Diderot to proclaim that all spectators looking at a Chardin feel an almost irresistible impulse to reach for the fruit and to drink from the glass. Chardin's domestic scenes are, to the contrary, approached as the perfect capture of a passing moment, as depictions of such fleeting instants as *The Game of Knucklebones* (Figure 14) with its image of a young woman about to catch the small ball she has thrown into the air or *The Morning Toilette* (Figure 15) with its depiction of a dutiful daughter sneaking a last glimpse of herself in the mirror as her mother prepares her for an outing. This sharp focus on a passing moment is seen as setting such images distinctly apart from the immobile permanence of his still-lifes where the passage of time, the choice of this instant as opposed to a moment before or a moment after, seems irrelevant to the work's dynamics. It is, it would seem, Chardin's reliance on two antithetical approaches to the primacy of the moment that defines the distinct registers of his art.

This dichotomy within Chardin's work has also led to two quite different interpretations of his place within the larger social and ideological context of his time. For those who favor Chardin the painter of domestic scenes, he is, more than any other French painter of the eighteenth century, the poet of the people. The nineteenth century, particularly during periods of inten-

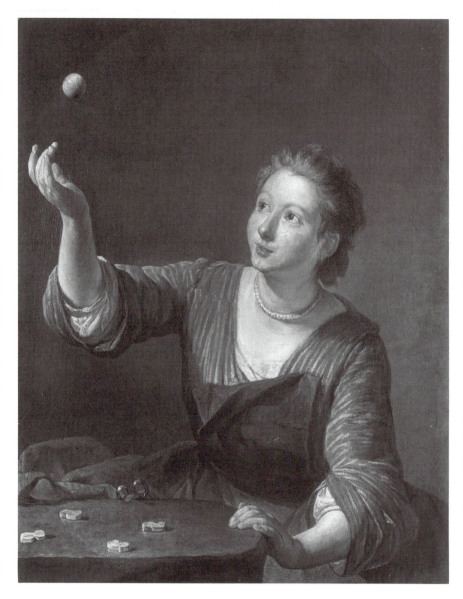

Figure 14. Jean-Baptiste Chardin, *The Game of Knucklebones*
Baltimore Museum of Art, Mary Frick Jacobs Collection, BMA 1938.193

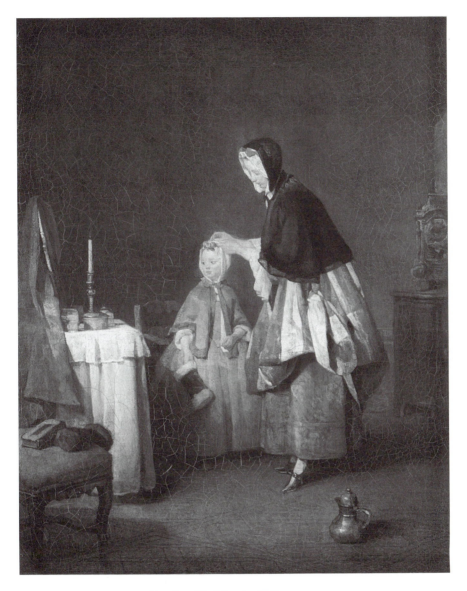

Figure 15. Jean-Baptiste Chardin, *The Morning Toilette*
Nationalmuseum, Stockholm

sified social strife, consecrated Chardin as the painter without whom any real image of the *ancien régime* would have remained forever hidden behind the dubious celebrations of the aristocracy offered by such artists as Watteau and Boucher. An unsigned article of 1848 in the popular *Magasin Pittoresque* proclaims that "there is a part of the century of Louis XV which would have remained unknown to us had it not been for Chardin's brush. Born to the working bourgeoisie (his father was a carpenter), raised in that class, living in its midst, he took his greatest pleasure from tracing onto canvas simple images of its everyday life."[3] For this writer, it is Chardin alone who shows us "a class completely distinct from that gaudy and flimsy court whose faults and excesses have been all too faithfully handed down to us" (104). After underlining the moral guidance to be drawn from Chardin's works, this writer concludes with an almost programmatic summary of what he sees as his abiding lesson. "What mystery is more profound or more sweet than that true treasure of human life conveyed by this delicate painter: honor, order, economy" (106). Exploiting a similar vein, the Goncourts answer the query "Who in fact is Chardin?" with the simple declaration "the bourgeois painter of the bourgeoisie" (120).

The bourgoisie in question here is not, of course, that nexus of money and property which would become so sturdy a whipping boy for the nineteenth and twentieth centuries. It is the *petite bourgeoisie*, the working bourgeoisie of Paris, which the Goncourts go on to call "the simple and pure figures of a bourgeoisie of struggle and work, happy in its place, its labor, and its obscurity" (121). Even Elie Faure, writing in 1921, could not resist making the metaphor of the honest workingman a centerpiece of his analysis of Chardin's art. "That fine painter Chardin does his job with love, like a good carpenter, a good mason, a good turner, like any good worker who has ended up falling in love with his material."[4] For Faure, it is a concern with *la vie morale* that provides the integrating principle of Chardin's characters and his personal background. "He knows that everything comes together, that the life of objects depends on the moral life of the people who use them, that the moral life of those people is in turn influenced by those objects. All that exists has a right to his loving respect" (4:227).

Those critics who focus on the other register of Chardin's work, his still-lifes, tend instead to emphasize the formal aspects of his art. Analyzing his careful arrangement of volumes, the play of light from one object to another, and his growing recourse to lighter tones and a less meticulous style of representation, these critics speak of a Chardin whose social attitudes are irrelevant to the essence of his art. In his study of the French

still-life from the seventeenth to the twentieth century, Michel Faré goes so far as to see a growing concern with art's social dimension as an explanation of the simultaneous eclipse toward the end of the eighteenth century of all interest in the still-life as a genre as well as in that category of Chardin's production. "The silent life of things was soon to be disturbed by the stridency of obstreperous young artists. Nostalgia for an heroic existence led them astray. The memory of the Greeks and the Romans made the everyday objects around them seem quite petty. David and his students drew their enthusiasm from great feats of arms that took place far from any kitchens. Vases of flowers and baskets of fruit suddenly seemed utterly unimportant to them."[5] Francis Ponge, sensing in Chardin's still-lifes a desire parallel to his own ambition to "feel religiously everyday reality [ressentir religieusement la réalité quotidienne]," offers a more convincing defense of Chardin. Convinced that "more and more recognition will be granted to those artists who have proven themselves by their silence, by their pure and simple abstention from themes imposed by the ideologies of the period," Ponge designates what he sees as Chardin's conscious choice of apolitical banality as the source of his true genius. "Try to render in as banal a style as possible the most common objects: that is when your real genius will appear."[6]

* * *

Our understanding of Chardin pays a price for this dichotomized vision of his work and the tendency to privilege either his domestic scenes or his still-lifes. How, the question becomes, might we describe the sum of his accomplishment without slighting one of its components? Moving beyond that opposition, can we integrate both categories of his work as complementary aspects of a single esthetic endeavor? Are Chardin's domestic scenes and still-lifes finally so unlike each other that appreciating one must imply a discounting of the other?

Puzzled by the overwhelming success of Chardin's scenes of domestic life, La Font de Saint-Yenne observed in his wide ranging *Réflexions sur quelques causes de l'état présent de la peinture en France* of 1747 that Chardin's is a talent "to portray, with a singularly naive truth that is unique to him, certain moments from daily activities that are in no way interesting, and which in themselves merit no attention."[7] As his left-handed compliment makes clear, what La Font finds troubling about these paintings "which nonetheless earned him a reputation even in foreign countries" is the fact that they seem to have no real point, no narrative organization, no story to tell, and

no moral truth to communicate to their audience. Throughout his essay, La Font champions a return to the high seriousness of classical history painting as a remedy to what he sees as the degenerate state of French painting at mid-century, as a limitation of its ambitions to the purely decorative. The point he would make in speaking of Chardin is that, even though his domestic scenes portray human subjects rather than inanimate objects, their lack of any clearly stated narrative intent places them far closer in spirit to the superficial prettiness of the still-life than to the serious exploitation of cultural and gestural codes characteristic of history painting and its exemplification of a moral lesson. For La Font, Chardin's scenes of everyday life, centering on children at play or women at work, may well be astounding in their realism, but, in terms of their semantic stakes, they might just as well be arrangements of flowers or the bounty of a successful hunt. Lacking in narrative development and moral intent, their representation of human subjects reduces them to the insignificance of inanimate objects.

La Font's prejudice in favor of classical history painting clearly leads him to misunderstand Chardin's art. But his censure is nonetheless helpful in grasping what, for the period, was unsettling about the way Chardin's domestic scenes addressed their spectators. The careful arrangement within history paintings of a series of significant details meant to be read as narrative served, more than anything else, to organize the spectator's vision of the painting. The image tells its story by integrating its carefully arrayed elements into a morally significant statement. To appreciate a history painting was to affirm one's membership in an educated elite defined by its ability to read an iconic text grounded in a culture shared by painter and audience. In Chardin's domestic scenes, to the contrary, the need to have mastered any cultural code disappears. The simplicity and directness of his scenes impose themselves without recourse to learned references or careful narrative organization. Rather than following a story, the spectators of Chardin's domestic scenes are invited to engage in a free-flowing contemplation of the image. They are called upon to look rather than to decode and interpret. With the familiarity and even banality of the scene confirming the spectators' adequacy to the image before them, their eyes wander freely over its surface as they indulge a fascination with what is so strikingly similar to and yet so obviously different from experience as they know it. Chardin's scenes of everyday household life rely, in this sense, on a dynamics of spectatorship that compromises the Academy's rigid doctrine of fixed boundaries between the response to a portrayal of human subjects and the response to a still-life.

Again, unlike history paintings but like still-lifes, Chardin's domestic

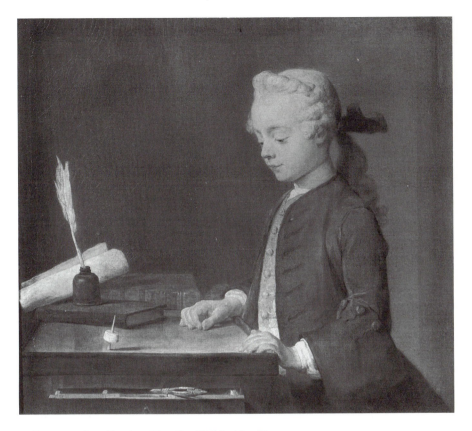

Figure 16. Jean-Baptiste Chardin, *Child with a Top*
Musée du Louvre

scenes never concentrate their focus on the organizing highpoint of any
"significant moment" implying the morally meaningful passage from one
psychological state to another. They portray instead scenes situated in an
indefinite, insignificant moment that, while perhaps fleeting in real life, is
mysteriously foregrounded and extended within the painted image. Be it
the moment of a boy fascinated by the apparently immobile movement of
the spinning top on the table before him in *Child with a Top* (Figure 16), or
of an adolescent suspending the movement of his hand as he calculates how
he might best place one more playing card on his cardcastle in *The House of
Cards* (Figure 17), Chardin's preference goes to moments of immobility and
fascination. Michael Fried, analyzing Chardin's role in secularizing and ap-

plying to the everyday world of domestic life what he calls an "absorptive tradition" that began in religious painting, makes the point that "Chardin's paintings of games and amusements, in fact all his genre paintings, are remarkable for their uncanny power to suggest the actual duration of the absorptive states and activities they represent."[8] Whatever before and after of story might be referred to in Chardin's domestic scenes are suspended and rendered irrelevant by his choice of these immobile, absorptive moments. So long as we insist on asking of his images the meaningful causality of some narrative significance, we will, like La Font, be forced to find Chardin's paintings "in no way interesting."

Chardin's paradoxical practice of reducing to a single absorptive moment an action within which the viewer might ask for some larger signifi-

Figure 17. Jean-Baptiste Chardin, *The House of Cards*
Trustees of the National Gallery, London

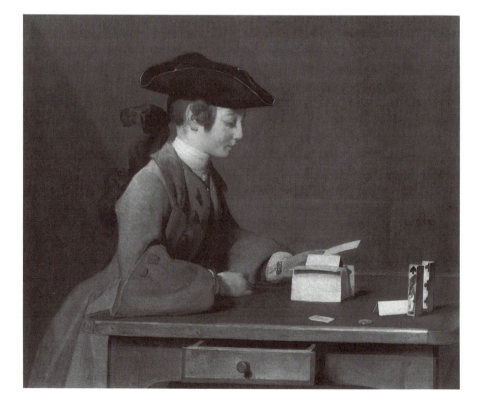

cance, of painting people as though they were elements in a still-life, was clearly a source of discomfort for many viewers. As a response to that discomfort, it became the practice, within the emblem-books which included engravings of his domestic scenes, to compensate for this lack of narrativized exemplarity by appending along the lower borders of the image a short verse morality. These brief texts had the effect of transforming the image into an allegory and establishing it as a vehicle of precisely the kind of didacticism precluded by Chardin's refusal of visual narrative.[9] To the engraving of *The Child with a Top*, for instance, the emblem books added:

Dans les mains du Caprice, auquel il s'abandonne
L'homme est un vrai tôton, qui tourne incessament;
Et souvent son destin dépend d'un mouvement
Qu'en le faisant tourner la fortune lui donne.

[In the hands of whim, as he surrenders to it,
Man becomes a spinning top, who never stops turning;
And often his destiny depends on a flick of the finger
Which, as it makes him spin, fortune imposes on him]

This semantic overloading, while essential to the emblem-books, is nonetheless a hijacking of Chardin's image, an attempt to put it to a use extraneous to the painting itself. Thomas Crow makes the point that not only did Chardin refrain from courting the popular success provided by this secondary venue of the emblem-books, but that an important segment of his international audience of aristocratic clients sought out or commissioned new versions of his domestic scenes precisely because they knew his variations on a genre previously associated with such Flemish masters as Adriaen Brouwer, Adrian Van Ostade and David Teniers would be "cleansed of its uncongenial moralizing and uncomfortably low humor."[10]

An example of how Chardin consciously emptied images drawn from that tradition of their narrative and moralizing content can be seen in the way he deploys the playing card within his domestic scenes. At various points in his career Chardin did no fewer than four different versions of *The House of Cards*. The basic scene of a boy seated at a table building a cardcastle is rendered with variations in the direction he faces, the presence or absence of a hat, in the details of the background, and in the view of a drawer opened toward the spectator where additional cards may or may not be seen. This image was, in all its versions, easy prey for the emblem-books. The engraving done by Pierre Filloeul was, for instance, accompanied by the following verse:

Aimable enfant que le plaisir décide,
Nous badinons de vos frêles travaux:
Mais entre nous, quel est le plus solide
De nos projets ou bien de vos châteaux.

[Lovable child abandoned to pleasure,
We make jest of your fragile constructions:
But between us, which is more solid
Our own plans or your cardcastles?]

In spite of its tenuous relation to Chardin's image, such verse did accomplish its purpose of moralizing the image. What, however, that verse struggles against, the reason why it had to be added, is the fact that Chardin's use of this motif explicitly departs from a long tradition employing playing cards as a symbol of the sense of touch. Chardin's eighteenth-century audience was very familiar with the way playing cards—like flowers evoking smell, musical instruments evoking hearing, glass surfaces evoking sight, and various foods evoking taste—served as emblems of the senses in a venerable tradition of still-lifes. Lubin Baugin's *The Five Senses* (Figure 18) is a good mid-seventeenth-century example of this genre. Even more to the point at hand, the equally allegorical genre of *Vanitas* paintings needed only the addition of a skull to transform its evocation of the five senses into an allegory of the bone-hard reality of death as the abolition even of the simple sense experience of grasping and shuffling a deck of cards. An unattributed *Vanité* from the school of Georges de La Tour (Figure 19), also of the mid-seventeenth century, arrays its emblems of the senses, with the playing cards occupying a prominent position to the lower left, as tokens of all that will become irrelevant to the eternal life of the soul once it has shaken off its mortal coil. Compared to such an image, Chardin's utter banalizing of the playing card as an element of innocent children's games can only be read as an explicit refusal of the more portentous connotations of such allegories. Chardin, by using the playing card outside any evocation of the other senses and by emptying his image of even the most allusive reference to death, spurns the conventions to which that object most obviously refers.

Chardin's short-circuiting of any moralizing or allegorical dimension within his domestic scenes can also be seen at the level of his technique. The execution of individual elements within his images is never informed by an attempt to guide the spectator's eye along an itinerary of signs the semantic importance of which is proportionate to the detail in which they are rendered. Chardin's preference goes instead to a style where, as Norman Bryson

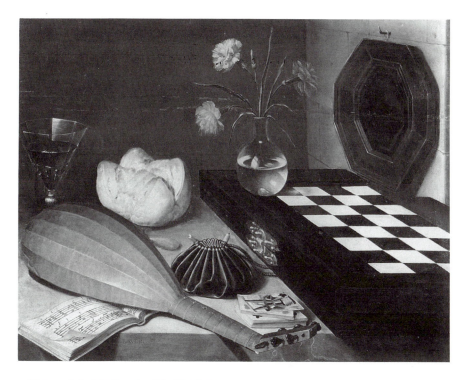

Figure 18. Lubin Baugin, *The Five Senses*
Musée du Louvre

has put it, "everything is evenly out of focus."[11] In *The House of Cards*, for instance, neither the boy's face nor his hands are executed with the precision and attention to detail that would have emphasized the image's potentially moralizing reading as a statement on the futility of exerting such concentrated effort toward so insignificant a result. By painting the only visible parts of the boy's body in a way that gives them no more prominence than the open drawer or the background, Chardin works against the fundamental chemistry of narrative amplification, against the spectator's desire to read the rendering of the human body as something more than a pattern of pigment on canvas. *The House of Cards* becomes not so much a meditation on some aspect of a human condition shared by artist and spectator, as a rendering of its human subject in such a way that it exists as an object occupying the canvas with no more moral eloquence than an object drawn from a still-life of flowers or game.

Even Diderot, one of Chardin's most militant champions, could not conceal his discomfort with this aspect of his domestic scenes. Speaking of the similar lack of attention to detail in *Saying Grace* when it was exhibited in the Salon of 1761, Diderot could only regret that "it has been some time now that this painter no longer finishes anything; he no longer takes the trouble to give any detail to his feet and hands." [12] The human figures within Chardin's domestic scenes, rather than conveying the moral import of some significant change anchored in the delineation of a present distinct from an implied past or future, assume instead the immobile, timeless, and all but inhuman aura of elements within a still-life.

* * *

Turning to the other major category of Chardin's works, the still-lifes, it now becomes clear that, rather than relying on an esthetic distinct from

Figure 19. School of Georges de La Tour, *Vanité*
Musée du Louvre

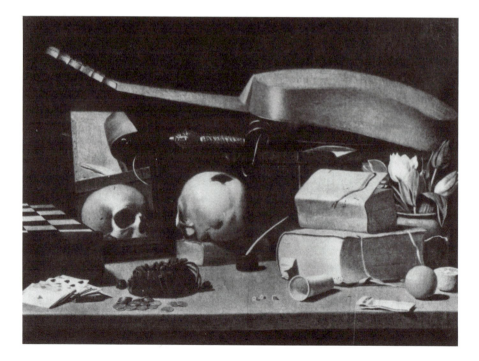

his domestic scenes, they share many of the unsettling characteristics of his treatment of human subjects. Critics have often remarked that what distinguishes Chardin's still-lifes from those of his Flemish sources is a greater emphasis on purely formal composition. In a work like *A Faience Pitcher, Three Cherries, a Brass Pot, and Two Herrings* (Figure 20), careful attention is given to the arrangement of objects, to the play of voids against solids, and to the consolidation of an integrating pyramidal structure. Gone from this work is any concern with presenting these objects as accouterments to a human presence from which they derive their real significance. While the Flemish masters of the still-life structured the objects within their scenes as arrangements carrying the still warm trace of a human presence only temporarily absent from the field of vision, Chardin's concentration on formal arrangement serves to elide from the image any reminiscence of human subjects they might reflect. The realism of Flemish still-lifes relies on a representation of inanimate objects everywhere fashioned by and for the men and women whose day-to-day existence they express almost as an aura inseparable from their physicality. In many examples of that genre, the reflection in miniature of a human subject hovering nearby can be seen in a mirror or polished surface. As implements of human activity, the objects represented on the canvas say more about their momentarily *hors cadre* users than they do about their own materiality or their relations one to another. René Demoris, in his study of how Chardin reworked the earlier tradition of the northern still-life, comes to the conclusion that "still latent in its Dutch practitioners, all human presence is resolutely expelled from Chardin's works."[13]

Demoris's remark can be taken a step further. Not only does Chardin strip away from his still-lifes any sign of a human presence that dominates the objects, but his treatment of those objects imposes on them a visual texture antithetical to the realistic style of other contemporary still-life painters. The objects within a Chardin still-life never have the finished, polished, almost photographic quality of those found in the works of a Desportes or an Oudry. One need only compare Oudry's *Still-Life with Pheasant* (Figure 21) with Chardin's *A Rabbit and Two Thrushes* (Figure 22) of the same period to realize that their shared classification as game-pieces masks an all but complete difference in style and technique. Comparing Chardin's elongated brush strokes and rough shapings of contrastive colors to Oudry's carefully blended tones and scrupulous rendering of detail helps us to understand why a contemporary commentator like the chevalier de Neufville would say of Chardin, "his way of painting is unique to him: we never see finished details or blended strokes; on the contrary everything is

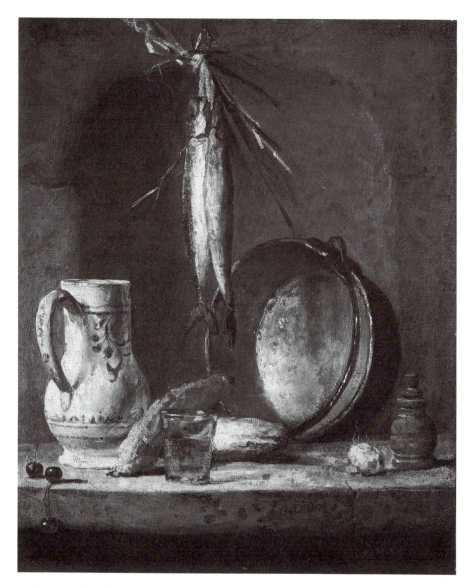

Figure 20. Jean-Baptiste Chardin, *A Faience Pitcher, Three Cherries, a Brass Pot, and Two Herrings*
Cleveland Museum of Art

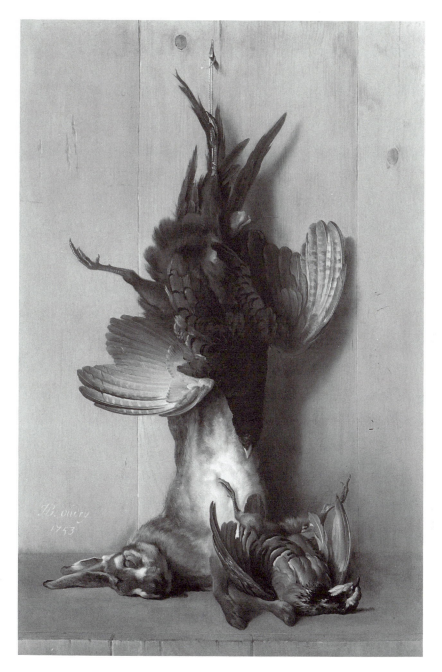

Figure 21. Jean-Baptiste Oudry, *Still-Life with Pheasant*
Musée du Louvre

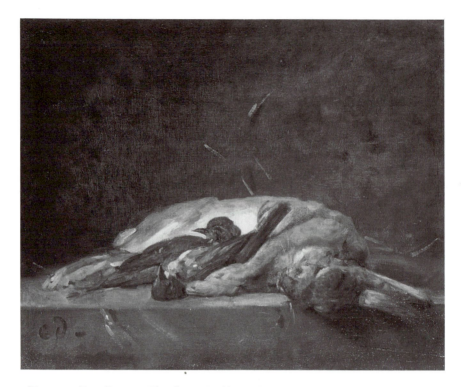

Figure 22. Jean-Baptiste Chardin, *A Rabbit and Two Thrushes*
Musée de la Chasse et de la Nature, Paris

coarse and rugged [du brute, du raboteux]"[14] and why even Diderot would
speak of Chardin's as "a rough and uneven way of painting [un faire rude et
comme heurté]" (*Salons*, 1:125).

Such observations are impressionistic but well founded reactions to the
way Chardin's still-life technique relies on what in fact is a disintegration
of the object's chromatic surface. Rather than a blending of tones that aims
at an immediately realistic effect, Chardin polarizes color contrasts to the
point where the delineation of the object results far more from a juxtaposi-
tion of chromatic oppositions than from any self-effacing finesse of design.
Writing in Frédéric-Melchior Grimm's *Correspondance littéraire* in 1750, the
abbé Raynal captured well the effect of this technique by comparing it to a
"mosaic built of many parts . . . a needlepoint tapestry done in cross-stitch
[une mosaïque de pièces de rapport . . . une tapisserie faite à l'aiguille qu'on
appelle *point carré*]."[15] The result, as though anticipating certain aspects of

pointillism, was an image that fascinated spectators with its unsettling status as obviously fabricated yet mysteriously verisimilar. It was only, they discovered, when they stood a certain distance away from it that it began to appear realistic. When looked at from closer up the impression of reality dissolved, leaving only a play of contrasting colors that refused to coalesce into the representation of a signified object. In his *Salon* of 1765, Diderot tried to describe the effect of this technique when he pointed out how "from close up, no one knows what the object is, and . . . as you move backwards to some distance it begins to take shape, ending up as what it is in nature" (2:114). What Diderot's description elides, however, is the troubling fact that the "nature" to which he would have the image finally correspond, within the singular style of Chardin's still-lifes, is revealed to be far more an effect than a model.

Chardin's use of color in his still-lifes involves not only a deconstruction of the object, but a systematic reorchestration of its chromatic elements toward the production of a harmony which has far more to do with the singularity of the fabricated image than it does with any pre-existing nature it supposedly sets out to copy. Rather than realism's immediate reference to a nature independent of its representation, Chardin insists on a style where the colors on the canvas primarily refer to themselves and their relative disposition. The Goncourts described this aspect of his style as "a systematic work of reflections which, even when it leaves a distinctness to individual tones, seems to envelop each object with the color and lighting of everything that surrounds it" (158). Chardin's two-phased technique of a decomposition of the represented object followed by a reorganization of its chromatic contrasts within an integrating harmony has the effect of producing an image which emerges from an atomistic opposition of its constituent elements. We are provocatively close here to what Diderot had to say about the cosmology of Epicureanism. Chardin asks us to behold not only the composite objects populating our world, but also the normally imperceptible interplay of their constituent atoms as they come together in those seemingly placid objects. Rather than offering a representation of nature that erases the traces of its status as fabrication, Chardin works against the still-life's subservience of the image to the natural model assumed to be its motivating principle. Chardin forces us to see a reality effect rather than reality.

Chardin's still-lifes break down before the spectator's eyes any possible opposition between circumstance and substance, between image and nature, between moment and duration. The represented objects question the concept of a pre-existing nature of which the image would be merely a copy.

They declare instead that what one might call nature is the product of relations crafted by the painter toward the always momentary temporality of the work's perception. Chardin's still-lifes are a reiterated attempt at what the Greeks called *kairos*, a seizing through color of an image afforded by the chance circumstances of reception. If Chardin painted as many as six different versions of the same arrangement of kitchen utensils, it was because each of them demonstrated that, behind the stolid mask of an apparent nature, there teemed an always changing and momentary play of relations rendering the finished work inadequate to what stood before him. No finished image, no matter how apparently perfect, could be more than the momentary reflection of a perception that put the lie to any illusion of a stable nature.

Subverting the traditional subordination of the passing moment to a stable nature, Chardin dissolves the traditional dichotomies imposed on his works. In the same way that his domestic scenes, refusing the moralizing narratives normally associated with that genre, establish their human figures as though they were elements within a still-life, so also his still-lifes emphasize not any stability of nature, but a complex chemistry of chromatic contrasts imposing themselves within the moment of the spectator's perception. In the same way that the movement normally inherent within domestic genre scenes is checked and redefined by a contrary tendency toward immobility and absorption, so also the traditional immobility of the still-life is, as rendered by Chardin, reanimated and put in motion by his chromatic experimentation. There is, in sum, only one Chardin at work in his domestic scenes and his still-lifes, a Chardin who shows us that painting, as an art of vision, celebrates a spectacle grounded in the force of the moment. His abiding concentration is on the moment as a temporality subverting the apparent securities of the conventionally realistic and the seemingly natural.

11

BOUCHER, FRAGONARD, AND THE SEDUCTIONS OF THE MOMENT

Having looked at how Chardin's subtle foregrounding of the moment re-drew the boundaries between the principal genres in which he worked, I would like to turn now to the two painters who, in terms of their style and subject matter, are most closely associated with the celebration of the mo-ment: François Boucher and Jean-Honoré Fragonard.

Of all the major eighteenth-century French painters, Boucher best ex-emplifies another, related sense of the term "moment" as I have been using it: the changing fortunes of the moment. By the time of his death in 1770, in spite of his having been named *premier peintre du roi* only five years earlier, his reputation was in steep descent. In his *Salon* of 1765, Diderot delivered the most apoplectic of his many diatribes against Boucher. As though strug-gling to include in his inventory of what he saw as that painter's nefarious influences every conceivable aspect of painting, Diderot declares him all but singlehandedly responsible for "the degradation of taste, color, composi-tion, character, expression, and design."[1]

For Diderot, whose influence has been enormous on the way Boucher has been seen by later generations of art historians, his work was abominable precisely because it was so successful. Boucher, as Diderot chose to see him, was little more than a panderer to the tastes of a degenerate aristocracy, a class personified by the most influential of his protectors, Madame de Pom-padour. Either directly or through her brother the marquis de Marigny, who was then the King's *directeur des bâtiments*, it was Madame de Pompadour who saw to it that, from 1745 on, Boucher thrived on crown patronage.

The shrillness of Diderot's attack, the fact that he condemned *every-thing* about Boucher's style, inevitably raises the question of why he so com-pletely dismissed an artist who stands as the most talented painter of the female form between Rubens and Renoir. The clearest insight into Dide-rot's hyperbolic rejection came in his earlier *Salon* of 1761. In 1761, as in his diatribe of several years later, Diderot could speak of Boucher only in absolutes. Just as he would later describe him as degrading absolutely every aspect of French painting, so also, but in the opposite direction, he is here

presented as possessing every talent expected of the successful painter—except one. "What color! What variety! What a wealth of objects and ideas! This man has everything, except truth" (1:112).

The "truth" Diderot refers to here has little to do with the verisimilitude of Boucher's figures, with the obvious unreality of his pastoral scenes, or with the notion of painting as mimesis. To the contrary, the "truth" Diderot finds as so totally lacking in Boucher's work is the distinctly moral truth of an image that concerns itself with instructing its audience at the same time it pleases them. If Boucher is criminally indifferent to truth, it is because his paintings make no attempt to drive home the kind of moral lessons that Diderot was beginning to admire so intensely in the works of a younger painter like Greuze, whose story-pieces dramatized familial and bourgeois virtues with an explicitness that placed them in a world utterly apart from anything Boucher attempted. The "truth" Diderot sees Boucher as degenerately betraying is that of a dramatic scene drawn from middle-class life, a scene so dependent on an implicit narrative that Diderot, as he describes Greuze's works, finds himself devoting long paragraphs to the prose amplification of all the elements that make up his didactic vignettes.

Diderot was, of course, correct in claiming that there is no hint of such manipulative sentimentality in Boucher's works. In the politically charged context of the growing conflict between aristocratic and bourgeois taste that characterized the 1760s, the absence of such moralizing effectively consigned Boucher, two centuries before the term was invented, to the realm of the politically incorrect. While today's arbiters of artistic taste would hardly feel comfortable espousing Diderot's esthetic values—painting as figurative representation and as moral instruction are, to say the least, out of fashion—Boucher nonetheless remains under the same cloud of political inappropriateness that he saw descending on him in the last decade of his life. Denounced as near pornography, his paintings of the naked female form are even today dismissed as purveying shameful pleasures not so much to a lascivious aristocracy long absent from the scene, but to a more noxious "male gaze" luxuriating in its patriarchal debasement of woman to the status of pure object. Boucher's female forms, the more recent doxa would have it, are nothing more than consumable bodies prettied up for the prurient tastes of an aggressively gendered and domineering male spectator. While one would be reluctant today to repeat the class snobbery behind Diderot's condemnation of Boucher's models as "Opera girls [filles de l'Opéra]" or of Marmontel's even more dubious designation of them as "backstage nymphs [des nymphes des coulisses]," it is by no means rare in contemporary criticism of

Boucher to find his paintings described as implicitly reducing women to the status of "sex workers" in a world where art, pornography, and prostitution all too easily become one and the same. The cultural conflicts generating Boucher's expulsion to the realm of the unacceptable may have changed enormously over the last two centuries, but their result has been a taboo which remains singularly tenacious. While an academic critic writing in the 1970s could lamely attempt to defend Boucher from cavalier dismissal by insisting that "from a modern viewpoint, he seems less objectionable, since most of his nudes are almost children,"[2] that defense has become at best ludicrous in our age of day-care center scandals and child pornography.

* * *

If Boucher's reputation remains marked by Diderot's condemnation, it is because his paintings so adamantly resist absorption within narratives of socialization. Boucher is, in this sense, very much a painter of the moment. His figures, captured in instants of perfect self-enclosure, remain abstracted from all those narratives through which society might impose its order and orthodoxy. The prototypical Boucher nude is a seated or reclining woman as in *Venus Asleep, Watched Over by Cupid* (Figure 23). The female figure appears before us as a startlingly singular inflection of flesh by posture. The figure's tones, traits, and forms incarnate a seductiveness the intensity of which is all the stronger for its being glimpsed in a moment delimited entirely by the specific instant of the spectator's perception of the image. Dimples, skin tones, strands of pearls, swaths of fabric, and the discarded accouterments of social life highlight the physical body as an incarnation of the random and unstaged moment.

Boucher very much shares Roger de Piles's anti-classical emphasis on "the first glance" and the necessity of capturing within the image a "grace" all the more surprising and riveting because it has been painted according to no obvious rules or traditional canons. For Boucher, the "grace" de Piles insisted on as the source of the image's power resides not only in the play of colors, but even more so in the image of the fascinating body constituted by that chromatic surface. Boucher's paintings rely for their effect on a carefully prepared dialectic between the continuing beauty of the represented human subject and the momentary surprise of an audience whose glance is abruptly captured by the image before them. In the same way that de Piles rejected as antithetical to the true nature of painting the Academy's emphasis on the allegorical encapsulation of discursive meaning, so also Boucher's human

forms dwell within a frozen moment closed to any interpretive elaboration beyond the instant of their startling apparition. The body we behold, cut off from narrative implications of past and future, quite simply *is*.

As in *Venus Asleep*, Boucher's nudes are often caught within sleep. The turned-away head and closed eyes form an explicit contrast with and intensify the spectators' sense of surprise at the apparition before them. In other variants on that disposition of figures, the female subject is awake, but, either because her head is turned to the side or because her eyes fail to engage those of the spectator, she appears unaware of her status as spectacle. This absence of any consciousness of the spectator on the figure's part has often been interpreted as Boucher's constituting his audience as voyeurs, as those who would watch without being seen. This in turn has generated a frequently-

Figure 23. François Boucher, *Venus Asleep, Watched Over by Cupid*
Musée Jacquemart-André, Paris

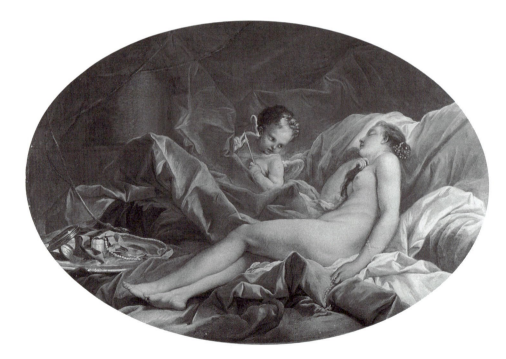

voiced reprimand of Boucher's paintings as offering his subjects in a state of near-pornographic sexual availability. Speaking of Boucher's staging of the erotic body, Norman Bryson makes the claim that "for its erotic content to be fully yielded up, the body must be presented to the viewer as though uniquely made to gratify and to be consumed in the moment of the glance."[3]

Such a judgment, equating Boucher's spectators with visitors to a brothel, neglects what I would argue is a different kind of visual dynamics initiated by his equally frequent depiction of central female subjects who, directly engaging the spectators' glance, refuse to exist only as available object. In *The Birth and Triumph of Venus* (Figure 24), the central female figure clearly returns the spectator's gaze, engaging the would-be voyeur in an almost Sartrean battle of *regards* that presupposes the figure's existence as subject as well as object. The conflict initiated by the returned glance upsets any facile eroticism of availability and puts in its place a contest of subjectivities between spectator and represented subject in which each struggles to establish the other as object. The female figure, challenging the spectator's privilege of looking, is caught within the crucial moment of the question she poses to the spectator upon whom her gaze is fixed. As painted image, this female figure will never, as the spectator ultimately must, turn away. It is her look and the question within that look—What of you might fascinate me as much as I do you?—that dictates the triumph that always follows the birth of Venus. No longer unseen and dominant voyeurs, the spectators find their status as desiring subjects objectified by and rendered dependent upon the strange and intractable subjectivity of a figure defined by the independence of the returned gaze.

The moment at the core of Boucher's most provocative paintings may well exist against the backdrop of a continuing, indeterminate, imperfect tense conveying the availability of the represented body. The image's ultimate force, however, derives from its concentration within a distinctly present moment of challenge which reaches out to and redefines the spectators surprised in their contested act of spectatorship. Boucher's paintings, whether mythological or pastoral, acknowledge the power of the desired body to resist the spectator's apprehension of them. They subtly qualify any attempt to transform the represented body into an episode from some larger narrative the spectators might amplify as a token of their distant mastery. Boucher's backgrounds of billowing clouds, swirling fabrics, turbulent oceans, and vaguely drawn countrysides manifest an indifference to the laws of verisimilitude and perspective that short-circuits the spectator's perception of them as parts of a world amenable to the continuities of story and

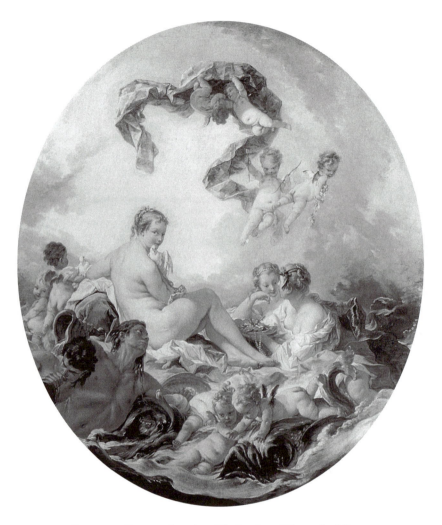

Figure 24. François Boucher, *The Birth and Triumph of Venus*
Halton Manor, England

narrative. Indifferent to any world they might share with their audience, Boucher's paintings stage their represented moment as one that remains outside any storied notion of time available for elaboration beyond the surprise of their perception.

* * *

Boucher's representations of the anti-narrative moment take two forms. On the one hand, his pastoral works rely on a dialectic of the momentary and the continuous that tends to abolish any distinction between the two. His rural scenes populated by contented countryfolk may focus on a specific place at a specific moment but that specificity, always generated by the strongly determinant conventions of the genre, serves finally to evoke an aura of timeless and continuing peace that excludes even the possibility of change resulting from an event that might threaten the self-enclosed serenity of the scene depicted. This interplay of difference and repetition, of the specific image and the generic convention, establishes Boucher's images of bucolic happiness as icons of the ideal, unchanging, and un-storied temporality which is the defining trait of the pastoral as a genre.

Boucher's second and more frequent celebration of the moment occurs in a distinctly socialized context very much subject to change. In these works, his human subjects, no longer miniatures absorbed within the self-contained beatitude of the pastoral countryside, move to the fore as subjectivities defined by the conflicting dictates of individual desire and social convention. One of Boucher's most successful drawings, *Woman Holding a Fan* (Figure 25) offers a perfect example of this dialectic. There is a clear tension in this image between the emblems of the young woman's integration within the realm of social expectation—the carefully coifed hair, the elegant earrings, and the stylish dress—and the abstracted, absent look in her eyes that conveys a sense of alienation from the social role she otherwise seems to play so well. The subject's eyes, clearly fixed on some imaginary elsewhere, capture a moment of profound hesitation that redefines the figure's relation to the dictates and expectations of the social. The moment inscribed within her eyes declares itself as that of a potential refusal. Its mute but eloquent interrogation serves to unravel the otherwise seamless continuity of norms that impose themselves as anonymous forces sustaining her sense of a socialized identity.

This same temporality of the moment prolonged by hesitancy becomes

Figure 25. François Boucher, *Woman Holding a Fan*
Trustees of the British Museum, London

a hallmark of the female figures within Boucher's scenes of couples caught at the moment of desire's eruption. In *Two or Three Things, Will You Do One of Them?* (Figure 26), the girl being implored by her young suitor looks neither at him nor away from him. She stares instead into an inscrutable elsewhere where she hopes to glimpse some answer to the questions she asks herself as she is summoned to respond to her partner's desire. Like the ambiguous message of her two hands (the left responding to its having been taken by the boy but the right held away from his body in a gesture unsure of what it wishes to signify) her eyes turn away and hesitate as they contemplate the uncertain implications of choosing to yield or to refuse. This instant of hesitation represents the moment's challenge to the continuing identity she knew before, its recasting of her sense of self through a response opening itself either toward joy or sorrow, but with no assurance as to which answer might imply which result. Boucher's frequent images of an imploring man and hesitant woman entirely absorbed within the moment created by their encounter foreground their portrayal of the ambiguous implications of existing as the object of another's desire. And it is always, as is the case here, the figure of the young woman who, unlike the more impetuous male, is endowed with the greater force of a self-reflective subjectivity, of an awareness of the stakes of the moment.

Boucher's choice of the moment to be represented within the ritual of courtship always goes to that of the woman's abstracted, hesitant, and conflictual consideration of what is implied for her sense of self by the male's far more instinctual and far less reflective declaration of desire. That moment, here rendered with an austere minimum of detail, became the *locus classicus* associated with Boucher's art. It prompted any number of far more explicit renditions of the same scene by a wide variety of artists. Pierre Aveline's engraving *The Pretty Kitchen Maid* (Figure 27), is an excellent example of how Boucher's basic scene so frequently solicited further elaboration. This engraving by Aveline presents itself as done from a painting by Boucher of the same title (*F. Boucher pinxit* can be read at the bottom left corner of the image), but its apparent source, now in the Musée Cognacq-Jay, is in fact of contested attribution. Whether that painting was done by Boucher or not is, for our purposes, less important than what the engraving tells us about how the prototypical moment within Boucher's work came to be submerged within a plethora of symbolic objects.

At the engraving's center we see a couple similar to the one in *Two or Three Things*, but here the woman is standing rather than seated. Her eyes, again unlike those of the male figure, are rendered with the same hesitancy

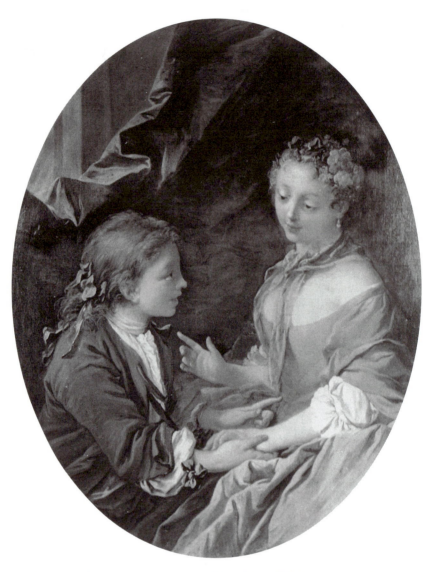

Figure 26. François Boucher, *Two or Three Things, Will You Do One of Them?*
Fondation Ephrussi de Rothschild

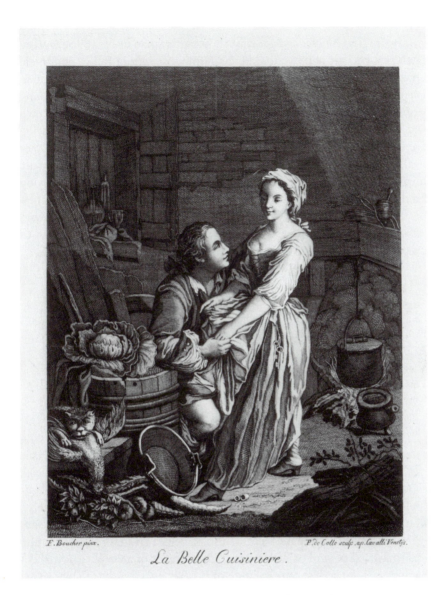

F. Boucher pinx. P. de Colle sculp. ap. Cavalli Venetis.

La Belle Cuisiniere.

Figure 27. Pierre Aveline, Engraving of *The Pretty Kitchen Maid*
Trustees of the British Museum, London

we saw in *Two or Three Things*. Rather, however, than using a simple green cloth as a background, we find here a farmhouse setting full of additional objects. Any tendency toward realism is, however, quickly checked by their overdone reinforcement of the situation's sexual implications. The young woman holds in her apron a number of eggs, one of which has already fallen and broken on the floor. To the woman's right, a pot boils over a roaring fire. To the left, the partially spread leaves of a cabbage lie exposed on top of the barrel. Lower and to the left, a cat prepares to gnaw the vulnerable white breast of a dead bird. Below the cat an array of assorted vegetables lying on the floor assume progressively more phallic shapes as a function of their proximity to the broken egg. Finally, as was the practice when engravings were done from a painting, a few lines of rough verse have been added to make even more explicit the already heavily allegorized sense of the image.

Vos oeufs s'échapent, Mathurine
Ce présage est mauvais pour vous,
Ce grivois dans votre cuisine
Pourroit bien vous les casser tous.

[Your eggs are falling, Mathurine
That's a bad sign for you,
This nasty fellow in your kitchen
Could well break all of them for you.]

The narrative overstatement of this engraving and its accompanying verse clearly betray Boucher's esthetic. Each of its added elements diffracts, banalizes, and allegorizes his concentration of the image into the delicate evocation of a moment poignant precisely because it remains focused entirely on the instant of hesitant choice defining the woman's subjectivity. Boucher's fascination with the female figure as a pensive as well as physical presence defined by the moment of choice before an unforeseeable future reaffirms itself even in paintings where the element of an explicit sexual encounter is lacking. The central figure of his *Pastoral Confidences* (Figure 28) is set apart from the other two women to her side and behind her. While they look directly at her, her eyes, heavy with the imagined implications of the confidence she has just shared with them, stare into the empty middle distance of the same unanswerable questions inscribed on the faces of Boucher's other female figures at the instant of desire's declaration.

The power of Boucher's eroticism is neither limited to nor entirely defined by an offering of the female body for the spectator's consumption, by

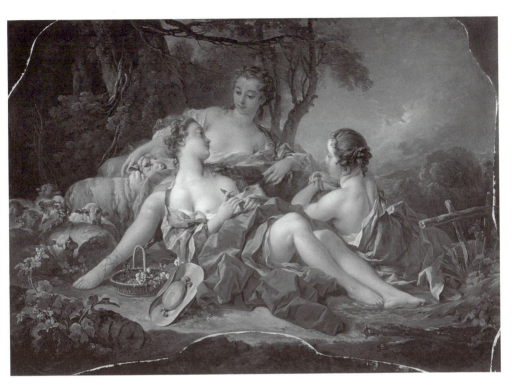

Figure 28. François Boucher, *Pastoral Confidences*
Los Angeles County Museum of Art, William Randolph Hearst Collection

an esthetic that reduced women to the status of pure objects within cliched narratives of male seduction. To the contrary, it is Boucher's female figures, far more than his overwrought male figures, who achieve the status of full-fledged subjectivities—either defying by the look they return or deflecting by the stare they avert the canonical sequence of declaration and capture defining libertine constructions of gender. His female figures, whether naked or clothed, rather than appearing yielding and available, retain a power to hold themselves apart within a moment of consciousness exterior to and subversive of the power of all those stories through which society would impose its sexual stereotypes. If Boucher, like any painter, invites his spectators to engage in an act of looking, his is a voyeurism inflected by its focus on the moment as the temporality of resistance to and specificity within narratives that would present themselves as necessary concatenations of cause and

effect. No less sensual for this concentration within the moment, his images speak of a desire which is eminently problematic, eminently individual, and eminently human.

* * *

On the back of two of the fourteen *Portraits de fantaisie* Jean-Honoré Fragonard painted around 1770, the two usually identified as his friend and protector, the abbé de Saint-Non, and the abbé's brother, Monsieur de La Bretèche, the artist inscribed the boast that they were completed "in one hour's time [en une heure de temps]." The moment, its compact concision defying expectation and belief, clearly had an essential role to play in the dynamics of Fragonard's art.

At the level of his technique, of the way he applied paint to canvas, what most distinguishes his style from those of his contemporaries is what many critics have described as a blurring of any distinction between the free-flowing rapidity of the sketch and the composed, more studied elaboration of the oil painting. Albert Châtelet sees the nervous fluency of Fragonard's style as heavy with implications for the kind of subjects he chose to portray. His, Châtelet claims, is "a way of painting that preserves the characteristics of the sketch, of jerky, broken touches, of entangled webs of strokes that cover the canvas without trying to melt together into a unity of subject."[4] The Goncourts, speaking of his work done in the red chalk of sanguine, see his way of handling that medium as providing the royal road to the essence of Fragonard's style. Crayon in hand, fully attuned to all the serendipitous opportunities of the moment's chance inspiration, Fragonard "never stops moving the chalk between thumb and index finger in daring yet inspired twirlings. He rolls it and twists it as he outlines the branches; he breaks it on the zigzags of his greenery. Everything that flows from this chalk he never sharpens is fine by him."[5] For the Goncourts, Fragonard's accomplishment becomes all the more stunning when we understand that his works, rather than presenting themselves as finished icons of a carefully executed intention, ask to be read as visual chronicles of the fortuities presiding over their production. "He has all the astounding luck of the rapid attack, of brusque and fluent sketching" (273).

Fragonard's obsession with bending his medium to the opportunities of the moment, with forcing it to respond as immediately as possible to whatever the moment might hold, affected even his sometimes eccentric choices of the paints he used. Fragonard often preferred a greenish yellow

pigment called *stil de grain* (from, as the elegant French term hardly suggests, the Dutch *schijtgroen*, literally "shitgreen") rather than the more commonly employed bitumen. He made this choice because *stil de grain* dried so much more quickly and, when a glaze was applied, produced a blond tone he found particularly appealing. This privileging of the moment, and of a *far presto* capable of capturing it, did, however, have its liabilities. While the *stil de grain* may have dried more quickly, many of Fragonard's finest works have since suffered badly from the oxidation and flaking caused by a too-rapid glazing. For the Goncourts, that unanticipated reaction becomes the symbol of a deeper and more costly impatience. "At bottom, the major cause of the deterioration of his paintings is his impatience to paint; he did not want to wait. He placed fresh layers of paint over others that were not yet dry. Because of that, there was a volitilization of the lower layers that quickly produced cracks on the surfaces of his paintings" (295).

There is an interesting parallel between what the Goncourts have to say here about the way Fragonard moved too quickly and recklessly from one coat to the next and the recurring charges leveled by those art historians who would dismiss the value of Fragonard's work. Criticism of Fragonard frequently centers around two words the connotations of which are far more negative in French than in English: *versatile* and *virtuose*. For Fragonard's detractors, his greatest fault lies in what they see as an inability to discipline himself, to refuse a too-indulgent complicity with what was clearly a prodigious natural talent. For these critics,[6] Fragonard's tendency to respond to the moment, for a moment, and then pass on to something entirely different (from, for instance, a history piece reminiscent of de Troy to an erotic scene in the style of Boucher to a genre painting one might take for a Chardin and even to a Greuzian religious composition like *The Holy Family*) amounts to a versatility that finally compromises any consequent accomplishment that might be called truly his own. For his admirers, Fragonard is an astounding synthesis and culmination of all that was best in the painting of his age. For his detractors, judging on the same evidence, the very breadth of his work denounces him as little more than a derivative plagiarist pathetically trying to do better in styles created entirely by others.

* * *

The real coherence of Fragonard's work, what establishes him as the prototype of his age, lies in his abiding fascination with the abrupt but intense temporality of the moment. Appreciated on its own terms, his re-

ceptivity to whatever opportunities the moment might present reduces to a belaboring scholasticism the strictures of those critics who would demand from him some obvious and one-dimensional coherence. To understand Fragonard is to appreciate how, throughout the various registers of his work, the moment erupts as a force subverting and redefining the contexts in which it appears.

This concentration on the primacy of a disruptive moment can be seen even in what would seem to be Fragonard's most traditional works, his history pieces. The most famous of these, *Corésus and Callirhoé* (Figure 29), was anxiously awaited by the Academy's authorities, who organized the Salon of 1765 as what they were sure would be a consecration of Fragonard's pre-

Figure 29. Jean-Honoré Fragonard, *Corésus and Callirhoé*
Musée du Louvre

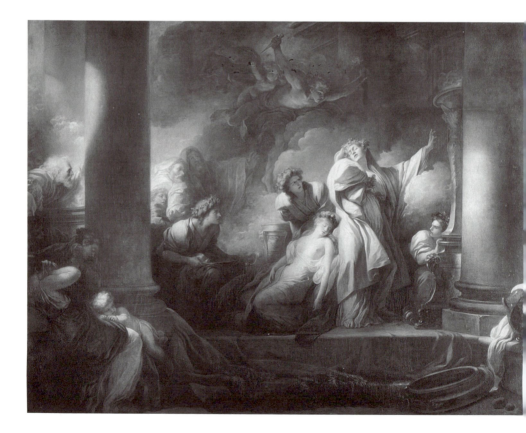

eminence in the favored category of history painting. Cochin and Marigny had already promised financing for it and scheduled it to be reproduced as a tapestry by the Gobelins. As it turned out, this painting marked the end rather than the beginning of Fragonard's academic career. He left his protectors bitterly frustrated when he turned his back on them, never again working in that genre and never again showing in that forum. Not unlike the subject of his painting, Fragonard seemed to find no more convincing proof of his mastery of history painting than to disappear from the arena of his triumph.

Based on a story from Pausanias's *Itinerary of Greece*, *Corésus and Callirhoé* represents a young priest of Bacchus, Corésus, who, after being rejected by the beautiful Callirhoé, spares her life at the very moment she is to be executed by plunging the sacrificial knife into his own heart rather than into hers. The painting's entire composition is riveted on the force of that unexpected moment when the dagger, held in Corésus's right hand, is deflected from its expected course. Every element of the painting—the contorted faces of the three young acolytes assisting in the sacrifice, the women and child to the left who fall away from the scene before them as from an explosion, the older men in profile whose faces mirror their astonishment, and the angel of despair hovering in the dark clouds that engulf the scene— provides an amplification and intensification of that which the moment has so unexpectedly wrought.

Diderot was so overwhelmed by this painting that, as he wrote his *Salon* of 1765,[7] he felt he had to find some way of approaching it that went beyond simple description. Finally, he adopted the conceit of a feigned conversation with his friend Grimm during which he tells him the story of a dream he had had the previous night, supposedly before he ever saw Fragonard's painting. In that dream he found himself in a dark cavern where he was chained to his seat. With his head in a vice, he could look only toward the stage he faced at the rear of the cave. All around him were other spectators in what clearly becomes a modernized version of Plato's cavern. Nearer the cave's entrance and outside the audience's view, other individuals project onto a screen moving images produced by a process that uncannily anticipates the invention of cinema. This dream become feature presentation turns out to be a direct enactment of Fragonard's *Corésus and Callirhoé*.

Diderot's elaborate contextualization of what he has to say about this painting not only shows that he felt direct description could never do it justice, but that he sensed something was missing from it, that it needed the narrative supplement only a prose contextualization could provide if it were

to be appreciated at its real value. His dream narrative becomes a vehicle for gaining control over that aspect of the painting that made its direct description so problematic: the fact that its every element is focused on a single paroxysmal moment of threatened beauty, tortured self-immolation, and bewildered astonishment. Diderot's dream narrative effectively dilutes the compact force of the image into a drama in five acts. Diderot's prose version takes the action back to its beginnings in a chaotic street scene where Corésus first declares his love to an indifferent Callirhoé. Diderot then describes how, after Corésus implored divine help in winning her heart, the city was striken with a libidinous madness of frenzied and indiscriminate copulation. It then became clear that the threatened city could be saved only by a blood sacrifice in the temple—a ritual in which Callirhoé was to be the designated victim. Only after Diderot has provided this narrative background did he feel he could proceed to a minute description of Fragonard's actual image.

More is involved in Diderot's recourse to this compensatory narrative than a pedantic display of classical culture. While, as we saw, the tradition of history painting always demanded that the artist's image focus on a "significant moment," on a crucial instant within an action flowing from the past and preparing the future, Fragonard imbued his image with so dense, so tight, and so self-sufficiently powerful an epiphany of the moment that a knowledge of the story added little to its effect on the spectators. The almost hallucinatory quality of this image of a sweeping arm plunging a dagger into the priest's own breast imposes itself on the audience as a riveting experience of the moment in its own right. With what was simultaneously his first and last history painting, Fragonard pushed the force of the moment to such an extreme that it left in pieces the conventions of the very genre it purports to illustrate. While the successful history painting was meant to illustrate and preserve the memory of actors and deeds of great significance, Fragonard's image perversely exults in the fact that a listing of the dramatis personae and their histories adds absolutely nothing to it. The mysteriously epicene if not feminine appearance of Corésus as the central male figure within the composition likewise compromises any link between the episode from Greek history and the actual image on the canvas. Diderot, seeing the painting but denying he had seen it, dreaming rather than analyzing, sensed and acted upon a discomfort that was inseparable from his fascination with this work.

* * *

A similar hypertrophy of the moment as a force undermining generic conventions can be seen in Fragonard's landscapes. That genre's isolation of a single geographic site was by definition intended to be the representation of a scene to which the temporal distinctions of then, now, and later are secondary. One of Fragonard's most powerful landscapes, *The Great Cypresses at the Villa d'Este* (Figure 30), was also shown during the Salon of 1765. Done during his stay in Italy, this sanguine drawing, while all but empty of human movement, hardly displays the placid stability of an unchanging scene. It is composed instead as a stark, unresolved dialectic between the vaguely drawn hints of the many-layered architectural detail in the central background and the towering, engulfing foliage of the trees that enclose the building in what appears to be an irresistible pincer. This same opposition between the inanimate and the living, between the constructed and the natural, between static stone and living body, is repeated in miniature at the end of the path leading to the castle. We see there two statues frozen in emphatic gesture as they flank two insignificantly small human forms who likewise extend their arms toward each other. Thanks to this dialectic of movement and stasis, the drawing's effective center of interest becomes what most clearly appears at its circumference: the vitality and immensity of the convoluted leafy forms which press their expanding assault even to the empty sky. As the shimmering surfaces of the trees draw attention to themselves as a limitless involution of intricate touches, the image becomes a breathtaking index of the artist's hand as it etched onto paper the force of the spectacle it set out to portray. This bravura performance of the always-moving hand subverts any perception of the drawing as a representation of some reality which may once have been there, at the Villa d'Este. Foregrounding instead the magic of its fabrication, the image becomes a testimonial to the dynamic freedom of that moment when the artist touches chalk to paper. The vitality of that moment that makes the paper vibrate with its communicated force inspired Jean-Pierre Cuzin to adopt an almost Goncourtian tone as he describes how "the stroke spins, rounds off, turns back on itself, tears away, plays out little zigzags, curls in fine spirals, then flares up, soars, and rebounds in infinite variations [le trait file, s'arrondit, se boucle, se déchiquète, joue de menus zigzags, frise en fines volutes, puis s'emporte, s'élance et rebondit dans d'infinies variations]."[8]

This same foregrounding of the moment within the landscape genre where it is least expected took a quite different form in Fragonard's oil painting entitled *The Storm* (Figure 31). Not a single element within this com-

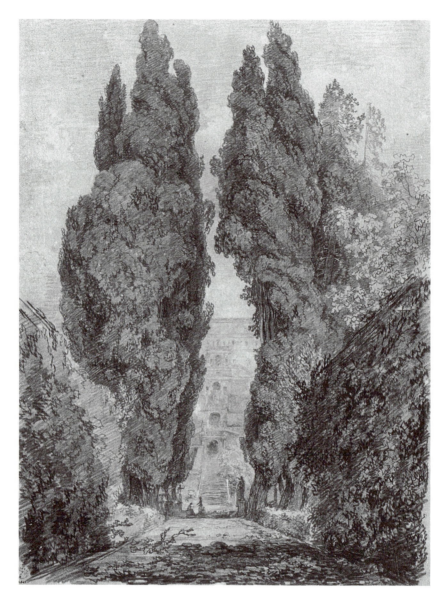

Figure 30. Jean-Honoré Fragonard, *The Great Cypresses at the Villa d'Este*
Musée des Beaux-Arts et d'Archéologie, Besançon

Figure 31. Jean-Honoré Fragonard, *The Storm*
Musée du Louvre

position is at rest. Nowhere in Fragonard do we find the stasis or serenity of calm country landscapes such as those depicted by Boucher in his placid pastoral studies. Everything in this image is as it is only for the brief instant of its apparition. The bellowing ox pulling the teetering cart, the straining backs of the men bent in effort behind it, the drover caught in mid-gesture as he forces his cattle forward, the streaming masses of sheep flowing to either side of the rock blocking their path, the shepherd moving up the hill from the lower right, and the menacing dog crouched at the bottom left will never again assume the positions and postures that define this particular moment. Even the massive weight of the wagon finds itself caught up by a wind, inscribing itself across the ever-changing storm clouds, which snatches up and animates the billowing tarpaulin stretched across the wagon's load. Every-

thing that might be assumed to be stable and unchanging—the rocks and surface of the ground—is painted with a fluidity and vagueness that makes them indistinguishable from the vectors of movement flowing around and over them. *The Storm* is structured as a movement and moment of intersection. It captures the fleeting convergence of such distinct elements as the sheep moving to the lower left, the wagon moving to the right, the cattle moving toward the rear, and the storm moving through the sky. While each element considered in isolation may have both a past and future, their intersection, the subject of the painting, is an exquisitely momentary fortuity no more stable and no more predictable than the swerving of its forms as they move along the random accidents of the terrain. This painting may be, in terms of traditional genre classifications, a landscape with human figures. At the level of its execution, of its visual surface, no distinction is possible between the human, the animal, and the mineral. All become one in a shared celebration of the moment's force.

* * *

The force of the moment so visibly present in Fragonard's history pieces and landscapes becomes even more explicit at the level of theme in the kind of painting with which his name is most immediately associated: subtly eroticized scenes from everyday life. These icons of desire, much like Boucher's, frequently depict a tension between social constraint and a disruptive moment threatening those conventions. In *The Lost Stakes* (Figure 32) the focus on a precise instant is underlined by the work's almost snapshot-like depiction of the two playing cards near the center of the lower border. The cards have fallen from the table, but they have not reached the cards that are already on the floor. This is also, of course, the equally precise moment when the decorum of a cardgame played for kisses yields to an eruption of a desire sanctioned by the game's outcome. The tension of the three young bodies drawn to each other yet held apart by the conventions of the game is suddenly broken by the boy's impetuous embrace. The girl being kissed reacts to his claiming the prize by turning her head away, but her backward movement is checked by the other girl, who, holding her companion's wrists to the table, allows her only a partial escape. The moment depicted here only becomes more pronounced for desire's deferral throughout the ritual of the cardgame. The game may mediate and delay the expression of desire, but its eventual explosion is determined by a run of cards falling equally as much by chance as the random encounters presiding over the birth of desire.

Fragonard's most notorious painting, *The Swing* [*Les Hasards heureux de l'escarpolette*] (Figure 33), highlights in its title this same foregrounding of chance [le hasard]. It presents the titillating image of that precise moment when the upward movement of the swing places the woman in a position where, by kicking up her left leg, she offers a most provocative view to the young man reclining near the base of the statue. While the subject and composition of this painting were, as the story has often been told,[9] commissioned by a monsieur de Saint-Julien who wanted his mistress portrayed as the woman on the swing and himself as the favored peeper, this work nonetheless functions according to a dynamics that was entirely Fragonard's. Saint-Julien had wanted the third figure in the painting, the man at the lower right, to be a bishop. Fragonard happily eliminated the vulgarity of

Figure 32. Jean-Honoré Fragonard, *The Lost Stakes*
Hermitage Museum, Saint Petersburg

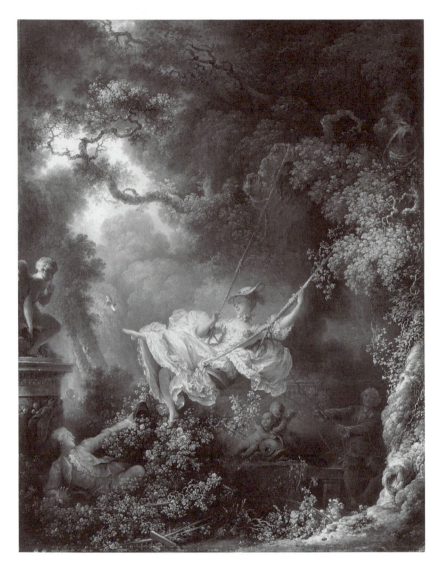

Figure 33. Jean-Honoré Fragonard, *The Swing*
Trustees of the Wallace Collection, London

that overdone contrast between religious austerity and secular exuberance in favor of what for him was a far more congenial opposition between age and youth. Hardly a bishop, the shadowed figure to the right is an old, white-haired man. Perhaps a father or husband, he sits in placid immobility on the heavy stone wall from which, in terms of color, he is almost indistinguishable. Equated with the constraint of stone and architectural design, the old man is an icon of control and continuity. His is the careful world of modulated causes and effects intended to insure that life continue as a predictable narrative free of surprises and with no unanticipated intrusions of a wayward desire. The two guide ropes he holds in his hands symbolize his intent to control the movement of the swing. They are an emblem of his mistaken belief that, no matter how far the swing might move away from him, he can always call it back with no more than a gentle pull in his direction. His is the realm of age, control, law, and the sense of a continuity intended to insure their perpetuation. The woman, her eyes fixed on the younger man who extends his unrealistically elongated left arm almost to the point where he can touch her with his hat, moves away from the space of age into the sunlit sphere of youth, desire, and the moment. With the same focus on the precise instant we saw in *The Lost Stakes*, this painting captures the exact moment when the young man's line of vision coincides with the alluring spectacle the girl would offer him. The movement of the woman's kick has made her slipper fly into the air. Caught here in mid-trajectory, it will land in the bushes near the statue and become the pretext of a search unlikely to be shared with the older man. While Fragonard's subject may have been suggested by his patron Saint-Julien, his execution of it demonstrates a brio establishing it as an icon of the moment as a force separating youth from age, desire from control, and the hazards of the chance event from the dictates of social decorum.

* * *

It was in the context of another commission, this time from the comtesse du Barry for a series of paintings to decorate the salon of the chateau Louis XV was building for her at Louveciennes, that Fragonard provided his most elaborate and thematically rich statement on the dialectics of desire's moment. As it turned out, du Barry refused Fragonard's work and used instead paintings by Joseph-Marie Vien which were more in the neo-classical style so rapidly gaining favor in the early 1770s. While Vien's rather stiff Louveciennes paintings are of limited interest, he did adjust his style to the neo-classical tastes of the day by portraying all his characters in Grecian cos-

tume. Fragonard's works, now part of the Frick Collection in New York, are currently listed under the collective title *Love's Progress*.

The first of them, *The Pursuit* (Figure 34), is a study in movement and surprise. Not unlike *The Lost Stakes*, this work portrays the moment when a declaration of desire by the single young boy sends the two young women and a girl at the center of the piece into a tumble. The figure to the right, in the midst of her spill and with one foot still off the ground, pushes against her companion, the object of the boy's affection, impeding her flight away from him. The fleeing woman and the young girl to the left are represented in mid-stride. With only one foot touching the ground, they hurtle toward the already fallen figure they are sure to join. Again, the eruption of desire produces a moment of chaotic intertwining. Initiating a use of symbolic statuary commenting on the actions of the human figures that will continue throughout the four images, Fragonard portrays the two cupids in the upper right clinging to each other on top of a dolphin which is perched at the cusp of a waterfall. The second painting, *The Meeting* (Figure 35) presents what is clearly a different couple. This change of characters marks the fact that, although these images are related thematically, they are not meant to be read as different episodes within a single story. Here again, the painting juxta-poses figures defined by their specific moments. For the man, it is that of his abrupt arrival within the central scene. He is pictured at precisely that in-stant when, his knee resting on the balustrade, the weight of his body shifts to his outspread right hand. About to swing himself over the ladder and place his foot on the conviently placed pedestal, he enters the space occu-pied by the seated woman. While the juxtaposed log and urn at the image's lower left leave little doubt that the woman is expecting him, the surprise of her gesture and facial expression catch her in a moment of troubled con-cern at how vulnerable their meeting remains to the arrival from the left of any unwanted representative of paternal or conjugal authority. This fear of intrusion by a third party is reiterated by the statue of Venus withholding from the cupid at her feet the quiver of arrows with which he would so glee-fully initiate any number of importunate jealousies.

The third painting in the series, *The Lover Crowned* (Figure 36), signals an abrupt shift in tone and theme. Rather than portraying a distinct mo-ment drawn from a context of movement and gesture, the image's center is occupied by a couple caught in a state of near immobility. The young man sits transfixed as he holds the hand of his beloved while gazing at her turned-away face. She holds above his head a wreath of roses symbolizing the gift of her affections. These figures, rather than being engaged in the furtive, un-

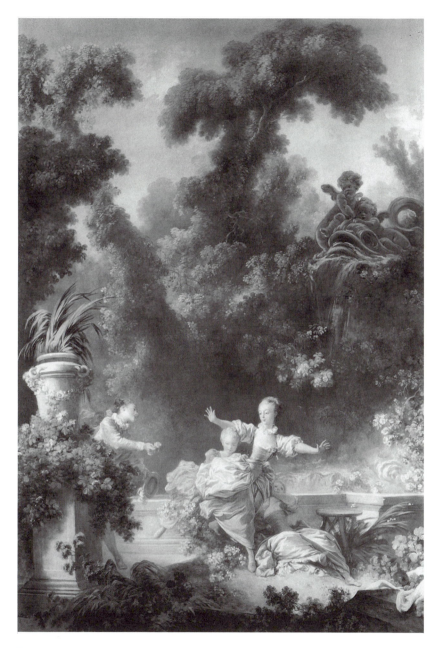

Figure 34. Jean-Honoré Fragonard, *The Pursuit*
Frick Collection, New York

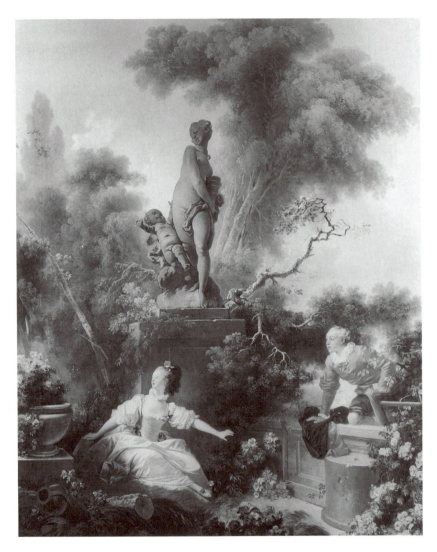

Figure 35. Jean-Honoré Fragonard, *The Meeting*
Frick Collection, New York

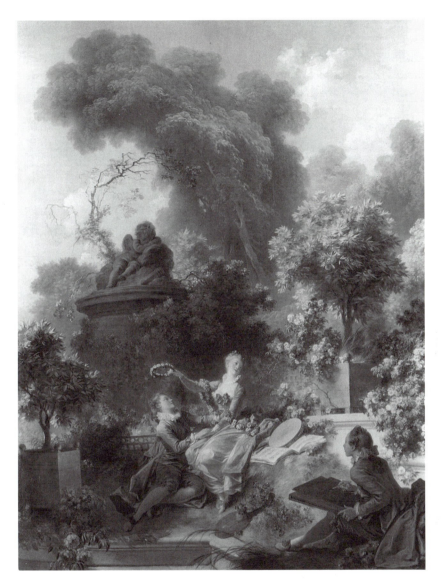

Figure 36. Jean-Honoré Fragonard, *The Lover Crowned*
Frick Collection, New York

authorized encounter of *The Meeting*, are lifted out of time and all potential disturbances of the moment by the shared love they imagine as eternal and unchanging. In fact, the couple has achieved this stasis beyond the redefinitions of the moment only because, as we see from the figure of the artist seated at the lower right, they are in the midst of a pose. The joy of love's crowning is prolonged and preserved only on the condition that the living, changing reality of the lovers become the subject of an act of representation intended to halt and supplement the fragility of what can in fact be only a passing moment. This image tells us that desire becomes love and movement pose, only as the couple's posing for their portrait denies the fact of their mutability. The scene at the painting's center will endure only so long as it subordinates itself to the scrutiny of a third party outside the pair who will fix within his frozen image what, in reality, is always in flux. Ominously enough, no image can be seen on the dark surface of the artist's sketchbook and the statue of cupid now lies sleeping alone on the pedestal in the background.

The final painting in the series, *The Love Letters* (Figure 37), returns to the depiction of a single couple. At the same time, however, it intensifies the theme of representation first introduced by the figure of the sketching artist. This lone couple is presented in closer physical proximity than any of the other couples in the four paintings. With his arms wrapped around her waist, the man clings to the woman's body as his head nestles against her neck. Yet, even in the midst of that intimacy, the stability of the scene depends on the mediation of their contact by an inanimate object. The man may stare lovingly at the woman's face, but her eyes do not return his look. The similar play of eyes in *The Lover Crowned* had the woman turned away from her lover's glance, her eyes lost in some distant reverie as she offered a fuller view of her face to the sketching artist. Here that third party is gone, but the woman's interest remains focused not on her partner but on the love letter she reads. Chosen at random from the pile of similar letters beside her on the pedestal, the letter we see her reading in the present of the image calls her doubly toward the past. As keepsake, the letter is a physical object drawing her back to that moment from the past when she first received it. As legible text, it leads back to the even earlier moment of the felt passions its words attempt to express. Again mirroring the scene it accompanies, the statue of Venus to the right clasps to her breast not a letter but a heart which likewise serves as a token of some past passion. Lost in the memory it evokes, she is oblivious to the cupid at her feet who tries in vain to call her back to the present.[10]

Love's Progress ends with two images suggesting that what would claim

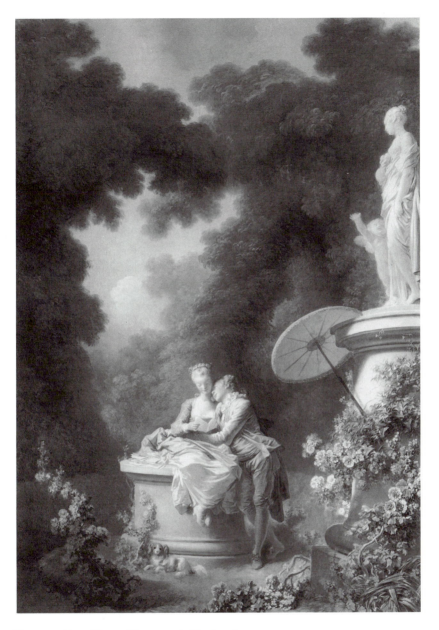

Figure 37. Jean-Honoré Fragonard, *The Love Letters*
Frick Collection, New York

to be a self-sufficient joy contained within an unchanging present is a myth. The present love would celebrate depends on recourse to acts of representation, either as the portrait being drawn or as the letters being read. These representations are necessary because, in the midst of an imposed stasis, they take their readers back to the moments of passion and desire they set out to capture. As representations of that moment, the portrait and the love letter are indispensable but necessarily inadequate supplements to the continuity of love's present. The placid present of a love shared, claiming to exist beyond the disruptions of the moment, is finally able to constitute itself only so long as it is sustained by some contact with the remembered moments of a lost past. It is, these images tell us, as the evanescence of the moment is denied that it reaffirms itself with the greatest force.

Conceived as an integrated cycle, du Barry's commission provided Fragonard with the rare occasion to extend his meditation on the moment across a series of four works. The images he produced do interact with and qualify one another in ways impossible within the context of any single painting. They do so, however, in a way which systematically undercuts their reading as an integrated narrative relying on the extended and cumulative semiosis of that form. We saw how each image introduces its own distinct cast of characters with no carryover from one scene to the next. While I referred to this cycle using its contemporary title of *Love's Progress*, its inherent ambiguities have led to its designation under such different appellations as *Amours des bergers*, *Les Ages de l'homme*, and *Les Ages de la vie*. For my analysis I adopted the order *The Pursuit*, *The Meeting*, *The Lover Crowned*, and *The Love Letters*. In fact, various art historians have argued for quite different orders, putting *The Meeting* before *The Pursuit* or *The Love Letters* before *The Lover Crowned*.[11] Recently, Mary Sheriff has used a comparison of the paintings' dimensions with those of the spaces they would have occupied at Louveciennes to argue that, rather than telling a story in four scenes, they were intended to be perceived as two pairs of mood-setting pieces: *The Pursuit* and *The Meeting* would have been seen by visitors to Louveciennes as they moved from the salon to the outdoor garden where "one can anticipate the unexpected surprise" and *The Lover Crowned* and *The Love Letters* would have been seen as those visitors later returned from the garden and would be charmed by images that "offer the sweet pang of reminiscence."[12] Sheriff finally argues that "the artist neither suggests the temporal priority of one over the other nor establishes a compositional movement from one to the next. . . . Fragonard leaves his viewers free to imagine the central scenes, to insert, if so inclined, their own experiences of love, to conjure fictive ones,

or even to fantasize about the other guests who filled the interior space of Madame du Barry's salon" (92). On the basis of that evidence, it is clear that Fragonard intended his images to work not as part of any linear narrative, but as the free-floating evocation of desire's unpredictable dynamics. As such, these paintings stand as emblems of a culture always open to and fascinated by the delights of the moment.

* * *

Fragonard's most visually dramatic depiction of the moment would come nearly a decade later in his painting entitled *The Bolt* (Figure 38). Through the force of its defining diagonal rising from lower left to upper right, this image's entire composition is focused on the precise moment when the man's outstretched forefinger makes contact with and pushes closed the bolt placed high on the bedroom door. The emphasis on the tensely outstretched finger uncannily recontextualizes Michelangelo's use of that same image to convey the power of the equally redefining moment of Adam's contact with the divine. As in that fresco for the Sistine Chapel, the finger's contact reverberates through every aspect of the work, defining not only the image's physical space but the attitudes and relations of the figures within it. The bedchamber of Fragonard's painting, a part of the socialized space of the residence enclosing it, becomes at this moment, and as a result of this gesture, an intensely private and closed space where its two inhabitants will enact a scenario meant only for the eyes of the single privileged other.

What has changed with *The Bolt* is the way Fragonard conveys the contour of the moment, the means he uses to express its dynamics. While he continues to use a limited number of symbols drawn from the traditional iconography of the erotic (the overturned vase at the extreme left, the single apple on the table, and the bouquet of roses on the floor to the lower right), these elements no longer receive the heavy emphasis they did in a work like *The Meeting*. More importantly, Fragonard has eliminated entirely from this painting the luxuriant foliage and landscape detail that occupied so prominent a place in *The Swing* and the four images of *Love's Progress*. What we see instead is a distinctly different style of undecorated, almost starkly rendered surfaces. A new intensity of coloration as well as a careful play of light and shadows replace what before was a sometimes encumbering attention to detail. For today's spectator, this image evokes all the hyper-eroticized claustrophobia of a Balthus interior. What might more appropriately be described as another element of Balthus's debt to Fragonard and *Le Verrou* can

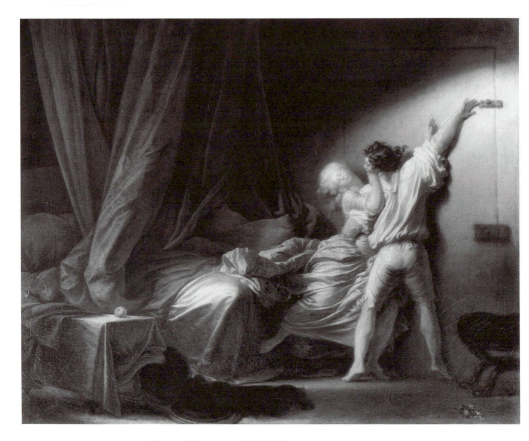

Figure 38. Jean-Honoré Fragonard, *The Bolt*
Musée du Louvre

be seen in the miniaturized intensity of the two faces as they lock on each other in a space electrified by their desire. The man's tensed neck muscles and fixed stare, even in the midst of his sweep toward the bolt, constitute him as an anticipation of the penetration to come. The woman, with her head thrown back and her eyes caught in a response to her lover, likewise anticipates her impending swoon.

Fragonard's rejection here of symbolic and decorative elements signals an entirely new approach to his representation of the moment. The two figures, rather than standing apart from a natural or architectural background, are here integrated within an overall movement of the image progressing from one border of the canvas to the other. The man, arched on his toes

as he strains upward toward the bolt, and the woman, likewise swept up and to the right by the arm that pulls her toward her lover, do not simply act within the space around them. Their bodies become indices of a diffuse erotic force permeating every aspect of the image. At the same time, this emphasis on movement finally serves to underline the painting's most innovative achievement: its stunning contrasts between light and darkness.

The Bolt is as complex an experiment in chiaroscuro as can be found in the French eighteenth century. Starting in the lower left corner, the dark form of the hastily discarded shawl builds from the center to the left where its point of greatest mass becomes a contrastive overture to a movement of light that begins as it faintly crosses the fabric spread out over the low table. Intensifying as it moves to the right over the white satin sheet, the light then plays through the intricate folds of the woman's dress as it animates the richness of its tones. Continuing its upward crescendo, the light reaches its point of maximal intensity on the white shirt and pants of the impetuous lover. The carefully delineated shadow along the right profile of his body indicates that the source of this light must be the animating glow of a late-afternoon sun so low on the horizon that its illumination thrusts upwards as it enters the unseen window of the room. Like a spotlight that gains in focus as it moves away from its source, the light finally fixes itself on the galvanizing elements of the bolt and the two hands, one hand in contact with the bolt and the other extended as far as it can reach, defining the end point of this upward sweep.

This orchestration of light and movement defines a temporality that is entirely of the moment. The image expresses that liminal instant when, after its figures have thrust upward toward the bolt, their movement will be abruptly reversed. Falling back, downward, and to the left, they will then be lost from view within the reddish, eroticized folds of the heavy canopy falling over the bed. Fragonard here expresses the primacy of the moment not through a decorative vignette asking to be read in terms of its thematics and symbolism, but through a complex study of light and movement embodying the very substance of the painter's craft.

* * *

For Fragonard, life and vitality lie not in the depiction of a continuity but in the transgressions, subversions, and reversals possible only within the fractured regime of the moment. His subjects, whether they involve the narrative reconstruction of a history painting, the natural beauty of a landscape,

or the erotic surprise of a genre piece, depend for their effect on the electrifying power of desire. Refusing the determinations of the past, that desire enforces a break that opens new dimensions of potentiality within the predictable continuities of existence.

The desire at the core of Fragonard's esthetic is not, however, one limited to his represented subject matter, to the human figures and vivid scenes that populate his canvases. At their strongest and most intriguing, his works recast the protocols of spectatorship by involving his audience in a dynamics of desire and interpretation that reaches out to and redefines their own status in relation to the image before them. More than any other painter of the eighteenth century, Fragonard is an artist of the unfinished, of the sketch or stroke executed with such elusive suggestiveness that his audience is never held at a distance from the image by any coldly perfect surface of photographic realism. Be it the puzzling disproportion of scale at work in *The Great Cypresses*, the impressionistic erosion of any defined line in *The Storm*, or the uncertain play of light against dark in *The Lost Stakes* and *The Bolt*, each of these techniques compromises what would otherwise have been the spectator's sense of mastery over a conventionally finished image. In ways far more effective than the recourse to theme and symbol in the commissioned pieces, these works convey a sense of the open, the unfinished, and that which is still in process. The audience, its involvement with the image intensified by its alluring incompletion, cannot relate to the work as distant observers asked only to interpret and to judge. Instead, Fragonard's spectators become uncertain participants in an always-renewed dialectic of imaginary identification and completion that continues the beguiling experience of the work's unfinished impetus. Fragonard is most eloquently a spokesperson of the Enlightenment when his paintings extend to their spectators this sense that life must be lived within the mystery and ambiguity of the moment as a force compromising the stasis of the known, the conventional, and the certain.

Fragonard's images are, in terms of their artistic context, both highpoints and holdovers. They incarnate, perhaps more completely than those of any other single artist, that dynamics of desire's moment so central to Enlightenment culture. Yet, as the rejection of his work for Louveciennes demonstrates, the newly dominant arbiters of correct taste had already opted for something quite different. The shape of that difference, its rejection of the moment's force, and the relation between an emerging Romanticism of sentiment and neo-classicism are nowhere clearer than in the work of Greuze and what his distinctly different esthetic both expressed and prepared.

12

GREUZE AND THE MOMENT
FORECLOSED

> La peinture est l'art d'arriver à l'âme par l'entremise des yeux.
> —Diderot, *Salon de 1769*

It is difficult to imagine a symbiosis more complete than that between Jean-Baptiste Greuze as painter and Denis Diderot as art critic. It is the rare art historical study of Greuze that does not rely heavily on Diderot's analyses of the paintings Greuze exhibited at the biennial Salons between 1759 and 1769. In the other direction, it was in large part his enthusiasm for Greuze's style of painting that shaped Diderot's art criticism. His amalgam of impassioned description, clearly partisan value judgments, and broad reflections on the nature and function of art owed much to the intensity of the reactions he felt in response to Greuze's works. In a very real sense, Greuze the painter and Diderot the art critic made each other what they have come to be.[1]

To understand Diderot's side of that equation, his passion for Greuze, one must begin by looking back at what we saw to be his equally strong antipathy toward Boucher. What Diderot had to say about Boucher forms a necessary background to his judgments of Greuze in the sense that everything Diderot chose to praise in Greuze flowed from the fact that he saw that young artist's work as antithetical to the horrors he dismissed as *le petit goût* of the disdained Boucher. The Boucher Diderot so severely castigated between 1759 and 1769 represented for him the pointless holdover of a style that had reached its summit twenty years earlier: the style of Van Loo, Natoire, and the other Rococo painters whom Diderot neither understood nor sympathized with.[2] Diderot became seriously interested in art only toward 1755 and was, in that respect, very much the spokesman of a generational conflict, of a programmatic refusal of a style he correctly sensed to be a thing of the past at the time he rote his *Salons*. Boucher, for Diderot and for the other neoclassical reformers of the 1760s, represented everything they were convinced had gone wrong with painting in France.

For Diderot, Boucher may well have been an accomplished craftsman, but, as we saw earlier, he denounced that mastery as one from which the

essential element of truth was lacking. When Diderot describes a Boucher painting, he cannot resist letting it become an endless inventory of juxta-posed objects: "women, men, children, oxen, cows, sheep, dogs, bales of hay, water, fire, a lantern, burners, pitchers, kettles" (1:112). Stepping back from what he has reduced to pure clutter, Diderot can only conclude that "one senses its entire absurdity" (1:112). After offering a similar cascade of ironic parataxis to describe a Boucher submission for 1765, Diderot laments that "all his compositions add up to an insufferable racket for the eye" (2:76). His final statement on Boucher in 1769 likewise ends with the obser-vation that "it was the most incredible crush [cohue] you ever saw in your life" (4:67). For Diderot, even Boucher's human figures disintegrate into little more than a juxtaposition of lascivious body parts: "This man only picks up a brush to show me breasts and buttocks" (2:78).

As his constant recourse to a mocking inventory makes clear, Diderot condemns Boucher above all for what he sees as a failure of the elements within his compositions to come together in the clear enunciation of a mean-ing that gives some sense of unity and synergy to the whole. To the simple question, "And so, my friend, have you understood anything from all this?", Diderot felt the honest viewer of a Boucher must always answer "No." One might admire Boucher's use of color, his attention to detail, and his variety of tone, but, for Diderot, the canvas as a whole always remained opaque and impenetrable. Diderot may concede that, even at the age of sixty-eight, Bou-cher still has "all the fire of a young man" (4:68). But, he is quick to add, it is a fire that gives no warmth. His unintegrated masses of disparate elements remain incapable of moving the spectator. "But what do you want me to make of a fire that leaves me cold? What does all this say to my heart, or to my mind? In this whole conglomeration of incidents, where is there a single one that involves me, stimulates me, moves me, instructs me?" (4:68–69).

For Diderot, Boucher's insignificance is a result of his having renounced any concern with the real world, any even fleeting evocation of the moral and psychological conflicts of life as it had actually to be lived. In the *Salon* of 1763 Diderot goes so far as to put in Boucher's mouth the most cavalier of responses to the charge that his subjects are vacuously unreal. Proclaim-ing fantasy to be his only interest, Diderot's Boucher blithely chirps that "I have never bothered myself with being true. I paint a mythical event with a storybook brush" (1:205). For Diderot, it is this obliviousness to the real that makes Boucher a ridiculous anachronism, a holdover from the es-thetics of Fontenelle, who, in his *Pastorales* of 1684 and his *Discours sur la nature de l'eglogue* of 1688, extolled the singular beauty of the unreal pastoral

worlds portrayed in D'Urfé's *Astrée* and Tasso's *Aminta*. Stubbornly loyal to a now-irrelevant style, Boucher is for Diderot an artist who failed to live up to the promise of his early works and who chose instead to produce a seemingly endless series of paintings "stuffed full of sheep and shepherds à la Fontenelle" (1:205).

Diderot's Boucher is also, however, someone far more sinister than an innocuous dreamer lost in a world of pastoral fantasy. In the *Salon* of 1765 Diderot, as we saw, portrays him as the incarnation of a hopelessly corrupted imagination. "And what can be in the mind of a man who spends his life with whores of the lowest station?" (II:75). Poisoned at its source, not only is Boucher's work meaningless, but its influence, like a rampant syphilis, threatens to corrupt the talents of an entire generation of younger painters. "This man is the ruin of all young students of painting. They have scarcely learned to use a brush and hold a palette than they are tormenting them-selves over stringing together garlands of putti, painting chubby and rosy buttocks, and launching themselves into every sort of extravagence" (1:205).

* * *

While Diderot's Boucher is the all-corrupting relic of an irrelevant past, his Greuze is a painter whose work flows from an entirely original synthesis. Greuze's singular accomplishment has been to combine the everyday real-ism of Northern genre painting with the moral seriousness of classical his-tory painting. Greuze's realism is no longer the superficial verisimilitude of seventeenth-century Dutch genre painting with its often rowdy depictions of scenes drawn from the banality of everyday life. While just as realistic as those earlier genre painters, Greuze enlists his mimesis in the service of an ethics. Not only do his scenes depicting life as it is lived around him turn their back on Boucher's indulgences in fantasy, but their moving portrayals of family life are imbued with an altogether original power to serve a higher moral purpose. What Diderot finds most fascinating about Greuze's art is the fact that his works are able to exercise a morally regenerative power even over the random spectators who happen to discover them in the Salons. When Diderot describes a work by Greuze, what he wants most to convey is its almost performative power to effect within the psyche of the specta-tor a response at the level of feeling and emotion that mirrors the inten-sity of sentiment first felt by the artist. For Diderot, to look at a scene by Greuze is, thanks to the force of the emotions evoked, not only to identify with that scene but to experience retroactively the noble sentiments origi-

nally experienced by its creator. Greuze's works become for Diderot secular versions of a religious ritual: offering the representation of emotion with a force compelling the spectator's identification, they re-establish a vital and restorative contact with the moral enthusiasm from which Diderot sees the artist first fashioning that image. With emotional response and social utility functioning as an equivalent to theological grace, the pathos of family relations replaces religion's concern with establishing a new basis for morality. For Diderot, Greuze is the high priest of a new religion of sentiment.

Speaking of *Filial Piety* (Figure 39), which Greuze exhibited during the Salon of 1763, Diderot first suggests that this scene of two younger genera-

Figure 39. Jean-Baptiste Greuze, *Filial Piety*
The Hermitage Museum, Saint Petersburg

tions devotedly caring for the aged and invalid father might better be titled "On the fruits of correctly raising one's children" (1:233). Diderot qualifies it as a "moral painting," a painting which has miraculously appropriated to itself a power to move its audience previously thought possible only within the realm of dramatic poetry. He finds within this image a power "to touch us, to instruct us, to correct us, and to encourage us to virtuous action." Before beginning his description of the work, Diderot recounts an incident that exemplifies the religious power of reconciliation he sees this work exercising on its spectators. In the midst of the crowd jostling to get close enough to see the painting, Diderot found himself fascinated by the reaction of one young woman, a reaction whose intensity draws not only her but even Diderot the critic into a fantasmatic celebration of familial ties. "If only you had been able to hear that young woman who, as she examined the head of your paralytic, exclaimed with a touching vivacity, 'Oh, my God! how he touches me! If I look at him any longer, I think I will cry.' And if that young woman had been my daughter! I would have recognized her as my own in that very reaction" (1:233).

After a careful description alternating between the clinical and the emotional of each of the figures gathered around the bed of the beloved father at the work's center, Diderot struggles to capture in a single sentence the unifying trait at work in this diversity of individual characters. "Everything is related to the main character, both what is happening in the present moment, and what was happening in the previous moment" (1:234). This synthesis of present and past constitutes what, for Diderot, is most essential to the power of Greuze's image. In an obvious sense, the painting shows us what is happening in the moment it depicts. But that is not all it does. That present moment, rather than existing in its own right, draws its power from its status as the culmination of an extended narrative action. While, as Michael Fried has put it, Diderot may insist on "the singleness and instantaneousness" of the moment depicted in Greuze's work, that moment's power always depends on its effectively conveying "the dramatic illusion of causal necessity on which the convention of unity depends."[3] What links present to past, and what empowers the image as moral lesson, is the narrative and dramatic structure dictating that each moment depend for its meaning on its integration within an on-going story which the image tangibly evokes. It is as Diderot tries to explain the extended temporality at the core of this image's force that his attention turns to the recently washed bedsheet hung out to dry near the staircase leading to the second floor. "Even the background recalls the care devoted to the old man. There is a large sheet hung

out on a line to dry. That sheet is very well chosen, both for the painting's subject and for its effect as art. One understands perfectly why the painter had to give it real prominence" (1:234).

The flat white surface of the bedsheet is crucial to the painting's dynamics because, even in its mute materiality, it evokes more eloquently than any human figure the protracted cycle of washing, drying, use, and rewashing which symbolizes the family's devoted attentiveness to its stricken founder. The drying sheet functions in this image in much the same way as, in so many films, the falling pages of a calendar are used to communicate the passage of time. The slowly drying bedsheet is the visual confirmation of the painting's renunciation of any specific, epiphanic moment in favor of a continuing narrative of repetition which heightens the emotional intensity of the instant actually depicted. The daughter's gesture of lifting up her father's pillow as the son-in-law feeds him his soup may be the moment captured, but the full pathos of that moment emerges only when it is placed in the context of the implied prolongation of that ritual effected by the shimmering presence of the sheet. It is because of this extended pathos, this intensity drawing its force from an extended temporality that Greuze, perhaps more than any other single painter, incarnates Diderot's insistence that "painting is the art of arriving at the soul by way of the eyes. If the effect stops at our eyes, the painter has covered only the lesser part of his path" (4:174).

What Diderot means by this trajectory from eye to soul, from perception to feeling, and from understanding to emotion can most clearly be seen in his response to Greuze's best known family scene, *The Village Bride* (Figure 40) of 1761. Speaking of this interior scene of a country family gathered around the daughter at the precise moment when the groom at her side has received from the girl's father the purse containing her dowry, Diderot remarks that "the subject is moving, and one feels oneself being overcome by a pleasurable emotion as one looks at it" (1:141).

What was most innovative about Greuze's rendition of this country marriage, a standard scene in genre painting, becomes evident when we compare it to a quite different version of the same theme done by Watteau, *The Village Bride* (Figure 41). The differences in conception and style between these two works are striking. Watteau's is a panoramic exterior scene encompassing an almost dizzying multiplicity of figures spread out over a wide expanse that ranges from the distant buildings on the right to the trees forming the work's left border. The bride and groom, holding hands, stand at the center of a semi-circle of figures occupying the lower left half of the painting. To the right and in the background, groups of other figures, jar-

Figure 40. Jean-Baptiste Greuze, *The Village Bride*
Musée du Louvre

ringly detached from the thematic center of the couple, illustrate a startling variety of unrelated postures. Watteau's figures, dwarfed by the surrounding trees and buildings, allow none of the emphasis on facial expressivity which will become the dominant characteristic of Greuze's version. Each of Watteau's sylistic choices contributes to a depiction of the marriage scene as a space of complex, multivalent social interactions where no single dominant focus shapes the work as a whole. The individual figures, always part of larger groups, come alive only as they appear before and interact with those around them. The actual marriage ceremony, a detail within the whole, is presented not as an event limited to the family, but as the occasion for far

larger and more anonymous social interactions. The marriage, in no way different from the fleetingly exchanged glances, the interrupted conversations, and the chance encounters spread out across the painting, is but one moment, a moment absorbed within a whole extending beyond the confines of the nuclear family. Watteau's *mise en scène* is that of a cinematographic wide angle shot where an almost Wellesian depth of focus captures an expanse of figures so variegated that they preclude any empathetic identification on the part of the spectator.

Greuze, to the contrary, moves his imaginary camera as close as possible to his carefully arranged group of twelve figures. The painting's spectators, rather than watching the scene as though from a distant promontory, take their place within the cramped country room. They are close enough to detect and compare every sign of emotion on the faces of the charac-

Figure 41. Antoine Watteau, *The Village Bride*
Charlottenburg Palace, Berlin

ters before them. All of Greuze's characters, unlike the ambiguous identities of Watteau's figures, are immediately recognizable in terms of their family roles. The groom and the bride's father, the bride herself and her mother, as well as an assortment of younger and older siblings, all assume clearly defined roles. They invite the spectator to identify with them and, on the basis of that identification, to savor and interpret the expressivity of their faces and postures. Rather than Watteau's privileging of a socialized swirl of the momentary and the fleeting, everything in Greuze's image consolidates an overwhelming continuity of self and sentiment over time.

Diderot luxuriates in the voyeuristic intimacy offered by Greuze's close-up. Describing the young bride, he notices "a perfectly formed bosom entirely hidden from view; but I would bet that there is nothing there lifting it up, and that it holds its shape entirely on its own" (1:142). Pushing his scrutiny well beyond the physical, he goes on to identify with and express in his own words the "effusions of the heart" he experiences as he looks at each of the figures within the scene. Speaking of the father seated in his chair, Diderot begins with an objective description: "The father is an old man of sixty, with grey hair, a kerchief wound around his neck" (1:142). He then identifies with the father so completely that he can speak in his place, giving the daughter a name and addressing the son-in-law. "Jeannette is sweet and sensible; she will be your happiness; try to be hers" (1:142). Enunciating the mother's mixed feelings of happiness and sadness at the prospect of her daughter's leaving the family, Diderot alternates, using free indirect discourse, between descriptions of her mood and quotations of her thoughts. "She is surely a bit sad to see her leave; but it is a good match. Jean is a good boy, honest and hardworking. She has no doubt that her daughter will be happy with him" (1:142). Diderot's successive identification with the mental state of each of the figures represented in the painting extends not only to the two young servants at the extreme left—"The two servants, standing at the back of the room, casually lean toward each other. They seem to say, through their postures and expressions: when will my turn come?"— but colors even the way he sees the hen and chicks scattered across the lower foreground. "And this hen that has led her chicks into the center of the scene, she has five or six little ones, just as the mother at whose feet she seeks her food has six or seven children" (1:142).[4]

In a study whose title ("Diderot dans l'espace des peintres" [Diderot in the Painter's Space]) well captures the ambiguity of what is happening in this text, Jean Starobinski makes the point that Diderot's descriptions of Greuze's works alternate between two contradictory postures. "Diderot, in

his criticism, brings together an extreme attention and a casual infidelity."[5] This unstable combination of antithetical attitudes results in a critical discourse which, while attempting to describe as exactly as possible the content of the painting, has the paradoxical effect of substituting itself for the work it claims to represent. "The critical act, one could almost say, is," Starobinski continues, "born by granting itself the power to push the work aside, to speak in its place." In his attempts to clarify and intensify for his reader the effect of Greuze's paintings, Diderot inevitably makes of them something different from what they are as images, even if that difference is only a greater and more limiting specificity of the work's intent and meaning.

We saw earlier, for instance, how, for Diderot, the young man feeding the paralyzed father in *Filial Piety* is obviously his son-in-law, the husband of the woman who must be his daughter. Another contemporary commentator on the Salon of 1763, the abbé Bridard de la Garde, argued for a different and equally valid reading. "This old man must be the father of the young man whom we saw in the other painting [*The Village Bride*] as he received the dowry from the hands of his bride's father. Now, it is she who is helping him during the last hours of her father-in-law."[6]

While there is little point in arguing for or against either of these interpretations, both of them, Diderot's and Bridard de la Garde's, exemplify how intensely Greuze's works drew their spectators toward a sympathetic amplification of the image, an amplification inspired by but at the same time curiously irrelevant to its source. Taking that same impulse even further, the abbé Jean-Louis Aubert found himself so moved by these paintings, *The Village Bride* and *Filial Piety*, that, for each, he composed and published a moral tale in verse. In his treatment of *The Village Bride* he could not resist adding to Greuze's cast of characters a "sensitive and generous financier" (a figure Diderot would certainly disdain as representing a class far more likely to be a client of the detested Boucher) who, happening upon the ceremony, is so touched by the tender affections he sees displayed there that he gives the young couple *un présent considérable*.[7] Later, in the poem inspired by *Filial Piety*, Aubert again added another character, this time a "depraved doctor" whose sense of humanity is renewed by the spectacle of the familial devotion he discovers in this simple setting. In both cases Aubert cannot resist taking Greuze's place and supplementing his cast of characters with figures who, themselves spectators, make explicit how it is we might be moved and spiritually revitalized by the scene on the canvas.

Aubert, even in his maudlin extremes, is responding to Greuze in a way entirely consonant with Diderot's own analysis of what lay at the base of

Greuze's power. The painter has carefully constructed his images in such a way that their combination of intense sentimentality and dramatic structure traces out a narrative space which the spectator cannot help but enter. To scrutinize Greuze's family dramas is not only to be drawn into an on-going story, but, by reason of the identification they solicit, to become the potential author of that same narrative. "He is . . . the first among us who set himself the task of bringing morality to art, and of portraying events from which it would be easy to compose a novel" (2:144). The present moment captured in Greuze's works points insistently toward a past and future the spectator cannot help but imagine as the logical complement of the moment's effect.

This dynamics of involved spectatorship is nowhere more apparent than in Diderot's reaction to *Young Girl Mourning Her Dead Bird* (Figure 42) when it was shown in the Salon of 1765. Immediately qualifying it as "perhaps the most interesting of the Salon" (2:145), Diderot is at first able to describe it only through a series of breathless exclamations, a prose unable to find its bearings as it struggles to enunciate what it feels to be the ineffable beauty of the work. "Delicious tableau! . . . How naturally she is positioned! How beautiful her head is! How elegantly her hair is done! How expressive her face is! . . . Oh, the beautiful hand! The beautiful hand! The beautiful arm! . . . Whether you are riveted before it, or come back to it later, you cry out: delicious! delicious!" (2:145). The effect for Diderot is so strong that, like a spectator become Pygmalion, he is moved to verify with his lips the astounding verisimilitude of the young girl. "You would draw closer to that hand to kiss it, were it not for your respect for that child and her suffering" (2:145). Renouncing that intrusion, Diderot resigns himself to a test by voice rather than by touch: "you are quickly surprised to find yourself conversing with this child, consoling her." For Diderot, the image's beguiling power lies in its ability to erase from the spectator's psyche any sense of the work's objective status as painting and to create instead an imaginary space of dialogue that transposes the work and its beholder into a shared plane of emotive irreality. The rest of Diderot's commentary will take the form of an anxious interrogation meant to coax out from the girl's mute sadness some indication of her past and future. Establishing himself as he who understands what the girl cannot put in words, Diderot pushes toward the relevant past for which the tears shed over a dead bird are only a metaphor. "So, little one, open your heart to me. Tell me the truth. Is it really the death of this bird that draws you so strongly and so sadly into yourself?" (2:146). Diderot's insistent questions evoke an undefined third person, an unspecified "he" who, appearing within an imperfect tense situ-

Figure 42. Jean-Baptiste Greuze, *Young Girl Mourning Her Dead Bird*
National Gallery of Scotland, Edinburgh

ating events that still reverberate within the present, is the real source of
the girl's sadness. "He loved you, he swore it to you [Il vous aimait, il vous
le jurait], and he had been swearing it for some time. He was suffering so
much and how could you bear to see someone you love suffer?" (2:146).
Once that absent presence has been introduced, once the bridge of metaphor
has been crossed, the vague duration of the imperfect is polarized around a
single, hyper-significant event expressed through a preterit moment when

all became clear. "That morning unfortunately your mother was absent. He arrived [Il vint]. You were alone. He was so handsome, so passionate, so tender, so charming! He had so much love in his eyes!" (2:146).

Stepping completely into the fantasy his dialogue shares with the painted image, Diderot goes on to evoke the visit he has just made to the boy's house and how what he saw there promises a future distinctly similar to the moment depicted in *The Village Bride*. "I just saw him at his father's house. He is charmingly gay, with a gaiety all around him share, and no one can resist" (2:146). The cherished bird may well have died because, preoccupied with her worries for the future, the girl had forgotten to give it food and water. But, Diderot's voice reminds her, she must not forget that the bird was a gift from her young suitor and that he is perfectly able to give her many more every bit as delightful as the first. "Ah! I understand. This bird, it was he who gave it to you. Very well, he will find another just as pretty" (2:147).

This painting is in fact one of a series of variants on the same theme to which Greuze returned again and again. It is only the choice of the metaphor for what has been lost that changes. In addition to the dead bird, Greuze painted images of a young woman disconsolate over the broken mirror that lies on the floor before her, over the eggs intended for market which have broken as they fell from her basket, and, with the heaviest symbolism of all, over the broken pitcher she holds as she stands next to a bubbling fountain. In each of these images, and it is this which Diderot's dialogue so well captures, the present moment depicted in the painting draws its force from the fact that it immediately evokes both a past and a future: the past of a virginity sacrificed to a movement of shared desire and the future of the girl's anxious uncertainty as to what will follow from that gesture of reciprocated love. In elaborating his extended dialogue with the image, Diderot is responding in the only way available to him, in words, to the overwhelmingly narrative drive so central to the power of Greuze's paintings.

* * *

It is hardly surprising that Diderot should have responded so strongly to works like *The Village Bride* and *Young Girl Mourning Her Dead Bird*. It is a commonplace of eighteenth-century scholarship to point out that Diderot, as the champion of the new theatrical genre known as *le drame bourgeois*, shared Greuze's devotion to artistic forms centered on the depiction of a bourgeois social milieu in which an intense sentimentality was enlisted in the service of secular moralities. For Greuze, as for Diderot's theater,

the principal focus of this art is the family unit and the relationships it implies. In Greuze's case, there is a clear preference for the relations between generations, between parents and children, rather than those between husbands and wives. The nuclear family provided Greuze with a repertory of themes so immediately legible, so obvious, and so universal in application that his images effortlessly generate a narrative context inviting his spectators to imagine the story behind the picture. While traditional history painting relied for its legibility on an acquired cultural knowledge, everyone, the unschooled as well as the schooled, could grasp the implicit narratives sustaining Greuze's images.

Greuze produced a number of works dealing with pathologies of the father-son relationship. Most often these center on wayward sons pictured either at the moment where their leaving the family home condemns it to economic ruin or at the later moment of the son's contrite return only to find that his father has already died. Presented under such titles as *The Ungrateful Son* and *The Son Punished*, these images of youthful egotism and its just desserts struck many commentators of the period as too graphically horrifying for polite viewing. In face of such reactions, Greuze's defenders insisted on the morally regenerative effect even of such negative images. Turgot, in a letter to Dupont de Nemours of October 15, 1771, did not hesitate to describe such scenes as "sublime pieces" and insisted that their vivid lessons on the wages of evil established them as forces for good that were finally "more eloquent and more useful that all the sermons in the world."[8] Reversing the pathology of the wayward son, Greuze presented at the Salon of 1769 a sketch titled *Death of an Unnatural Father, Abandoned by His Children* (Figure 43). In it the final agony of a man who has driven his children away takes place in a wretched attic room. As the cadaver contorted in rage falls from the bed, his passing is accompanied only by the fleeting presence of a neighboring woman who takes advantage of the moment to steal his purse and even the sheet in which he has died. Greuze's family moralities rarely took as their subject a discord between husband and wife. The best known exception to that exclusion is *The Blind Man Deceived* (Figure 44). Here an unfaithful wife furtively caresses the lover crouched at her right as her blind husband sits in a chair holding her left hand. Even in this scene, however, the decrepitude of the much older husband, so clearly contrasted to the youthfulness of his wife and of her almost imbecilic lover, gives the image a resonance as much generational as it is conjugal.[9]

Whatever their thematics, Greuze's domestic scenes are set in the closed

space of a room cut off from the larger world beyond it. The Greuzian family, be it peasant or bourgeois, is defined not in terms of any social specificity, but by its relation to the universal forces of age (leading to illness and death) and desire (leading to sexuality and marriage). Only rarely, as in *The Benefactress* (Figure 45) do we see an explicit reference to the reality of social class. In this image the invalid father relates not so much to his own son standing behind his bed to the far right as to the young daughter of a wealthy benefactress who is being instructed in a proper concern for those less fortunate. The mother urges her clearly reluctant daughter to present the gift of a purse to the sick man lying in his bed with his arms stretched toward her. This image depends for its effect on the spectator's perceiving the clearly marked

Figure 43. Jean-Baptiste Greuze, *Death of an Unnatural Father, Abandoned by His Children*
Musée Greuze, Tournus

Figure 44. Jean-Baptiste Greuze, *The Blind Man Deceived*
Pushkin Museum, Moscow

Figure 45. Jean-Baptiste Greuze, *The Benefactress*
Musée des Beaux-Arts, Lyon

class differences between the two families. Even here, however, the work's intended message is not so much that of a reconciliation of class differences as it is a moral lesson on charity for the young.

Greuze's most costly miscalculation as to the universal appeal of his family narratives came with his decision to use that structuring principle for his *Septimus Severus and Caracalla* (Figure 46). Submitted to the Academy in 1769 as the long overdue reception piece necessary for his acceptance as a full member within that body, the painting failed utterly to achieve its purpose. Hoping to be admitted as a history painter, Greuze took as his subject an incident from Roman history in which the Emperor Severus reprimands his son Caracalla for having tried to have him assassinated. The father, pointing

with one hand at his sword and with the other at his brooding son, ironically suggests that he ask Papinial, the balding centurion at the far right, to run him through.

Once this painting was submitted to the Academy, everything went wrong. Not only did the Academy reject the work, but, in a gesture calculated to repay Greuze for his earlier and notorious insults of that body, it admitted him only as a genre painter. Even the heretofore admiring Diderot could find nothing positive to say about this work. After enumerating its shortcomings, he concluded "no color, no truth in the details, nothing

Figure 46. Jean-Baptiste Greuze, *Septimus Severus and Caracalla*
Musée du Louvre

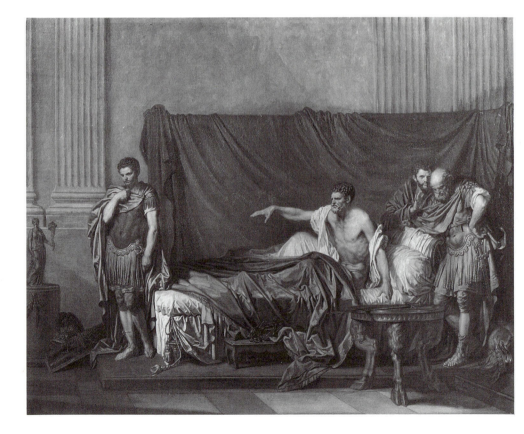

really finished. A pupil's piece, too good to leave much hope of anything better. No harmony; everything is flat, hard, and dry" (4:107).

The failure of this painting was in large part a result of Greuze's overweening conviction that, with a single image, he could satisfy two quite different audiences: the Academy's history painters and the enthusiasts of his family scenes. In fact, he alienated both. For Cochin and his allies in the Academy, Greuze's transposition of his stock father-son conflicts onto figures drawn from Roman history yielded only an intolerable parody. Roman armor and togas alone could never make up for the absence from this image of any aura conveying the grandeur of the martial and political virtues of historical figures expected to function as visual metaphors for the merits of monarchy. There remained an unbridgeable gap between Greuze's invitation to his audience to identify with his characters as another version of themselves and the history painters' quite different emphasis on a majesty setting spectators apart from subjects they were asked to admire only from a reverent distance. There is something the Academy could only perceive as ridiculous in Greuze's transposition of pouting son and scolding father into the heroic domain of the Roman and the imperial. The large drapery behind the emperor's bed stands out almost as an involuntary memory of the drying bedsheet that worked so well in *Filial Piety* but which hangs here in complete irrelevance. For Diderot, the consistent champion of Greuze as the single painter in France capable of demonstrating the humanity and nobility of the lower classes, Greuze's choice of subject had betrayed the most powerful aspect of his art.

* * *

Given how abruptly Diderot could reject Greuze's art when he tried to illustrate this episode from Roman history, the question arises as to how much Diderot's overwhelming emphasis on Greuze's narrative impulse represents a valid response to his work. For Diderot, Greuze's best works were, as we saw, pictorial stimulants to the novels he felt inspired to imagine as he stood before them. For him, Greuze was a novelist in paint and chalk. The power of his works came from the fact that the present they depicted immediately resonated with an implied past and future transforming the image's single moment into the emblem of a full-fledged story. Was this, the question must be asked, the way Greuze himself saw his art?

Greuze offers a number of answers to that question. In April of 1781,

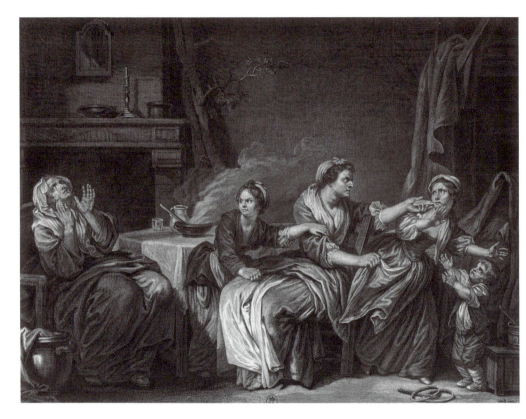

Figure 47. Jean-Baptiste Greuze, *The Stepmother*
Bibliothèque Nationale

preparing for the release of an engraving titled *The Stepmother* (Figure 47), he sent a long letter to the *Journal de Paris*. His intent was to drum up public interest in the work and maximize its sales. Describing his letter as a *note historique* on the soon to be released image, he explains that he had long been fascinated with the figure of the stepmother but that all his previous attempts at representing what that term implied had left him unsatisfied. His real inspiration, what would finally allow him to produce an adequate image, came not from his having resolved any formal problem, but from a linguistic source, from a sentence spoken by a stranger and overheard by chance as he crossed the Pont-Neuf. The exchange, "What a stepmother! Yes, she gives her bread, but she breaks her teeth with that bread,"[10] was for him a "ray of light" finally illuminating the image he would draw.

After explaining the work's source, Greuze goes on to enumerate his cast of characters: the wicked stepmother toward the center, her stepdaughter to the right, her preferred natural daughter to the left, the despairing grandmother of the stepdaughter at the far left, and the stepdaughter's innocent three-year-old brother at the far right. Once these figures have been introduced, Greuze summarizes in two sentences the mini-narrative inspired by the overheard observation. "I assume that it is the dinner hour and that the unfortunate young girl is about to take her place at table like the others. It is then that the stepmother takes a piece of bread and, holding the girl by her apron, forces it into her face" (76). The rest of his letter, adopting a discursive strategy strangely reminiscent of that employed by Diderot in his descriptions of Greuze's Salon pieces, combines an expressive reading of the emotions conveyed by each face ("misery and fear" for the stepdaughter, "acute suffering" for the grandmother, etc.) and an identification with the characters that allows the artist to speak in their place. "Why are you hitting me? I have done you no wrong," cries the stepdaughter (76). The despairing grandmother speaks instead to her dead daughter: "Oh, my daughter, where are you? What unhappiness we have, what bitterness" (76). Finally, as though he were composing the final strophe to a fable, Greuze enunciates the underlying moral of the image. "I tried to portray through this moment the kind of carefully planned hatred that can only come from a deep-seated hatred. . . . In sum, I wanted to paint a woman who mistreats a child who does not belong to her and who, committing a double crime, has corrupted the heart of her own daughter" (76). One could, of course, equally as well deduce from this letter that Greuze knew his audience just as well as he did his art. His letter says perhaps less about his esthetic principles that it does about his skill at whetting the interest of those newspaper readers who might purchase such an engraving. His potential buyers were far more likely to be stimulated by the edifying story he now allowed them to hang onto the image than by any abstract discussion of its formal qualities.

There exists, however, another particularly intriguing document which both clarifies the importance of narrative structure to Greuze's art and offers an inventory of, for the most part, unexecuted works that illustrate the principles of his esthetics. The manuscript entitled *Bazile and Thibault, or Two Upbringings* is partially in Greuze's hand and partially dictated. The manuscript describes in separate paragraphs twenty-six individual scenes that tell the stories of its two protagonists, the good Bazile and the bad Thibault.[11] Three of the paragraphs correspond to works Greuze actually produced, while the other twenty-three have no direct equivalent in his known *oeuvre*

even though they frequently evoke scenes quite close to those of his existing works. The entire series is a meditation on family life, on how every stage of an upbringing contributes to the child's destiny. The right choices by the parents will lead to the child's prosperity and the continuation of the family into yet another generation. The wrong choices will lead not only to the death of the childless son, but to the death even of those parents who so ill prepared him for the realities of the world.

Greuze's first twenty scenes are structured as contrastive pairs that show us the crucial turning points on those roads to happiness and despair. Scene One describes Bazile's birth as a joy that cements the happy union of his devoted parents. Scene Two introduces Thibault and evokes not a birth but a separation: that of Thibault's departure in the arms of a wet nurse from parents who show next to no concern with what will become of him. Scene Three describes the young Bazile reconciling his parents after a minor domestic quarrel. Scene Four shows a terrified Thibault being brought back to a family he has never known by the wet nurse who represents his only mother. The subsequent pairings draw equally significant contrasts between the two boys as they grow into young adults. Whereas Bazile has a natural tendency to act charitably toward the less fortunate, Thibault spends his time pulling the feathers from birds he then feeds to the family cat. While Bazile's success in his schoolwork never gets the best of his innate modesty, Thibault spends his days destroying the vines of his poor neighbors. While Bazile's sense of self-discipline leads him to work late into the night, Thibault's mother spoils him with breakfasts served in bed at ten in the morning. The arrival of puberty is greeted by Bazile's father with a prompt visit to the local surgeon where his son can contemplate the horrible sores on the faces of the syphilitics being treated there. Thibault's father, when he discovers his son raping a servant, is more amused than upset as he points out to the unfortunate girl, "My child, it is hardly going to kill you" (158).

The so far separate but parallel stories of the two young men come together as both are sent by their parents to live in a nearby seaport. While Bazile defines himself in that larger world by singlehandedly turning back an English raiding party and becoming the town's hero, Thibault takes advantage of the commotion to run off with the *procureur*'s daughter whom he has cajoled into stealing all her father's gold. Caught and brought back to the town, Thibault is sent to prison, while Bazile goes on to so distinguish himself before a visiting prince that he is invited to become the prince's first secretary. The tenth pair of descriptions presents the two boys-become-men returning to their respective families. The now-established Bazile stops on his

way home at a farm where he asks for the hand of his childhood sweetheart, Marion Bastier. The miscreant Thibault returns to find his mother dying with shame at his fate and his father impoverished by the cost of having secured his release from prison. The final pairs of contrastive paragraphs follow Bazile's continuing success as he returns to court. His meritorious service will lead to his being named *lieutenant criminel* of the major provincial towns and to yet another tearful departure as he takes leave of his second parents of the prince and his wife. It is in executing his duties as magistrate of the criminal court that Bazile will sit in judgment on Thibault, who, fallen in with whores and thieves, has murdered a young man for his purse. The manuscript ends with two scenes that contrast the happiness of Bazile's marriage and the promise of children to come with the heavy pathos of a subterranean prison cell where Thibault, as he awaits his death sentence, is visited by his now widowed father and his grandmother. The father, appalled at the progeny he has produced, commits suicide before the eyes of his son.

In terms of theme, these descriptions mark an important extension of the scope of Greuze's moralizing reflection, one that will be crucial in understanding his relation to the thematically different yet structurally similar work of David as the most important heir to Greuze's redefinition of the relation between image and audience. Unlike the enclosure within the family unit of Greuze's best-known domestic scenes, there is in this text a continuity between family and society, between father and prince as parallel and complementary dimensions of a unified symbolic order. In the eyes of both family and state, the young Bazile is the perfect son, citizen, and judge. The consolidation of this identification between father and prince comes as Bazile pronounces a death sentence on his implicit twin, that darker version of the self, whose crimes express a refusal of civil law that flows from the absence of any paternal law.

In terms of its form, *Bazile et Thibault*'s structure, especially at those moments when the text most clearly departs from its original intention, provides proof of the distinctly narrative intentions of Greuze's art. The early paragraphs, roughly the first ten pairs of descriptions, read very much as transcriptions of specific, easily visualized scenes. With a careful attention to such details as facial expression, posture, and the spatial relations between characters, they read as verbal notes for paintings to be executed. Each paragraph retains a semantic independence and focuses on a single image sufficient in itself yet open to the expansion of its meaning that will be effected by the paragraphs that precede and follow it. Within the final third of the manuscript, however, this primacy of the visual image is forgotten and the

paragraphs read instead as chapter summaries. A concern with advancing the narrative thrust eliminates any concentration on a single, focused image. Paragraph 23, "The Prince rewards Bazile," presupposes at least two distinct moments as necessary background to the image with which it concludes:

Bazile returns to the service of his prince. He is charged with a very important mission abroad. He carries it out with the greatest distinction. To reward him, the prince arranges to have him named judge of the criminal courts in the most important cities of his realm. Bazile, now having been appointed to that posititon, takes leave of his benefactor who appears quite moved by the departure of his protégé. This scene takes place in the presence of the princess and various members of her entourage.[12]

Greuze brought this novel in images to a close with what is clearly its most melodramatic scene: that of Thibault's father killing himself before the eyes of his son and his mother. But a fourth party is also present. This final scene closes with the sentence, "The jailor turns his head away in fright and seems to call for help" (161). Forced to behold the terrifying scene that has taken place before him, the jailer becomes a figure within the image of all those virtual spectators who might one day have stood before this unexecuted hyperbole of a family's destruction. His presence and his horrified physiognomy show how important such an absorption of the spectator within the image was to the efficacy of the moral lesson that stands at the core of Greuze's art. The jailer's face, twisted in repulsed fascination, cues the reaction of any spectator who might perceive this image as Greuze intended it. Greuze's spectator is at the same time outside the image yet within it. The power of his moral narratives presupposes that there be no gap between inside and outside, between perception and feeling, between character and spectator, between image and life.

It is this emotional absorption of the implied spectator within the image's moral intent that defines Greuze's art. And it is by reason of that adhesion that Greuze stands distinctly apart from the other eighteenth-century artist whose work *Bazile et Thibault* most clearly evokes. William Hogarth's "modern moral subjects" were well known in England long before Greuze began his career. Not only was Hogarth's work available in Paris when Greuze was painting, but the focus on storytelling through images shared by these two artists led various contemporaries to see a clear link between them. The anonymous author of the *Lettres d'un voyageur à Paris à son ami Charles Lovers demeurant à Londres* of 1779, for instance, writes back to his English friend that, although there was as yet no French Hogarth in the sense of someone who had produced in images "a story or a sustained fic-

tion with a moral goal," Greuze was certainly the one French artist "from whom one might expect this kind of mute novel."[13]

The Hogarth series most obviously similar to *Bazile et Thibault* was his *Industry and Idleness* of 1747.[14] This sequence of twelve engravings was intended to tell the story of two young men, one good and the other bad, in such a way as to instruct the apprentice class of eighteenth-century London as to how they might acquire the moral virtues necessary to a coveted middle class station. As Hogarth expressed it in his *Autobiographical Notes*,

The Effects of Industry & Idleness Exemplified in the Conduct of two fellow prentices in twelve points Were calculated for the use & instruction of those young people wherein everything necessary to be convey'd to them is fully described in words as well as figure.[15]

Industry and Idleness tells the parallel stories of two young apprentices, Francis Goodchild and Thomas Idle. The first story will lead its hero to the position of Lord-Mayor of London, while the second story will bring its protagonist to a public hanging at Tyburn. The twelve images that make up Hogarth's work adopt a narrative structure similar to the one used by Greuze in *Bazile et Thibault*. Hogarth, unconcerned with any portrayal of childhood, opens his series with an image titled *Fellow Prentices at their Looms* (Figure 48) that shows the two young men together at the common starting point of their careers to come. To the right, Francis, shuttle in hand, works diligently at his loom. To the left, Thomas is drunk and asleep before his own. The ale tankard and tobacco pipe symbolize his inability to separate work from dissipation. Tacked to the beam above his head, a page from Defoe's *Moll Flanders* signals the real center of his interests. Francis, to the contrary, reads only the well preserved copy of *The Prentice's Guide* we see open at the foot of his loom.

This opening image of the two characters together, as will also be the case in *Bazile et Thibault*, is followed by four contrastive pairs of images symbolizing key points in their trajectories as the two young men progress along their divergent paths. Concerning their attitudes toward religion, Francis is shown piously attending church services with the daughter of his employer, Mr. West. Thomas, on the other hand, never enters the church but spends his time trying to cheat the rowdies with whom he gambles in the graveyard beside it. Concerning their work habits, Francis's devotion to his assigned tasks quickly leads to his attaining the greater status and responsibility of an overseer. Thomas's dismal performance results in his being dismissed and forced to go to sea as a common sailor. The following pair of images con-

centrates on their sexuality. Francis, now placidly married to Mr. West's daughter, is seen distributing alms to the poor from their luxurious lodgings at the factory where the sign shows that he has now become a full partner in the family business. Thomas, as he is shown in Plate 7, *The Idle Prentice Returned from Sea & in a Garret with a common Prostitute* (Figure 49), now lives as a street thief. The engraving shows him as he is startled from a fitful sleep by a cat that falls down the chimney of the sordid room he shares with a prostitute examining the jewelry and watches of their latest take. The following pair of images sums up where their lives have taken them. Francis, now sheriff of London, is seen at a celebratory banquet. Thomas, betrayed by his whore, is arrested for murder in a fence's tavern. The tenth engrav-

Figure 48. William Hogarth, *Fellow Prentices at their Looms*
Trustees of the British Museum, London

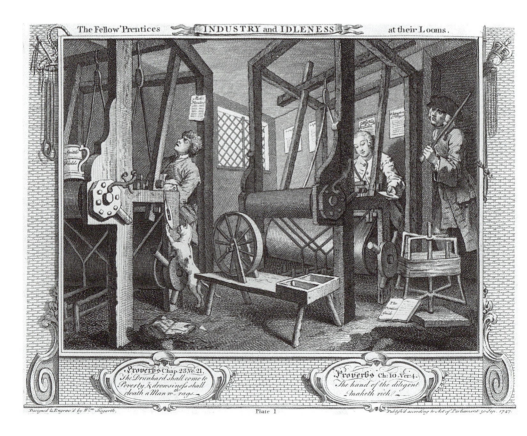

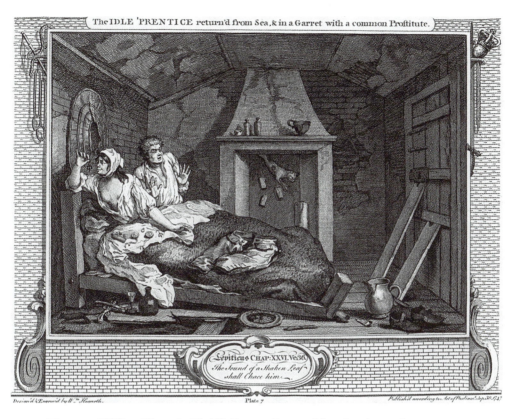

Figure 49. William Hogarth, *The Idle Prentice Returned from Sea & in a Garrett with a common Prostitute*
Trustees of the British Museum, London

ing brings the two characters back together in a shared space that embodies their utterly different stations in life. Francis, now an alderman of London exercising the same authority as Bazile when he became *lieutenant criminel*, reluctantly imposes a death sentence on Thomas for the murder that he has committed. The final pair of images shows Thomas being led to his execution before the crowd at Tyburn while Francis parades before the Prince of Wales as the new Lord-Mayor of London.

As even this rapid summary of Hogarth's engravings makes clear, the differences between his and Greuze's work are equally as pronounced as the similarities of their narrative techniques. *Bazile et Thibault* centers almost exclusively on scenes relating the individual to the nuclear family. Hogarth,

on the other hand, makes no reference to the families of his main characters except for the occasional presence in the image of Thomas's broken-hearted mother. The relevant forces at work in Hogarth's world exert themselves beyond the limits of the family unit. They express instead larger social and economic structures that define the mercantile milieu in which both Francis and Thomas will live out their destinies. His images center first on the workplace and then on the higher and lower social stations into which success or failure will propel his protagonists. For Hogarth, the shape of the individual's life is explicitly related to work, production, and social class. The parent-child relation, here present in the person of the employer's daughter, is only another opportunity for social and economic advancement. No reference is made to children as an eventual result of Francis's marriage. Whatever elements of the family appear within these images become meaningful only as metaphors of the economic. Greuze works in exactly the opposite direction. The prose vignettes describing the careers of Bazile and Thibault achieve their meaning as metaphors of beneficent or pernicious relations between parent and child. Even the figure of the prince, representing a social world that extends beyond the family, relates to Bazile more as father than as the instance of any authority extending beyond the family. For Greuze, the economic and the social exist only as thinly disguised metaphors of the familial.

Nothing, however, more starkly separates Hogarth and Greuze than the overwhelming presence in *Industry and Idleness* of an irony totally absent not only from *Bazile et Thibault* but from all Greuze's work. Even with his first appearance on the mill floor, the smug saintliness of Francis's face as well as his almost comic contrast to Thomas's dissipation short-circuit any affective identification the spectator might make with the character. Plate 4, *The Industrious Prentice, a Favourite & entrusted by his Master* (Figure 50), shows Francis as a foreman, now dressed in the same style as Mr. West, holding the keys and daybook that symbolize his new authority. Other elements within the image, the rows of identical women forced to sit for long hours before their looms and the conspicuously poxed porter arriving with bolts of cloth, undercut what might otherwise have been the spectator's easy identification with this image of the diligent young man's advancement. Hogarth's final engraving, Plate 12 titled *The Industrious Prentice, Lord-Mayor of London* (Figure 51), shows Francis passing before the royal box in his official carriage. The triumphant Francis is, however, only a small detail within the context of a tumultuous crowd scene. To the bottom right, drunken soldiers discharge their arms at random. In the viewing stand at the far left a man forces himself upon a woman who claws at his face. Below her, a young boy

takes advantage of the scaffolding to look up her skirts. In the central foreground a crude bench has collapsed, sending its occupants into the mud to the delight of the laughing chimney sweep.

Adopting an esthetic totally at odds with the effect solicited by the appalled jailer in the final line of Greuze's program for future paintings, Hogarth's irony never invites the spectators to equate the space they occupy with the space within the image. With an outside never absorbed by the inside, with perception never becoming one with feeling, identification has no place in Hogarth's art. Rather than the heavy sentimentality enforced by Greuze's images of a son basking in the admiration of his delighted parents,

Figure 50. William Hogarth, *The Industrious Prentice, a Favourite & entrusted by his Master*
Trustees of the British Museum, London

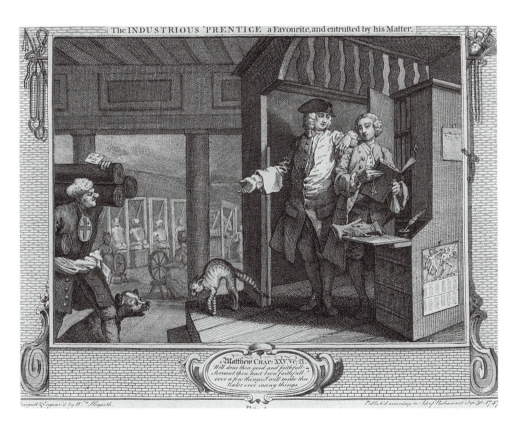

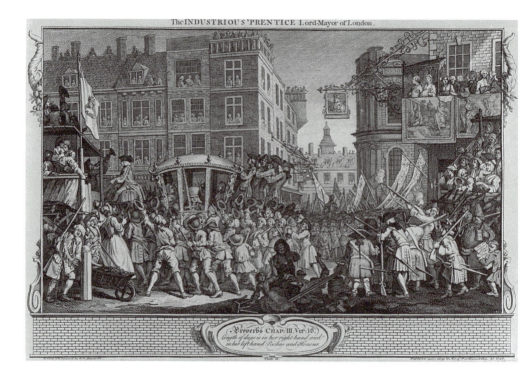

The INDUSTRIOUS 'PRENTICE Lord-Mayor of London.

Proverbs CHAP: III. Ver: 16.
Length of days is in her right hand, and
in her left hand Riches and Honour.

Figure 51. William Hogarth, *The Industrious Prentice, Lord-Mayor of London*
Trustees of the British Museum, London

Hogarth offers only a dreary world of workers performing for their bosses. Even the villain, Thomas Idle, is never portrayed as an occasion for smug moralities, but provides instead, as we saw in Plate 7 of the attic room, a parody of depravity short-circuiting even negative identification with the character. Hogarth presents his narrative as a "progress" toward glory or ignominy that takes place entirely under the winkingly satirical yet coldly objective sway of social and economic forces. Greuze, to the contrary, seeks to ensnare his spectator within an emotionally charged narrative held up as a mirror reflecting back on its audience all the sentimental intensity of the family allegories he portrays.

* * *

Greuze, relying on a narrative that excludes irony, brings to an end the esthetics of the moment that has been the subject of this study. In spite of the fact that many critics today dismiss his works as outrageous exercises in manipulation, Greuze stands as a focal artist of the eighteenth century. Paradoxically, it is his rejection of the moment that establishes his art both as a return to the central tenets of seventeenth-century classicism and as an anticipation of what French painting would become during the Revolution and its aftermath.

As concerns his return to classicism, his signature pieces such as *The Village Bride* and *Filial Piety*, once we move beyond their clearly anti-classical choice of popular as opposed to elevated subject matter, mark a revival of the central ambitions through which Le Brun sought to define the specificity of the Academy painters. French classicism was, more than anything else, a devaluing of the *Maîtrise*'s emphasis on technique and craftsmanship. It favored instead an emphasis of design as a vehicle for clearly enunciated references to narratives reflecting and consolidating the monarchy as the indispensable principle of social order. Classical history painting began and ended in the episodes it sought to illustrate. Its goal was to establish its images as inspiring examples for the elite they addressed. Simultaneously celebratory and inspirational, its images depended for their effectiveness on the capture of a moment that carried with it a before and an after that reflected the durability of the monarchy for which they were always a metaphor.

Greuze, however unorthodox his subject matter, relied equally heavily and equally effectively on that same subordination of the image's moment to its narrative prolongations. While the practitioners of classicism scrutinized history as a repository of exemplary anecdotes suitable to the edification of both triumphant rulers and grateful peoples, Greuze directed his scrutiny in another direction. Renouncing courtly grandeur in favor of more humble precincts, Greuze mobilized the archetype of the family to move and instruct an audience extending far beyond the limits of any single class. His dramas of fathers, mothers, and children sought to convey an intensity of emotion and sentiment so acute as to be universal in their pretentions.

In terms of the story I have tried to tell in these pages, Greuze's return to the rhetoric of classicism must be seen less in terms of what it restored than of what it foreclosed. While respecting de Piles's anti-classical dictate that the image must move its spectators, Greuze rejected his insistence that didacticism was both secondary and parasitic to painting's celebration of color and its self-sustaining animation of the visual image. For Greuze, to

return to Diderot's formulation, the eye had always to become an avenue to the soul.

Greuze's program of "teaching by moving" set itself up against the celebration of the moment at work in artists like Watteau and Chardin. While those earlier painters set out to capture the unsettling intensities of a moment grounded in the fullness of a present sensation excluding narrative continuity, Greuze embraced the projected narrative as the motive force of his overwhelming moralizations. Greuze's figures are incomprehensible outside their adhesions to or departures from values associated with the symbolic orders of family and narrative.

Greuze stands in opposition not only to such artists from an earlier generation as Watteau, Chardin, and Boucher, but also to his contemporary, Fragonard, who, although six years younger, died one year after Greuze in 1806. In terms of dates, Fragonard represents the final stage of the moment's lingering heritage. As the integrating focus of his work, the moment's force established his portrayals of nature and society as backdrops awaiting their vitalization by the redefining abruptness of desire's eruption. Greuze, refusing Fragonard's preference for the instant when everything is suddenly subject to change, presents instead scenes whose moments draw their intensity not from any break or challenge, but from a fated coherence of present with past and future. Greuze seeks to display, as movingly as possible, a continuity of the symbolic order that defines the emotional and moral valence even of those who revolt against it.

It is in this respect, in terms of his celebration of a social order guiding the passage from past to future, that Greuze initiates the suppression of the moment's disruptive force that will characterize the future of French painting. David's neoclassicism, the signature style of the coming Revolution, must from this perspective be seen not so much as a break with what came before, but as a logical continuation of Greuze's refusal of the moment's heritage. Greuze and David both reject any privileging of the disruptive, inaugural moment in favor of narrative moralities that consolidate the image's didactic function. For Greuze, as we saw, the representation of the authority holding sway over the world beyond the family always repeated the figure of the father. Bazile's prince is simply a patriarch presiding over a larger domain.

David will redefine Greuze's equation of private and public, of familial and social. His historically crucial modification of that equation will exalt the demands of the state over those of the family.[16] While David may reverse Greuze's priorities, the emotional force and didactic value of his images re-

main firmly grounded in Greuze's celebration of the family unit. The notion of a duty to republic and fatherland incumbent upon all citizens was, for David and his contemporaries, a new and necessarily vague concept. Visualizing it, making it tangible, depended not on representing it in its own abstract terms, but on establishing it as a similar yet superior version of the Greuzian family. In works like *The Oath of the Horatii* of 1785 and *The Lictors Bringing Brutus the Bodies of His Sons* of 1789, eloquent classical examples of civic virtue are represented as a wrenching and heart-rending renunciation of sentiments grounded in relations between parent and child or between brother and sister in favor of a higher duty to the state. David and his disciples effectively work within and reconfigure the Greuzian thematics of the family in such a way that the intense emotions manipulated by their predecessor now find themselves enlisted in the service of a patriarchal state.

Greuze's and David's shared fidelity to a principle of authority that eradicates the irrationality of the disruptive moment would continue long into the nineteenth century. Whatever the tenor of the regimes in power, republican, imperial or monarchical, they retained a careful control and exploitation of public commissions so as to foster the production of art works that consolidated the legitimacy of the powers that were. The official painters of a stunningly diverse succession of governments offered what finally amounted to minor variations on the Greuzian thematics of the state as a father to whom so much was owed and from whom so much could be expected.

Taken together, Greuze and David fashioned from their rejection of the moment an esthetics of identification and emotional intensity which, whatever the agenda it was associated with, profoundly redefined the social function of the image. Greuze and David stand as the initiators of art as a form of propaganda which was to become progressively more indistinguishable from art in any other sense of the word.

We may today look with bemused condescension at Greuze's maudlin iconography of the family. The fact nonetheless remains that, whether it is through cinema, television, or photography, but always more profoundly than we would wish to admit, we continue to be manipulated by an exploitation of the narrative and didactic power of the image for which Greuze was the crucial harbinger.

CONCLUSION

We have seen how, across a wide sweep of its literary and artistic culture, the French Enlightenment was marked by a new and defining awareness of the moment. In its many forms, the moment's temporality of the caesura set the tone for an age that affirmed itself against the reigning orthodoxies of church, monarchy, and patriarchal culture. The voices of the moment spoke instead of other ways of looking at individual happiness, political freedom, and the prerogatives of private life.

Rousseau and Casanova, near the eves of their deaths, wrote their very different autobiographies as testimonials to the singular power of the remembered moment. For each, the present of writing the recollected moment provided an intensity of feeling that had been overlooked in the on-rushing hustle of everyday experience. Be it Rousseau's memory of his first vision of Madame de Warens a half century earlier or Casanova's intense pleasure in the evocation of moments offered to his readers as a source of shared laughter, both turn their writing not to the telling of a story understandable only in terms of an impossible totality, but to the resurrection of detached, fulgent moments that remain outside of and beyond any careful flow of narrative.

Removed from any master narrative coherent with a comprehensive restatement of their lives, their final experiences of the moment stand in stark contrast to that other version of life's ending that was so frequently a theme in Greuze's family imagery. As we saw in his *Filial Piety* and *An Unnatural Father, Abandoned by His Children*, the father's deathbed was an icon to which Greuze returned again and again throughout his career. Whether that ending took the positive form of a passing comforted by the attentions of a devoted family, or the negative form of a death endured within the most bereft solitude, Greuze's many versions of that image, positive and negative, rely on a portrayal of the moment which is antithetical to what we see in Rousseau and Casanova.

For Greuze, that final moment is not a moment at all. Whether cloyingly happy or terrifyingly sad, that moment occurs as the culmination and completion of a family history coterminous with the sense of the life we see coming to a close. Without the weight of a past recalled by the presence or

absence of other family members, Greuze's paintings have no meaning. At the level of their most fundamental semiosis, his images contradict everything the spokespersons of the moment have shown us. Defining the final sense of life as a function of the family's continuity, Greuze affirms within a context of maximum sentimentality that the moment holds no meaning outside the story of which it is a part.

Greuze's deathbed moralities represent an appropriate end to the recognitions of the moment I have tried to describe in these pages. Why, the question becomes, is Greuze's reduction of the moment to the service of story so much more comprehensible for us than the celebrations of the moment I have examined here? Why, put differently, are we so far removed from the Enlightenment's sense of the moment that we grasp it only with the tentativeness of an archeologist examining artifacts from a culture so distant that they disintegrate into meaningless shards?

The beginning of an answer to that question lies in what we saw to be the relation between Greuze's family moralities and David's icons of republican virtue. Both artists, in spite of their differences, rely on a shared reference to a larger and distinctly narrative context for the successful comprehension of their work. Their didactic ambitions demand that the spectator perceive the image not as self-sufficient moment, but as an episode within some larger history. The relation of image to story is a relation of part to whole. The visual image simultaneously refers to, validates, and strengthens its sustaining narrative context. For Greuze, the relevant story was some version of the parent-child relation, its felicities and pathologies. For David, the relevant story was the much larger context of a civic and republican universalism.

It is, I would argue, precisely within this enlarging of the relevant narrative context as we pass from Greuze to David that we begin to understand the reasons for the moment's demise. What most characterizes our modernity is the expansion and multiplication of the relevant contexts in whose terms we are asked to define the sense of the moments making up our existence. All such contexts become real for us, summon us to participate in them, and thereby redefine our sense of ourselves only to the extent they are incarnated in and given force by implicit narratives in which we become actors. The triumph of democracy, the victory of the proletariat, the struggle for universal equality, and the extension of the free market system are only a few of the many and often contradictory narratives in terms of which individuals have been called upon to understand and define the succession of moments making up their lives. All such contexts and the ideals they repre-

sent are able to inflect individual existence only to the extent they become stories of which we are the chapters.

* * *

The Enlightenment was, in a metaphoric but also real sense, a light perceived through the gap between two narratives and two ideologies, one waning and the other waxing, that defined its beginning and end. It was as the ideology of a divine providence reconciling God, king, and subject gave way that the Enlightenment began. Likewise, it was as a new ideology of progress summoned all to participate in its still-to-be-written narrative of secular salvation that the Enlightenment came to an end.

Standing outside these two versions of coercive synthesis, the Enlightenment was an age without a single unifying context, without a single unifying narrative, and without a single unifying ideology. Renouncing the drive toward any integrating system, Enlightenment culture flowed instead from a unique and abiding fascination with the multiple, chaotic, and subversive fruits of the moment. Its celebration of the passing instant in all its forms established that period as an elaboration of new forms of non-coercive conviviality, of literary representations recognizing the idiosyncracy of the individual, and of artistic practices privileging the viewer's sensual perception over the constraints of narrative invention. The Enlightenment redefined the way all were invited to understand such fundamental endeavors as the expression of desire, the quest for happiness, and the securing of social justice. Recognizing the relativity of all established norms, the Enlightenment embraced a diversity of previously unutterable epistemologies all of which looked to the epiphanies of the moment as the grounding of their modest yet exhilarating constructions. As a series of moments with no single story to tell, the Enlightenment declared itself instead the sum of its disconnected experiences of the moment as an instance of freedom and indeterminacy that made everything possible yet nothing inevitable.

If any single trait summarizes the heteroclite culture we call the Enlightenment, it is its recognition of the moment and of chance as forces at work in every human enterprise. It was no longer the chance that had been refused as a scandalous affront to the universality of God's plan for creation and not yet the chance that would be dismissed as the residue of a human ignorance soon to disappear before the progress of scientific knowledge. The sense of chance at the core of the Enlightenment was a chance seen as inseparable

from the human condition, a chance which recognized the force of the moment as the ultimate temporality of our happiness as well as our suffering.

If attempts to describe chance's moment tend to become a poetry of counterpoised antinomies, it is because, like the remnants of some lost culture, they find no fit within the expansion of narrative contexts that has only intensified during the centuries separating us from the Enlightenment. The individual consciousness finds itself ever more mediated by the multiplication of information and the proliferation of contexts generated by the press, radio, film, television, and the vast new technologies of digital communication. Living with and through these media, we are constantly enjoined to define *our* position through reference to stories told of what is happening in every precinct of the globe and beyond. These countless narratives have produced a cacophony of interpellations to which no individual can hope to be adequate in any effective sense. Besieged by stories and contexts rarely of our making but always of our responsibility, the perception of our lives as perhaps the sum but never the story of our moments of freedom, happiness, desire, and suffering becomes a contradiction of all we are told we must be. Rendered uneasy by the ubiquitous proofs of our inadequacy to the contexts thrust upon us, we fabricate yet more narratives of our own exculpation and victimage. Those stories, enlisting others as their adherents if they are to be validated and our pain recognized, demand that the cure for our ills come by inflicting on others that from which we suffer. Caught in a spiral of ever greater proportions, we forget even the possibility of the moment. As ever more numerous stories solicit our credence, the conflict among their competing versions of the nomological reduces to nothing the faint whispers of the moment and its ontology.

What has been lost with the Enlightenment's sense of the moment is a dimension of our liberty. With its passing has gone our freedom, in the heat of the moment and without a moment's notice, to live and to choose differently than as the plethora of narratives asking us to define ourselves through their imperatives would dictate. The moment is the temporality of a freedom that refuses the responsibilities flowing from all those impersonal ideals that would enlist us as their instruments. To live for the moment is, in a sense that expression has now all but totally lost, to risk the present. Its successes and failures, as well as our exaltations and dejections, are the only refuge from those storied pasts and futures drawing ever tighter limits around the freedom of our present.

NOTES

Introduction

1. *Enlightenment and the Shadows of Chance: The Novel and the Culture of Gambling in Eighteenth-Century France* (Baltimore: Johns Hopkins University Press, 1993).

2. *Principien der Wahrscheinlichkeitsrechnung* (Tübingen: J.C.B. Mohr, 1927).

3. *The Unbearable Lightness of Being* (New York: Harper & Row, 1984), 48.

4. *Pensées de Pascal*, ed. Léon Brunschvicg (Paris: Garnier, 1961), 119–20.

Chapter One. Versions of the Moment

1. Jean-Jacques Rousseau, *Confessions*, in *Oeuvres complètes*, ed. Bernard Gagnebin and Marcel Raymond, 5 vols. (Paris: Gallimard, Bibliothèque de la Pléiade, 1959–95), 1:290.

2. This quotation is from Rivarol, *Discours préliminaire du nouveau dictionnaire de la langue française*, a text first published when he was in exile in Hamburg in 1797. See *Rivarol*, ed. Jean Dutourd (Paris: Mercure de France, 1963), 124.

3. Denis Diderot, "Prospectus," in *Oeuvres complètes*, ed. Herbert Dieckmann, Jacques Proust, and Jean Varloot, 25 vols. (Paris: Hermann, 1975–90), 5:91.

4. *Mémoires secrets de Bachaumont*, ed. Adrien Van Bever, 2 vols. (Paris: Louis-Michaud, 1912), 2:172.

5. *L'Ardeur et la galanterie* (Paris: Gallimard, 1986), 103.

6. *Les Masques fragiles: esthétique et formes de la littérature rococo* (Lausanne: L'Age d'Homme, 1991), 74.

7. These examples are taken from Pierre Larthomas, in his *Le Théâtre en France au dix-huitième siècle* (Paris: Presses Universitaires de France, 1980), 66. See also on the *parades* and their cultural significance, Thomas E. Crow, *Painters and Public Life in Eighteenth-Century Paris* (New Haven, Conn.: Yale University Press, 1985), 48–54.

8. See, for instance, *La Surprise de l'amour* and *La Seconde Surprise de l'amour*.

9. *Les Effets surprenants de la sympathie*, in *Oeuvres de Marivaux*, 12 vols. (Paris: Duchesne, 1781), 5:484.

10. *La Dispute*, scene 15, in *Théâtre complet* (Paris: Seuil, 1964), 513.

11. *Le Triomphe de l'amour*, act I, scene 6, in *Théâtre complet*, 307.

12. *Le Spectateur français* (Paris: Duchesne, 1761), 2:232–33.

13. Act I, scene 4, in *Théâtre complet*, 359.

14. *La Vie de Marianne*, ed. Frédéric Deloffre (Paris: Garnier, 1963), 377.

15. First published in Latin, this text was translated into French under a num-

ber of different titles—*La Satyre sotadique de Luis Sigea*, *La Satyre sotadique*, *Les Discours de Luisa Sigea*, and *Le Meursius français*—their profusion undoubtedly resulting from attempts to escape censorship.

16. *Geometry in the Boudoir: Configurations in French Erotic Narrative* (Ithaca, N.Y.: Cornell University Press, 1994), 92. This study, although primarily devoted to Sade, offers an interesting if rapid treatment of the genre's earlier history.

17. *Le Hasard du coin du feu*, in *Oeuvres de Crébillon fils*, ed. Pierre Lièvre, 5 vols (Paris: Le Divan, 1929–30), 1:209.

18. *Un Homme aimable*, cited in Patrick Wald Lasowski, *Libertines* (Paris: Gallimard, 1980), 29.

19. For an analysis of how this restriction relates to the aristocratic culture for which Crébillon wrote, see my chapter "Crébillon's Game of Libertinage" in *Enlightenment and the Shadows of Chance*, 198–228.

Chapter 2. Lahontan and the Moment Between Cultures

1. After a long period of neglect when only the *Dialogues* remained in print, the efforts of Réal Ouellet have produced a new and well-documented edition of the whole of Lahontan's work as well as a wealth of collateral documents. See *Oeuvres complètes de Lahontan*, 2 vols. (Montréal: Presses de l'Université de Montréal, 1990). All quotations from Lahontan's works will be cited in parentheses in the text according to this edition. I have used the English translation which appeared in London in 1703, the same year as the works' first French publication. This translation has been re-edited by Stephen Leacock as *Lahontan's Voyages* (Ottawa: Graphics Publishers Limited, 1932).

2. Letter from Brouillan of December 14, 1693, cited in Lahontan, *Oeuvres complètes*, 2: 1141.

3. Letter from Leibniz, cited in Lahontan, *Oeuvres complètes*, 2:1150.

4. When Adario addresses the same question in the *Dialogues*, his response is a similar concatenation of verbs. "He ought to be expert in marching, hunting, fishing, waging war, ranging the forests, building huts and canoes, firing guns, and shooting arrows. He ought to be indefatigable and able to live on short rations upon occasion. In a word he ought to know how to go about all the exercises of the Hurons," *Oeuvres complètes*, 2:851.

5. *Mémoires pour l'histoire des sciences et des beaux arts* of July 1703, 1110, cited in Lahontan, *Oeuvres complètes*, 2:1183.

6. *Nouvelles de la République des lettres*, January 1703, 91, cited in *Sur Lahontan, comptes rendus et critiques*, ed. Réal Ouellet (Québec: Editions l'Hêtrière, 1983), 36.

7. See the essay "Des cannibales" and its treatment of the Indians of Brazil.

8. Caillois defines this concept as follows: "What I call the sociological revolution is the mental attitude which consists in pretending to be foreign to the society in which one lives, and looking at it from the outside as though seeing it for the first time." *Rencontres* (Paris: Presses Universitaires de France, 1978), 92.

9. Cited in *Sur Lahontan, comptes rendus et critiques*, 106.

10. "L'altération du récit: les *Dialogues* de Lahontan," *Etudes Françaises* 22, no. 2 (1986), 76.

11. For a son, this control extended to the age of thirty, before which time the father could disinherit him if he married without his consent.

Chapter 3. Diderot and the Epicurean Moment

1. "Epicuréisme" in *Oeuvres complètes*, 14 : 268. All subsequent quotations from this article will be followed by parentheses enclosing the page reference according to this edition.

2. The exact page references for the various passages from Brucker that Diderot used in composing his article are given by John Lough and Jacques Proust, the editors of this volume of the *Oeuvres complètes*, as notes to pages 267 and 268. They show clearly how freely Diderot not only recast but reorganized the material from his source.

3. On this subject, see Jeffrey Mehlman, *Cataract: A Study in Diderot* (Middletown, Conn.: Wesleyan University Press, 1979).

Chapter 4. Graffigny's Epiphany of the Moment

1. *Lettres d'une Péruvienne*, in *Lettres portugaises, Lettres d'une Péruvienne, et autres romans d'amour par lettres*, ed. Bernard Bray and Isabelle Landy-Houillon (Paris: Garnier-Flammarion, 1983), 257. For the English translations I have followed both the 1758 English translation that appeared in London of the 1747 (and therefore incomplete in relation to the 1752 edition) version of the novel, *Letters Written by a Peruvian Princess* (New York: Garland Press, 1974) as well as David Kornacker's recent translation titled *Lettres from a Peruvian Woman* (New York: Modern Language Association, 1993). For an interesting critique of that translation, see David Smith, "Graffigny Rediveva," *Eighteenth-Century Fiction* 8, no. 2 (October 1994), 71–78.

2. For an extensive discussion of the the *Lettres'* publication history, see English Showalter, "*Les Lettres d'une Péruvienne*: composition, publication, suites" in *La Communication par l'imprimé au dix-huitième siècle*, 54, no. 1–4 (Brussels: Archives et Bibliothèque de Belgique, 1983), 14–28.

3. For a discussion of other contemporary reactions to Graffigny's novel by Abbé Raynal, Pierre Clément, Elie Fréron, and Joseph de La Porte, see Janet Gurkin Altman, "A Woman's Place in the Enlightenment Sun: The Case of F. de Graffigny," *Romance Quarterly* 83 (1991), 261–73.

4. Turgot to Mme. de Graffigny, cited in *Lettres d'une Péruvienne*, ed. Gianni Nicoletti (Bari: Adriatica Editrice, 1967), 459.

5. Pierre Hartmann argues convincingly that Turgot was responding not to the 1747 version of Graffigny's novel, but to her manuscript for the augmented version of 1752 which contained far more explicit criticism of French society. See "Turgot lecteur de Mme. de Grafigny" in *Vierge du soleil/fille des lumières: la Péruvienne*

de Mme. de Grafigny et ses suites (Strasbourg: Presses Universitaires de Strasbourg, 1989), 121.

6. Louis Etienne, "Un Roman socialiste d'autrefois," *La Revue des Deux Mondes* 94 (July 15, 1871), 454. This article is also reproduced as an appendix to Nicoletti's 1967 edition of the *Lettres*.

7. See David Smith, "The Popularity of Mme de Graffigny's *Lettres d'une Péruvienne*: The Bibliographical Evidence," *Eighteenth-Century Fiction* 3, no.1 (October 1990), 1–20. While Smith hazards no explanation for the novel's fall from popularity after 1835, Janet Gurkin Altman offers the politically correct but only partially satisfying hypothesis that the French could hardly be sympathetic readers of Zilia's story when, simultaneously, they were beginning the construction of their colonial empire in Algeria and the first generation of women raised under the patriarchal Napoleonic Code was coming of age. This hypothesis does not address the fact that mid-eighteenth-century France had considerable if frustrated colonial ambitions in North America. It also says little of the drop in the number of translations published outside France after 1835.

8. See Vivienne Mylne, *The Eighteenth-Century French Novel* (Manchester: Manchester University Press, 1965), 148.

9. *Le Roman jusqu'à la Révolution* (Paris: Armand Colin, 1967).

10. Susan Lee Carrell, *Le Soliloque de la passion féminine ou le dialogue illusoire: étude d'une formule monophonique de la littérature épistolaire* (Tübingen: Gunter Narr Verlag, 1982), 92.

11. Nicoletti's edition (see note 4) appeared in 1967 from a small Italian press and at least made the novel available outside the rare book rooms of research libraries.

12. Nancy K. Miller, *The Heroine's Text: Readings in the French and English Novel, 1722–1782* (New York: Columbia University Press, 1980) as well as "The Knot, the Letter and the Book: Graffigny's *Peruvian Letters*" in *Subject to Change: Reading Feminist Writing* (New York: Columbia University Press, 1988), 125–61 and "Men's Reading, Women's Writing: Gender and the Rise of the Novel," *Yale French Studies* 75 (September 1988), 40–55. See also Jack Undank's "Grafigny's Room of Her Own," *French Forum*, 13, no. 3 (Spring 1988), 297–318.

13. See *"Les Lettres d'une Péruvienne* dans l'histoire du roman épistolaire" in *Vierge du soleil/fille des lumières*, 93.

14. "Graffigny's Epistemology and the Emergence of Third-World Ideology" in *Writing the Female Voice: Essays on Epistolary Fiction*, ed. Elizabeth C. Goldsmith (Boston: Northeastern University Press, 1989), 172.

15. *Encylopédie*, 2:44.

16. Garcilaso de la Vega, El Inca, *Royal Commentaries of the Incas and General History of Peru*, trans. Harold V. Livermore (Austin: University of Texas Press, 1966), xi.

17. Elizabeth MacArthur, "Devious Narratives: Refusals of Closure in two Eighteenth-Century Epistolary Novels," *Eighteenth-Century Studies* 21, no. 1 (Fall 1987), 18.

18. The quipus' intersection of the materially numeric and a memorized discourse could become problematic, especially when, in the wake of the Spanish conquest, they were used to represent concepts from that new culture. Referring to an

explanation of the Christian doctrine of the Trinity, Garcilaso recounts how "instead of God three in one, he said God three and one makes four, adding the numbers in order to make himself understood," *Royal Commentaries*, 682.

19. Martha Ascher and Robert Ascher, *The Code of the Quipu* (Ann Arbor: University of Michigan Press, 1981). Even so eminent an anthropologist of pre-Columbian cultures as John R. Swanton could not, in 1943, resist the same leap of faith we find in Graffigny's assumptions about the nature of the quipus. Deciding that the physical evidence must be incomplete and that Garcilaso was wrong, Swanton argued that the Incas' considerable accomplishments in agriculture, medicine, and statecraft make it unthinkable that they not have had a writing system: "Something of the kind [i.e. a writing system] is called for by the accomplishments in other fields of the people who employed it. It is demanded by the very splendor of the Andean civilization as a whole." See John R. Swanton, *The Quipu and Peruvian Civilization*, Anthropological Papers 26. Smithsonian Institution, Bureau of American Ethnology, Bulletin 596 (Washington, D.C.: U.S. Government Printing Office, 1943). The Ascher study makes it clear, however, that that demand cannot be met.

20. A number of critics have pointed out that Zilia's ideal of a final peace within a sentient self-containment anticipates a posture more often associated with Rousseau's *Julie* and the fifth of his *Rêveries du promeneur solitaire*. See Henri Coulet, *Le Roman jusqu'à la Révolution* (Paris: Armand Colin, 1967), 383; Jürgen v. Stackelberg, "Madame de Grafigny, Lamarch-Courmont et Goldoni: 'La Peruviana' comme 'réplique littéraire'" in *Mélanges à la mémoire de Franco Simone: France et Italie dans la culture européenne* (Geneva: Slatkine, 1980), 520; and Joan DeJean in her introduction to the *Lettres* (New York: Modern Language Association, 1993), xvi.

Chapter 5. Rousseau's Moment Beyond History

1. For a fuller discussion of the circumstances of this moment, see volume one of Maurice Cranston's biography of Rousseau, *Jean-Jacques: The Early Life and Work of Jean-Jacques Rousseau, 1712–1754* (New York: W.W. Norton, 1983), 227–30.

2. *Lettres à Malesherbes*, in *Oeuvres complètes*, 1:1135. Subsequent quotations from this work will be cited parenthetically in the text. Emphasis mine.

3. *Discours sur l'origine de l'inégalité*, in *Oeuvres complètes*, 3:122. Subsequent quotations from this work will be cited parenthetically in the text. The translations follow that of Roger D. Masters and Judith R. Masters in *The First and Second Discourses* (New York: St. Martin's Press, 1964).

4. Georges Poulet offers an excellent description of savage man's limitation to the present: "He exists entirely within the present moment, because there are no others. If there are no others, it is because the plenitude of each moment fills his soul within each moment, leaving no incompletion and therefore no desire to return to a better past or to anticipate a more seductive future." *Etudes sur le temps humain* (Paris: Plon, 1949), 163.

5. For two excellent and in many ways complementary discussions of imagination's relation to consciousness and language in Rousseau, see Jacques Derrida, *De la Grammatologie* (Paris: Editions de Minuit, 1967), 235–377 and Paul de Man,

Allegories of Reading: Figural Language in Rousseau, Nietzsche, Rilke, and Proust (New Haven, Conn.: Yale University Press, 1979), 160–88.

6. *Les Rêveries du promeneur solitaire*, in *Oeuvres complètes*, 1:995. Subsequent quotations from this work will be cited parenthetically in the text. The translations follow those of Charles E. Butterworth in *The Reveries of the Solitary Walker* (New York: New York University Press, 1979).

7. For an analysis of the impossible discursive enterprise at the heart of the *Dialogues* see Michel Foucault's Introduction to the 1962 Armand Colin edition of the *Dialogues*. That text has been reprinted in *Michel Foucault: dits et écrits, 1954–1988*, 3 vols., ed. Daniel Defert and François Ewald (Paris: Gallimard, 1994), 1:172–88.

8. Jean Starobinski has succinctly captured the shape of this enterprise with his observation that: "The act of writing becomes happy for Jean-Jacques only from the moment he no longer addresses any audience outside himself." See *Jean-Jacques Rousseau: la transparence et l'obstacle* (Paris: Gallimard, 1971), 171. See also on this subject, François Roustang's "L'Interlocuteur du solitaire" in *Individualisme et autobiographie en Occident*, ed. Claudette Delhez-Sarlet and Maurizio Catani (Brussels: Editions de l'Université de Bruxelles, 1983), 167–76.

9. For analyses of the complex foundations of the self-sufficient happiness described in *Les Rêveries* and its relation to other aspects of Rousseau's works, see Bronislaw Baczko, *Rousseau: solitude et communauté* (Paris: Presses Universitaires de France, 1974) and Raymond Trousson, *Jean-Jacques Rousseau: heurs et malheurs d'une conscience* (Paris: Hachette, 1993).

Chapter 6. Casanova and the Moment of Chance

1. "The history of philosophy begins with a death notice: the disappearance of the ideas of chance, disorder, and chaos." Clément Rosset, *Logique du pire* (Paris: Presses Universitaires de France, 1971), 9.

2. For a reading of Casanova's choice of *la lingua francese* as *lingua franca*, see Jay Caplan, "Vicarious *Jouissances*: or Reading Casanova," *MLN* 100 (September 1985), 803–14.

3. Happily, the unavailability in French of Casanova's work as he wrote it was remedied in 1994 when Lafont republished the Brockhaus-Plon version in its inexpensive Bouquin series. It is a compliment to American scholarship that by the late 1960s a complete and high-quality translation of Casanova's original French text was available in English. See *History of My Life*, trans. Willard R. Trask, 6 vols. (New York: Harcourt, Brace, & World, 1966–1968).

4. *Une insolente liberté: les aventures de Casanova* (Paris: Gallimard, 1983), 10.

5. *Le Bal masqué de Giacomo Casanova* (Paris: Editions de Minuit, 1984), 173. This text has been translated by Anne C. Vila as *The Quadrille of Gender: Casanova's "Memoirs"* (Stanford, Calif.: Stanford University Press, 1988). Strangely enough, the closing postscript from the French version is omitted from the English translation.

6. *Histoire de ma vie*, 12 vols. (Weisbaden and Paris: Brockhaus and Plon, 1960–1962), 8:179. All subsequent quotations from Casanova's *Histoire* will be indi-

cated according to this edition. The translations follow Willard R. Trask's English edition of 1966–68.

7. *Mémoires, lettres et pensées* (Paris: Editions François Bourin, 1989), 776.

8. *Casanova ou la dissipation* (Paris: Grasset, 1961), 39.

9. 2 vols. (Amsterdam [Lugano]: Chez Pierre Mortier, 1769), 2:224–30.

10. See *Casanova: un voyage libertin* (Paris: Denoël, 1985), 16.

11. Robert Abirached as well as Stefan Zweig in his *Adepts in Self-Portraiture: Casanova, Stendhal, Tolstoy,* trans. Eden Paul and Cedar Paul (New York: Viking Press, 1928) are examples of the first attitude. As for those exonerating him, not entirely convincing defenses of Casanova the gambler can be found in J. Rives Childs, "Casanova as Gambler," *Casanova Gleanings* 3 (1960), 4–14 and Francis-L. Mars, "Casanova et le Pharaon," *Cerf-Volant* (October 1960), 22–26.

12. On the history of probability theory, see Lorraine Daston's *Classical Probability Theory in the Enlightenment* (Princeton, N.J.: Princeton University Press, 1988).

13. Quoted in Philip Longworth, *The Rise and Fall of Venice* (London: Cornstable, 1974), 272.

14. See on this subject the chapter "Gambling as Social Practice" in my *Enlightenment and the Shadows of Chance,* 29–66.

15. The *Encyclopédie* article "Combinaison" and its exposition of what we would today call probability theory provides an excellent illustration of that science's growing semantic impact on a wide range of pre-existing philosophical terms. See *Encyclopédie,* 1:648.

Chapter 7. De Piles and the Moment's Glance

1. On the growing importance of a public audience for the practice of painting, see Thomas E. Crow, *Painters and Public Life in Eighteenth-Century Paris,* 48–55.

2. *Word and Image: French Painting of the Ancien Régime* (Cambridge: Cambridge University Press, 1981), 29.

3. *The Fronde: A French Revolution* (New York: W.W. Norton, 1993).

4. *Roger de Piles et les débats sur le coloris au siècle de Louis XIV* (Paris: Bibliothèque des Arts, 1957), 23.

5. Quoted by Teyssèdre from a late seventeenth-century *Relation* describing the ambitions of the Academy in its earliest years. See *Roger de Piles,* 15.

6. For a study of the relation between the theory of painting and rhetoric throughout this period see Jacqueline Lichtenstein, *La Couleur éloquente: rhétorique et peinture à l'âge classique* (Paris: Flammarion, 1989) which has been translated as *The Eloquence of Color: Rhetoric and Painting in the French Classical Age* (Berkeley: University of California Press, 1993).

7. *Mémoires, contes et autres oeuvres,* ed. P. L. Jacob (Paris: C. Gosselin, 1843), 308.

8. Cited by Jean-Marie Apostolidès in *Le Roi-Machine: spectacle et politique au temps de Louis XIV* (Paris: Editions de Minuit, 1981), 145.

9. *L'Art de peinture de Charles Alphonse Dufresnoy, traduit en français avec des*

remarques très nécessaires et très amples, [1668] second edition (Paris: Langlois, 1673), 135.

10. On this subject, see Thomas Puttfarken, *Roger de Piles' Theory of Art* (New Haven, Conn.: Yale University Press, 1985), 44.

11. Preface to *Idée de la perfection de la peinture demontrée par les principes de l'art* (Le Mans: Ysambard, 1662).

12. *Entretien sur les vies et les ouvrages des plus excellents peintres anciens et modernes* [1666–1668] (Trévoux: Imprimerie de S.A.S., 1725), 82.

13. *La Couleur éloquente*, 172.

14. "L'Expression générale et particulière," in Henri Jouin, *Conférences de l'Académie royale de peinture et de sculpture* (Paris: A. Quantin, 1883), 154–55.

15. For a study of the responses to this question from Bellori in the late seventeenth century to the end of the eighteenth century, see Francis H. Dowley, "The Moment in Eighteenth-Century Art Criticism," *Studies in Eighteenth-Century Culture* 5 (1976), 317–36.

16. *Cours de peinture par principes* [1708] (Paris: Gallimard, 1989), 8.

17. *Conversations sur la Connoissance de la Peinture* (Paris: 1677), 77.

18. "Dissertation sur les parties essentielles de la peinture," republished in *Revue Universelle des Arts* 18 (1863), 188–211.

19. *Oeuvres de Pascal*, ed. Léon Brunschvicg, 14 vols. (Paris: Hachette, 1904), 12:12.

20. See on this subject Alfred Bäumler, *Das Irrationalitätsproblem in des Asthetik und Logik des achtzehnten Jahrhunderts bis zur Kritik der Urteilskraft* [1923] (reprint: Darmstadt: Wissenschaftliche Buchgesellschaft, 1975) and Erich Köhler, "'Je ne sais quoi'—Zur Begriffsgeschichte des Unbegreiflichen," in *Esprit und Arkadische Freiheit. Aufsätze aus der Welt der Romania* (Frankfurt and Bonn: Athenum Verlag, 1966), 230–86.

21. Denis Diderot, *Salons*, ed. Jean Seznec and Jean Adhémar, 2 vols. (Oxford: Oxford University Press, 1959), 1:223.

Chapter 8. Du Bos, Poussin, and the Moment's Force

1. For more detailed analyses of Du Bos's relation to this philosophical current, see Ernst Cassirer, *The Philosophy of the Enlightenment*, trans. Fritz C. A. Koelln and James P. Pettegrove (Princeton, N.J.: Princeton University Press, 1951), 322–25; Jacques Chouillet, *L'Esthétique des Lumières* (Paris: Presses Universitaires de France, 1974), 40–47; and Rémy G. Saisselin, *Taste in Eighteenth-Century France* (Syracuse, N.Y.: Syracuse University Press, 1965), 63–71.

2. *Réflexions critiques sur la poésie et sur la peinture* [1719] (Geneva: Slatkine Reprints, 1967), 2.

3. See "Towards a Theory of Reading in the Visual Arts: Poussin's *The Arcadian Shepherds*," in *Calligram: Essays in New Art History from France*, ed. Norman Bryson (Cambridge: Cambridge University Press, 1988), 68.

4. See Jacques Thuillier, *Nicolas Poussin* (Paris: Fayard, 1988), 149; Pierre Ros-

enberg, *Nicolas Poussin 1594–1665* (Paris: Réunion des Musées Nationaux, 1994), 281; Christopher Wright, *Poussin's Paintings: A Catalogue Raisonné* (London: Hippocrene Books, 1985), 189; and Erwin Panofsky's "Et in Arcadia Ego: On the Conception of Transcience in Poussin and Watteau" in *Philosophy and History: Essays Presented to Ernst Cassirer*, ed. Raymond Klibansky and H. J. Paton (Oxford: Clarendon Press, 1936), 236–38. A shorter version of this same essay, dealing only with Poussin, was later published as a chapter in Panofsky's *Meaning in the Visual Arts: Papers in and on Art History* (Garden City, N.Y.: Doubleday, 1955).

 5. *Nicolas Poussin* (New York: Pantheon Books, 1967), 127.

 6. Panofsky makes the point in his 1936 version of "Et in Arcadia Ego . . . ," 232 that, according to the rules of Latin grammar, the initial *et* should modify *in Arcadia* and not *ego*, thus making it death who is speaking. Finally, however, he takes the position that both translations are consonant with the changed intent of the two paintings. See also on this point David Carrier, *Poussin's Paintings: A Study in Art-Historical Method* (University Park: The Pennsylvania State University Press, 1993), 29.

 7. See *Détruire la peinture* (Paris: Galilée, 1977), 82–114

 8. See *Regarder Ecouter Lire* (Paris: Plon, 1993), 18–22.

 9. In his article "On the Critical Fortunes—and Misfortunes—of Poussin's 'Arcadia,'" *Burlington Magazine*, 121 (February 1979), 95–107 Richard Verdi shows that Du Bos's was only one in a long line of "misdescriptions" of Poussin's painting—descriptions that correspond neither to the Chatsworth nor to the Louvre version, but to Du Bos's text. That lineage includes Diderot writing in 1758, the Abbé Delille in 1782, Joseph Droz in 1815 and Alexandre Lenoir in 1821. Verdi offers the convincing hypothesis that Du Bos may have taken as Poussin's work a painting of 1686 by Aelbert Mayering, one of Poussin's Dutch imitators, which does depict shepherds visiting a tomb on which there is a female *gisant* (97, note 26). The influence of Du Bos's work throughout the eighteenth century can also be seen in the fact that the Chevalier de Jaucourt, in his article for the *Encyclopédie* entitled "Paysagiste," offers an analysis of Poussin's *Arcadian Shepherds* which is a word-for-word copying of Du Bos's text, eccentric description and all. See also the article by Thomas Bauman, "Moralizing at the Tomb: Poussin's Arcadian Shepherds in Eighteenth-Century England and Germany," in *Opera and the Enlightenment*, ed. Thomas Bauman and Marite Petzoldt McClymonds (Cambridge: Cambridge University Press, 1995), 23–42 for an examination of how, in an age before museums, Du Bos's prose description exercised a far greater influence on opera than did either of the two actual paintings.

 10. We do have evidence that spectators reacted in a quite similar way to the actual Chatsworth version of Poussin's painting once it became more widely known through the Ravenet engraving of 1763. Thomas Bauman quotes a German correspondent who saw a copy of the engraving in London that year and described it for the readers of Christian Felix Weisse's *Bibliothek der schönen Wissenschaften und der freyen Künste* as portraying shepherds who "are suddenly moved in an instant in which they entertained anything but melancholy thoughts . . . there radiates from their faces great confusion and disquiet [eine grosse Bestürzung und Unruhe]," *Opera and the Enlightenment*, 26.

Chapter 9. Watteau's Incarnate Moment

1. Edmond and Jules de Goncourt, *L'Art du XVIIIième siècle*, 3 vols. (Paris: Fasquelle, 1912), 1:80.

2. "La Vie de Watteau," reprinted in *Notes critiques sur les vies anciennes d'Antoine Watteau*, ed. Pierre Champion (Paris: Edouard Champion, 1921), 75–114, 100–101.

3. The most complete description of the circumstances surrounding Watteau's admission to the Academy can be found in Edouard Michel, Mme. Robert Aulanier, and Hélène de Vallée, *Watteau: l'embarquement pour l'Ile de Cythère* (Tours: Editions des Musées Nationaux, 1939). See also the more recent *Jean-Antoine Watteau: Einschiffung nach Cythera l'Ile de Cythère* (Frankfurt am Main: Stadtische Galerie im Stadeleschen Kunstinstitut, 1982).

4. See Robert Tomlinson, *La Fête galante: Watteau et Marivaux* (Geneva: Droz, 1981).

5. An important exception to this preference can be found in Donald Posner, *Antoine Watteau* (Ithaca, N.Y.: Cornell University Press, 1984), 195.

6. See "The Real Theme of Watteau's *Embarkation for Cythera*," *Burlington Magazine* 103 (1961), 180–85.

7. See "*L'Embarquement pour Cythère* de Watteau, au Louvre," *Gazette des Beaux-Arts* 45 (1955), 91–102. I speak of "what seemed to be" this work's autumnal atmosphere because the cleaning of the painting in the early 1980s and the removal of several coats of yellowed varnish revealed an image which is almost springlike. See on this subject Margaret Morgan Grasselli and Pierre Rosenberg, *Watteau, 1684–1721* (Washington, D.C.: National Gallery of Art, 1984), 460–64. For further repercussions of this exhibition, see *Antoine Watteau, 1684-1721: le peintre, son temps et sa legende*, ed. François Moureau and Margaret Morgan Grasselli (Geneva: Slatkine, 1987).

8. See "*Pellegrinaggio a Citera*, 'Fête galante' o 'danse macabre,' " *Paragone* 331 (1977), 9–22.

9. See the chapter "Die Sehnsucht nach Kythera" in *Rokokomalerei: sechs Studien* (Mittenwald: Maander, 1980). Bauer first made this argument in his earlier article "Wo liegt Kythera? Ein Deutungsversuch an Watteaus 'Embarquement,' " in *Wandlungen des Paradiesen und Utopischen [Probleme der Kunstwissenschaft, Bd. 2]* (Berlin: de Gruyter, 1966), 251–78.

10. *Watteau's Painted Conversations: Art, Literature, and Talk in Seventeenth- and Eighteenth-Century France* (New Haven, Conn.: Yale University Press, 1992), 32.

Chapter 10. Chardin and the Moment Beyond Nature

1. This chronology, with sometimes major variations, represents the consensus of scholarly opinion. See Albert Châtelet and Jacques Thuillier, *French Painting from Le Nain to Fragonard*, trans. James Emmons (Geneva: Skira, 1964); Georges Wildenstein, *Chardin*, ed. Daniel Wildenstein, trans. Stuart Gilbert (Oxford: Cas-

sirer, 1969); Pierre Rosenberg, *Chardin*, trans. Helga Harrison (Lausanne: Skira, 1963); Michael Levey, *Rococo to Revolution: Major Trends in Eighteenth-Century Painting* (New York: Praeger, 1966); and Philip Conisbee, *Chardin* (London: Phaidon, 1986).

2. *L'Art du XVIII siècle*, 1:104–6.

3. *Magasin Pittoresque* XVI (May 1848), cited by Pierre Rosenberg in *Chardin* (Paris: Editions de la Réunion des Musées Nationaux, 1979), 271.

4. *Histoire de l'Art*, 5 vols. (Paris: G. Cres, 1921), 4:226–27.

5. *La Nature morte en France: son histoire et son évolution du XVIIième au XXième siècle*, 2 vols. (Geneva: Pierre Cailler, 1962), 1:238.

6. "De la nature morte et de Chardin," in *Nouveau Recueil* (Paris: Gallimard, 1967), 171–72.

7. *Réflexions sur quelques causes de l'état présent de la peinture en France* [1747] (Geneva: Slatkine Reprints, 1970), 109.

8. *Absorption and Theatricality: Painting and Beholding in the Age of Diderot* (Berkeley: University of California Press, 1980), 49–50.

9. For a more detailed analysis of how Chardin's images were used in emblem-books of the period, see Donat de Chapeaurouge, "Chardins Kinderbilder und die Emblematik," *Actes du 22ième congrès d'histoire de l'art, Budapest 1969* (Budapest, 1972), 2:51–56 and Ella Snoep-Reitsma, "Chardin and the Bourgeois Ideals of His Time," *Nederlands Kunsthistorisch Jaarboek, 1973* 24 (1973), 147–243.

10. *Painters and Public Life in Eighteenth-Century Paris*, 137.

11. *Word and Image: French Painting of the Ancien Régime*, 119.

12. Diderot, *Salons*, 1:125.

13. "La Nature morte chez Chardin," *Revue d'Esthétique* 4 (1969), 369.

14. *Description raisonnée des tableaux exposés au Louvre*, cited by Rosenberg in *Chardin*, 80.

15. *Correspondance littéraire*, 16 vols. (Paris: Garnier, 1877), 1:464.

Chapter 11. Boucher, Fragonard, and the Moment's Seductions

1. Diderot, *Salons*, 2:75.

2. Helmut Hatzfeld, *The Rococo: Eroticism, Wit, and Elegance in European Literature* (New York: Pegasus Press, 1972), 23.

3. *Word and Image: French Painting of the Ancien Régime*, 92.

4. *La Peinture française de Le Nain à Fragonard* (Geneva: Skira, 1964), 249.

5. Edmond de Goncourt and Jules de Goncourt, *L'Art du XVIIIième siècle*, 3:299.

6. A typical example of this reaction can be found in François Fosca, *Le Dix-huitième siècle de Watteau à Tiepolo* (Geneva: Skira, 1952), 90–98.

7. See *Salons*, 2:188–98.

8. *Jean-Honoré Fragonard* (Fribourg, Switzerland: Office du Livre, 1987), 60.

9. In a note to their study of Fragonard, the Goncourts give a long quotation from the *Journal de Collé* where he first tells this story dating from October of 1766

of how Saint-Julien, after the painter Doyen refused him, offered the commission to Fragonard. See *L'Art du XVIIIième siècle*, 3:271–72.

10. For a different interpretation of this and the other statues and a close reading of these paintings' iconographic symbolism, see Wilibald Sauerländer, "Über die ursprüngliche Reihenfolge von Fragonards 'Amours des bergers,'" *Münchner Jahrbuch der Bildenden Kunst* 19 (1968), 147. Concerning this statue, for instance, Sauerländer sees love (the cupid) imploring the help of friendship (the female with the heart) as an allegory of the man's attempt to win over the woman who, via the letter, remains faithful to an absent letter writer. Sauerländer's somewhat compulsive interpretation then declares the dog at the foot of the pedestal as well as the parasol at the statue's base (useful whether it rains or shines) to be symbols of fidelity.

11. In the catalog for the Fragonard exhibition of 1987, Pierre Rosenberg signals the limited interest of the many elaborate arguments among art historians over what might be the correct ordering of these works: "For those who recognize Fragonard's taste for improvisation, his lack of concern for narrative exposition and exactitude, the idea of a *progression* in the series does not appear very convincing." See *Fragonard*, ed. Pierre Rosenberg (New York: Metropolitan Museum of Art, 1988), 323.

12. Mary D. Sheriff, *Fragonard: Art and Eroticism* (Chicago: University of Chicago Press, 1990), 82.

Chapter 12. Greuze and the Moment Foreclosed

1. Greuze's inseparability from Diderot continues to inform both exhibitions and scholarship on the artist. A few recent examples are *Greuze et Diderot: vie familiale et éducation dans la seconde moitié du XVIIIième siècle* (Clermond-Ferrand: Conservation des Musées d'art de la ville de Clermond-Ferrand, 1984); *Diderot et Greuze: actes du colloque de Clermond-Ferrand, 16 novembre 1984*, ed. Antoinette Erhard and Jean Ehrard (Clermond-Ferrand: Adosa, 1986); and Friedrich Sieburg, *Greuze und Diderot* (Zurich: Mannesse Verlag, 1989).

2. For an excellent study of the limits of Diderot's artistic education, see Georges Brunel, "Boucher, neveu de Rameau" in *Diderot et l'art de Boucher à David* (Paris: Réunion des Musées Nationaux, 1984), 101–9.

3. Michael Fried, *Absorption and Theatricality*, 91.

4. Diderot's reading of the chickens is not an exaggeration. In *Filial Piety*, the same echoing of the work's larger thematics can be seen in the puppies nursing at the lower right of the image.

5. Published in *Diderot et l'art de Boucher à David*, 40.

6. Cited in *Diderot et l'art de Boucher à David*, 236.

7. "L'Accordée de village, conte moral" *L'Année littéraire* 4 (September 27, 1761), 212–14.

8. *Oeuvres*, ed. Gustave Shelle (Paris: Alcan, 1913), cited in *Diderot et l'art de Boucher à David*, 251.

9. For an interesting psychoanalytic reading of Greuze's representations of

the family, especially the figure of the senescent father, see the chapter "Greuze and the pursuit of happiness" in Norman Bryson, *Word and Image: French Painting of the Ancien Régime*, 136–44.

10. This letter was published in the *Journal de Paris* on April 13, 1781. It is reproduced in Anita Brookner, *Greuze: The Rise and Fall of an Eighteenth-Century Phenomenon* (London: Paul Elek Limited, 1972), 76.

11. *Bazile et Thibault* was found in the papers of Caroline de Valory after her death. She was Greuze's niece or godchild and published one of the first biographies of the painter in 1813 as a preface to her comedy entitled *L'Accordée de village*. Mentioned by the baron Boutard as early as 1805 in the *Journal de l'Empire* of 11 Frimaire An XIV (December 2, 1805), this mansucript was first published under the title "Un Roman de Greuze" by Philippe de Chennevière in the *Annuaire des artistes* of 1861, 266–73. It was later published, along with an English translation, as an appendix to Brookner's *Greuze*, 156–64.

12. Brookner, *Greuze*, 160.

13. *Lettres d'un voyageur à Paris à son ami Charles Lovers, demeurant à Londres sur les nouvelles estampes de M. Greuze intitulées la "Dame bienfaisante," la "Malédiction paternelle" et sur quelques autres estampes d'après le même artiste* (Paris: 1779), 2–3.

14. For a helpful study of this series, see Sean Shesgreen, "Hogarth's *Industry and Idleness*: A Reading," *Eighteenth-Century Studies* 9, no. 4 (Summer 1976), 569–98.

15. Quoted in *Engravings by Hogarth*, ed. Sean Shesgreen (New York: Dover Publications, 1973), no page number, text accompanying Illustration 60.

16. On the importance to David's and his disciples' art of a combination of classical erudition and an intense pathos of familial bonds, see Thomas E. Crow, *Emulation: Making Artists for Revolutionary France* (New Haven, Conn., Yale University Press, 1995).

INDEX

294 Index